Visual Communication Research Designs

Keith Kenney

Routledge
Taylor & Francis Group

NEW YORK AND LONDON

First published 2009
by Routledge
270 Madison Ave, New York, NY 10016

Simultaneously published in the UK
by Routledge
2 Park Square, Milton Park, Abingdon, Oxon OX14 4RN

Routledge is an imprint of the Taylor & Francis Group, an informa business

© 2009 Taylor & Francis

Typeset in Galliard by
Keystroke, 28 High Street, Tettenhall, Wolverhampton
Printed and bound in the United States of America on acid-free paper by
Edwards Brothers, Inc.

Library of Congress Cataloging in Publication Data
Kenney, Keith.
Visual communication research designs / by Keith Kenney.
p. cm.
Includes bibliographical references and index.
1. Visual communication. 2. Visual communication—Research.
3. Research—Methodology. I. Title.
P93.5.K46 2009
302.2 22—dc22
2008025834

ISBN10: 0–415–98869–1 (hbk)
ISBN10: 0–415–98870–5 (pbk)
ISBN10: 0–203–93101–7 (ebk)

ISBN13: 978–0–415–98869–8 (hbk)
ISBN13: 978–0–415–98870–4 (pbk)
ISBN13: 978–0–203–93101–1 (ebk)

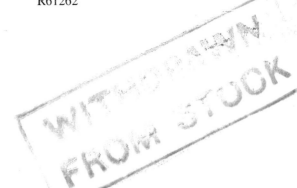
V̶i̶s̶u̶a̶l̶ ̶C̶o̶m̶m̶
Designs

Visual Communication Research Designs offers detailed guidance for using a variety of research methods to investigate visual communications. This book embeds each method—interview, draw-and-write, diary, Photovoice, case study, visual ethnography, focus group, discourse analysis, and content analysis—within a research design. Chapters begin with a brief, engaging story, such as:

- Why people really include visuals on Facebook.
- Why Picasso could draw but barely pass elementary school.
- How camera phones can be used for intimate communication.

They then address key research components for each method, such as theoretical perspective, units of analysis, sampling, data analysis, data display, quality control, advantages/disadvantages, ethical issues, and the resources needed to complete the research.

Author Keith Kenney provides a consistent voice as well as a variety of perspectives from eleven contributors, each describing his/her work on a particular research project. With this book, Kenney moves visual communication away from a medium-centered approach (such as television or film) to a communication-centered approach (including intrapersonal, interpersonal, group, organization, public, and mass communication).

Providing explicit, practical guidance in an accessible, understandable format, this book will facilitate more and better research about visual communication.

Keith Kenney (Ph.D. Michigan State University) is an associate professor in the School of Journalism and Mass Communications at the University of South Carolina. He is the founding editor of *Visual Communication Quarterly*, and he served as an editor of the *Handbook of Visual Communication*. He continues to shoot documentary-style photographs and videos.

Contents

Illustrations

Figures

Tables

Contributors

Aaron Ahuvia is a professor of marketing at the University of Michigan-Dearborn School of Management. He is former associate editor for the *Journal of Economic Psychology*. His research looks at consumers' involvement with products and services they love, as well as the nature of contemporary consumer culture. In addition to many academic publications, his research has been quoted in *Time*, *The New York Times*, *The Wall Street Journal*, major publications in Europe and Japan, and has appeared on public radio talk shows as well as popular television shows, such as *Oprah*.

Craig Denton is Professor of Communication at the University of Utah, where he directs the Documentary Studies Program and is on the Environmental Humanities faculty. He is the author and photographer of *Bear River: Last Chance to Change Course*, *People of the West Desert: Finding Common Ground*, and *West Desert: Photographs of Lake Bonneville Basin*, among other books. His current work, *Hidden Water*, photographically documents the uses and misuses of surface water in Salt Lake Valley.

Nicole Ellison is an assistant professor in the Department of Telecommunication, Information Studies, and Media at Michigan State University. Currently, she is exploring the social capital implications of Facebook use and the nature of "friends" online. Her previous research has examined the formation of virtual communities and the ways in which telecommuters use information and communication technologies to calibrate the permeability of their work/home boundaries, as explored in her 2004 book, *Telework and Social Change*.

Eric Green is a doctoral candidate in the Clinical and Community Psychology program at the University of South Carolina. Information about his research on forced migration can be found at www.displacedcommunities.org. Upon graduating he will begin a postdoctoral research fellowship at the NYU/Bellevue Program for Survivors of Torture in New York City.

Lars-Christer Hydén is Professor of Health Communication at Linköping University, Sweden. His main focus is on language and social interaction especially in health settings and the role of narrative in the cultural interplay

of illness and health. Ongoing research is concerned with narration in Alzheimer's disease and aphasia. He has, together with Sonja Olin Lauritzen, edited the book *Medical Technologies and the Life World: The Social Construction of Normality* and with Jens Brockmeier the book *Health, Illness, Culture: Broken Narratives*.

Keith Kenney is an associate professor in the School of Journalism and Mass Communications at the University of South Carolina. In 1994, he was the founding editor of *Visual Communication Quarterly*. He is an editor of *Handbook of Visual Communication*, published by Lawrence Erlbaum in 2005. He continues to shoot documentary-style photographs and videos.

Wendy Kozol is Professor of Comparative American Studies at Oberlin College. Her research and teaching interests include feminist theories and methodologies, visual culture studies, transnationalism and popular media, citizenship, militarization, and human rights activism. She is the author of *Life's America: Family and Nation in Postwar Photojournalism* and has co-edited two anthologies (with Wendy Hesford): *Haunting Violations: Feminist Criticism and the Crisis of the "Real"* and *Just Advocacy: Women's Human Rights, Transnational Feminism and the Politics of Representation*. She is currently working on a new book tentatively titled *Visible Wars and American Nationalism: Militarization and Visual Culture in the Post-Cold War Period*.

Lawrence J. Mullen is an associate professor in the Hank Greenspun School of Journalism and Media Studies at the University of Nevada Las Vegas. He teaches and conducts research in the related areas of visual communication and visual literacy.

Leysia Palen is an assistant professor in the Computer Science Department at the University of Colorado, Boulder, where she is also a faculty affiliate with the Technology, Learning and Society Institute (ATLAS), and the Institute for Cognitive Science (ICS). Professor Palen was awarded a 2006 National Science Federation Early CAREER grant to study information dissemination in disaster events. She works on a broader stream of research concerning computer-mediated interaction. She has been interviewed for articles in the *New Scientist*, *The New York Times*, the *Boston Globe*, *National Public Radio*, and other publications.

Carl Stafstrom, MD, PhD is Professor of Neurology and Pediatrics and Chief of the Section of Pediatric Neurology at the University of Wisconsin School of Medicine and Public Health, Madison. His research interests include mechanisms of epilepsy in the developing brain, cognitive consequences of seizures at different ages, dietary approaches to neurologic disease, and the use of art to explore psychosocial adjustment issues in children with neurologic disorders. He is the author of more than 200 scientific and medical articles, chapters, and commentaries. He is very active

in teaching medical students and residents and has received numerous teaching awards.

Rob Walker is Director of the Centre for Applied Research in Education at the University of East Anglia in the UK. His current research interests are in how university students learn from complex sets of case evidence, in involving children in the design of displays in museums and galleries, in the uses of visual evidence in research, and in the design of educational spaces.

David Weintraub is an instructor in the School of Journalism and Mass Communications at the University of South Carolina, where he teaches visual communications and writing. He is the author of eight books on hiking and kayaking in the San Francisco Bay Area and Cape Cod, and he has also written many newspaper and magazine articles on photography and adventure travel.

Acknowledgments

I thank my contributors, beginning with David Weintraub, who wrote a chapter, and the following people, who wrote sidebars: Aaron Ahuvia, Craig Denton, Nicole Ellison, Eric Green, Lars-Christer Hydén, Wendy Kozol, Lawrence J. Mullen, Leysia Palen, Carl E. Stafstrom, and Rob Walker. Several additional people helped me with this book. I thank my MA students Carrie McCullough and Jiedi Sun for offering numerous, valuable editing suggestions. I thank my colleague Scott Farrand for creating the graphics. And, most important, I thank my wife, Susanna Melo, for suggesting ways to make the text easier to read and for putting up with my absences on many weekends.

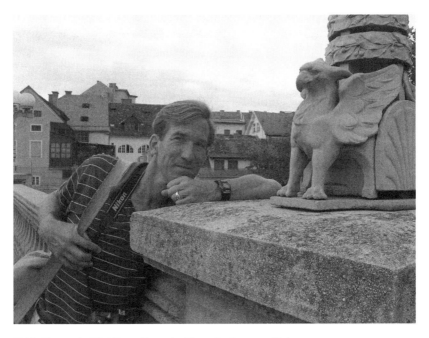

Keith Kenney in Ljubljana, Slovenia. Photo by Susanna Melo

Preface

More consumers are communicating visually than ever before. One reason has to do with technology. Consumers buy, and use, digital cameras in mobile phones, digital cameras that fit in your pocket, digital SLR (single-lens reflex) cameras, and digital camcorders. Another reason has to do with the Internet. I, and many others, spend hours connected to the Web. We check our e-mail messages and see that people have sent us new pictures of their children or vacation. We look for information, and in addition to written text, we find photographs, audio slideshows, videos, and animations. We want to join in the fun by creating our own profile on Facebook.com and our own home pages. We want to share our pictures and videos with others.

In addition to consumers, more professionals are communicating visually now than ever before. Newspapers, magazines, radio stations, and television stations all use a full range of multimedia tools to attract viewers to their websites. In addition to people who work for media industries, others also create or interpret visuals as part of their jobs. If you work in business, you need visuals to help sell your products. If you work in anthropology, biology, chemistry, economics, or education, you also need to communicate visually. I could continue listing professions, but you get the point.

If I am correct, and consumers and professionals are increasingly using visuals to communicate, then more universities should offer more courses in visual communication, and departments across a college campus should incorporate visual communication ideas and practices into their existing courses. Indeed, I believe both are happening.

If as a society we recognize the increasing importance of visual communication, then researchers should be conducting more research about visual communication. Again, I think this is occurring. To support this assertion I point to the creation of three new journals since 1994.

I begin with 1994 because that is when, with the help of many people, Jim Gordon and I created *Visual Communication Quarterly*. I was the first editor, and Jim was the publisher. Actually, the National Press Photographers Association (NPPA) officially published the journal, but Jim convinced NPPA that a research publication would serve the interests of photographers in the newspaper and television industries as well as professors who teach visual

communication. Jim used part of his budget as editor of *News Photographer* magazine to print the early issues of *Visual Communication Quarterly* and to distribute them in *News Photographer* four times a year. Now, of course, Lawrence Erlbaum publishes the journal. In addition to *Visual Communication Quarterly*, two other journals were born: *Journal of Visual Culture* and *Visual Communication*.

If courses and research related to visual communication have increased since 1994, then you would expect that universities would be launching PhD programs in order to produce professors who could teach those courses and conduct those research studies. And you would be wrong. I do not believe than any university in the United States, at least, has a doctoral program emphasizing visual communication.

If not a doctoral program, then you would expect that scholars would be writing books on how to conduct visual communication research, and, again, you would be wrong. You can read books on visual research and you can read books on communications research, but, until now, you could not read a book that would explain how to conduct visual communications research.

So how have people like me, visual communications professors, learned to teach and do research? I received an excellent education from Michigan State University, but I never took a single course about visual communication during my doctoral program. Most of my courses concerned quantitative research methods and mass media theory.

After I graduated, I read everything I could that might help me understand visual communication better. I read Roland Barthes, Sol Worth, John Berger, Susan Sontag, Stuart Hall, John Collier, Howard Becker, Susanne Langer, Nelson Goodman, among others. I read the *Journal of Visual Sociology*, *Journal of Visual Anthropology*, and *Journal of Visual Literacy*.

When reading these books and journals, I encountered two problems. One problem was how to apply my quantitative research training to conduct research on the ideas about visuals. To meet this challenge I began to teach myself about qualitative research designs. The other problem was how to apply ideas from the fields of sociology, anthropology, and education to the field of communication. To meet this challenge I simply read more and more about communication.

In short, learning how to conduct visual communication research has been hard. It still is a challenge, but I hope this book helps. By providing explicit, practical guidance in a way that is easy to read, this book should enable more people to conduct more and better research about visual communication.

I would like to think that professors teaching visual communication research courses would assign this book to their students. I also hope that people teaching research methods courses in journalism and mass communications courses would recognize the value of studying the visual aspects of media and that they would use this book in conjunction with a media research textbook. I hope that professors who teach visual research in other fields, such as sociology, anthropology, education, marketing, geography, tourism, nursing, and public

health would recognize the connections between communications and their particular field and that they would find useful the book's detailed explanation of ways to collect and analyze data. Finally, some professors teaching qualitative research in the social sciences and humanities may choose to assign this book, instead of their current textbook, because they understand the rising importance of visual communication and they want to help their students investigate visuals in our society.

1 Like an Espresso but Without the Insomnia

Explanation of the Title

Visual Communication Research Designs—the title's meaning may seem obvious, but I will be changing the meaning of some of these words, so please read carefully.

First, I define **communication** as a social process. Communication is social because it involves interactions between people. Communication is a process because it consists of an ongoing series of exchanges. In these exchanges, one person uses symbols to intentionally send a message; then others interpret the message's meaning and respond. With this definition, mass media are not in the communication business. Mass media are in the information business, the entertainment business, the persuasion business, and the money-making business. People may seem to interact with the media when they talk back to a TV program, and they may seem to be engaged in a process when they become hooked on media content, but people are not really communicating with a medium (TV), a company (CBS), a show (*CSI Miami*), or an actor (David Caruso). On the other hand, I include mass media in this book because so many people think of the media when they think of visual communication.

Next, I define visuals by example. **Visuals** include drawings, paintings, photographs, videos, films, computer graphics, animations, and virtual reality displays. Visuals do not include sculpture and architecture, which belong to the plastic arts. Nor do visuals include the performing arts, such as music, theater, and dance.

Next, I define **visual communication** as a social process in which people exchange messages that include visuals. Visual communication differs from visual display. You know something is a **visual display** when one person uses visuals to express ideas or feelings, but that person does not particularly care who sees the visuals, when they see the visuals, or whether they respond to the visuals. Creators of the visuals, however, hope their audience will understand at least some of their intended meaning.

Next is research. To conduct **research** means to investigate. Scholars may use the scientific method to investigate a phenomenon or they may use some other method, such as an analytic, critical, historical, or legal method, but their

goal is to advance human understanding. Their forms of data collection and analysis are open to invention, and a critical community judges the value of their efforts.

Rather than dividing research into scientific versus non-scientific camps, however, I prefer to divide research into three groups: investigations based on the natural sciences, the social sciences, and the humanities. To make some gross generalizations, **natural science researchers** use experiments and other quantitative methods to study the rules of nature. They accurately observe and objectively measure things that they can see. **Social science researchers** study people, not nature. They use interviews, observations, analysis of documents, and other qualitative methods to interpret the meaning of people's lives. Some of the things they study, such as thoughts and feelings, cannot easily be observed or measured. **Humanities researchers** also study people, but they do not use scientific methods. Instead they use analytic or critical methods to understand how culture influences people and how people influence culture. Humanities include the fields of history, law, literature, languages, philosophy, religion, the performing arts, and the visual arts.

I think of the social sciences as straddling the natural sciences and the humanities because people interact with nature's rules and they interact with culture. When a natural force acts upon people or when people act upon nature, then the natural sciences provide a suitable role model. On the other hand, when culture influences people and when people influence culture, then humanities provide a better model. Social scientists must pick from both models and also must make compromises.

All three groups conduct research that is appropriate for their goals and questions, but society does not value all three equally. Our culture currently believes that natural sciences are superior to social sciences, which are superior to the humanities. Since this is a culture-based belief and not one of nature's rules, it can change from place to place and time to time. Meanwhile, however, the ways that natural science researchers advance human understanding have more legitimacy, authority, power, and funding than the ways that humanities researchers advance human understanding.

So where does the communication field fit into this three-group classification? To me it seems obvious that communication can fit into the humanities side of the social science group because communication is governed by culture more than by nature's rules. Many communications scholars want to follow the natural science model, which has more authority and funding, but, as I said, communication involves people and culture, not nature. If you agree, then qualitative, analytic, and critical methods should be used to study communication.

And where does visual communication fit? I believe visual communication, as a subset of communication, fits into the humanities side of social science. This idea, however, may disturb my school's senior faculty members, who were trained to use quantitative methods, not qualitative, analytic, or critical methods. They might be thinking, "No tables with statistics? No levels of

significance? No intercoder reliability?" They simply might not understand how to conduct or evaluate such research, and they might be suspicious of the unknown.

Next, I define a **research design** as a plan for how the investigation will be conducted. As a plan, a research design deals with four problems: what questions to study, what information is relevant, how to collect that information, and how to analyze the information. A research design, therefore, enables you to link the investigation's research questions with its conclusions.

Finally, we return to the beginning—visual communication research designs. Confusion may arise about whether the phrase refers to research about visuals or whether it refers to any research that uses visual technology. For this book, the answer is both and more. You can use **visual communication research designs** to study visuals that were created by participants or researchers. You can also use visual communication research designs to study participant-created visuals and researcher-created visuals. In this book:

- Three of the research designs involve a non-visual method (interviews, discourse analysis, and interpretive analysis) to study visuals that people had created without prompting from a researcher.
- Two designs involve a non-visual method (diaries, case study) to analyze visuals that people knew a researcher would want to study.
- One research design involves a non-visual method (focus group) to study visuals that the researchers had created.
- Two designs ask participants to create visuals (draw-and-write technique, Photovoice).
- One research design requires that the researcher create visuals (visual ethnography).

Goals

My contributors and I had several goals in mind as we wrote this book.

One, we want to tell you something new and interesting about visuals. To meet this goal, we begin each chapter with a brief story. For example, we explain:

- Why people *really* include visuals on Facebook.
- Why Picasso could draw but barely pass elementary school.
- How you can use camera phones for intimate communication.
- Why Zana Briski created the Oscar-winning documentary film *Born into Brothels.*
- How a professor with Skype could serve on a virtual thesis committee.
- How Lauren Greenfield created the visuals for the book and film called *Thin.*
- How prosecutors used visual persuasion to help convict Michael Skakel of murder.

- How photos in *Life* magazine maintained power relationships and ideologies.
- How the media contribute to the sexualization of Miley Cyrus and other girls.

In fact, you will find stories throughout the book about how people use visuals.

Two, we advocate mending the split in communications programs. At the university where I work, communication is taught in two completely separate departments. You can study mass media, such as advertising, public relations, television, and newspapers in the School of Journalism and Mass Communications; or you can study speech and rhetoric at the interpersonal or public levels of communication in the English Department. This split may have made sense at one time, but with the tremendous influence of the Internet, it does more harm than good. We use the Internet as a worldwide mass medium as well as to send and to receive personal e-mail messages. We also join chat rooms, which resemble group or public communication. And we use intranets for organizational communication. People are creating content and distributing content for one other family member, 20 friends, 200 employees, and millions of strangers in multiple cultures. By explaining research designs at all levels of communication, this book demonstrates the value of thinking about communication as a single field, with a common set of theoretical perspectives and methods.

Three, we want to tell you something new and interesting about *research designs*. If your graduate program focuses on **quantitative research**, then use this book to learn about the *other* types of research—qualitative and humanistic research. If your graduate program focuses on **qualitative research**, then think of this book—like espresso—as a stimulant. It will stimulate your interest in additional research designs. You will learn how to use draw-and-tell, Photovoice, diaries, case studies, discourse analysis, and content interpretive analysis. We hope you will be so excited after reading these chapters that you will lose sleep thinking about when and how to apply them to your own research.

Four, we want to provide practical, systematic guidance on how to design visual communication research studies. It seems obvious to us that you would want to learn how to conduct visual communication research. Not only is such work fun, it is also rewarding. Academia needs visual communication professors to teach all of its photography, graphics, video, and Web design courses. Academia also wants to hire professors who can conduct research. Finding visual communication teacher-researchers, however, is difficult because the field is so new. In fact, no communications doctoral program emphasizes visual communication. And even if such a program existed, students could not find books to help them learn how to conduct visual communication research. Until now. *Visual Communication Research Designs* is the first book that explains how to design visual communication research studies.

To continue with our goals for this book, a fifth goal is to explain our ideas

as clearly as possible. You may have already noticed some of our techniques. First, we frequently number our points so that you can follow our thinking step by step. Second, we use active voice, which means that you always know *who* said or did something. Third, we use concrete examples to clarify and reinforce our abstract points. Fourth, we boldface words when we first define them and we include boldfaced words and their definitions in the glossary at the end of the book. Fifth, we avoid wordiness so you will not have to sort through the clutter to find the essential idea. Sixth, we use short sentences so that you will not need to absorb too many ideas at once. Seventh, we hope you have noticed the lack of jargon. Eighth, we include figures in order to visually as well as verbally present our ideas.

Like all authors, we need goals when writing, but we also need to know if we have met our goals. We will only know if we have succeeded if you either buy this book or you send us an e-mail message. We hope you will do both. Contact Keith Kenney at kkenney@sc.edu.

Organization

Most books about research design include a separate chapter about **theory**, research questions, sampling, methods, analysis, and ethics. In this book, we cover these same topics, and more, but not in separate chapters. Instead, we have a theory section for each of the nine chapters. We also have a research questions section for each of the nine chapters. In fact, we write about 15 different topics in each of the nine chapters.

The book's format offers advantages and some potential disadvantages. One advantage is that you can learn nine complete research designs from start to finish rather than having to assemble parts of research designs from different chapters. Another advantage is that you can easily compare research designs, and, as you know, you can understand one thing better when you can compare it to others. A third advantage is that each method for collecting data is directly connected to a theoretical perspective. This is important because theory influences method and method influences theory. A possible disadvantage to this format would be redundancy. We've tried to avoid redundancy by describing a variety of theoretical perspectives, goals, methods, units of analysis, and so on. Moreover, instead of repeating content, we simply refer you to the place in the book where we discuss that topic. Another potential disadvantage is that you may not realize there is no one right way to do anything in qualitative research. We organized the material so that we explain one way of analyzing data in Chapter 3, but that might not be the ONLY way to analyze such data. You could try using the data analysis method covered in Chapter 4, for example. Another potential disadvantage is that you may think that the qualitative research process follows a straight line from beginning to end. It does not. A graphic of the research process would include lots of arrows pointing in both directions and looping around from the bottom up to the top. Each aspect of the process would be connected to several other aspects.

Table 1.1a Overview of the research designs

Chapter	Title	Level of communication	Theoretical perspectives	Goals	Methods
2	Putting your best "cyberface" forward	Intrapersonal	How communication and media influence people's self-identities	Basic research: learn how people use visuals for impression management	Interview
3	I don't want to talk about it; I want to *draw* it!	Interpersonal, face to face	A visual symbol system's role in society; Coordinated Management of Meaning	Applied research: improve communication between people who cannot talk	Visual-spatial intelligence tests; draw-and-tell
4	Reach out and hug someone	Interpersonal, distance, phone	Interpersonal Process Model of Intimacy	Basic and applied: learn how people use camera phones for intimate communication	Diaries
5	We shall act and overcome, together	Group, face to face	Paulo Freire's ideas	Action research: empower a specific community	Photovoice
6	Working for two universities 5,000 miles apart	Group, distance, computer-mediated communication	How video improves connection, communication, collaboration; Social Information Processing; Hyperpersonal Interaction	Evaluation research: gauge effectiveness of using video for a virtual thesis committee	Case study
7	Traditions are group efforts to prevent the unexpected	Organization	Organizational culture	Personal or applied: visually describe the culture of an organization or a social group	Visual ethnography
8	That story's ridiculous; look, here's what happened	Public	Visual persuasion from neurobiology, narrative studies and visual media studies	Applied research: determine how people might use visuals to create a story at a trial	Focus groups
9	Everything you wanted to know, but were powerless to ask	Mass	Interrelationship of discourse and power	Basic research: determine how photos and texts construct a particular version of reality	Discourse analysis
10	Sex on TV: a content *interpretive* analysis	Mass	Cultivation theory; social modeling; social schema	Basic research: learn the nature of sexual information on television	Variations of content analysis

Note: The nine chapters cover various research designs for studying different levels of visual communication.

Table 1.1b Overview of the methods and analysis sections

Chapter	Units of analysis	Sampling	Data analysis	Data displays	Credibility, transferability, and dependability
2	Themes from interviews	Purposeful sample of 12 people with social networking profiles	Code themes with the constant comparative method	Cognitive maps	Auditor; naturalistic and analytic generalizations; check for representativeness
3	Visual symbols from children's drawings	Convenience sample of 80 children between 2nd and 5th grades	Code symbols; rate symbols; create metaphors	Correlations of drawings and diagnoses; drawings and visual tests	Triangulation; intercoder agreement
4	Entries from diaries; or answers to multiple-choice questions and Likert scales	Purposeful sample of 10 couples, who communicate intimately	Code answers and scales from diaries	Line graph of changes in intimacy over time	Member checking; check for reactivity
5	Comments on the community from group discussions	10 volunteers from a community	Use connection strategy	List of projects in progress or completed	Collaboration with community volunteers
6	Virtual thesis committee	Purposeful sample of one or more virtual theses committees	Use case analysis meetings; pattern matching	Case dynamics matrix	Triangulating; replications
7	Chunks from video and photographs produced by the researcher	Purposeful sample of 100–200 observations and 30–50 interviews	Code activities' structure, timing, space, artifacts and troubles	Video and photos in a book, DVD, or website	Peer reviewer; thick description; negative cases
8	Opinions about visuals from a focus group	Purposeful sample of 3–5 groups; each group has 6–9 people	Study sequences of conversation; answer 12 questions	Vignettes	Same moderator for all groups; check for alternative explanations
9	Groups of photographs and written texts that are related in some way	Purposeful sample	Write memos to keep track of content, context, and findings	Table with headings for photos, content, context, construction, and ideology	Persuasive account based on a clear step-by-step analysis
10	Character, scenes, or shots from TV programs	Probability sample of TV programs with 80 scenes of sexual behavior	Code characters, scenes, or shots	Content analytic summary table	Random sample; intercoder agreement

Note: The nine chapters cover four types of research—basic, applied, action, and evaluation research—and each type of research has its own goals. Methodologies explain how evidence will be collected; data reduction and analysis produce the findings; data displays enable readers to draw conclusions; and measures of quality include: credibility, fittingness, and auditability.

Table 1.1c (Dis)advantages, ethical issues, and required resources

Chapter	Advantages	Disadvantages	Ethical issues	Resources
2	You obtain: participants' perspective, face-to-face interaction, data with depth and nuance	Respondents may forget, distort, misinterpret, or lie	Emotional harm; push for too much or too little information; power imbalance	Time for training to conduct interviews and analyze interviews
3	Children feel: empowered, comfortable; they give more information and lie less	Children may lack drawing skills, copy pictures, reveal too much, give "right" answers	Children and voluntary participation, loss of privacy, anxiety, cognitive dissonance	Cooperation from children, parents, teachers, principals; expert coders
4	You gain: many data points at many times, less biased data	You may receive less recognition; your group may feel less empowered if no results	Proper level of compensation; invasion of privacy	Time to recruit participants; financial incentives for participants
5	Participants: collaborate, learn, benefit directly, see their photos in exhibitions	Researchers may receive less recognition; participants may become discouraged	Emotional harm, loss of privacy; power imbalance; ownership of data	Money for photography, facilitator, participants, and projects
6	You: build and extend theory; gain confidence in findings	Cannot generalize to other cases, only to theory	Investigator biases	Time for triangulation and replication
7	Viewers: see rich visual descriptions, hear natural sounds, hear members' voices	Participants may react to you and your cameras	Informed consent; voluntary participation; power imbalance; illegal activities	Time for money for fieldwork; photography skills; multi-tasking skills
8	Participants: feel stimulated, feel empowered, gain mutual support	The group, moderator, and researcher all affect the collection and interpretation of data	Confidentiality; over-disclosure of information	Money for room hire, snacks, incentives, transactions, and a trained moderator
9	Readers: learn how photo/text packages express ideological values	You need knowledge from many different academic disciplines	None	Money for travel to archives and other sites
10	You: study any type of content, repeatedly, unobtrusively, from the past and present	You may, wrongly, associate frequency of content with significance of content	Investigator biases	Multiple coders who have expertise or who regularly view your content

Each chapter begins with a discussion of a **theoretical perspective**, which is a general explanation of what is going on with the people, events, and settings you plan to study. Based upon this general explanation, you can begin to refine your goals, develop relevant research questions, select appropriate methods, and identify potential threats to the quality of your conclusions. After completing the research process, you will connect your particular conclusions back to the larger issues of the theoretical perspective. Although few people may care about your particular study, many scholars and practitioners should be interested in how your study contributes to the theoretical perspective.

Some of this book's theoretical perspectives include well-defined communication theories, such as the Coordinated Management of Meaning, the Interpersonal Process Model of Intimacy, and Cultivation theory. Other theoretical perspectives include new and still under-developed maps of relatively unexplored territory. For example, we try to explain a) a visual symbol system's role in society, and b) how access to visual information can improve coordination. Other chapters' theoretical perspectives resemble a general group of ideas more than a specific theory. For example, we discuss Paulo Freire's ideas about conscientization and anthropologists' ideas about organizational culture.

With a theoretical perspective in place, the second section covers possible goals. Your goals explain why you want to conduct a particular research study. You may have personal goals. For example, you might want to a) improve some situation you are involved in; b) satisfy your curiosity about a topic; or c) advance your career (Maxwell, 2005). You may have practical goals. For example, you might want to influence some policy or practice. Or you may have intellectual goals. For example, you might want to a) understand the meaning of something; b) understand how a particular context influences the way people act; c) generate new theory; d) understand a process; and e) explain why something happened. This book covers goals related to: basic research, applied research, action research, and evaluation research, which will be explained later.

The third section—research questions—tells you what you most want to understand so you can start channeling your energy in that direction. They are more general and vague than hypotheses.

Qualitative researchers prefer research questions because they begin their investigations with general thoughts about a phenomenon. As they strive to make sense of their general thoughts, they collect a lot of data. They conclude their research process with a general statement that explains their data. Quantitative researchers prefer hypotheses because they begin their investigations with a review of the literature, which gives them a specific idea about a phenomenon. To confirm their idea, they follow a standard procedure for collecting data. They conclude their research process by stating that the data either confirm their initial idea or, occasionally, that they were surprised by their findings.

To use a detective analogy, qualitative researchers keep searching for clues until they identify the criminal. They go wherever their clues lead and take as long as needed. On the other hand, quantitative researchers receive a tip from a stranger, and they follow department policies in order to confirm the tip. Quantitative researchers continue to investigate their initial suspect until they can arrest the suspect, or . . . if they received a bad tip or if they botched their inquiry, they start over, with a new suspect and/or a new investigation.

The fourth section provides a brief description of the method for collecting data so that you can easily connect the general theoretical perspective with the method. Later, in the methods section, you learn the details of how to interview, observe, solicit diaries, conduct focus groups, and so on.

The fifth section identifies the units of analysis, which, in general, are related to your research questions. Your research questions specify what the study is about. If they concern the meaning of photographs, then photographs are your unit of analysis. If your research questions concern sexual behavior on TV programs and in movies, then your unit of analysis might be scenes of sexual behavior in those media. When determining the units of analysis, you also need to think ahead to the end of the research process. You need to ask yourself what type of analysis you plan to do. If you are going to code symbols in drawings, then symbols are your unit of analysis. If you are going to analyze how sending a photo message causes a change in intimacy, then photo messages are your unit of analysis.

The sixth section concerns sampling. Researchers care about sampling because it controls the quality of inferences they can make from their study's results. They must decide how to select these members (sampling scheme) and the number of participants or cases to select (sample size).

This book describes two basic types of sampling schemes: purposeful and probability. Qualitative researchers generally use **purposeful sampling**. They deliberately—not randomly—select individuals, settings, or activities; and they make their selections to obtain the best information to answer the research questions—not to represent the population. Qualitative researchers deliberately select cases to obtain rich data because they will generalize from their data to their variables—not from their cases to their population. **Rich data** is defined as detailed and varied information that provides a full and revealing picture of issues of central importance to the study's goals and research questions.

Qualitative researchers can change the sample throughout the research process. If some initial findings indicate a promising line of inquiry, they can sample additional people, events, or places. If other findings indicate a dead-end, they can stop investigating those cases. In fact, researchers continually redraw and refocus their samples because they want to do the best possible job of defining a variable and of discovering variation within the variable. In order to best measure their variables, researchers look for a) the typical case because this case represents the variable's core; b) the atypical case because

this marks the variable's outer boundaries; and c) the negative case because this distinguishes the variable from its context and from other variables.

Quantitative researchers generally use **probability sampling**. First, quantitative researchers determine how the population varies and whether those variations might affect their findings. For example, if quantitative researchers sample people, then gender, age, race, income, wealth, education, political beliefs, religious beliefs, marital status, number of children, and so on might be relevant for some research questions. Second, they divide their population into the relevant groups, called stata. Third, quantitative researchers randomly select cases from each group to ensure that their sample represents the population. Fourth, they collect data about the sample. Fifth, they use statistical methods to determine whether what they learned from the sample should hold true for the population.

To determine the sample size, researchers consider their goals, questions, and their research design. For example, if qualitative researchers use an interview design (Ch. 2), they might select twelve people (Guest, Bunce, and Johnson, 2006). If quantitative researchers use a correlational research design (Ch. 3 and Ch. 10), then they might sample sixty-four participants for one-tailed hypotheses and eighty-two participants if researchers use two-tailed hypotheses (Onwuegbuzie, Jiao, and Bostick, 2004). If qualitative researchers use a case study design (Ch. 6), then they might select three to five cases (Creswell, 2002). For an ethnography (Ch. 7), they generally study one cultural group (Creswell, 2002), and they might conduct thirty to fifty interviews (Morse, 1994). For focus groups (Ch. 8), researchers might select six to nine participants per group (Krueger, 2000); and three to six focus groups (Krueger, 2000).

The seventh section—methods—describes how to collect data to answer the research questions. The book primarily describes qualitative methods, but three of the designs (draw-and-write, diary, content interpretive analysis) have quantitative aspects.

One major difference between qualitative and quantitative methods concerns underlying assumptions about society. Quantitative researchers assume the social world is as concrete and real as the natural world. They believe they can accurately observe and objectively measure the social world. Qualitative researchers, on the other hand, assume the social world is a pattern of symbolic relationships sustained by human action and interaction. Qualitative researchers interpret those symbolic relationships, but they realize that they cannot know for sure what people intend to do, what they believe, or what they feel about other people. Only the people themselves can know, or think they know; even then, people's thoughts and emotions constantly change.

The two groups also have different assumptions about people. Quantitative researchers assume that external forces in the environment shape people. These stimuli condition people to respond to events in predictable ways. Qualitative researchers, on the other hand, assume that people interpret their social and natural environments and orient their actions in ways that are meaningful to

them. People use language, visuals, and other symbol systems to create and to interpret their world of symbolic significance.

Because of their different assumptions, the two groups use different methods to conduct research. Quantitative researchers conduct experiments on "subjects" in a laboratory and they survey people whom they will never meet. They follow standardized procedures and they use standard instruments so they can assign numbers to pre-determined categories so they can compare their results with other researchers' results. Qualitative researchers, on the other hand, need to spend a long time getting to know particular individuals and their complex lives. They ask individuals questions and they observe individuals' actions at home or work in order to understand those individuals' particular points of view. Instead of putting their faith in a standard instrument, with proven reliability and validity, qualitative researchers must trust themselves. They are their research instruments. The study's quality depends upon their skills, including their ability to gain access and establish trust with the individuals they study.

We describe the data collection process in an explicit, systematic manner so you can confidently collect your own data. You should not, however, think of the methods sections as cookbook recipes that will produce a "tasty" product. You will need to substitute some ingredients and adjust cooking times because you have a different personality and skill set from other qualitative researchers and because the people you study differ from other people. But do not worry; just get started; and you will improve with experience.

The eighth section focuses on data analysis. **Data analysis** transforms mountains of data into pithy findings. It consists of examining, categorizing, tabulating, or otherwise recombining evidence. Analysis is driven by your goals and research questions. They determine how you organize the data, make sense of this data, and end up with a useful interpretation.

Quantitative researchers, with their evidence represented by numbers, can use various software programs and numerous standard statistical techniques to analyze their data. They can present their findings succinctly in a table.

Qualitative researchers are not so lucky. Instead of working with numbers, they work with words and visuals. Their hundreds of pages of transcripts and hundreds of photographs, drawings, or pieces of video are neither standardized nor easily entered into software programs. Some scholars (Miles and Huberman, 1994) believe you need roughly two to five times as much time for processing and ordering qualitative data than the time needed to collect it. Moreover, there are no absolute rules for qualitative data analysis. As with data collection, your training, skills, and insights—not a standard procedure—will determine the quality of your data and analysis.

Qualitative analysts, however, have one advantage over their quantitative peers. Instead of waiting to begin analysis until after all of the data have been collected, qualitative analysts conduct provisional analyses early in the data collection process. Based on this early analysis, researchers collect additional data. They cycle back and forth between thinking about the existing data

and generating strategies for collecting new, often better, data (Miles and Huberman, 1994). As a result, qualitative analysts avoid missing blind spots in their data collection, and their analysis becomes an ongoing process that energizes their work.

To help you meet the challenge of analyzing different types of qualitative data, we present some guidelines. These are guidelines, not recipes, and you must use judgment when applying them. To develop such judgment, seek opportunities to collaborate with more experienced analysts.

This book explains three major ways to analyze data: categorizing strategies, connecting strategies, and memos. **Categorizing** means a) organizing the data set; b) immersing yourself in the data; c) dividing the data into relevant chunks (units of analysis); d) creating categories that you can use to answer your research questions; e) assigning (coding) those chunks to different categories; f) interpreting the results of coding; and g) searching for alternative interpretations. We suggest coding for interview data, draw-and-write data, diary data, and the content interpretive analysis design.

You can also use **connecting strategies** to analyze data. Whereas categorizing fractures the data set into smaller sub-sets, connecting assembles small pieces until they form a large narrative, or story. We suggest connecting for the Photovoice design, case study data, and focus group data.

You can also use memos to analyze data. Memos consist of your ideas about the data. You don't formally categorize the data, and you need not create a story about the data, but as you informally do some of both, you write down your ideas. We suggest memoing for discourse analysis. For our last research design, visual ethnography, any or all of the analysis strategies would be appropriate.

How do you know whether to use a categorizing or a connecting strategy? One suggestion is to determine whether you are taking a variable-oriented approach or a case-oriented approach. In a variable-oriented approach you are interested in the correlations among variables in order to build or test theory. You compare and contrast many cases. In a case-oriented approach, you consider each case as a whole entity in a bounded context. You are very interested in the details of each case. You look for associations, causes, and effects within a case. Later you may compare and contrast a limited number of cases in order to form more general explanations.

The ninth section concerns **data displays**, which are visual formats that compress and organize data so that people can draw valid conclusions about the data (Miles and Huberman, 1994). Researchers use two general formats: a matrix display or a network display. **Matrix displays** show how two lists—set up as rows and columns—intersect. For example, in Table 1.1 you can read across the rows to learn about a chapter and/or you can read down the columns to learn about the parts of a research design. Since the matrix covers nine chapters and fourteen parts of a research design, it has 126 cells. From reading these cells, you can learn all about the book. The other display format, **network displays**, shows collections of nodes (points)

connected by links (lines). This book explains several displays, including content analytic summary tables, context charts, case dynamics matrix, and causal networks.

The tenth section explains how visual communication researchers take steps to ensure the quality of their research. In a quantitative methods book, quality would be assessed via reliability and validity. **Reliability** refers to the consistency, stability, and dependability of a test (or other data-gathering instrument). Investigators get comparable results every time they give the tests to comparable subjects because they have developed consistent habits in giving the test and scoring its results. They have managed to minimize the errors and biases in the testing procedures. Reliability is different for qualitative research because the researcher is more responsible for the data than the test or data-gathering instrument. **Validity** means that the research instruments and tests measure what they were intended to measure. Validity is different for qualitative research because researchers are trying to interpret people's thoughts, feelings, and behaviors. These may include many contradictions; they may change; they may be unknown to the individuals; and they may be so nuanced that researchers can never get them right.

This book, like many qualitative research books, uses credibility, transferability, and dependability to assess quality. A study has **credibility** when researchers present such faithful descriptions or interpretations of a human experience that the people having that experience would immediately recognize it as their own. In addition, after reading the report, other researchers and readers can recognize the experience when confronted with it. **Transferability** concerns the range and limitations of the findings beyond the context in which the study was done. To ensure transferability, qualitative researchers collect rich data and then generalize from their data to their variables. **Dependability** means that other researchers can clearly follow the reasoning used by the study's investigator. In addition, they can arrive at a similar conclusion given a similar situation.

In addition, when judging the quality of a qualitative study, ask yourself these questions. How much training and experience did the researcher have? How familiar was the researcher with the people, events, and places he or she studied? Could he or she draw people out? How much did people alter their behavior when they became aware they were being studied? Was the researcher dogged in investigating the phenomena? Did he or she ward off premature closure? How candidly did the researcher write about his or her potential bias and his or her experiences with data collection and analysis?

The eleventh section explains how the Internet has affected visual communication research designs. For example, one chapter explains the advantages and disadvantages of e-interviews. Another chapter explains how PDAs (personal digital assistant), wireless technology, and the Internet have transformed the collection of diary data. Another explains how hyperlinked Web sites improve the display of visual ethnographic research.

The twelfth section explains the method's advantages and disadvantages. Interviewers, for example, provide insights into how people interpret events, but people have poor or distorted recall and they may lie or withhold information. Diaries provide accounts of events as they occurred in their natural contexts, but people find them intrusive and burdensome. Case studies produce solid findings and help build theory, but people may react to the presence of researchers, and the results of case studies cannot be replicated easily.

The thirteenth section discusses ethical issues researchers might encounter when they use a particular research design.

All researchers who study people must obtain approval from their Institutional Review Board (IRB). An **IRB** is a committee at U.S. colleges, hospitals, and research institutes that is required by federal law to ensure that research with humans is conducted in a responsible, ethical manner. To gain IRB approval you must respond to these questions:

1. In relation to your goals: How will your research benefit the individuals you will study? You do not want to marginalize or disempower participants.
2. In relation to your research questions: How will you explain the purpose of your project to individuals? You do not want to deceive participants.
3. In relation to data collection: How will you gain access to your research site and subjects, and what will your entry letter look like? How will you obtain informed consent and what will your informed consent form look like? What kinds of interactions will you have with your subjects? What risks will subjects take—such as accidental disclosure of harmful information—and how will you reduce those risks?
4. In relation to data analysis: How will you protect the anonymity of individuals and incidents? You want to use aliases for individuals and places to protect their identities. Who owns the data once it is collected and analyzed? You want to make a personal agreement with participants about the ownership of data. How will you guard your data? You want to explain where the data will be kept and when (if) it will be destroyed. How will you ensure an accurate account of the data? You want to use one or more strategies to check the accuracy of the data with participants.

Visual communications researchers must always pay particular attention to informed consent and to privacy.

Informed consent ensures that people not only agree and consent to participating in the research of their own free choice, without pressure or influence, but that they are fully informed about what it is they are consenting to. Visual communication researchers must work harder than other researchers to obtain informed consent because they must get consent not only from the participants in their study, but also from others, who both appear in their photographs/videos and who are affected by their visuals.

A consent form includes (Creswell, 2003):

1. The right to participate voluntarily and the right to withdraw at any time, so that the individual is not being coerced into participation.
2. The honest purpose of the study so that individuals understand the nature of the research and its likely impact on them. When you anticipate that your description of the group will be flattering, you can readily explain the study's purpose. On the other hand, if you anticipate that some members of the group will resent the ethnographers' description, then you may try to hide the study's true purpose. Avoid this impulse or your subjects will, correctly, consider you unethical.
3. The procedures of the study, so that individuals can reasonably expect what to anticipate in the research.
4. The right to ask questions, obtain a copy of the results, and have their privacy protected.
5. The benefits of the study that will accrue to the individual.
6. Signatures of both the participant and the researcher agreeing to these provisions.

Guarding informants' privacy normally means that researchers offer them confidentiality or anonymity. **Confidentiality** means that information about participants is private and should only be revealed with participants' consent. **Anonymity** means that participants remain nameless. If visual researchers want to publish or display photographs, videos, and drawings that identify participants, then participants will lose their privacy, and without privacy, people may not agree to participate. Visual researchers, therefore, may have greater difficulties recruiting participants.

The fourteenth section concerns the resources, such as time, personnel, and money, which you might need to complete the research design. When calculating which resources you may need, break down the study into manageable tasks, such as: a) planning; b) meetings of research team; c) meetings among principal investigators; d) site visits in the field for data gathering; e) data analysis; and f) report writing. In addition, build in time and money for training because, as mentioned earlier, the quality of a qualitative study is only as good as the investigators who collect and analyze the data.

The fifteenth, and final, section provides advice. Think of this section as a kind of summary with bullet points.

Distinctive Contributions of *Visual Communication Research Designs*

In summary, we believe this book is distinctive in several ways:

1. We distinguish visual communication—a social process in which people exchange messages that include visuals—from visual display—creating visuals without knowing your audience and without receiving a reply.

2. We position visual communication on the humanities side of social science.
3. We recommend studying visual communication at the intrapersonal, interpersonal, group, organization, and public levels of communication, as well as the mass communication level.
4. We offer guidance for creating nine research designs appropriate to the study of visual communication.
5. We connect each research design with a theoretical perspective.
6. We use a consistent format for every chapter. This format provides comprehensive coverage of fifteen aspects of a research design.
7. We include a glossary of terms and their definitions in relation to visual communication research.

2 Putting Your Best "Cyberface" Forward

Theoretical Perspective

Mark Zuckerberg put Harvard's class directory online because he thought it might be interesting to have access to other students' profiles. Other students were also interested in seeing a photograph and some basic facts about their classmates. In fact, so many students wanted to see others' online profiles that within twenty-four hours of its birth, February 4, 2004, Thefacebook.com had between 1,200 and 1,500 registrants (Cassidy, 2006). Zuckerberg realized that millions of young people might want to present themselves to others and make friends in an online environment, so he opened the site to students from other campuses. A year later, the social networking website **Facebook.com** was the second-fastest growing major site on the Internet (Cassidy, 2006). Within four years of its birth, Facebook had 70 million members, and according to comScore Media Metrix, a company that tracks online traffic, Facebook was the fifth most trafficked website in the world. Today users can join networks organized by city, workplace, school, and region to interact with other people.

Almost half of Facebook users return to the site every day in order to update their profiles, to read messages on their "wall" and to both read and write messages on others' walls. In other words, they stay in touch with their online friends. Duncan Watts, a sociologist at Columbia University, compares spending time on Facebook to hanging out at a mall. Both serve the essential purpose of seeing and being seen. "You're with your friends, but you're also creating the possibility that you'll bump into someone else, in which case you might meet them, or at least be noticed by them" (Cassidy, 2006).

Facebook is more than a social networking site. It is also an identity-building site. An **identity** is a sense of self; it is a persistent understanding of one's physical, psychological, and social self. People shape and project their identities on Facebook. In fact, Facebook has become "a platform for self-promotion, a place to boast and preen and vie for others' attention as much as for their companionship," writes John Cassidy for *The New Yorker* (Cassidy, 2006).

Imagine if you wanted to conduct a research study about the self-promotion aspect of Facebook or another social networking site, such as LinkedIn (20 million subscribers), Friendster (58 million), hi5 (70 million), Facebook

(70 million), or Myspace (110 million) (**Wikipedia.org**: list of social networking websites). How would you begin?

I suggest studying Erving Goffman's ideas about impression management for a general explanation of what is going on when people create their personal profiles. **Impression management** consists of people's efforts to both define themselves and control information that others have about themselves in order to influence others' opinions. When people create social networking profiles, they emphasize certain aspects of their personality in order to win the approval of their peers. They are putting their best "cyberface" forward (Rosenbloom, 2008).

Erving Goffman, author of *The Presentation of Self in Everyday Life* (Goffman, 1959), uses a theater analogy to explain impression management. The word "theater" comes from the Greek "theatron," which means "place of seeing." In theater, actors present themselves to others. In everyday life, people also make self-presentations. Instead of following a script, however, people decide by themselves how to perform in a front stage area for a particular audience. Then people withdraw backstage, where they can put aside their onstage role, check their appearance, and reapply make-up.

Impression management and Goffman's theater analogy also seem to apply to social networking profiles. People think about their identities. For example, I think of myself as a photographer. Then people think about others with similar identities. For example, I would consider how photographers present themselves in public. Then people create a profile to present their identity to others.

To continue the theater analogy, in addition to hearing actors talk to other actors, we see them and their clothes, body language, and gestures. Similarly, when people present themselves on Facebook, they talk about themselves and they show visuals of themselves. They carefully write self-descriptions about their political and religious affiliations, likes and dislikes, values, and accomplishments in life. People publicize their social connections with talented friends, successful sports teams, media role models, and popular musicians. They also use *lots* of photographs and videos. For example, people upload 14 million photographs daily to Facebook. As a result, Facebook is by far the largest photo site on the Web.

In the theater, actors sometimes perform more than one role within a play. Similarly, people's profiles also include more than one aspect of their identity. For example, in addition to showing that I am a photographer, my profile could show that I am a husband, father, teacher, researcher, runner, and gardener.

In the theater, everyone in the audience sees all of the actors' identities. Similarly, everyone—friends, co-workers, complete strangers—sees all of a person's content on his or her website. Facebook users may not worry about potential employers checking out their photographs because they consider such snooping unethical. Employers, however, know they can use everything in the public domain in order to evaluate you (Balakrishna, 2006). You should

assume that since employers *can* find your Facebook profile, they might before deciding whether or not to hire you.

Unlike actors, you can, of course, limit access to some friends. For example, one of your professors may be your "friend," but you don't want him or her to see a photograph of you losing badly at beer pong. You cannot, however, completely avoid embarrassment for two reasons. One, other Facebook users can write and leave photographs on your wall, and several hours (or days) may pass before you realize someone has posted an undesirable message. One survey of Facebook users found that half had discovered unwanted pictures linked to their profiles (Tufekci and Spence, 2007). Two, you lack complete control because another user—imagine a "friend" named Henry—may post a humiliating photograph of you on his profile. You don't want everyone to see you that way, so you remove your link to Henry's profile, but you can't force Henry to remove your picture. Even worse, Henry may also have tagged the photograph with your name. If so, people can use your name in a search and quickly find the unflattering image. As one former Harvard student wrote: "A single user with low privacy restrictions 'overcomes/ruins' all the protective and restrictive steps taken by peers" (Cassidy, 2006).

In the theater, when a company stops putting on a particular play, actors audition for a different role in different plays. In real life, when I leave one group of people and I move to another location to interact with a different group, then I can play a different role. In the online world, however, people cannot change roles easily. They have one profile. One exception is Facebook's Limited Profile. It allows users to create a second profile that omits some of the content from their original profile.

I hope you noticed that Goffman's dramaturgical approach to impression management includes both *intra*personal communication and *inter*personal communication.

People use intrapersonal communication when they think about themselves and the role they should play. They try to maintain and enhance their self-esteem by giving themselves pep talks and by recalling positive, rather than negative, information about their past actions. In addition, people watch their own actions, become aware of their own thoughts and feelings, and make direct attempts at self-assessment in order to confirm their sense of self (Markus and Wurf, 1987).

People use interpersonal communication to convey their identity to others. They show their identity to members of their group in order to build solidarity, and to those not in their group, in order to emphasize who does not belong.

People also use interpersonal communication when they seek feedback from their audiences. Sometimes people want to hear an honest assessment of the role they have played; other times they are simply seeking approval. For example, when people want to honestly evaluate themselves, they compare themselves with superior others. When they want to make themselves feel good, they compare themselves with inferior others (Markus and Wurf, 1987).

In addition to intrapersonal and interpersonal communication, the media also affect people's—especially teenagers'—self-identities. The **Media Practice Model** begins with the assumption that adolescents are forging a cohesive sense of self and figuring out where they fit in the world (Steele and Brown, 1995). As teenagers watch TV and listen to popular songs, they passively learn about the common teen culture. From teen culture, adolescents begin to realize they are similar and dissimilar to some other teens. Based upon this developing sense of self, teenagers select particular media content to fulfill their entertainment and information needs. As they become more actively involved with the media, they begin to interpret its content. Then they begin to seek out more specialized information from niche magazines, the Internet, newspapers, and movies so they can apply this information and continue to build their self-identities. Finally, they create Web pages to present their unique identities to others.

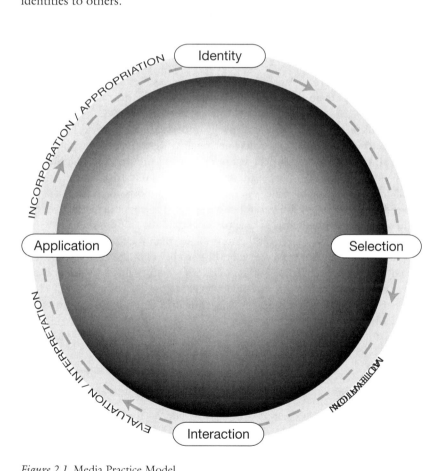

Figure 2.1 Media Practice Model

Source: Steele and Brown (1995)

In addition to Goffman's dramaturgical perspective and the Media Practice Model, you might want to add some ideas about photography in order to complete your theoretical perspective.

Facebook users may intuitively realize what researchers have proven: that they should show photographs of themselves with friends who are either physically or socially attractive. Women who were average in looks were rated higher when viewed in a photograph in which they were posed alongside other women who were more attractive (Melamed and Moss, 1975). Even later, when these average-looking women were viewed with other average-looking women, they continued to be perceived as more attractive. A second study reports that photographs showing attractive friends positively affect viewers' ratings of Facebook profile owners (Walther et al., 2008).

No wonder people sometimes cut out unattractive friends from photos they wish to include on their websites. In a response to a *New York Times* article about self-presentations in cyberspace, one reader, referring to his/her homepage, writes: "Cropped my overweight friends out of the photo. Like horizontal stripes, they made me look fatter." Another letter writer said, half-jokingly, "Cropped my overweight, handicapped, elderly, and unattractive friends from the picture. Also removed friends who suffer from acne and those who buy clothes from the Salvation Army. Funny how they no longer speak to me."

Facebook users might also intuitively understand that viewers associate physical attractiveness with a positive personality. Research again supports this bit of common sense. It indicates that our outer appearance plays an influential role in determining how people think of us and respond to us. Especially for initial encounters, the evidence overwhelmingly supports the notion that we respond much more favorably to those we perceive as physically attractive than to those we see as unattractive (Knapp and Hall, 2006).

To appear taller, skinnier, and better-looking than they are in reality, some people alter photos. For example, in another response to the article about self-presentations (Rosenbloom, 2008), one letter writer said, "My friends and I have discussed the 'fat girl face tilt,' where we are pictured with our chins pointing down (only focusing on one chin instead of the other two), or pictures taken from above one's head (slimming the face, emphasizing the breasts)."

Goals

This chapter's theoretic perspective explains how communication and the media influence people's self-identities. Now you need to specify your goals, which you can begin to do by deciding whether you want to do basic research, applied research, action research, or evaluation research. I suggest **basic research**, which people conduct to generate or test theory and to discover knowledge for its own sake. Basic researchers publish their reports in scholarly journals.

For basic research, you might want to learn how people use visuals, in particular, for impression management. You could investigate how people think about their visual identities, how people react to each other's visual identities, and how people borrow from the media when they create their visual identities. You could research such matters for cyberspace or real life.

Research Questions

Theoretical perspectives and goals both set the stage for research questions. For this chapter, you could investigate:

1. What were people thinking when they created their websites? What were their intended purposes?
2. Do people's gender, ethnicity, age, and socio-economic status affect the way they think about making self-presentations online?
3. Do humble people create more realistic self-identities? If people create ideal self-presentations, then how far can they go in fostering distorted impressions before they label such behaviors as deceitful? How old can the pictures be when people want to portray what they look like? How much digital enhancement is permissible? Is it acceptable to include attractive friends and edit out unattractive ones? Can/should people hire professional photographers for websites? Do they think they will suffer any negative consequences from creating ideal self-presentations?
4. Do people adjust their self-presentations based on feedback from real-world friends, cyberspace friends, and others?
5. Do media influence people's online self-presentations? Do niche magazines, television, or other people's websites have a greater influence? How do people adjust their websites based upon the influences from media?
6. Do people use more words or more visual images when creating self-presentations? How do they choose to use words or images?
7. Do people create websites showing more differentiated identities or less differentiated identities?
8. How do people feel about researchers studying their homepages and profiles on social networking sites? Should researchers get permission from each owner of the website they study?

Brief Description

Researchers generally use interviews when they want to study individual's thoughts, feelings, and experiences. When they conduct such interviews, researchers adopt the role of either a miner or a traveler (Kvale, 1996).

A **miner interviewer** tries to unearth valuable knowledge that is waiting in the person's interior. The miner interviewer digs for nuggets of information that are unpolluted by any leading questions. The interviewer then purifies these nuggets of information by drawing out essential meanings during

analysis. Finally, the interviewer measures the nuggets' purity by correlating information with either an objective real world or subjective inner experiences.

In contrast, the **traveler interviewer** roams freely, eliciting inhabitants' stories without a structured list of questions. The journey not only yields new knowledge, but it changes the traveler interviewer. Upon reflection, he or she uncovers previously taken-for-granted values. At the end of the journey, he or she interprets local inhabitants' stories and retells them for people back home. If the traveler interviewer works well, then these new narratives ring true. The stories are aesthetically pleasing and affect people emotionally.

Oprah Winfrey resembles a miner interviewer. She asks questions, and the person responds with information that seems authentic. When Oprah probes deeper, the person's self-defenses seem to fall away. Question by question, Oprah gets the person to reveal his or her private self, and we learn about that person's ideas, attitudes, and feelings.

Social scientists, however, believe interviewees not only respond to questions, but they also make self-presentations (Abel and Stokoe, 2001; Lee and Roth, 2004). For example, guests on Oprah's show realize the show attracts a huge audience. They want to take advantage of this opportunity to become famous, so they present their self in whatever way they believe will be most useful. In addition, guests have previously watched the program so they know how guests should behave. They tailor their talk and body language to what Oprah and the audience expect to hear and see.

Oprah also engages in self-presentation. She asks questions to get information, but part of her never forgets about the television cameras and her multi-million-dollar image. Researchers, therefore, cannot begin to analyze an interview transcript before they have interpreted the interview as a combination of information and self-presentation (Rapley, 2001).

Units of Analysis

Since the goal is to learn how people use visuals for impression management, and since your method is to interview people, your unit of analysis might be themes in those interviews. Themes are also known as categories, codes, data-bits, chunks, and conceptual labels (Ryan and Bernard, 2003). For this book, **themes** are defined as the fundamental concepts researchers are trying to describe in order to answer their research questions. Themes appear in texts, paintings, sounds, and movies. They come in many shapes and sizes. Some are broad and sweeping, while others are more focused. In the beginning of a study, however, you should try to identify as many smaller themes as possible. Later you can decide to a) combine some smaller themes into larger ones; b) drop some smaller themes from your analysis; or c) keep the smaller theme because it is vital.

Sampling

In order to obtain an adequate quantity of your units of analysis—themes from interviews—you need to draw a purposeful sample of at least twelve people. To obtain the richest data, you would try to interview young and middle-aged people; honest and less-than-honest people; people with a few online friends and people with many friends; people who consume a lot of media and a little; as well as people who are more and less visually oriented.

To find people who can provide rich data, you can use snowball sampling. The **snowball sampling** process begins by asking knowledgeable people: "Who knows a lot about what I'm researching? Whom should I talk with?" These people tell you about others, who then suggest other people to interview. For this study, start the snowball rolling with people with strong visual self-presentations on their profiles.

Methods

In order to learn how people use visuals for impression management, you could interview people who have created profiles on a social networking website. This section explains: a) skills you need to conduct interviews; b) how to prepare good questions; c) how to conduct an interview; and d) how to transcribe the recorded interview.

Skills You Need

One important skill you need to develop is **bracketing**, defined as setting aside, as much as humanly possible, past assumptions, preconceived ideas, and personal experiences that seem so normal that you take them for granted. Bracketing occurs throughout a study.

When asking questions, you bracket by remaining aware of how your background experiences and scholarly knowledge may prejudice the way you ask questions. To raise your awareness, ask a colleague to interview you using the same questions you intend to ask others. Your answers should reveal something about your ideas and experiences. Later you can compare your answers and respondents' answers in order to decide whether your preconceptions may have influenced the way you questioned others.

When analyzing the transcripts, you bracket by adopting a skeptical attitude. During analysis, you may quickly note recurring patterns among separate pieces of data. Based upon these patterns, you may then quickly jump to a conclusion. Instead, you should notice the patterns, but remain open to disconfirming evidence. Ashworth and Lucas (2000) recommend bracketing during analysis by: a) writing summaries; b) looking for surprises; c) adopting a variety of imaginary roles in the process of reading transcripts; d) reflecting through self-interrogation; e) describing the participant's experience in real or imaginary letters to friends.

A second important skill is listening. Listening means not only hearing the respondents' exact words, but also making keen observations about what else might be going on. You need to pick up on implied information, the emotions behind their words, and the context of what they are saying. You must quickly analyze this knowledge and then decide which additional questions to ask. By listening well and remaining flexible, you improve your chances to learn something unexpected.

A third skill involves learning background knowledge about the issues. In an interview, you are doing more than recording a respondent in a mechanical fashion. You are also interpreting the information on the fly. Without a firm grasp of the issues, you would not notice if several sources contradict one another. Nor would you know when to ask for additional information.

The effort needed for bracketing, listening, analyzing implied information, and interpreting answers in terms of background knowledge will leave you mentally and emotionally drained at the end of the day.

Preparing Good Questions

One way to get useful responses is to realize that the questions are for you more than for the respondents. Questions are your reminders regarding the information that needs to be collected and why (Yin, 2003). The purpose is to keep you on track as data collection proceeds.

A second way to achieve worthwhile responses is to ask six types of questions (Patton, 1990):

1. Questions about what a person does or has done.
2. Questions about what the person saw, heard, touched, tasted, and smelled.
3. Questions about a person's opinions, goals, intentions, desires, and values.
4. Questions to learn about people's emotional responses to their experiences and thoughts.
5. Questions to elicit factual information and knowledge.
6. Questions about the person's background, such as age, education, occupation, residence, and so forth.

A third suggestion for obtaining helpful responses is to ask the six types of questions in the following order (Patton, 1990). Begin with uncontroversial questions about what the person (1) does and (2) senses, since such questions encourage people to talk descriptively. After people have verbally relived their experience, you can ask about their (3) opinions and (4) feelings. Hold off on (5) knowledge questions because people need to provide some context before they state the facts, and such information can be threatening to the speaker. Spread boring (6) background and demographic questions throughout the interview. Finally, ask present tense questions first because people answer those with greater ease.

If you follow these recommendations in order to learn about people's visual self-presentations online, you might ask:

1. How do you choose the content for your home page? How do you decide when to update it?
2. If I visited your webpage, what would I see? What would I hear? What do people write when they leave comments?
3. What is your goal for your home page? What do you think about it? What would you like to see happen?
4. To what extent are you satisfied with your home page? Do you feel anxious when strangers visit it?
5. How many people visit your site? How long have you had this webpage? What can people do on your site?
6. What are your age, education level, and job?

A fourth way to gain beneficial answers is to consider your opening question carefully. If you ask an abstract question such as "What does this image symbolize for you?" participants will struggle to respond. A better line of questioning might be, "Can you tell me about the time when you took this picture?" Such a question keeps the dialogue focused on a specific experience rather than on an abstraction, which enables the respondent to provide a fuller, more detailed description of an experience. A **description** uses words and visuals to create a mental image of an event, scene, experience, sensation, or emotion. It does not include judgments about whether what occurred was good or bad, appropriate or inappropriate, or any other interpretive judgments. A description simply illustrates what occurred.

A fifth suggestion is to ask "how" questions, not "why" questions. Although you may normally ask "how come" people did something, "why" questions often solicit a defensive response. Respondents may feel they need to justify their actions, or they may not know the reasons. On the other hand, when you ask "how" questions, respondents answer at length. They tell stories, give reasons for whatever they have done, and talk about how other people's actions contributed to the outcome (Becker, 1998). For example, "How did you decide what to say about yourself in your profile?" and "How did you convey a certain impression of yourself with your profile?" By asking "how" you'll learn the steps in the process and website history.

Sixth, when wording questions in order to get rich responses, include presuppositions (Patton, 1990). For example, ask "What comment had the greatest impact on your perception of your webpage?" Such a question implies that comments naturally affect people's perceptions. You may also ask, "How do the media influence your feelings about yourself and your friends?" This question's premise (the media influences your feelings) stimulates an answer (about how the media influences your feelings) before you can decide whether you agree with the premise.

If at all possible, you should pre-test your interview with people like your planned interviewees. You want to determine if the questions work as intended, and if not, how to revise the questions (Maxwell, 2005).

Conducting the Interview

During the interview, your role will be to create an atmosphere in which people feel safe to talk freely about their experiences and feelings (Thompson, Locander, and Pollio, 1989). To make respondents comfortable, researchers attempt **neutrality**, which means they neither react favorably nor unfavorably to people's responses, but they appreciate people's willingness to share ideas and feelings with them. As one scholar writes, "What is essential in interviewing is to maintain a working research partnership. You can get away with phrasing questions awkwardly and with a variety of other errors that will make you wince when you listen to the tape later. What you can't get away with is failure to work with the respondent as a partner in the production of useful material" (Weiss, 1994: 119).

You will also need to be aware of the signals you consciously or unconsciously send to interviewees. If you ask for elaboration of a story, they will learn to provide more detailed responses. If you move from one question to another without follow-up, they will learn to use more succinct, focused responses.

You also need to remain alert to signals respondents consciously or unconsciously send. If you trespass on some unpleasant areas of their lives, or areas they do not want to talk about, they will send signals. Your response will profoundly affect the interview. If you ignore the cue and plunge ahead, they may lie, change the subject, or withdraw. If you defer, you may lose valuable information. If you demonstrate that you received the message and will, at least to some extent, respect their desires, the interview will continue. You can direct respondents back to this unpleasant area later.

During the interview, try to avoid: long, complicated questions; yes-or-no questions; vague questions; affectively worded questions; double-barreled questions; thinking ahead to the next question; helping respondents search for a good answer; interrupting; using jargon, labels, or any terms that the respondent has not introduced; losing control of the interview; and fitting answers to your preconceived ideas (Patton, 1990).

Transcribing the Recorded Interview

Interviewers generally audio record or videotape their interviews; transcribe the recordings; code the transcription; and then interpret the codes.

The transcription stage may seem like a mechanical step, but qualitative researchers disagree (Lapadat and Lindsay, 1999). Transcription represents a recording, so researchers must decide "What is a useful transcription for my research purposes?" (Kvale, 1996: 166). Then they should reveal the choices they made about whether to include notes on respondents' body language,

hesitations in conversation, the situation's context, the interviewer's questions, and interviewers' thoughts. Before transcribing, researchers also decide whether the audience for the transcript is the original interviewees, other researchers, or practitioners.

In addition to their conversations, researchers may also take notes for three reasons. First, it helps them to check what people said earlier in order to formulate new questions. Second, taking notes facilitates later analysis, including locating important quotations from the tape itself. Third, they may wish to avoid the time and cost of transcribing all of the interviews and, instead, they may just expand their notes from the taped record whenever they need more detail for their analyses.

Data Analysis

After you have interviewed your sample of people and transcribed the recordings, you need to identify your units of analysis—themes—and then use a categorizing strategy to code those themes. **Coding** is way of assigning units of meaning to the information compiled during a study.

This chapter explains two general ways to create categories, and Chapter 10 suggests additional ways.

One way is to create a provisional list of categories before collecting any data. This list comes from your theoretical perspective, goals, and research questions. For a study of self-presentations online, you might use: a) ideal versus realistic self-presentations; b) word-heavy or picture-heavy self-presentations; and c) photos showing physically attractive, neutral, and unattractive individuals. Creating a list of codes prior to collecting data forces researchers to tie research questions directly to the data. Analysts, however, should redefine or discard coding categories that seem ill-fitting, or overly abstract.

A second way involves creating categories after you have collected the data, seen how it functions within the study's context, and considered its variety. This is essentially the "grounded" approach advocated by Glaser and Strauss (1967). With this strategy, the categories fit the data better than the previous generic-categories-for-many-uses strategy.

A variation of this grounded approach is called the constant comparative method (Glaser and Strauss, 1967). With the **constant comparative method**, researchers identify incidents, events, and activities; then they constantly compare this information to an emerging category in order to develop and saturate the category. They later combine categories into a theoretical explanation of what happened (Glaser and Strauss, 1967). It includes twelve steps (Hycner, 1985).

First, data reduction begins by reading each typed transcript, becoming sensitized to each participant's train of thought, and taking notes. You want a sense of the whole interview—the context—so you can more easily record units of meaning later on. You dwell on what participants say as well as how they say it. Meanwhile, in the back of your mind, ask "What does this tell me

about the way the person understands his/her self-presentation?" In other words, what must this website mean to the participant? You may end up with about half a page of notes for each person, which you can then use to develop an individual profile to improve your empathetic understanding of the participant's experience.

Second, you become immersed in the data. Re-read the transcripts, but instead of focusing on each individual's experience, you want to compare several people's experiences. You might want to construct a table to facilitate such comparisons.

Third, divide the transcripts into **data units**, which are blocks of information with the same meaning; these units might take up several pages or could be as short as a phrase. From these data units begin to develop a list of non-repetitive, non-overlapping statements of what each person said. At this point, do not think of the data in terms of your research questions. Just stay close to the literal data, crystallize and condense what people said.

Fourth, during this process, quotes and small excerpts should be interpreted within the context provided by a particular interview. Researchers have different opinions about whether data units should be interpreted within the context of one interview or the context of all the interviews. Some prefer to interpret a quote from "Tom" in the context of his interview (Akerlind, 2005). Others advocate taking the smaller chunks from each particular transcript and combining chunks into a larger pool of meanings. These researchers worry that working with separate transcripts focuses the analysis on the individual interviewee rather than the group of interviewees (Akerlind, 2005).

Fifth, re-read the transcripts, this time looking for data units relevant to your research questions. The resulting list of statements will be shorter than your previous list because instead of summarizing everything someone said, you'll only include ideas related to your project. For example, look for statements about strategies and game plans; different identities, roles, or aspects of the self; differences between an individual online and in real life; ideal versus realistic portrayals; symbols or metaphors; reactions or feedback; friends included or excluded; privacy or worries.

Sixth, if you have not already done so, you need to train a panel of impartial judges. They need to validate, modify, or invalidate your units of relevant meaning because this work requires judgment, and judgment introduces the potential for bias. **Bias** occurs when researchers could not bracket and they could not remain neutral. It occurs when researchers bring a personal interest to the study. They should either acknowledge how their backgrounds and professional experiences may influence the collection and analysis of data, or they need to design their studies to reduce such subjectivities. Your panel of judges may include graduate students who participate in your project in exchange for your help in their projects.

Seventh, your panel of judges confirms or changes your units of relevant meaning. Then it eliminates any redundancies among the units of relevant meaning.

Eighth, you and your panel of judges then try to cluster units of relevant meaning and decide whether they represent a common theme. In the beginning, compare meaning units with each other, but only look for similarities. If several data units seem to belong together, then they may represent a theme. For example, after grouping references to flattering, vanity, enhance, improve, sexy, and attractive together, you might label these ideas "put your best cyberface forward."

Ninth, focus on dissimilarities among relevant meaning units. Re-read the transcripts and ask: "What is Sally saying that is different from Fred?" If, after comparing meaning units, you decide some units differ substantially from the others, then you may have found a new theme. For example, after further study, you might decide that flattering, vanity, enhance, improve, sexy, and attractive do not really form a single theme. Instead, the attributes seem to represent two or more themes. Vanity might be a description of a person's true self, which a person recognizes because of kidding from friends. Sexy and attractive might describe aspects of the self a person wants to present to others via some improvement and enhancement. Flattering might describe one type of interaction that shapes a person's self-image and self-presentation.

Tenth, to decide if the differences merit creating a new theme, you must go back to the pool of transcripts, and compare this possible theme with everything said in all of the interviews. In the context of all of the interviews, does this possible theme resemble existing themes, or does this possible theme differ substantially? Deciding can be difficult because sometimes people say similar things, but their words have different meanings, or people say different things, but their words have the same meaning. For example, several interviewees may have talked about how they sometimes lie when presenting themselves online, but some might be more forthright than others. Candid people might say "deceit" or "trick," while guarded people might say "spin" or "strategy." Moreover, although one person may have used strategy to refer to a trick, another person may have said strategy and meant game plan. After comparing each theme with data in all the transcripts, write a summary for each interview, incorporating the themes you discovered.

Eleventh, at this point, ask your team of coders to repeat your efforts and create their own lists of themes within the interviews. This task again requires judgment and skill, which again means presuppositions might interfere with the analysis process (Akerlind, 2005).

Twelfth, after everyone finishes coding, they meet together to compare their results. During this meeting, each analyst refers back to the sorts of things people said in the transcripts to justify his or her particular set of themes. When two analysts use a different phrase for the same theme, they combine their descriptions to form one theme. When two analysts use the same phrase for different themes, they split their descriptions into two themes. The team then focuses on the parts of transcripts that do not fit the proposed themes, and, if necessary, the team debates themes that someone believes may not represent any part of the transcripts. Then the team considers how a change in any one

theme may affect all of the themes. This second review of the data, therefore, results in modification, addition, or deletion of the thematic descriptions, and it continues until the modified themes seem to be consistent with the interview data.

Data Displays

Qualitative and quantitative researchers use categorizing strategies to analyze their data, but qualitative researchers may not report the frequencies of units within each category. In this case, for instance, they might use a cognitive map to describe the meaning of each person's online self-presentations. A **cognitive map** displays a person's beliefs about a particular topic as well as the relationships among the beliefs (Miles and Huberman, 1994: 134).

To create a cognitive map, list the words a participant uses in relation to his or her self-presentation. Then draw a rectangle around each word and e-mail participants the list of boxed words. Ask participants to create a drawing

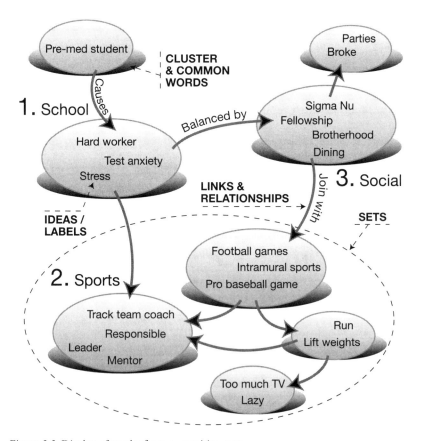

Figure 2.2 Display of results from a cognitive map

by arranging the rectangles in a way that represents their identity. Have participants return the diagrams as e-mail attachments or via fax. When you receive the results, ask them "Why are the concepts arranged this way?" Then, draw lines around concepts that belong together and create a name for the group. Finally ask each participant: "What relationship is there between the first group and the second?" Use their answers to name the links between groups.

Researchers who conduct interviews generally include several quotations from interviewees. For a study about social networking websites, they would also provide screen shots of different types of self-presentations on different sites. The data display, therefore, would include a participant's cognitive map, some quotations, and some screen shots of their site.

Credibility, Transferability, and Dependability

When researchers use interviews to collect their data and they use categorizing strategies to analyze these data, they can use one or more procedures to improve the quality of their conclusions. For example, in a review of thirty-two interview studies, Baxter and Eyles (1997) found that interviewers:

- Provide a rationale for why interviews, rather than another method, were used to address the research questions;
- Use more than one method to study the problem;
- Describe the sample of people, places, and actions;
- Quote interviewees in the data display section;
- Describe, in detail, how the interviews were conducted;
- Describe how the interviews were converted into themes for building theory or answering research questions;
- Tell how a close relationship was developed with respondents;
- Use revisits to clarify meaning;
- Report how contacts with respondents were made to verify researchers' interpretations;
- Explain how the study's findings supported or refuted not only the research questions, but also the theoretical perspective underlying the study;
- Demonstrate how the link between data and concepts made sense to both the researchers and the interviewees.

To ensure credibility, the research report should bring the interviewees' experiences to life. Readers should believe the manuscript accurately represents the subject matter. They should also believe the report clarifies or expands their appreciation and understanding of the subject matter.

To ensure transferability, interviewers can use naturalistic or analytic generalization. **Naturalistic generalization** rests on personal experience; you understand how things are in one case and you expect them to be similar in other cases (Kvale, 1996). For example, your daughter and her friends all post

similar pictures on their websites; you look at some other websites and see similar pictures; therefore you expect all high school and college students make similar self-presentations on their websites.

Analytic generalization involves reasoned judgment about the extent to which the findings from one study can be used as a guide to what might occur in another situation (Kvale, 1996). For example, you interview dozens of middle-class high school and college students about self-presentations on their websites and you expect that other middle-class students would give similar responses if they lived in the same culture during the same time period.

To ensure dependability, researchers may hire an **auditor.** An auditor is an independent scholar who systematically compares the researcher's data collection and analysis processes to a set of norms or standards and issues a professional opinion. An auditor might check for representativeness of the data, researcher effects, and rival explanations.

To check for representativeness of findings, auditors assume your guilt (lack of representative findings) and then they use one of the following tactics to prove your innocence. One, auditors conduct more interviews. Two, auditors look purposefully for contrasting, negative, extreme, and countervailing results. Three, they sort the interviews systematically and then fill our weakly sampled types with additional interviews. Four, auditors add a few randomly sampled interviews.

Internet

Researchers using the interview method have been able to take advantage of the Internet by conducting interviews via e-mail.

E-interviews offer four advantages over face-to-face interviews. First, they save researchers time and money by eliminating the need to travel and to transcribe audiotapes or videotapes. Second, e-interviews allow researchers to interview people who would ordinarily be outside their geographical or social reach. Third, busy interviewees and researchers may appreciate the flexibility of asynchronous interviews because finding a mutually convenient time to talk to each other may be difficult. Fourth, computer-mediated communication (CMC) leads to higher levels of spontaneous self-disclosure compared to face-to-face discussions due to heightened self-awareness (Joinson, 2001). **Computer-mediated communication** is a process of human communication via computers. People create, exchange, and interpret information in formats such as instant messages, e-mails, and chat rooms.

In spite of the apparent strengths of e-interviews, researchers should be aware of several challenges. First, unlike face-to-face interviews, e-mail interaction is asynchronous. Respondents may choose to reply instantly or they may let three or four weeks go by. The extra time allows respondents to reflect, draft a reply, and even re-draft an answer, so their responses might be more calculated (Bampton and Cowton, 2002). The extra time hurts interviewers, who must attempt to preserve participants' interest after the first few e-mail

exchanges (Kivits, 2005). To maintain participants' interest, researchers can ask questions pertinent to the participant's experience. They should also remain patient and preserve their sense of humor.

Researchers who study online self-presentations might want to use e-interviews, with their asynchronous interaction, because the point of their investigations is to understand respondents' calculated attempts to create a desired impression on others. On the other hand, if researchers wish to minimize the amount of impression management during interviews and maximize the amount of authentic information, then face-to-face interviews, with their greater spontaneity, could offer better data.

A second challenge of e-interviews is to establish a trusting interpersonal relationship without access to non-verbal data. Neither party can see smiles, gestures, body language, and so forth. Nor can they notice each other's speed of talk, loudness, and pitch. Interviewers and respondents also have limited means for emotional or empathetic communication (Crichton and Kinash, 2003). Because of these limitations, they cannot quickly become comfortable with each other.

Without non-verbal cues, interviewers also have greater difficulty managing the flow of messages. To know when respondents' interest wanes or they feel fatigued, interviewers must rely on hints such as slower responses (indicating waning interest), and a decline in the length and quality of responses (indicating fatigue). To know when the interview is about to end, so they can be sure to cover critical issues, researchers must establish some ground rules. For example, they can tell respondents how long the interview may last, or they can send respondents a list of the issues they want to cover (Bampton and Cowton, 2002).

A third challenge with e-interviews is that researchers generally ask more than one question at a time. Sending several questions, however, may discourage respondents and cause them to send brief responses for each question. As a result, researchers may obtain less information from e-interviews than those conducted face-to-face (Chen and Hinton, 1999). You can make the process more interactive, however, by sending some introductory questions and then responding to participants' replies before sending additional questions. Having more than one question-and-answer episode helps achieve the conversational characteristics of a good interview (Bampton and Cowton, 2002).

A fourth challenge is that respondents must have access to reliable technology and be willing to use this technology. Access should not be a problem for participants in studies of online self-presentation, but technology always presents challenges. For example, either person may not receive a message because of a breakdown in an e-mail system.

Advantages and Disadvantages

Interviewing people offers several advantages over other methods for collecting data:

1. As with diaries, you can learn about people's thoughts, feelings, and behavior from the people's perspective. You don't need to observe people and then try to interpret what you see. You don't need to interpret documents and other artifacts that people had produced in the past.
2. As with Photovoice studies, ethnographies, and focus groups, you can interact face-to-face with respondents when you use interviews. You can adjust your questions to fit the changing situation. You can respond to questions from participants.
3. As compared with surveys, you can obtain data with depth, nuance, and complexity. You also gain contextual information.
4. As with the draw-and-tell, Photovoice, and focus group methods, you can give participants some control over the research process. In a sense, you collaborate with respondents during an interview.

Qualitative researchers collect more data by interviewing people than by using any other methodology, but interviews have their disadvantages:

1. Respondents may forget what happened. At best they recall about half of their communications with others, and their memories decay exponentially with time (Bernard et al., 1984).
2. Respondents may distort what happened; their emotional state at the time of the interview may affect their recall (Patton, 1990).
3. Respondents may misinterpret questions due to cultural differences.
4. Respondents may lie or withhold information. In fact, a review of the literature of informant accuracy lead to one overwhelming conclusion: "on average, about half of what informants report is probably incorrect in some way" (Bernard et al., 1984).

Ethical Issues

Institutional Review Boards (IRBs) sometimes exempt interviews from review because they consider interviews low-risk methods (Lindlof and Taylor, 2002). Under two circumstances, however, IRBs require review: a) if the questions concern highly personal topics or illegal activities; and b) if the questions will be directed toward members of a vulnerable population, such as children, homeless people, medical patients, prison inmates, and people with physical or mental disabilities.

Especially with sensitive questions and vulnerable populations, one ethical issue concerns emotional harm to respondents and interviewers. Respondents may begin crying, and as a result, interviewers may feel guilt at not being able to help the respondent and for being, in some ways, responsible for the respondent's emotions. Then interviewers must determine whether to stop pursuing that line of questioning. The decision, however, may be too late because even if interviewers attempt to steer the discussion gently toward less sensitive topics, respondents may keep returning to the sensitive topic in order

to rationalize their actions and feelings (Sin, 2005). Respondents may also become emotional if they learn things about themselves that they did not know—or were not aware of—before the interview (Patton, 1990). Remember that although respondents signed consent forms, you must safeguard them from harm.

A second issue with sensitive questions and vulnerable populations concerns informed consent. Members of a vulnerable population may not understand the concept of voluntary participation, so interviewers should never use coercion to gain access. In addition, members of a vulnerable population may live in institutions where "voluntary" has a different meaning, so interviewers should never allow institutional leaders to coerce people on researchers' behalf.

A third issue, which interviewers always face, concerns access to information (Brinkmann and Kvale, 2005). Interviewers want as much information as possible, while at the same time they want to respect the privacy of the informant. On the other hand, interviewers want to be as respectful to the informant as possible, with the risk of getting material that only scratches the surface.

A fourth ethical issue concerns power. Brinkmann and Kvale (2005) describe five issues related to power between interviewers and respondents.

1. Interviewers define the interview situation. They initiate the interview, determine the interview topic, pose the questions, follow-up on the answers, and also terminate the conversation. Their research project sets the agenda and rules the conversation.
2. The interview is a one-way dialogue. The role of the interviewer is to ask, and the role of the informant is to answer.
3. The interview is an instrumental dialogue. Unlike a good conversation, the interview is not a joint search for truth, but a means serving the researcher's ends.
4. The interview may be a manipulative dialogue. Researchers often follow a more or less hidden agenda because they want to obtain information without the informant knowing what they want. Interviewers may also use subtle therapeutic techniques to get beyond the subject's defenses.
5. Interviewers have a monopoly on interpretation. They maintain an exclusive privilege to report what the informant really meant.

A fifth issue concerns the ethics of studying websites more than the ethics of interviewing. You should check with your IRB whether you need to ask people's permission to study their websites. "The rules were made for a different world, a pre-Facebook world," said Samuel D. Gosling, an associate professor of psychology at the University of Texas, Austin. "There is a rule that you are allowed to observe public behavior, but it's not clear if online behavior is public or not" (Rosenbloom, 2007).

Resources

Like most qualitative research, acquiring the necessary skills and doing the actual work requires plenty of time. You may need training on how to select appropriate kinds of questions and how to ask those questions. To gain some practice, you could record yourself interviewing your peers. Afterward, you could discuss the recorded interviews with the respondents, with both of you sharing ideas on how both could improve.

You may also need training on how to analyze your mountain of interview data. Ideally, you could join experienced researchers as they develop descriptive themes and analyze their results. Checking, testing, and probing the proposed set of themes with experienced interviewers will help you understand the analytical process.

You will also need time to a) identify participants via snowball strategies; b) interview forty or so people; c) transcribe and analyze those interviews; and d) create a visual display of the results.

Advice

1. Select participants with different demographic attributes, different characters, and different levels of expertise.
2. Never begin an interview cold. Spend several minutes making small talk to set the person at ease and to establish a comfortable relationship.
3. Remember your purpose. You are conducting an interview to obtain information, so try to keep the respondent on track.
4. Ask questions about a specific—not general—situation because you can only interpret meaning within a context. Pose questions that make their experience clear.
5. In the interviews, do not be satisfied with monosyllabic answers. If respondents give yes or no answers, be sure to probe with questions such as "Can you tell me a little bit more about that?" or "What else happened?" A simple pause and an uncomfortable silence might give participants more opportunity to reflect and, therefore, yield additional information.
6. Offer appropriate non-verbal responses. Do not present yourself as uninterested or unaware.
7. Practice interviewing skills and have them reviewed periodically so you can make changes if necessary.
8. Practice applying the skill of bracketing during interviewing and during the coding process.
9. Have at least two researchers analyze the data.
10. Think about what you can give to respondents in return for their time and inconvenience of being involved in your research. Do something that makes them feel it was a worthwhile experience and they were not being used. At a minimum, send a thank-you note. If you want to do more, provide a gift, service, or some other acknowledgment of your appreciation.

Further Viewing

Impression management on YouTube
http://www.youtube.com/watch?v=MySImOlnRgs&feature=related

Re: impression management on YouTube
http://www.youtube.com/watch?v=KOM15m4P1HY

Re: impression management on YouTube
http://video.google.com/videoplay?docid=2871909313933095050&q=impression+management&ei=7hMbSKbDDJiAqwLpkdTRAg&hl=en

Online Dating Research

Nicole Ellison

After I graduated from college in 1991, I worked for several years in Los Angeles at technology companies—first at Voyager, which made innovative CD-ROMs, and then at a video game company. Around this time the World Wide Web was becoming popular, and I decided to apply to graduate school so I could spend more time thinking about technology and less time just making it. My fascination with the social impacts of new technologies led me to the Annenberg School for Communication doctoral program at the University of Southern California. At this time, the concept of online, or virtual, communities was getting more attention from academics, the popular press, and individuals who joined Usenet newsgroups or AOL chat rooms in order to connect with individuals who shared their interests and passions, but not necessarily their geography. The work of Sherry Turkle, for instance, described individuals who connected with one another on Multi-user dungeons, domains, or dimensions (MUDs) and Mud Object Orienteds (MOOs), creating online personae that bore no resemblance to their offline identities. For these users, the Internet was a kind of identity playground where they explored fantastical alternate selves with others from around the globe. On the Internet, the famous cartoon in the *New Yorker* claimed, nobody knows you are a dog.

Online dating sites such as Match.com and Yahoo! Personals, on the other hand, are very different. Few users of these sites want to be surprised when they finally meet the person they have been intensely e-mailing for three weeks. By 2002, when I started exploring the phenomenon, online dating sites were becoming more mainstream—a trend that has continued. Today online dating is one of the most lucrative forms of legal, paid, online content. According to a recent Pew Internet study, 11 percent of all Internet-using adults in the United States—about 16 million people—say they have gone to an online dating web-site. The industry as a whole saw revenues of about $900 million in 2007 (JupiterResearch, 2008).

For me, online dating represented a fascinating new twist in online culture and communication because of the anticipated face-to-face interaction inherent in these sites. I had studied how individuals presented themselves, bonded with, and formed impressions of others in online communities where participants were unlikely to ever meet face-to-face. But online dating differed from these online contexts in one important way—if the initial interactions went well, participants knew they would meet offline. How would this affect the way in which they presented themselves online? How might it change the way they interacted with one another?

With any form of self-presentation, we strive to present ourselves in a manner that will best enable us to achieve our goals. Most online dating

participants seek a romantic partner and thus will be motivated to present themselves as attractive and desirable. In some online environments, individuals have a good deal of freedom to present themselves in any way they choose. With online dating, however, these online interactions are constrained by the fact that users anticipate meeting one another offline. How did this affect users' presentation strategies? How did users decide what were acceptable "white lies" and which acts of deception were deal-breakers? How did they manage the tension between the desire to portray oneself as desirable and attractive (which is much easier to do online than in "real life") and the need to be honest?

I began putting together a research program designed to address these questions. I applied for and received an internal grant of about $3,000 to pay for interviews and transcription from California State University-Stanislaus, where I was an assistant professor. Around this time I ran into a friend and Annenberg alum, Rebecca Heino, at an academic conference and talked to her about the project. She expressed interest and joined the project, as did another Annenberg alum Jennifer Gibbs. Gibbs actually met her husband on Match.com in 1998 and thus had a professional and personal interest in the topic. We had the makings of a successful academic collaboration in that our general research interests overlapped, but our specific areas of interest and expertise were sufficiently different for us to carve out different papers and methodological approaches. We also were friends, which was helpful for a number of reasons. First of all, we enjoyed one another's company and being able to joke about the project made it more fun, and easier to get through the stressful, boring, or painful periods of the project. We knew our relationships would outlast the project and were motivated to avoid disappointing one another. As a team, we settled on a few customs that helped us balance our work and personal relationships—for instance, at the beginning of each conference call we would spend a few minutes checking in with one another and sharing recent news. We also laid out roles and expectations explicitly. For example, we knew we each wanted to be first author on one publication from the project's data, so from the beginning we laid out three different papers that would be written from the paper (two of which have been published and a third which is under review at a journal). I took the lead on an article examining self-presentation in online dating using the qualitative data, which Heino and I coded, later published in the *Journal of Computer-Mediated Communication* (Ellison, Heino, and Gibbs, 2006). Gibbs focused on the survey data and explored issues of self-disclosure for an article in *Communication Research* (Gibbs, Ellison, and Heino, 2006). Both articles were published in 2006 (*JCMC* in January and *CR* in April), which was interesting because the *CR* article was actually accepted months earlier, but because *JCMC* is online the production cycle was much shorter.

With our increased production power, we were able to be more ambitious than the project outlined in my earlier proposal. We redesigned the project to

include both qualitative (interviews) and quantitative (survey) data, and approached one of the major dating companies to see if they might be interested in supporting our research. We were lucky to find someone in the market research department who was interested in the kinds of questions we were asking and the free consulting we offered. Essentially, we agreed to do a research report for them and to include some questions that were of interest to them in our instruments. The organization agreed to provide a random sample of its users, which was very valuable to us. Because many online dating users hide their profiles, any sample we gathered from the website would be biased. Also, drawing the sample from the site's database of paid subscribers had the benefit of eliminating the many users who had signed up for a free membership and posted a profile but were not active on the site. The site also agreed to give interview participants a free one-month credit to the site as an incentive, which helped us recruit people and helped them increase traffic to the site. We decided to survey a random sample of users and to interview about thirty users in the Los Angeles area and another, more rural area in Northern California.

In order to create our interview protocol, we reviewed the existing literature on computer-mediated communication (CMC), other forms of mediated match-making (such as newspaper personals), and related topics such as impression formation and self-presentation online. We created an interview protocol that covered the topics we were interested in while allowing for enough flexibility that new or unplanned topics could emerge. One of the most challenging aspects of the protocol, and something we struggled with, was to design a way to ask people if they were deceptive in their profile. There is a significant bias against admitting deception, even to a researcher you will never meet in person. How could we ask people whether they lied on their profile without asking "Did you lie?" Additionally, some individuals may have included incorrect information in their profile but did not consider these embellishments to be lies. We came up with a few creative approaches, such as asking people what their friends would think about their profile if they saw it.

We then tested this protocol with mock interviews with friends who had done online dating in order to see which questions worked and which needed to be adjusted. The following is a selection of questions from our final interview protocol:

- What prompted you to start [using online dating sites]?
- Overall, how do you think online dating compares to traditional dating? Probe on this.
- Describe a successful experience using an online dating service.
- Describe a disappointing experience using an online dating service.
- Do you have any horror stories to share?
- Probe: How about horror stories that have happened to others?

- How did you decide what to say about yourself in your profile?
- Probe: Are you trying to convey a certain impression of yourself with your profile?
- Probe: What is it?
- Probe: If you showed your profile to one of your close friends, what do you think their response would be?
- How did you choose your screen name and tag line?
- If photo: How did you decide which photo to include?
- If no photo: Why did you decide not to include a photo?
- Do you think most people using this service describe themselves accurately?
- Probe: What kinds of things do people lie about?
- What criteria do you use when deciding who to respond to? How important is the demographic information provided in the profile? What kinds of things turn you off?
- Is it important to you that you see a photograph before corresponding with someone? Why/why not?
- Thinking about specific qualities you look for in someone you meet online, how do these compare to the qualities you look for or notice when you meet someone for the first time through traditional ways, for instance, at a party?

Another challenge was encouraging people to be self-reflexive about the process of creating an online representation of self. For some, answering these questions seemed effortless and they were able to talk openly about their goals, process, and experiences. Others were more reticent or just answered, "I don't know" when asked why they created their profile as they did. For these individuals we used probes to try to encourage them to be self-reflexive about their actions, but these were not always successful.

All three members of our research team conducted interviews. We corresponded with the participants over e-mail to set up a time and date, and then called them and recorded the interviews using digital or analog recorders. Interviews typically took about forty-five minutes and most participants seemed to enjoy the opportunity to reflect on their experiences. Online dating was fairly novel, especially for users from more rural areas.

Although we tried other methods at first, we ended up using a professional transcription service to transcribe the interviews. This is one of the most boring and painful tasks in the research process, and I would encourage anyone who can to outsource it. The interviewer who did each interview then listened to the entire interview again while proofreading and correcting the interview transcript. This was probably one of the more tedious research tasks, but we felt it was necessary, as we wanted to be sure that the transcripts were accurate and some of the terms and phrases used by our participants might not be

transcribed accurately by someone unfamiliar with the culture and terminology of online dating.

After the interviews were corrected, we imported them into a qualitative data analysis program called Atlas.ti and began the laborious process of coding. Heino and I went through each interview, assigning codes to each exchange and discussing the meaning of each code, whether each code was unique, and how they related to one another. I was particularly interested in the self-presentational components and therefore decided to focus on this aspect while Heino was interested in the metaphor of the marketplace and how it influenced participants interactions, behavior, and perceptions.

Writing the manuscript that was eventually published in the *Journal of Computer-Mediated Communication* was a long, long process entailing many drafts. We submitted one early version to another journal only to have it be rejected, with a note from one of the reviewers that it did not provide any insight that could not be "coughed up" by any undergraduate bemoaning the travails of campus romantic life. We realized that although the manuscript needed to be stronger, it also needed a home and an editor that "got it"—a journal that was friendly toward and respectful of work in the area of online communication.

We had disagreements about many stages of the project, and though they were usually resolved amicably, at times our personal relationships were strained. Although co-authored papers are collaborative efforts, in the end it is usually the first author who needs to shape the analytic framework and major contributions of the paper, and this can be a lonely and frustrating process. This particular paper came together during a summer when I had more freedom to browse through the theoretical literature and more time to think about what the data meant and the patterns they represented. When the manuscript was finally accepted for publication, we worked hard to fine-tune every sentence, but then endured a lengthy negotiation with the online dating organization that decided late in the process it did not want to be named in an online journal. The person we had worked closely with had left the company, and his replacement was less friendly toward academic researchers. Despite this last-minute excitement, the article was published earlier than projected and is now one of the most-downloaded articles in the journal. We are all proud of the work we have done together, and the fact that our friendships survived the process intact.

3 I Don't Want to Talk About It; I Want to *Draw* It!

Theoretical Perspective

When **Pablo Picasso** began to say his first baby words, he also began to draw. In fact, his first word is said to have been *piz*, which is short for *lapis*, which refers to a drawing pencil (Gardner, 1993).

As a young child, Picasso drew in order to express himself. According to his longtime friend, Gertrude Stein, "Picasso wrote painting as other children wrote their ABCs. He was born making drawings, not the drawings of a child but the drawings of a painter. His drawings were not of things seen but of things expressed, in short they were words for him and drawing always was his only way of talking and talks a great deal" (Burns, 1970: 4).

By the age of nine, Picasso was drawing competently. He could draw plants, animals, and manmade objects; he could draw people—young and old, healthy and diseased, grotesque and sensual. We know this because his family saved virtually every scrap of paper Picasso drew on, as well as numerous notebooks, schoolbooks, pieces of wood, and other surfaces with drawings. Appraising Picasso's visual talents, one scholar writes: "He evinced skill in noticing visual details and arrangements, thinking in spatial configurations, remembering virtually every live and painted scene that he had ever witnessed" (Gardner, 1993: 141).

Although skilled in drawing, Picasso was lousy in school. In fact, he feared and hated school. He made "noisy, terrible scenes" as his family maid "dragged him through the streets by brute force" (Gedo, 1980: 14). He would feign illness and make a thousand excuses in order to stay home. When in class, Picasso was so distraught he could hear nothing and learn nothing. All he could do was watch the clock, wait for his father, and repeat to himself (sometimes aloud): "At one o'clock, at one o'clock" (Gedo, 1980: 14).

Not only did Picasso have a severe school phobia, he also had a severe learning block. He could not concentrate. He had difficulty in learning to read and write. He had even greater difficulty mastering numbers. To make it through grade school, Picasso required backdoor connections, extensive tutoring, and blatant cheating (Gardner, 1993). As a result, he never had a positive relationship to the world of scholarship and to intellectuals.

One possible explanation for Picasso's ability to express himself with drawings, but not with words or numbers, comes from research about the functional roles of drawing. According to Anna Stetsenko, head of the PhD program in Developmental Psychology at CUNY (City University of New York), children draw to communicate with adults, to express emotions, and to exercise control over the world of pictures (Stetsenko, 1995). All three functions seem to apply to Picasso.

Imagine if you wanted to conduct a research study about why some people, such as Picasso, can draw better than they can write. Well, maybe Picasso is the exception. Instead, you might want to study why more people do not use drawings for interpersonal communication. If so, you might begin by studying children and our educational system.

Pre-school children use both drawing and writing to "tell" adults about their ideas and feelings. "Drawing is a natural mode of expression for children age 5 to 11. Long before youngsters can put their feelings and thoughts into words, they can express both conscious and unconscious attitudes, wishes and concerns in drawings. Drawing is a non-verbal language, a means of communication" (Koppitz, 1968: 283–284).

In school, however, children are taught to write. Teachers do not adequately nurture children's spatial intelligence during the golden window of opportunity between the ages of five and seven (Gardner, 1982). As a result, at about the age of ten, children lose interest in drawing (Stensenko, 1995; Gardner, 1993). Adults seldom draw pictures to express their understanding or to send a message to others.

So we know why people do not use drawings for communication, but, as a visual communication researcher, you might wonder if people *could*. In the next section, I draw on the work of Gunther Kress and Theo van Leeuwen (1996) to develop a six-step theoretical argument that people can use drawings to exchange messages.

The first point of the argument is that several different types of symbol systems are available for people to send messages. We may use words, numbers, gestures, musical notes, movements, and, in Picasso's case, drawings.

A **symbol** is defined as something a person uses to intentionally represent something other than itself (DeLoache, 2004). This simple definition has more value than you may realize. Although it uses the vague word "something" twice, which would seem detrimental, the word "something" emphasizes that virtually anything can be used to represent virtually anything else. Words, pictures, gestures, and an infinite list of other possibilities can be used to refer to thoughts and feelings. Notice that in this definition, a symbol may not have a purely arbitrary, formal, or conventional relationship to what it represents. A symbol could resemble its referent or not. To be a symbol, however, people must intentionally use something to refer to something else. In fact, intention is both a necessary and a sufficient condition to qualify as a symbol.

The second point of the argument is that although people use several types of symbol systems, they can employ some systems more skillfully than others.

Picasso, for example, could draw well because he was particularly "intelligent" when it came to using visual symbols.

Howard Gardner, a psychologist based at the Harvard Graduate School of Education who laid out the theory of multiple intelligences in *Frames of Mind* (Gardner, 1983), defines **intelligence** as a biological and psychological potential to solve problems or to fabricate products (Gardner, 1983). You can think of an intelligence as a information-processing device or as a mental organ. Your level of an intelligence is partly determined by your genes because at birth you have certain "raw patterning abilities." You can expand an intelligence, however, with experience and motivation. If you live in a music-loving culture, for example, and if you want to play music, then you will likely make a conscious effort to master the principal components of musical intelligence: pitch and rhythm.

According to **Multiple Intelligences theory** (Gardner, 1983), people do not have one intelligence; everyone has a mixture of seven intelligences (although since then he has suggested people may have eight or nine intelligences). His original list included: linguistic, musical, logical-mathematical, spatial, bodily-kinesthetic, interpersonal, and intrapersonal intelligences. Later, Gardner added naturalistic intelligence and he continues to investigate whether there is an existentialist intelligence. Because people's multiple intelligences are not connected, people can be "smart" in one, but not in the other six intelligences. Each person develops a unique intelligence profile based upon his or her raw patterning abilities and life experiences.

One of the seven intelligences is spatial intelligence, which Gardner sometimes calls visual-spatial intelligence, and others may refer to as visual-spatial thinking. **Spatial intelligence** is defined as the ability to represent the spatial world internally in your mind. Some chess players, for example, can recall all the moves from previous games; sailors can visualize a route across the ocean; and sculptors can anticipate how a beautiful form will emerge from a block of stone.

Spatial intelligence helped many notable scientists. Leonardo da Vinci used it in his painting, sculpture, drawing, engineering, anatomy, architecture, and inventions. Albert Einstein used visual and spatial forms to carry out experiments in his mind. He once said, "The words of the language, as they are written and spoken, do not seem to play any role in my mechanisms of thought. The psychical entities which seem to serve as elements in thought are certain signs and more or less clear images which can be voluntarily reproduced or combined . . . The above mentioned elements are, in my case, of visual and some of muscular type" (McKim, 1972: 28). Other examples include Friedrich Kekule and the structure of the benzene ring, James Watson and Francis Crick and the structure of the DNA molecule, and Buckminster Fuller and the development of the geodesic dome.

Spatial intelligence also helps graphic artists, photographers, cinematographers, Web designers, typographers, and cartoonists. They use colors, shapes, lines, and sizes to create visual displays. They may also have a better memory

for pictures than for words. Michelangelo, for example, had accurate visual recall that enabled him to re-create without effort images he had seen in the past. "He had a most tenacious memory; he could remember and make use of the works of others when he had only once seen them; while he never repeated anything of his own because he remembered all he had done" (Vasari, 1957: 322).

Design engineers work with spatial intelligence. They use sketching as an individual thinking tool as well as an interactive communication tool (Henderson, 1991). Design engineers even "argue" by sketching. They see drawings, critically analyze them, then erase and improve them. According to one design engineer, you never "get two designers who just sit down and just talk. Everybody draws sketches to each other" (Henderson, 1991: 461).

The third point is that each symbol system has benefits and drawbacks. Consider the difference between writing and images (I adapt the following from Kress, 2003). Words name both things and the relations between things. Authors write words in a sequence. They provide a strict reading path, from left to right, and from top to bottom. Images, however, show things and the location of things. The things are arranged in space, which provides a sense of connection and hierarchy. Image makers do not provide a strict reading path; they show everything at once.

To better understand the difference between writing and images, consider the way we learn about the findings of a research study. If we read text, we probably need to know some special vocabulary in order to make sense of the results. We follow a clearly defined reading path, and we need to read several pages in order to learn everything. On the other hand, if we view a display, we can probably understand the results just by looking at the numbers or other visual elements. There is no conventional reading path. We can read across the rows of a table, or we can read down the columns. We can first look at one specific number in a table or we can look for overall trends. Moreover, we can see all of the results at once, in one matrix or network display.

People may use multiple symbol systems in order to create a message. With multiple systems, people can take advantage of each system's benefits in order to communicate clearly with their intended audience. As a result, each symbol system supplies only some of the information in the message. No symbol system needs to carry all of the meaning.

To understand how people take advantage of the strengths of different symbol systems, consider a standard magazine advertisement with a large photograph, headline, some copy, and a logo. The photograph generally carries information advertisers wish to imply because they would be embarrassed or sued if they boldly stated the same points in writing. For example, advertisers cannot write: "You are a lonely man, but if you buy this product, attractive women will cling to you and gaze at you adoringly." Advertisers can, however, show a picture that implies this message. When they want to convey information that will not get them into trouble, advertisers use words. The words tell us the product's name, some of its features, and perhaps where it can be

purchased. So the visuals "promise" consumers wealth, power, and the attention of the opposite sex, while words tell consumers how to buy the product.

The fourth point is that although each symbol system has its own strengths and weaknesses, society values some symbol systems more than others. For example, until recently, our society valued language the most for communication purposes. Lawyers and executives, who mastered language and reasoning skills, received society's perks. We assumed that language "is fully adequate to the expression of anything that we might want to express: that anything that we think, feel, sense, can be said (or written) in language" (Kress, 2000: 193).

The **No Child Left Behind Act of 2001** is a controversial United States federal law that strives to improve the performance of U.S. primary and secondary schools by increasing the standards of accountability for states, school districts, and schools. It also provides parents more flexibility in choosing which schools their children will attend. Additionally, it promotes an increased focus on reading/language arts, writing, and math. Students are also tested in science three times, once in each of these time periods: grades 3–5, 6–9, and 10–11. Since the law was passed, primary and secondary school teachers do not spend much time preparing students to draw, sing, dance, write poetry, and act in plays. They also spend less time on physical education.

In addition, schools must use "scientifically based research" strategies in the classroom. The research must involve large quantitative studies with control groups. Schools cannot use case studies, ethnographic studies, or personal experience (or the research designs in this book!) in order to improve teaching strategies.

Perhaps the No Child Left Behind Act emphasis of reading, writing, math, and science, as well as "scientifically based research" will prepare today's students for a rich, fulfilling life in the future. Perhaps tomorrow's college admissions committees and employers will prefer students who can pass standardized tests measuring math and English language skills.

Or perhaps, as the fifth point suggests, students will need to use different symbol systems in the near future. The fifth point is that new technologies can change society's preferred symbol systems. For example, a dramatic proliferation of computer and multimedia technologies has been changing everything from the ways people work, to the ways they communicate with each other, and the ways they spend their leisure time (Kellner, 2004). With this new technology, people realize they need multiple literacies, including media literacy, computer literacy, and visual literacy. In the future, people need to know how to use the Web to find information; to collaborate with remote partners via videoconferencing; to use photography, video, drawing, animation, and music to empower others; and to interpret these multimedia messages competently.

With the increased use of multimedia technologies, people may need to use a different part of their brains. The **brain** is divided into a left and right hemisphere, and each hemisphere processes different types of information in

different ways. Whereas the left hemisphere processes information sequentially, the right does so simultaneously. The left hemisphere is more analytical, verbal, and logical; while the right is more holistic, imagistic, and intuitive. Our future leaders will likely take more advantage of the right hemisphere of their brains. As Daniel Pink writes, "The R-Directed aptitudes so often disdained and dismissed—artistry, empathy, taking the long view, pursuing the transcendent —will increasingly determine who soars and who stumbles" (Pink, 2005: 27).

The sixth, and final, point of the argument is that during a transition period—such as the present, which gives increasing importance to visuals and decreasing importance to language—opportunities for miscommunication may also increase. Imagine a person—let's call her Courtney—has a combination of intelligences that make understanding and creating visual messages particularly easy. Imagine that I, on the other hand, have a combination of intelligences that make understanding and creating verbal, written, and mathematical messages particularly easy. This mismatch of intelligences could affect conversations I have with Courtney. We may struggle in the same way people from different cultures have difficulty communicating.

The **Coordinated Management of Meaning (CMM) theory** addresses such problems of miscommunication. According to this theory, interpersonal communication is successful when two people attempt to make sense out of the sequencing of messages in their conversation and they have sufficient resources available for the process of coordination. Resources include the stories, symbols, memories, and concepts that people use to make their world meaningful. When two people lack compatible resources, or when they have unequal levels of resources, they have difficulty coordinating their conversation. For example, Courtney can draw well, but I have no drawing resources. I have highly developed linguistic and logical intelligences, which Courtney lacks. In such a situation, coordination would be challenging.

If people cannot coordinate their conversation, then they may become frustrated, but using a more-of-the-same strategy will only escalate the conflict. In other words, if Courtney does not understand what I am saying, talking louder or slower will not help. In the same way, Courtney can draw image after image, but I will never be able to answer with a drawing. According to CMM theory, neither side can blame the other because both sides have responsibility for the situation they make together. To improve the conversation, we need additional resources and we need some rules.

In CMM theory, people use two types of rules. **Constitutive rules** refer to how behavior should be interpreted within a given context. We can understand another person's intention because the constitutive rules tell us what certain types of behavior mean. For example, if Courtney has difficulty explaining the structure of her family, I could ask her to draw her family tree. She could use red markers for birth parents and blue markers for adults who later married into the family. **Regulative rules** refer to some sequence of action that an individual undertakes, and these rules dictate what happens next in a conversation.

The rules guide our behavior in conversations. For example, Courtney and I could agree to continue revising the drawing until we both understand her family tree; and then we could resume our oral conversation until we encounter another obstacle.

Goals

Few studies have tested this theoretical argument concerning a role of visual symbol system in society. I also am unaware of research that uses CMM to study miscommunication between people with mismatched spatial and linguistic intelligences. You could, therefore, use basic research in order to learn whether audiences with low spatial intelligence can properly interpret the **denotative and connotative meanings** of drawings. These two related concepts refer to the production and interpretation of meaning at different expressive levels. Denotation refers to the primary, blunt, obvious meaning of a sign or text. Connotation is the secondary, nuanced, implied meaning of a sign or text.

Others, however, may wish to conduct an applied research study. **Applied research** informs action, enhances decision-making, and applies knowledge to solve problems. It is judged by its usefulness in making actions more effective and by its practical utility to decision-makers, policy-makers, and others who try to improve the world.

For applied research you might want to help improve communication between people who cannot easily talk with each other or write to each other. You could investigate miscommunication between children and adults or between people with high and with low visual-spatial intelligence. Your results would benefit people outside of academia.

Research Questions

In order to learn how people can use drawings for interpersonal communication, you could ask questions such as:

1. Can people with high spatial intelligence visually express their ideas and feelings better than people with low spatial intelligence? Can they draw better? Can they photograph better? Can they use type better? Can they design Web pages better?
2. What advantages do visual symbol systems have over linguistic systems? What disadvantages?
3. Why do children enjoy drawing but then stop when they become teenagers? Do children who never stop drawing end up in careers such as design engineering?
4. Is our society becoming more visually oriented? Do right-brain-oriented people reap the benefits?

5. Can people with high spatial and low linguistic intelligence communicate well with people who have high linguistic and low spatial intelligence?

6. Can people translate meanings from one symbol system into another symbol system without much loss? If not, then in which symbol system do people think? Do they think in words or pictures (or sounds, movements, or mathematical symbols)?

7. Do people with high visual-spatial ability have a motivational edge in graphic design? In architecture? In mechanical engineering?

8. Does early interest in a field of study help people develop visual thinking because they need to think visually, or does high visual-spatial intelligence spur an interest in occupations that need this particular intelligence?

9. How does teaching a topic in a verbal form compare with a strongly visual-spatial format? How can teachers adapt their curriculum to benefit students with intelligences other than verbal or logical intelligences?

10. Under what conditions do visual-spatial factors reinforce, or interfere with, the learning of parallel verbal material? If teachers want students to understand the U.S. history in the Civil War period, how many intelligences should they incorporate in the learning experience? If teachers ask students to draw, to perform a skit, or listen to the sounds of war, will this improve or hurt students' scores on standardized tests?

Brief Description

Researchers generally use the draw-and-tell technique when they want to learn if drawing can improve communication between children and adults. The **draw-and-tell** method is very simple: researchers ask children to draw, and then they can ask children to talk about their drawings.

Draw-and-tell becomes especially valuable when a) children will have conceptual or linguistic difficulties expressing themselves orally; or b) children will find the issues too difficult or challenging to talk about (Backett-Milburn and McKie, 1999). For example, researchers use the technique to explore children's beliefs about health and illnesses.

Researchers can also use the draw-and-tell technique to test the theories of Multiple Intelligences (MI) and Coordinated Management of Meaning (CMM) if they first divide a class of children into groups that score either high or low on visual-spatial tests. High scorers would be expected to read visuals rather than words in order to solve a problem, and they would be expected to use more visuals to express themselves than children who scored low on visual-spatial tests.

Using visuals to help someone talk is also called **autodriving** because the visual stimuli drive the questions, and the participants respond by explaining the visuals. Autodriving resembles **elicitation**, which occurs when researchers show visuals to participants, who then explain the images, as well as what is missing in the photographs. Variations of this design have also been called

video-cued narrative, video-cued recall, visual interviewing, reflexive photography, and hermeneutic photography.

Units of Analysis

Since the goal is to help improve communication, and since your method is the draw-and-tell method, your unit of analysis might be symbols in participants' drawings. For example, Stafstrom and Havlena (2003) asked children to draw a picture of what it is like to have a seizure. The children drew emergency vehicles, shaking of limbs, falling, drooling, distorted eyes, tongue biting, nausea, dizziness, lip smacking, and sleep.

Sampling

In order to obtain an adequate quantity of your units of analysis—visual symbols from children's drawings—and in order to correlate those symbols with the children's results on visual-spatial intelligence tests, you need to draw a sample of at least eighty children.

Draw-and-tell researchers commonly use a convenience sample of 100 to 200 children between the second grade and the fifth grade. **Convenience sampling** is fast, inexpensive, and opportune. It is probably the most common sampling strategy as well as the least desirable because it is neither purposeful nor strategic.

In one larger study, which will be discussed throughout this chapter, three doctors asked 226 children aged four to nineteen to draw their headaches (Stafstrom, Rostasy and Minster, 2002). Primary care physicians or pediatric neurologists in the Boston area had referred these children, so the researchers lacked a random sample. The children, however, had varied socioeconomic, ethnic, geographic, and racial characteristics, so readers could assume similar results would occur with other groups of children.

Methods

In order to improve communication between people who cannot talk to each other, you could assess people's visual-spatial intelligence, and for people who score high, you could ask them to draw-and-tell. This section explains a) how to assess visual-spatial intelligence; and b) how to use the draw-and-tell technique.

Assessing Visual-spatial Intelligence

In order to test theories of MI and CMM, researchers need to know which children have high and low spatial intelligences. Fortunately, scholars have

created several tests with established reliability and validity for measuring spatial intelligence. Some of these tests use spatial imagery tasks, while others use visual imagery tasks. **Spatial imagery** refers to representation of the spatial relations between parts of an object, the location of objects in space, and movements of the objects (Kozhevnikov, Hergarty, and Mayer, 2002). **Visual imagery** refers to a representation of the visual appearance of an object, such as its shape, size, color, or brightness (Kozhevnikov, Hergarty, and Mayer, 2002). Some people get high visual imagery scores because they can construct vivid, concrete, and detailed images of individual objects in a situation. Others can get high spatial imagery scores because they can imagine spatial transformations such as mental rotation. Surprisingly, visually intelligent people seldom score high on both visual imagery and spatial imagery tests (Kozhevnikov, Kosslyn, and Shephard, 2005).

Original test image Highlighted test image

Figure 3.1a Snowy Pictures Test: The object is to identify the umbrella hidden in the original text image

Figure 3.1b Gestalt Competition Test: The object is to recognize an incomplete rendered object. This drawing is the head of a hammer

Source: Educational Testing Service

Original shape

Comparison shapes

Figure 3.1c Mental Rotations Test: The object in this test is to identify the original shape among the three comparison shapes

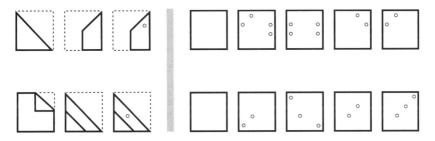

Figure 3.1d Paper Folding Test: The object is to imagine the folding and unfolding of the pieces of paper. The figures on the left represent a square piece of paper being folded. The last of the squares has one small circle indicating where the paper has been punched. One of the five squares to the right shows where the holes will be when the paper is unfolded. You must determine which of these squares is correct

Researchers commonly use the Snowy Pictures Test, the Gestalt Completion Test, and the Minnesota Paper Form Board Test to measure a person's visual imagery abilities.

The **Snowy Pictures Test** (which resembles the Degraded Pictures Test) measures "speed of closure," or the ability to look at different pieces of shapes,

quickly put shapes together, and see an object. The test-maker degrades several line drawings by either deleting meaningful information or by adding random lines that obscure meaningful information. The participant tries to recognize common objects, such as an umbrella, scissors, or table, in the degraded drawings. The **Gestalt Completion Test** differs because it requires participants to use mental imagery to assemble pieces into a whole object. The test-maker deletes parts from a black-and-white picture (rather than a line drawing). The participant mentally puts the pieces together to identify the object. The **Minnesota Paper Form Board Test** is a more difficult variation of the Gestalt Completion Test. Participants view five pieces, some or all of which can be put together to create an object in outline form. The participants must indicate which of the pieces, when fitted together, would create the object.

Researchers also commonly use three tests to measure spatial imagery abilities. The **Cube Comparison Test**, for example, requires participants to mentally rotate a line drawing of a three-dimensional cube. Each test item presents a) two views of a cube with letters and numbers printed on its sides; and b) four pictures of the same cube after it has been rotated in various ways. Participants must decide which of the four pictures of the cube that had been rotated best matches the original two views of the cube. The **Mental Rotations Test** resembles the Cube Comparison Test, but requires greater spatial imagery skills. Instead of matching cubes, participants must match complex three-dimensional objects. Participants study the original drawing and compare it with three similar shapes that have been rotated. On the **Paper Folding Test**, each item shows successive drawings of two or three folds made in a square sheet of paper. The final drawing shows a hole being punched in the folded paper. The participant must select which of the five drawings shows how the punched sheet would appear when fully opened.

The six visual and spatial imagery tests discussed in this chapter have obtained internal reliability scores above 0.8 when used with adults. Using the tests with children, however, may require additional testing for validity and reliability. Children may either be too young to take these tests or the tests may not accurately indicate children's spatial and visual intelligences.

In addition, a self-report questionnaire has been developed to measure people's spatial imagery and visual imagery abilities (Blajenkova, Kozhevnikov, and Motes, 2006). The Object-Spatial Imagery Questionnaire has proven to be reliable. For example, the statement: "I prefer schematic diagrams and sketches when reading a textbook instead of colorful and pictorial illustrations" correlates positively with other spatial imagery measures and negatively with other visual imagery measures. Studies that indicate scientists rate higher on spatial imagery and visual artists rate higher on visual imagery help establish the questionnaire's validity.

Using the Draw-and-Tell Technique

After acquiring institutional review board (IRB) approval, researchers ask school principals and the relevant class teachers for their help in completing the project. Researchers then send a letter to the children's parents. This letter explains the purpose of the study and the research procedures. Teachers collect the complete consent forms.

Researchers generally go to schools to use the draw-and-tell technique. They help with any questions that arise and they act as a scribe for any child who needs help in writing something on his or her drawing. Researchers, however, may let teachers conduct the draw-and-tell technique so it seems as similar as possible to a normal teaching session.

Teachers begin by explaining the project to the children and asking if they would like to take part in the project. Teachers reassure the children the project is not a test and the researchers do not want to measure their drawing ability. Then teachers generally conduct a warm-up exercise in order to create a relaxed atmosphere.

For the draw-and-tell exercise, teachers give children blank white paper and a choice of drawing instruments, such as a pencil with eraser, colored markers, or crayons. Teachers then read, rather than paraphrase, the researchers' clear, simple, and neutral instructions. They do not provide additional instructions and they try to avoid asking leading questions, so that children can draw without undue bias. For example, in the headache study, the instructions said: "Please draw a picture of yourself having a headache. Where is your pain? What does your pain feel like?" Instructions for other draw-and-tell studies include: a) draw pictures of all the things you do to make you healthy (Gabhainn and Kelleher, 2002; Pridmore and Bendelow, 1995); b) draw a picture of a person with cancer, a person with AIDS, and a person with a cold (Gonzalez-Rivera and Bauermeister, 2007); c) please draw a young person who uses drugs (McWhirter, Young, and Wetton, 2004); d) draw a picture of what it is like to have a seizure (Stafstrom and Havlena, 2003); e) draw how you see your spinal cord injury in your mind (Cross, Kabel, and Lysack, 2006); f) think about a time when you felt afraid, and draw it (Driessnack, 2006); and g) "Draw a star, celebrity or famous person who you would like to be. If there's nobody you'd like to be, at all, then choose someone who you think is good or cool" (Gauntlett, 2004).

Children have as much time as they need to complete their pictures. If children have a hard time getting started, or if they say something like "but I can't draw," then teachers or researchers use gentle persuasion and respond with a phrase like "we don't expect you to be an artist."

After the children finish their drawings, researchers and their assistants individually meet with each child to learn about the meanings of various symbols in his or her drawing. Sometimes children's explanations surprise researchers. For example, a particular color may have specific, important associations for a child but seem unimportant to the researcher until the child talks

about the drawing. Researchers use this information to cross-validate their interpretations of children's drawings and to ensure that they honor children's perspectives throughout the analyses (Gonzalez-Rivera and Bauermeister, 2007).

As children talk about their drawings, they may adopt the role of a teacher, proud artist, confessor, or someone interested in the researcher's reactions. No matter which role they adopt, children take control over the interview situation. Researchers record these one-on-one conversations and transcribe the interactions later. They attach an identifying code to the drawings and notes so the children may remain anonymous.

After researchers collect the drawings, they hold a group discussion to allay any anxieties that may have arisen. For example, if researchers asked children to draw and tell about their fears or their illnesses, then the children might become apprehensive.

Data Analysis

After you have scored the visual-spatial intelligence tests and collected the children's drawings, you need to identify your units of analysis—symbols—and then use a categorizing strategy to code those symbols.

Researchers use three strategies to analyze symbols collected via the draw-and-tell method: a) they assign symbols to categories; b) they rate the meanings of symbols with scales; c) they create metaphors to summarize the symbols.

To assign symbols to categories, researchers create a checklist of all of the visual symbols that appear in all of the drawings. Then they divide those symbols into two or more categories and they code the symbols in each drawing. For example, in order to study children's drawings of headaches, two pediatric neurologists created a checklist of features that did, and that did not, characterize migraine headaches (Stafstrom, Rostasy, and Minster, 2002). Specific migraine features included depictions of a pounding or throbbing pain, vomiting, sensitivity to light or sound, a desire to lie down or sleep, avoidance of exercise or movement, and signs of weakness or confusion. All other symbols belonged in the non-migraine headache category. Then the doctors counted the symbols in each drawing, and based on their frequencies, they decided whether the picture looked more like a migraine or a non-migraine headache.

Researchers may also use a series of scales to analyze the drawings (Fury, Carlson, and Stroufe, 1997). A scale is a type of **composite measure**, which means several indicators of a variable are combined into a single measurement, usually represented by a number. Researchers use scales when no single indicator can provide a valid and reliable measurement of a complex variable, such as degree of prejudice or religiosity. Instead, they create several items, each of which provides some indication of the variable (Babbie, 1983).

Researchers also use scales when they want an ordinal-level measurement. For example, they may use a **Likert scale**, which includes five choices: strongly agree, agree, neutral, disagree, and strongly disagree. Researchers can measure

the direction and intensity of people's responses to various statements with a Likert scale. Researchers also use scales because they summarize information into a single numerical score, yet they retain the specific details of the individual indicators.

To construct a scale, researchers note several people's responses to several items. For example, researchers might measure vulnerability by asking several people to look at a picture of a small child amongst large trees at night. Each person would rate the intensity of the feeling of vulnerability he or she felt when viewing the picture. People could assign the picture a one if it made them feel secure or a five if it made them feel vulnerable. Then researchers might ask the same people to look at another picture and again rate its degree of security–vulnerability. Then researchers would sum the scores from the two pictures in order to begin to create a pattern of responses. Researchers would continue this process of eliciting responses and noting patterns across pictures until they could construct a scale that people consistently agreed was an accurate measure of the feeling of vulnerability.

After creating one scale, researchers might create others. For example, to supplement the vulnerability scale, they might create an anxiety scale, with anxious at one end and calm on the other. After creating a number of scales, researchers would ask raters to apply the scales to the drawings.

When experts code or rate the drawings, they should be ignorant of the clinical history of the children. Experts should also remain ignorant of the results of visual-spatial tests.

If you feel uncomfortable counting symbols and using rating scales, then perhaps you could analyze drawings by making metaphors. **Metaphors** involve comparing two things via their similarities and ignoring their differences. As partial abstractions of concrete things, metaphors play an immense and central role in the development of theory (Miles and Huberman, 1994).

To make a metaphor, you would notice several particular symbols in a drawing or group of drawings and then form a single generality about the drawing(s). You are not describing the drawings, instead you are comparing the drawings to something, and, therefore, you are moving up a notch to a more inferential or analytical level. You step back from the welter of observations of symbols in 100 to 200 drawings and say, "What's going on here?" The answer might be three to six metaphors about the meanings of the drawings. These metaphors serve as steppingstones toward theory.

Data Displays

When quantitative researchers use categorizing strategies, they generally report their results as a **frequency distribution**, which is an organized display that shows how often each different piece of data occurs. With the draw-and-tell method, for example, you would show how often each visual symbol appeared in the sample of drawings.

If your goal is to improve communication, then you might want to report how well each child could draw the symptoms of his or her headache. "Good" drawings would match doctors' diagnoses. Stafstrom, Rostasy, and Minster (2002), for example, found that drawings with migraine symbols matched the clinical diagnosis of migraines 87 percent of the time, and drawings without migraine features matched the diagnosis of a non-migraine headache 91 percent of the time. In other words, a child who drew migraine symbols had a nine-fold greater chance of having a clinical migraine rather than a non-migraine headache.

You might also correlate each child's score on the visual-spatial intelligence tests with that child's ability to accurately draw his or her symptoms. For example, Charles and Sandra might score high on the tests and also create "good" drawings, while Mary and Ethan might score low on the visual tests and their drawings might not match the doctor's diagnosis. Correlations will be discussed further in Chapter 10.

Instead of reporting how well each child could communicate his or her symptoms, you could report how well each symbol represented a symptom. For example, if children with migraine headaches always drew a picture that showed vomiting, and if children without migraines never drew a picture that showed vomiting, then a symbol of vomiting would be an accurate predictor of migraines. Most symbols, of course, do not serve as perfect predictors of illnesses. Drawings of dizziness, for example, were only associated with correct diagnoses of migraines 66 percent of the time (Stafstrom, Rostasy, and Minster, 2002).

Researchers who use the draw-and-tell techniques generally include in their reports examples of different types of drawings. They also describe features that readers might have overlooked or not understood. For example, they might explain that zigzag lines indicate shaking if, indeed, during the "tell" part of the study, children had said that their zigzag lines indicate shaking. With this information and the drawings themselves, readers can assess researchers' interpretations.

In addition to the drawings, draw-and-tell researchers provide the transcript of one child talking about his or her drawing. The transcript includes the researcher's questions, such as "Tell me about your drawing" and "Where are you in this picture?" as well as the child's responses.

Credibility, Transferability, and Dependability

When researchers use the draw-and-tell method and they use categorizing strategies to analyze their data, they can use triangulation and intercoder agreement to improve the quality of their conclusions. **Triangulation** occurs when researchers deliberately seek evidence from different sources, methods, and investigators. They then compare the results in order to obtain a more complete and contextual understanding of the individual, group, or organization being studied.

In a study of adults with heart problems (Broadbent et al., 2004), for example, evidence from physicians' diagnoses was compared with evidence from adults' drawings. The results matched or the drawings were better than the diagnoses. The study began when researchers asked heart patients to "Please draw a picture of what you think your heart looked like before your heart attack and another picture of what your think has happened to your heart after your heart attack." Of the fifty-nine patients, twenty-seven drew damage to their hearts and thirty-two drew no damage. For the pictures of heart damage, researchers measured the percentage of the heart that had been drawn as damaged. The researchers concluded: "Patients' drawings of damage on their hearts after a MI [myocardial infarction] predict recovery better than do medical indicators of damage. Drawings offer a simple starting point for doctors to assess patients' ideas when discussing their heart condition and an opportunity to counter negative illness beliefs" (Broadbent et al., 2004: 583).

Draw-and-tell researchers can improve the transferability of their results in several ways. One, they can fully describe the characteristics of their sample of people, settings, and processes so that readers can compare their sample with other samples. Two, they can discuss how the situation may have limited their ability to generalize the results. In the headache study, for example (Stafstrom, Rostasy, and Minster, 2002), researchers could report if the children had been treated many times for migraines, and, therefore, would be expected to already know migraine symptoms, which they could then draw. Three, draw-and-tell researchers could mention how findings from one study were replicated in another study. For example, after discovering the usefulness of children's drawings in the diagnosis of headaches (Stafstrom, Rostasy, and Minster, 2002), Carl Stafstrom again used the draw-and-tell method, but this time studied children's drawings of seizures (Stafstrom and Havlena, 2003).

Draw-and-tell researchers can demonstrate dependability by using more than one coder/rater/metaphor maker and then measuring the **intercoder agreement**. This is defined as the percentage of agreement between several coders (raters and metaphor makers) coding the same communications material. To measure agreement between coders, they divide the number of coding agreements by the total number of coding decisions. Intercoder agreement will be discussed further in Chapter 10.

Internet

Researchers using the draw-and-tell method have not yet taken advantage of the Internet. Nor are people exchanging drawings on the Internet in order to communicate. People are, however, exchanging videos.

When one person uploads a video on YouTube or other videosharing website, some respondents write comments, but others respond with a video. They are exchanging video messages rather than oral or written messages.

Advantages and Disadvantages

The draw-and-tell technique has several advantages over the use of question-naires or interviews:

1. Children feel empowered because they have time to reflect about what they want to "say" and they become active participants in the research study (Pridmore and Lansdown, 1997).
2. Children feel comfortable talking about their pictures because the focus shifts from them to the visuals (Pridmore and Bendelow, 1995: 486). Talking about images seems natural, whereas being interviewed seems strange and stressful.
3. Children give more information with draw-and-tell than with words alone. Children who drew and talked about their drawings gave researchers twice as much verbal information as did children who only talked about their experiences (Wesson and Salmon, 2001).
4. Children may lie less with draw-and-tell than when simply talking with researchers (Young and Barrett, 2001: 146).

The draw-and-tell technique also presents some disadvantages:

1. Children may lack the necessary skills for drawing different objects and ideas, so they may just draw what they know how to draw.
2. Children may simply copy pictures they have previously seen, or they may confer with their neighbors, rather than draw their own ideas (Backett-Milburn and McKie, 1999). In one study, "so much conferring took place that some of the pupils' responses lacked variation" (MacGregor, Currie, and Wetton, 1998: 317).
3. Children may reveal more than they might otherwise choose. For some children, non-communication may be a deliberate strategy rather than a perceived deficit (Backett-Milburn and McKie, 1999).
4. Children may give the "right" answers. The immediate social context may influence what the children draw. The way that children define the research task and what it means to them has a considerable effect on what they draw (Backett-Milburn and McKie, 1999). In school, for example, teachers normally ask questions to see if their students know the "correct" answers, so children may perceive the draw-and-tell technique as a kind of test. If so, children will give the "right" answer, which may not correspond with their true thoughts or actions.
5. Researchers may misinterpret or over-interpret the children's drawings.

Draw-and-tell researchers try to control sources of bias by carefully instructing teachers about the practicalities of administering the research, but they could, like other qualitative researchers, devote time and attention to learn about the biases that inevitably occur in every study (Backett-Milburn and McKie, 1999).

Ethical Issues

When researchers use the draw-and-tell method in schools, they have difficulty knowing if children are participating voluntarily. For example, although parents and children may have signed the proper forms, children may find it difficult to refuse to take part in a research study located in a classroom setting (Pridmore and Bendelow, 1995). To help with this problem, you could offer an alternative activity for children who remain in their classroom but who opt out of the project.

A second issue concerns children's rights to privacy. In a classroom setting, even if researchers could guard children's drawings from the direct scrutiny of classmates, they cannot protect children from others' teasing after the study (Backett-Milburn and McKie, 1999). If other students learn about a child's ideas, the child may suffer from shame and loss of self-esteem. Moreover, if researchers show participants their reports to obtain feedback, and if those reports include drawings, then children lose their confidentiality.

Another potential problem concerns anxieties raised by subject matter such as cancer, drugs, AIDS, seizures, and other health issues. Drawing, as a medium of expression, has the potential to tap into emotions more powerfully than the spoken word (Backett-Milburn and McKie, 1999).

Even drawing less overtly sensitive topics may cause problems such as cognitive dissonance. For example, if children draw healthy and unhealthy products, they may later discover to their surprise that they or their parents consumed some unhealthy foods. This discovery could cause dissonance because "my mummy would never give me anything unhealthy to eat" (Backett-Milburn and McKie, 1999). Holding a group discussion after the project can help address such problems.

Resources

In addition to the cooperation of children, parents, teachers, and principals, you need time for children to tell you about their drawings and you may need the help of experts to interpret their drawings.

Advice

1. When asking children to draw, use simple and brief instructions in order to minimize your influence upon the results.
2. When asking children to tell, be a curious and attentive listener.
3. Give children at least two age-appropriate visual imagery and spatial imagery tests.
4. Give children an age-appropriate adaptation of the Object-Spatial Imagery Questionnaire.
5. Compare the imagery test results with the questionnaire results in order to learn whether they agree.

6. Use outside experts to code the drawings and transcripts if possible, and if not, then use people who do not know the children's health or their drawing capabilities.
7. Compare the draw-and-tell results with a clinical diagnosis when the study concerns health, or compare the draw-and-tell results with information gathered by interviewing adults who know the children in order to establish validity.
8. Correlate the draw-and-tell results with the results from the visual-spatial tests to learn whether children with either high visual imagery abilities or high spatial imagery abilities can express themselves better with drawings than children who score lower on such tests.
9. Conduct longitudinal studies to track children with differing visual-spatial abilities as they grow older. Discover if children who draw well end up having successful careers in a visually oriented field. As children get older, try to measure whether they think in words or pictures. Look for opportunities to take advantage of visual-spatial intelligence.

Further Viewing

Children drawing
Children draw God
http://video.google.com/videoplay?docid=-1881119428532150226&q=
children+draw&ei=0hkbSI7wEoWqrgLMytXHAg&hl=en

Children in Thailand draw tsunami
http://video.google.com/videoplay?docid=3262960451453584079&q=
children+draw&ei=MxobSPbcFp_UrQLfxMXQAg&hl=en

Children in Iran drawing peace and friendship
http://video.google.com/videoplay?docid=9164937761792119324&q=
children+drawing&ei=rBobSKvxM5y2rALMurjUAg&hl=en

Drawing Dad's cancer (multimedia)
http://video.google.com/videoplay?docid=7465328730716087900&q=
drawing+illness&ei=WRsbSKeGApm-qQKtnLTEAg&hl=en

Theory of multiple intelligences
Howard Gardner on his theory
http://video.google.com/videoplay?docid=2900715537074365410&q=
multiple+intelligences&ei=RBwbSJGyLIKKrQKb4_zTAg&hl=en

Explanation of Gardner's theory
http://video.google.com/videoplay?docid=5686311086556372093&q=
multiple+intelligences&ei=RBwbSJGyLIKKrQKb4_zTAg&hl=en

Understanding Children's Headaches Through Drawings

Carl Stafstrom

As a pediatric neurologist, I am frequently asked by pediatricians and family practitioners to evaluate a child with headaches, determine a diagnosis (headache type and cause) and formulate a treatment plan. A main goal in such a clinical evaluation is to differentiate between the common types of headache (migraine vs. tension/muscle contraction headache) as well as rule out a headache caused by a more serious medical condition, such as a brain tumor or other cause of increased intracranial pressure. The conventional manner of proceeding with such an evaluation involves:

1. Obtaining a history of the symptoms from the child and parent, including location of the pain, duration of the pain, presence of any accompanying symptoms such as nausea, vomiting, abnormal visual phenomena, precipitating and relieving factors, time of day that the pain is worse, whether the pain worsens with changing position, movement, or exercise.
2. Performing a physical examination to assess whether it is appropriate to worry about a more serious neurological condition.

When asking such questions of adolescents and adults, reliable answers can usually be obtained. However, younger children are less sophisticated with their ability to describe their symptoms and may not be able to easily express their feelings in words. These age-related factors limit my ability to determine headache type and, therefore, prescribe the appropriate treatment.

The accompanying chapter describes our headache drawing study in children (Stafstrom, Rostasy, and Minster, 2002). The idea to use children's headache drawings as an adjunct to the clinical history was somewhat serendipitous. In the years prior to the study, when discussing a child's general health with a parent, I would often hand the child a piece of paper and pencil and encourage them to draw a picture (to keep the child occupied while I spoke with the parent). In viewing these pictures, I was often astounded that many children presenting with headaches drew dramatic pictures of their headaches. From here, the idea arose that I might be able to formalize children's headache drawings to aid in the diagnosis of different kinds of headache. That is, the drawing might be a way to circumvent verbal limitations and access directly, by way of drawing, a child's feelings and symptoms. Therefore, I devised a clinical study as described in the accompanying chapter.

The instructions were kept simple. I would hand the child a blank piece of 8.5" × 11" white paper, a no. 2 pencil, and ask the child to draw a picture of himself or herself having a headache. I tried to limit any more direct instructions,

so as not to bias the child's drawing. The child was allowed an unlimited amount of time to draw. Typically, a child would look quizzically at me for a moment, then "a light bulb seemed to click" and the child energetically began drawing a picture. Almost every child participated willingly, and appreciated the chance to show me their symptoms in pictorial form. Again, I was amazed at some of the results. Children drew their headache pain as a variety of painful objects hitting their head, such as hammers either from the inside or outside, drum sets inside their head, ice picks, sledge hammers, jack hammers, baseball bats, and even a high-heeled shoe. Such intense pain is characteristic of migraine headaches as opposed to headaches caused by muscle tension or stress. Other characteristics of migraines depicted artistically included nausea with an urge to vomit, extreme sensitivity to light or sound, and a desire to lie down on a bed. All of these symptoms are characteristic of migraines. The other major headache type, tension or muscle contraction headache, does not typically include those clinical features. Therefore, I hypothesized that the drawing itself could be used to differentiate between types of headache.

I designed a simple experiment, to compare my clinical diagnosis, based on interview, history, and physical examination, with an independent diagnosis that could be inferred based on features depicted on the headache drawing. For this part of this trial, I required the assistance of other pediatric neurologists who were expert in diagnosing headaches. Two colleagues, Dr. Kevin Rostasy and Dr. Anna Minster, were provided with a stack of headache drawings and asked to rate each one as being more consistent with a migraine headache or with a non-migraine headache, based only on the picture. They had no access to any other clinical or historical data. There was a high degree of agreement between the artistic diagnoses made by my colleagues, as evidenced by a high kappa score. That is, Drs. Rostasy and Minster agreed that a given picture was migraine or not migraine more than 92 percent of the time. Then, I compared my own clinical assessment, to derive a two-by-two table, into which each drawing could be categorized. That is, on one axis was the artistic diagnosis (migraine or non-migraine) and on the other axis was the clinical diagnosis (migraine or non-migraine). Therefore, each drawing could be rated as either a true positive, true negative, false positive, or false negative for migraine headache. Based on these data, I could derive the sensitivity and specificity of any given headache drawing for a migraine or non-migraine etiology. In addition, I could analyze specific features of the drawings (such as the presence of pounding pain, nausea, or vomiting, focal neurologic deficit) and derive the positive predictive value of a given drawing feature as to the likelihood that the clinical diagnosis would suggest migraine or non-migraine. We found that children's drawings had a very high sensitivity and specificity for predicting migraine headaches. If a picture depicted sharp or pounding pain, vomiting, or visual symptoms, the chance that the clinical diagnosis was migraine exceeded

90 percent. All of these analyses, as well as numerous headache drawings, are found in our published report (Stafstrom, Rostasy, and Minster, 2002).

The benefit of such a study is that we now have an adjunct method to evaluate headaches in children, and we are not solely reliant on just the clinical history to diagnose children's headaches. There are no blood tests, imaging studies, or other diagnostic evaluations that can be used to diagnose headache type, other than to exclude the rare situation of brain tumors or other intracranial abnormalities. This drawing method adds to the clinical confidence of making a particular diagnosis. Our method involves trivial expense (only the cost of a piece of paper and pencil!), does not require a federal grant, and has a high degree of sensitivity and specificity for diagnosing headaches in children, a population with which it is ordinarily very difficult to achieve this degree of certainty. Furthermore, the task is fun! Children find it very enjoyable to draw and express themselves, and this method affords them some empowerment over their symptoms. It is also enjoyable for physicians who are evaluating children with headache, allowing them to better understand how a child feels about his or her pain. Finally, parents derive insight into how their child feels about their symptoms.

It must be mentioned that my method is not strictly "draw-and-tell," since there was no systematic attempt to have the child describe what he or she drew. If I was uncertain about the meaning of some aspect of a child's drawing, I would occasionally ask him or her to explain it, but this information was not available to the independent rater of the drawings (my colleagues). A study incorporating post-drawing descriptions could certainly be designed. Another aspect of the study that bears discussion is the potential for bias. Many of my patients could have been "sensitized" by previous medical encounters to think about their headache in a certain way. For example, other health care practitioners might have asked the child directly whether the headache was dull or pounding—this could consciously or subconsciously influence their drawing. Also, in our media-laden culture, advertisements for headache pain relievers abound; some of these ads depict lightening bolts or hammers striking a person's head—again, raising the possibility that a child has observed and internalized such an image. Although such biases cannot be fully controlled for, the high correlation of artistic features with independent clinical diagnosis lessens the likelihood that these factors affected our conclusions.

I have since expanded the initial study in several ways. A longitudinal study of children who were seen in my practice on more than one occasion for headaches was performed. This study entailed comparing a child's drawing at the second and subsequent visits with that from the first visit. Typically, a child would be treated in some way for their headache after their first visit, so subsequent pictures would reflect treatment success or failure. Indeed, we found that longitudinal headache drawings can be used as a reliable guide to

clinical response (Stafstrom, Goldenholv, and Douglas, 2005). Children whose headaches improved with a particular treatment, whether it be medication, self-relaxation techniques, or avoidance of headache triggers, typically drew pictures that depicted less severe pain and reflected improvement in overall well-being. On the other hand, children whose headaches did not improve with treatment drew pictures that showed continuing pain which was just as severe as that drawn in their first picture. The other modification in the second study was to allow the child to use colored pencils—this adaptation produced pictures with an even richer repertoire of meaning. For example, most children used the colors red or black to depict severe pain, and softer colors to reflect less severe pain. An example of a child's headache drawing, demonstrating pounding pain and photophobia (sensitivity to bright light), is provided in Figure 3.2.

I now have a file containing more than 1,000 headache drawings, representing a gold mine of clinical information about children's self-perceptions of their headaches for future studies. Planned analyses include comparing headache drawings of children with headaches with parent drawings, if the parent happens

Figure 3.2 Drawing by a 10-year-old girl with migraine headaches. She depicts pounding pain (black hammer) and photophobia (extreme sensitivity to light—in this case wearing sunglasses when exposed to sunlight)

to also have headaches. In addition, I would like to test this method "in the field," that is, in general pediatrics clinics where children initially present with headaches, to empower general pediatricians or family practitioners to use this tool as an adjunctive diagnostic aid. While this method has proven useful in my subspecialty pediatric neurology practice, I am confident that it will also assist practitioners in the primary care setting.

In addition to headaches, I have also undertaken studies of children's artistic impressions of other neurologic symptoms, including seizures, tics, and brain tumors. Children with epilepsy often have low self-esteem, as they deal with the unpredictability and stigma of chronic seizures. Drawings by children with epilepsy confirm a low self-image, including pictorial representations of isolation, helplessness, and anxiety (Stafstrom and Havlena, 2003). Using techniques of children's art analysis (Klepsch and Logie, 1982), we are attempting to use artwork to enhance the self-image of children with epilepsy and other chronic disorders.

In general, the use of children's drawings as a self-expression of their symptoms and feelings can be applied to almost any acute or chronic medical disorder, with the usefulness of such studies limited only by the creativity of the practitioner.

4 Reach Out and Hug Someone

Theoretical Perspective

Imagine your significant other has either taken a trip or lives a great distance away. Of course you want to stay connected, so you may call him or her several times a day. You could also send flowers or small gifts. Even better, you could send a hug . . . if you both have a **Hug Shirt** ("Best Inventions 2006"). This shirt has sensors that record the strength of your touch as you give yourself a hug. The Hug Shirt also records your skin warmth, heartbeat rate, and the amount of time you hug yourself. Your mobile phone picks up this information via a Bluetooth accessory. You then call to send a hug to your friend, whose mobile phone transmits the information to his or her special shirt, which has actuators that reproduce the sensations of touch, warmth, and emotion.

A Hug Shirt uses the sense of touch to facilitate intimate communication between a parent and child or between two lovers. In addition to the Hug Shirt, researchers have developed a Hand Holding device that simulates the warm touch of holding hands and a Sensing Bed device for romantic couples that are not co-located (Vetere et al., 2005).

Imagine if you wanted to conduct a research study about intimate communication, but you do not (yet) have a Hug Shirt, Hand Holding device, or Sensing Bed device. You could study camera phones. People use their camera phones for five reasons.

One, people take pictures with camera phones in order to preserve memories. Moreover, when people later tell stories about their pictures, they are using camera phone pictures to construct memories. With camera phones, people chronicle everyday, mundane activities (Kindberg et al., 2005; Okabe, 2005). They use their camera phones to capture text or other scenes that they want to remember. As one person said: "It's like a chronicle of life. I just like to save pictures and archive points in my life. . . . [Later] I come back and look at them and get a feel for where I was and where I've come" (Van House and Ames, 2005: 6).

Two, people take pictures with camera phones in order to make self-presentations on social networking sites, such as Facebook. They may take self-portraits or they may photograph their pets, meals, belongings, and other parts of their lives, in order to influence how others see them.

Three, people take pictures with camera phones in order to express themselves. They may take artistic, funny, or experimental pictures to explore and express their view of the world. People often display such pictures on a photo-sharing website such as **Flickr**. People like Flickr because its organization tools allow images to be tagged and browsed easily. As of November 2007, Flickr hosts more than two billion images (Auchard, 2007).

For the first three objectives, people could use any camera—not just a camera phone. The next two points, however, show how camera phones have radically changed the ways people think of images and use images (Van House and Ames, 2005).

Four, people use camera phones to create social presence. **Social presence** refers to a subjective sense of being with others even though people are separated (Howard et al., 2006). If we stay in frequent contact with personal photographs, then we can feel as if we are sharing experiences (Aoki, Szymanski, and Woodruff, 2005; Counts and Fellheimer, 2004). As a result, the "missing" person almost seems present (Ito, 2005).

Five, people take pictures with camera phones in order to have a visual conversation. A **visual conversation** occurs when people send a photographic message, rather than a voice or text message, because they think a visual is more efficient and/or effective than voice or text. For example, someone might send a picture of traffic to show why he or she will be delayed, and the other person might reply to such a visual message. The photograph is the message, although text may be added.

People can use camera phones to create social presence and have a visual conversation because they always carry their camera phones and they can instantly share their pictures via MMS.

MMS (multimedia messaging service) is a standard for mobile phone messaging services that allows one to send and receive not only textual messages, but also pictures, video-clips, and recorded sound files, within certain size limits. The MMS phone represents a new kind of mobile media, combining the qualities of the digital camera, the Internet, the voice recorder, and the mobile telephone.

When other people receive a multimedia message on their phones, they receive a new message alert; the visual message opens on the screen; the text appears below the image; and the sound begins to play automatically. Even if recipients' phones are not switched on, the multimedia messages will be stored and sent to the recipients as soon as they switch on their phones. If a recipient has a non-compatible phone, then he or she will receive an SMS message along the lines of "You have been sent a picture message." The recipient will then be given a website address, where he or she can view the visual message.

In summary, photographs taken with a camera phone resemble a jotted note. Picture messages require less expense and less time to produce, are more casual, and are shorter lived than photographs taken with other cameras. Camera phone pictures are messages that travel quickly and effortlessly through the air to another person's mobile phone, e-mail account, or a website, such as Flickr

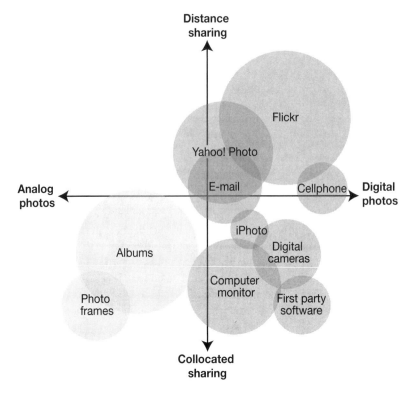

Figure 4.1 Ways of sharing digital and analog photos

Source: Kim and Zimmerman (2006)

or Yahoo! Photo. On the other hand, pictures taken with "regular" cameras end up in an album or photo frame, where anybody who walks by can view the pictures.

Next I will explain a) the concept of intimacy; b) the Interpersonal Process Model of Intimacy; and c) how camera phone pictures foster intimacy.

Intimacy does not refer to sex, but is defined as a (often momentary) feeling that results from self-revealing disclosures and partner responsiveness. A rich amount of common knowledge, as well as trust and commitment, precede intimate communication. During intimate communication, emotions, rather than information, are important, and emotional messages may include mutual stroking, handholding, and hugging. Private intimate communication may also be playful and ambiguous because intimate partners often share an idiosyncratic view of the world that others cannot readily understand.

According to the **Interpersonal Process Model of Intimacy** (Reis and Shaver, 1988), intimacy begins when a speaker discloses personally relevant thoughts and feelings to a listener. The listener then responds by conveying that he or she understands the speaker's message and feels positively toward

the speaker. The listener then becomes the speaker and he or she discloses personally revealing information and emotion. As this cycle of disclosing and responding continues, intimacy grows.

Self-disclosure—a key component of the Interpersonal Process Model of Intimacy—includes two types: emotional and factual. Emotional disclosure (private feelings and opinions) contributes more to building intimacy than factual disclosure (personal facts and information) because emotional disclosure lies closer to the core of your self-identity. Emotional disclosure opens the way for listeners to support core aspects of your identity (Reis and Shaver, 1988).

The model's other key component—partner responsiveness—depends more upon the speaker's perceptions than the listener's actions. In other words, a listener may genuinely try to understand the speaker's needs. A listener may validate the speaker (confirm that he or she is a valued individual). A listener may also care about the speaker (show affection). But unless the speaker recognizes this understanding, validating, and caring, intimacy will not develop. Only if the speaker perceives a partner's responsiveness will he or she make additional factual and emotional self-disclosures.

Camera phone pictures that are casual, short lived, and intended for a particular person can improve intimate communication in several ways.

One, photo messages can foster self-disclosure. For example, you might send a picture of your healthy salad at lunchtime or a picture of yourself paying attention (to the instructor?) in your evening class. By revealing your activities and inner feelings to your partner, you develop intimacy.

Two, photo messages can acknowledge others' thoughts and feelings. For example, your friend might send a picture of a dress she's thinking of buying. You may then respond with a picture of yourself either smiling and giving the thumbs-up sign or grimacing in mock horror. Either way, you communicated, validated, and cared about the shopper.

Three, camera phone messages can support **commitment**, which means both partners think of their relationship as ongoing for an indefinite period of time. When people send photo messages, they stay connected, and their connections reinforce their commitment to each other (Liechti and Ichikawa, 2000). For example, parents might send pictures of their children to the children's grandparents. The grandparents then feel connected to their children, who sent the photo messages, as well as to their grandchildren, who are the subjects of the photographs. The photo messages show that the generations care for each other's welfare and that they have a lasting and mutually positive relationship.

Four, phone messages can communicate emotion. They often offer little factual information, but instead say "I love you," which, of course, promotes intimacy. For example, you might send a special Valentine's Day photo message or New Year's message (Look, Laddaga, and Shrobe, 2004). The British sent 448 million photo messages in 2007, including 2 million on New Year's Eve (Look, Laddaga, and Shrobe, 2004).

Five, camera phone pictures can function as gifts. When couples exchange photographs, they exchange symbolic signs of value that resemble gifts (Taylor and Harper, 2003). In addition, tourist groups or people at parties might exchange reprints or camera phone pictures in which they appear together. Such reciprocity in exchanging images serves to cement social relationships.

Six, photo messages can keep intimacy fresh. When couples send playful, flirting, creative messages, they reinforce the idea that they have a special, private relationship (Vetere et al., 2005). For example, you might surprise your partner with a picture of yourself getting ready for the dinner-and-dancing date you will both enjoy that evening. Such surprises, especially if they involve humor, can amuse both people.

The Interpersonal Model of Intimacy and the six uses of photo messages fit James Carey's ritual model of communication.

The **ritual model of communication** emphasizes emotions and connection more than information. People use ritual communication for sharing, participation, association, and fellowship (Carey, 1988). For example, during holidays and on special occasions, people gossip, joke around, catch up, and make plans. Although they are exchanging information, they are also bonding. In fact, they may care less about the content of their conversation than that they could get together and talk. We also engage in ritual communication every morning when we ask "How are you doing?" in order to acknowledge someone's presence, rather than walk by as if we never saw the person. We usually neither expect nor receive a lot of information in response.

Photographs play an important role in ritual communication. For example, people take pictures to celebrate birthdays, baptisms, Christmas holidays, bar mitzvahs, debutante balls, vacations, graduations, marriages, reunions, more births, retirements, and deaths. They take such pictures in order to build a shared history. They do not take such pictures in order to discuss an issue or to persuade another person.

The **transmission model of communication**, on the other hand, emphasizes the purposeful exchange of explicit ideas and information across time and space. For example, advertisers send messages, not because they want to become your friends, but in order to persuade you to buy a good or service. Researchers who adopt this model primarily study how communicators influence a message's content, and how content affects audiences' attitudes and behavior.

Goals

This chapter's theoretic perspective explains how people might use photo messages for intimate communication and how such photo messages fit the ritual model of communication better than the transmission model. Few researchers, however, have studied photo messages or the use of visuals for intimate communication. You could, therefore, conduct basic research to learn how people use camera phone pictures to maintain intimate relationships.

On the other hand, you could take an applied research approach by beginning with a problem—the need to develop and maintain intimacy in a hectic, stressful society—and then consider whether camera phones provide a partial solution.

Research Questions

Research about the effects of camera phone messages has just begun. Results have been based upon small samples of people, sometimes in Japan, sometimes in Finland, so what we do not know far exceeds what we (think) we know. Some potential research questions are:

1. How do people use photo messages to create and maintain social relationships? Do people of different ages, genders, and socioeconomic statuses use camera phones the same way? Will quiet people send fewer pictures? Will people with high visual-spatial intelligence prefer to send photo messages?
2. Do photo messages contribute to self-disclosure and partner responsiveness? Do they support commitment, communicate emotion, enable reciprocity, lead to expressive exchanges, and facilitate presence-in-absence?
3. Do husbands and wives (or boyfriends and girlfriends) differ in the way they use camera phones? Do they differ in the way they establish and maintain intimacy?
4. Do couples with more satisfying relationships perceive their acts of interpersonal communication (including sending and receiving photo messages) as more intimate than couples in less satisfying relationships?
5. How much can photo messages increase feelings of intimacy? Do people prefer photo messages to text or audio messages when creating or maintaining intimacy? How does video differ from photographs when mobile multimedia becomes more common? How do people decide which to use?
6. What factors affect intimacy on an hour-by-hour basis? Do people need photo messages more on weekends? At certain times of the day?
7. Do camera phone pictures primarily build and maintain relationships among peers, or are they used across generations? How do photo messages among friends compare with photo messages between family members of different generations? Do we send photo messages for birthdays instead of cards?
8. Do people using camera phones save their photo messages? Do they share them with other close friends or family members?
9. What types of games do people create to entertain themselves with photo messages?
10. What types of rituals will intimate couples create that take advantage of camera phones? Do photo messages supplement or replace other types of rituals?

Brief Description

When researchers want to study intimate communication, they often solicit diaries. **Solicited diaries** are participants' detailed accounts of everyday social activity, as well as their thoughts and emotions. Participants create these diaries for a researcher.

Researchers find diary studies more appropriate for understanding intimate communication than interviews, surveys, or direct observation. Diaries are better than observation because researchers cannot follow people throughout the day and notice the private photographs they send to their significant others. And even if researchers could observe people's behavior, their presence might alter participant behavior and contaminate the study's results. Diaries are better than interviews and surveys because participants record data *in situ* (in the actual situation). Rather than trying to recall what had happened a day, week, or month ago, people write their current thoughts, feelings, and actions. Moreover, unlike surveys and interviews, diaries measure change over time.

In fact, participants may record entries several times a day, and if they record entries before and after a photo message was sent (or received), then researchers can infer the causes and effects of the photo messages. For example, researchers can relate the mood of the sender (confident about the relationship or worried) to features of the photo message (entertaining, tender) and, finally, to results of the interaction (self-disclosure, emotional expression). Such inferences may not be as valid as ones based on experimental studies, but researchers cannot ethically use experiments to study intimacy. Moreover, the artificial conditions of an experiment would ruin the spontaneity of intimate communication.

In summary, diaries provide an efficient, non-intrusive means to collect qualitative and quantitative data, *in situ*, from several participants. Since the data show changes in thoughts, feelings, and actions over time, they are suitable for studies of frequent, yet brief, exchanges of photo messages for intimate communication.

Units of Analysis

Since the goal is to understand how people use camera phone pictures for intimate communication, and since you are using diaries to collect data, your unit of analysis would be entries or responses to multiple-choice questions from those diaries.

Diary studies can include structured data, unstructured data, or semi-structured data. **Structured data** (fixed responses) means that researchers determine the possible answers to a question or the points on a scale. Participants mark their choice, and researchers can quickly conduct a quantitative analysis of the results. **Unstructured data** (open responses) means that researchers provide questions that cannot be answered with a "yes" or "no" or simple piece of information. Participants write whatever they wish, and

researchers code the information as described in Chapter 2. **Semi-structured data** means that researchers provide prompts that partly limit the range of suitable responses. Participants follow researchers' prompts, and researchers can code this information more quickly than unstructured data.

Diary researchers find that a fixed-response format has two advantages over an open-response format. One, with fixed responses, participants can complete their diary entries in one to three minutes (Hormuth, 1986). They can take a quick break from their activity without calling attention to themselves. On the other hand, if participants describe what they thought, felt, and did in their own words, they would need far more than three minutes, and as a result, they might quickly become annoyed with the task. Two, people might recall minor events and their reactions to those events if they responded to fixed-response questions rather than be faced with blank sheets of paper. Open-ended response formats are useful, however, when researchers need to develop a fixed-response format for later research (Stone, Kessler, and Haythornthwaite, 1991).

I recommend you collect structured data from multiple-choice questions and Likert scales in order to measure the Interpersonal Process Model of Intimacy's four key variables: self-disclosure, partner disclosure, perceived partner responsiveness, and intimacy. To measure self-disclosure, you could ask participants to respond to the statement: "I disclosed very little factual information": Strongly Agree—Agree—Neutral—Disagree—Strongly Disagree. To measure partner disclosure, you could give them the statement: "My partner disclosed a great deal of emotional information": SA—A—N—D—SD. For perceived partner responsiveness, they could rate the statement: "My partner supported me a great deal": SA—A—N—D—SD. To measure intimacy, you could use the statement: "I felt very little closeness to my partner": SA—A—N—D—SD (Laurenceau, Barrett, and Rovine, 2005).

Diary studies using structured data can produce thousands of data points. For example, if researchers asked ten couples (twenty people) to make five diary entries for every day, for two weeks, and for each entry individuals had to respond to ten questions, then the final study could have 14,000 data points.

Sampling

In order to obtain an adequate quantity of your units of analysis—entries from diaries or answers to multiple-choice questions and Likert scales—you need to draw a purposeful sample of at least ten couples with different needs for intimate communication. For example, you might want to enlist couples right before and after they have a baby; couples who just had their second or third child; unmarried childless couples in new relationships; unmarried childless couples in long-lasting relationships; couples who are separated by distance; and couples experiencing a major stressful life event. You might also require participants to have owned a camera phone for at least one month and to have sent at least ten phone messages per week.

Researchers can use several tactics to recruit couples. One, they could place advertisements in the local area newspaper and post flyers at various public locations. Two, they could contact couples based on newspaper announcements of engagements, weddings, and anniversaries. Three, they could recruit people who work in jobs that require lots of travel.

You should describe participants in your research report so that readers can determine to what extent they can generalize your results to other populations. For example, you include this level of detail:

> High school student. Newly licensed driver. Drives long distances around metro area for sports activities. Two parents and an older brother living at home. Shares mobile phone, which has text messaging capability, with mother. Shares Internet-based communication methods, including e-mail, instant messaging, and chat rooms with brother. Shares landline phone with parents and brother.

Researchers generally offer participants financial or other incentives because they realize making regular diary entries interrupts people's lives and requires conscientious effort. Researchers want to provide enough incentive that participants will complete all of their entries, but not so much that participants will be tempted to make up false entries. Two studies gave participants $30 (Laurenceau, Barrett, and Rovine, 2005; Alliger and Williams, 1993) while another offered $50 and entry into a lottery drawing for a $1,000 prize (Cranford et al., 2006). Palen and Salzman (2002) gave people $100 for participating in three interviews (beginning, middle, and end of the study) and they gave $1 a day for every day people called in diary entries. Consolvo and Walker (2003) gave people $50 for participating and $1 for each completed questionnaire; the total possible incentive was $120. In another study, Consolvo and colleagues (2005) gave people $60 to $250, depending upon their level of participation. Sohn and colleagues (2008) gave people $3 a day and various other bonuses so that each person could earn a maximum of $80.

After obtaining a sample of participants, researchers make two decisions about how to sample time. One, they may decide how often participants should make diary entries by either referring to the literature on diaries or the literature on their specific topic. According to the diary literature, some researchers have asked people to write seven to ten times a day for seven consecutive days, while others request responses four times a day for three months. According to the (scant) literature about communication between intimate friends, researchers might expect couples to send at least four camera phone messages per day: in the morning before work, at lunch and dinner, and before going to bed. They would, therefore, request diary entries at those times as well as some additional occasions. Researchers, however, must worry about participant fatigue. If researchers require more responses, then they ensure that participants need less time to complete each response.

Two, after determining the number of times they need diary entries, researchers must decide on their sampling scheme. For probability sampling, researchers may first divide a week into different groups, or strata. For example, they may divide a week into weekdays and weekends, daytimes and evenings. Then diary researchers would decide whether to sample all the groups equally or to give more weight to some time periods. For example, they might decide to elicit several responses before dinner and before bedtime because they suspect that people living alone or apart from loved ones may feel greater need for connection at those times. Researchers must also decide whether to require responses at fixed or random moments within a time period. If they used a fixed time, then researchers might ask participants to write in their diary at the end of each evening in the sample. If researchers used random times, then they need to signal participants when they want an entry. Signal-based studies require participants to carry an electronic device that emits a sound or vibration.

Diary researchers could also use a type of purposeful sampling called **criterion sampling**. Criterion sampling means that researchers include people in their sample when a person has experienced the key phenomenon (or criterion); researchers exclude everyone that has not experienced the phenomenon (or criterion). For example, the criterion might be "received a photo message." If so, then everyone who receives a photo message becomes part of the sample and writes a diary entry.

Methods

In order to understand how people use camera phones to maintain intimacy, you could ask people to write diaries. This section explains: a) technologies for collecting diary data; b) participant training and monitoring procedures; and c) follow-up sessions.

Technologies for Collecting Diary Data

Diary researchers use paper, electronic devices, or a voice-mail system in order to collect data. Researchers choose a specific technology based upon three factors: a) how they want to alert participants to complete a diary entry; b) how they want to deliver the questions; and c) how they want to capture people's responses. These three factors, as well as incentives, determine participants' rate of compliance and their reports' completeness, or the quality.

Before the introduction of electronic devices, or voice-mail systems, diary researchers asked participants to either write in paper booklets or to mark fixed-response questionnaires. Researchers still use paper diaries, but they cannot signal participants when a diary entry should be completed. Instead, they have to trust that participants will remember to write at the appropriate time. Researchers include within the paper diaries the study's questions

and instructions for answering those questions. These instructions stress the importance of recording events as soon as possible after they occur. They explain what to include and exclude in a diary entry as well as the level of detail researchers require. The instructions also ask participants to not let the diary research influence their behavior. Researchers designate one page for each diary entry, and each page has open or closed questions. For open questions, researchers might provide prompts in order to jog respondent's memory.

Researchers have reported alarming rates of non-compliance for paper diary studies (Stone et al., 2002). They found that participants often either failed to carry their diaries with them or they forgot to make an entry. Instead of simply leaving the entries blank, as a sign that they had forgotten to write in their diaries, participants would later "catch up" and fill in all of their missing entries, which is called **hoarding** (Stone et al., 2002). Hoarding lowers the study's validity because instead of responding *in situ*, participants must try to recall what they had been thinking, feeling, and doing. In a recent article, however, which reports on three separate studies that compare paper and electronic diaries, researchers defended paper diaries. They conclude that "compliance is much more an issue of study design and participant motivation than it is an issue of whether a diary is administered in paper-and-pencil form or electronically" (Green et al., 2006).

Respondents answer open questions with more detail in paper diaries than electronic diaries because people find writing difficult with electronic devices, especially under mobile conditions (Sohn et al., 2008). Researchers, however, must type the diary entries and then they must use qualitative coding techniques to analyze the data.

Now diary researchers often give participants **PDAs** (**personal digital assistants**), a type of hand-held computer, also known as a palmtop computer. PDAs can be used as a calculator, clock, calendar, address book, video recorder, media player, phone, keyboard, and GPS (Global Positioning System). With these electronic devices, researchers have precise control over when participants receive an audible or vibrating signal to respond. Researchers can pre-program these devices to signal participants at scheduled or random moments. Researchers can use free and user-friendly software such as the Experience Sampling Program to load questionnaires on electronic devices. Moreover, researchers can rearrange the order of the questions or they can use the electronic device to deliver the questions in a random order. Researchers can even change later questions based on how participants respond to earlier ones.

Participants can use a keypad to mark their responses to multiple-choice questions. With electronic diaries, researchers do not need to spend time transcribing entries or entering data from questionnaires. As a result, they minimize data entry mistakes. Participants can write their (often brief) answers to open questions, or, if researchers had installed voice recognition software, they can make verbal diary entries. These verbal entries may need to be transcribed.

Researchers report good rates of compliance for electronic devices. They

find that people often complete a diary entry within the recommended two to fifteen minutes of receiving a signal. Sometimes, of course, people cannot respond so promptly. They may be driving a car, playing sports, attending church, taking a test, or talking to a customer. In these situations, researchers might instruct participants to write at the next opportune moment.

Researchers also like to use hand-held computers because they can confirm participants' compliance. They can record when participants made an entry and how much time it took them to write it. If a participant does not respond within a specified amount of time after a signal, then the device records a missing entry. Software then tabulates these missing entries and produces an objective index of compliance (Barrett and Barrett, 2001).

Downsides of electronic devices are: a) the devices cost more to buy, set up, and maintain; b) the devices may be intimidating to people who have never used one; c) the devices must be carried throughout the study; d) the devices may be difficult to use for people with visual or motor-skill impairments; e) the devices do not offer stable data storage—if the batteries run out or fallout, the data disappear; f) electronic devices may be damaged, lost, or stolen. On the other hand, electronic devices make recruiting participants easier because people find the novel technology exciting to use.

Instead of using paper diaries or hand-held computers, researchers may ask participants to use their mobile phones to call in their reports to a dedicated voice-mail line (Palen and Salzman, 2002). As they did with electronic devices, researchers can use mobile phones to signal participants to respond. They can use the voice-mail greeting to provide instructions and to remind participants about future interviews or a debriefing session. Researchers can put their questions on the voice-mail system, and they can regularly change the order of the questions. They can also use a telephone voice menu to provide new questions based upon previous responses.

Setting up a voice-mail system requires working with voice-mail administrators. Palen and Salzman (2002) recommend considering the following issues:

1. Mailbox type: does it provide prompts and receive keypad input?
2. Message length: does it ensure adequate recording time?
3. Mailbox memory: is the memory size large enough, especially when studies span extended, holiday weekends?
4. Message life: can you adjust when messages expire?
5. Data protection: are messages backed up?

Voice menus are also known as "touchtone hell" and are hated by those who have waited through repeated long prompts in order to talk with the "right" person at a financial institution or utility company. To avoid similar difficulty and frustration, some diary researchers visually display the voice menu on the mobile phone screens of participants (Yin and Zhai, 2006). Visual displays really help when studies use complex menu trees.

A new improvement on voice-mail diaries is called the snippet technique (Sohn et al., 2008). Instead of completely answering the questions, people send a small piece of information *in situ* via their chosen media (voice, SMS, photos). This information is then posted to a website. Later, participants log onto the website, view their snippets, remember the situation, and then answer a set of diary questions on the web diary.

The snippet technique offers several advantages (Brandt, Weiss, and Klemmer, 2007). One, it lowers the *in situ* data entry burden from minutes to seconds. Two, it only requires a mobile phone, which people always keep with them and which they know how to use. Three, it allows participants to choose a medium that they feel most comfortable with and/or that best fits the situation.

Which medium people use to record their snippets affects their ability to recall information for complete diary entries. Carter and Mankoff (2005) found that picture snippets led to more specific recall than other media. They also found that audio snippets were easier to use when information could not be represented visually and when people felt uncomfortable taking a picture.

Researchers report relatively low rates of compliance with voice-mail diaries. Palen and Salzman (2002) calculated compliance by multiplying the number of participants by the number of days in the study; then they divided this total by the number of diary entries that were made. Their total participation rate was 42 percent for one study and 25 percent for another. With paper diaries, however, people may have hoarded entries, which is not possible with voice-mail diaries, and with voice-mail diaries, researchers know exactly when participants made their diary entries.

Although participation rates may be low with voice-mail diaries, Palen and Salzman (2002) found the quality of the responses were high. Moreover, Morrison, Leigh, and Gillmore (1999) found participants reveal more detail when they call a voice-mail system than when they write in paper diaries.

An advantage of both the voice-mail and electronic diaries is that researchers gain immediate access to participants' reports. Researchers do not need to wait until people mail them the diaries or meet with them face to face. On the other hand, voice-mail diaries need to be transcribed, and accurate transcription of voice-mail diary data takes about five times longer than the recording itself (Palen and Salzman, 2002).

In general, researchers can help ensure a high rate of compliance by monitoring participants and providing feedback with either face-to-face meetings or phone calls. At the end of the study, researchers need to explain to their readers the percentage of required responses participants completed; how they handled missing data; how they defined a timely response; and how delayed data might bias results and affect validity.

Participant Training and Monitoring Procedures

Researchers generally begin training by asking participants to sign an informed consent form, provide demographic information, and complete some pre-study

questionnaires or rating scales. Researchers then briefly explain the study. For example, they may say the study concerns how people think and feel about their social interactions with others. Researchers might then ask participants to keep records of all their social interactions for a certain number of days.

Researchers then explain the procedure for completing the diary entries. They also define critical words, such as intimacy, which participants may mis-interpret as sexual activity. Researchers emphasize the importance of answering honestly. They stress that people should report life as they experience it—with all the joys and problems. Researchers also emphasize the importance of completing an entry as soon as possible after each signal or interaction unless they really need privacy. In addition to their oral instructions, researchers provide written instructions, which participants can refer to throughout the study.

Researchers ask participants to complete practice diary entries and, upon completion, they review these entries with participants. Researchers may give participants some training with the beeper or hand-held computer by allowing participants to use these electronic devices for a day. Researchers then answer any questions about completing entries, using the technology, and potential problems with compliance, such as objections from superiors to their partici-pation. Researchers also give participants a telephone number to call in case they encounter a problem with equipment failure, or any other situation, such as a sudden illness that would prevent participants from completing their responsibilities.

To monitor participants using paper diaries, researchers can ask participants to mail diary entries on a daily basis, and they could provide addressed and stamped envelopes for that purpose. For electronic or voice-mail diary studies, researchers should access the data directly each day. Researchers can also call couples every few days to answer any questions, to ensure they are completing diaries appropriately, and to remind couples of the importance of completing the diaries independently.

Follow-up Sessions

After the time period for writing diaries ends, researchers collect the diaries. They may also interview participants to check the internal consistency of participants' accounts; to fill in omissions; and to move beyond recorded events into more general experiences (Elliott, 1997). Researchers may also provide a short questionnaire about participants' experience with the beeper or PDA, the degree to which the method disrupted or influenced their regular activities, and their self-perceived accuracy in filling out the questionnaire (Hormuth, 1986). Researchers may ask several specific questions about the accuracy of participants' entries. For example, they may ask if participants completed any entries from memory (more than an hour after the signal or event). If they did, then researchers ask what percentage of entries were completed from memory (Laurenceau, Barrett, and Pietromonaco, 1998). Researchers emphasize they

would not penalize participants in any way if they did not follow instructions, but that researchers were interested in obtaining an accurate picture of their data.

Data Analysis

After you have collected the diaries, you need to analyze the data. If you generated unstructured data by having people write entries, then follow the coding procedure described in Chapter 2. If you generated structured data by having people answer multiple-choice questions or complete Likert scales, then use the coding procedure described in Chapter 3.

Earlier I recommended that you ask people to answer multiple-choice questions or complete Likert scales because then you could obtain thousands of time-based pieces of data relatively quickly. With such a data set, you can initially analyze your data two ways. You can either compare many variables for one person, or you can compare several people for one variable. For example, you can study how levels of intimacy fluctuate over time for a single person, and you can study how intimacy at dinner hour compares among several people.

As a first step in data reduction, researchers might want to find the mean for each participant's responses to a particular question/scale. For example, researchers may compute an average intensity rating of intimacy for each participant over the two-week study. Researchers can use this aggregated data to describe how people differ from each other. Researchers could also average these results to discover a typical person's level of intimacy.

For the second step, researchers may use more advanced multi-level statistical models in order to calculate changes in variables over time. Researchers need such complex models because the data points may not be independent (Bolger, Davis, and Rafaeli, 2003). **Independence** refers to the absence of a statistical relationship between two data points or two variables. In other words, knowing the value on one data point/variable provides no information about the values that will be found on another data point/variable. Within-person data, however, are likely to be associated, not independent. For example, a person's response at 6:30 pm may influence his or her next response, which may occur half an hour later. Moreover, diary reports adjacent in time may be more similar than those more distant in time (Bolger, Davis, and Rafaeli, 2003). To use analytic strategies that overcome these problems, and other problems, you should consult a quantitative research book or an article that explains this type of analysis for diary studies (Alliger and Williams, 1993; Cranford et al., 2006; Laurenceau and Bolger, 2005; Laurenceau, Barrett, and Rovine, 2005; Lippert and Prager, 2001). Your analysis will require more effort, but in return you can discover whether men and women's levels of intimacy change over time in the same way or different ways.

For the third step, researchers may use additional advanced multi-level statistical models in order to learn how a particular event (such as receiving

a photo message) causes a particular effect (such as increasing a person's level of intimacy) (Bolger, Davis, and Rafaeli, 2003).

Data Displays

When researchers display the results from diary studies, they often use line graphs. For example, Figure 4.2 shows levels of intimacy on the y-axis and units of time on the x-axis. A separate line represents each of the four participants' level of intimacy as it rises and falls over time. The graph shows how people known as A and B consistently had higher levels of intimacy. You can also see that C's and D's lower levels of intimacy varied little.

In order to show how a particular event (such as receiving a photo message) causes a particular effect, you would again use a line graph showing levels of intimacy and units of time, but you would use a separate panel for each of the four participants. In addition, you need to show when each participant experienced an outside influence, such as receiving a phone message.

In Figure 4.3, participants 1 and 2 had high average levels of intimacy, and participants 3 and 4 had moderate-to-low levels. Participants 3 and 4 also received more phone messages and they experienced greater variability in daily intimacy. Finally, participants 1 and 2 felt small increases in levels of intimacy upon receiving a phone message, while 3 and 4—particularly 4—encountered large increases, and participant 4 felt a high level of intimacy for more than a single day.

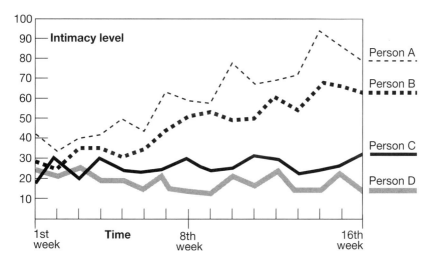

Figure 4.2 Display of diary data showing means and variances for effects of photo messages on intimacy levels of four participants

Source: Bolger, Davis, and Rafaeli (2003)

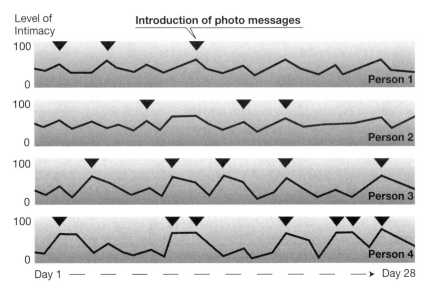

Figure 4.3 Display of diary data showing effects of photo messages on intimacy levels of four participants

Source: Bolger, Davis, and Rafaeli (2003)

Credibility, Transferability, and Dependability

When researchers use diaries to collect their data, researchers determine the quality of their data by member checking. With **member checking**, participants look at a researcher's data and interpretations so that they can confirm the credibility of the information and the overall explanation–theory of the situation. Without the benefit of member checking, researchers are forced to rely more exclusively on their own perceptions.

In addition, diary researchers seek answers to these questions (Hormuth, 1986):

1. Did the person respond to the signals on time? To preserve the purpose of the random sampling of times, signals should be responded to immediately. Researchers can check this by participants' self-reported time of writing for each diary entry as well as their answers to a post-research questionnaire. If problems appear, researchers should compare the reports answered within a short time period to those answered after a longer time period.

2. Did the quality of data decline over time? People may use the same responses across time or they hoard their responses and complete all their forms/entries at one time near the end of the study. Researchers can check lazy, habitual reporting by comparing the reports made at the beginning

of the study with those made toward the end. They can check faking by requiring participants to turn in their completed forms on a daily basis.

3. Did people become so self-aware that they changed their thinking and behavior? For example, completing mood measures five times a day might alert someone to insights such as, "I am the kind of person who needs a lot of positive reinforcement," or "I am happy when I help others who are appreciative." Such reflections may cause the person to volunteer more than normal. Researchers can try to check this by rating open-ended answers to the question "What were you thinking of when you received a signal?" Participants' answers may indicate higher self-consciousness than normal. Researchers can remedy this problem, and the others, by using multiple research designs.

In addition to member checking, researchers can check for **reactivity**, defined as the influence of the researcher on the setting or individuals studied. Diary researchers have a difficult time not affecting the results of their studies because participants often guess—rightly or wrongly—what researchers want to learn. Participants then change their answers to "help" researchers get "good" results. For example, researchers may ask, "Do you buy a gift for your spouse whenever you spend more than two days away?" and a participant suddenly realizes: "I need to buy my spouse a gift the next time I take a trip."

Internet

Researchers using the diary method have embraced the Internet because it makes their jobs simpler in several ways. One, PDAs and wireless access give researchers a chance to quickly change the questions or the order of the questions based upon participants' responses. Two, instead of collecting data for later transfer to a master computer for analysis, data from electronic devices can be transmitted over a wireless network directly to the master computer (Barrett and Barrett, 2001). Three, the transferred data can directly enter a statistical software package or other programs for immediate analysis. Four, researchers can track compliance in a timely manner and give feedback to participants as soon as they detect problems.

On the other hand, wireless networking brings some added costs. First, researchers must pay for wireless network connections per PDA or palmtop. Second, researchers must give added attention to data security because transmission may be intercepted by a third party or lost because of network glitches (Barrett and Barrett, 2001).

Advantages and Disadvantages

Diary studies offer five advantages over other research designs.

1. You gain many data points at many points of time, so you can learn about daily, weekly, or seasonal cycles.

2. You can learn about events that would not be amenable to observation because a) they take place outside of specific time or space boundaries and/or b) the presence of an observer would likely alter people's behaviors.
3. You get less biased data than with surveys since little time elapses between an experience and a participant's account of that experience.
4. You gain both a record of, and a reflection on, experiences. Participants have an opportunity to think about what they said and to participate in the analysis of their behavior (Elliott, 1997).
5. You give participants a chance to explain what they did not do and what they had intended to do (Elliott, 1997).

Diary studies also have certain disadvantages.

1. You place a great burden on participants, who need a high level of commitment to complete their responsibilities properly. As a result, researchers must worry about self-selection bias and attrition. Some types of people will not volunteer for such intrusive studies, and less motivated people may drop out after a few days of being interrupted throughout their day.
2. You need to use short diary instruments that take a few minutes to complete in order to make the studies less onerous. To make best use of participants' time, researchers should use diary studies when they anticipate a significant change may occur.
3. You can only make weak inferences about cause and effect.

Ethical Issues

Researchers must provide just compensation for participants' cooperation in the burdensome tasks of completing diary studies, but at what point does incentive shade into coercion (Scollon, Kim-Preito, and Diener, 2003)? IRB committees may frown upon too much compensation.

A more obvious ethical issue concerns researchers' intrusion into people's private lives. On the one hand, participants retain a great deal of control over diary information. They decide when to respond to signals and what to report. On the other hand, cooperative people end up revealing much about their thoughts and behaviors. Moreover, technological advances, such as putting GPS devices in PDAs, could intrude on privacy even more.

Resources

When recruiting for a study on private matters, such as intimate communication, you may encounter a high refusal rate in relation to the number of people you contact. Repeated contacts—either personally, by mail, or by telephone—may be necessary.

Data collection costs are generally higher with diary studies than with personal interviews. You need to provide generous compensation for participants in diary studies. You may also need to buy and maintain the PDAs or hire a voice-mail system.

You must also invest your time because you need to keep checking with participants to motivate them and to answer questions. If you used open-ended questions, then, as with interviews, you will need a lot of time to analyze the results.

Advice

1. Have a single point of contact for all data collection activities to help develop continuity and loyalty (Palen and Salzman, 2002).
2. Provide periodic reminders by phone contact if you cannot meet face to face. A spirit of collaboration and respect tends to improve compliance because such personal interactions raise compliance rates.
3. Recruit couples who are not in college. Too many researchers use college students, yet intimacy among students cannot be generalized to larger populations because student couples differ from working "real world" couples.
4. Issue a base level of compensation and provide bonuses after achieving higher participation levels (Palen and Salzman, 2002).
5. If you use a voice-mail system, then program the proper phone number into participants' mobile phones and show them how to speed dial (Palen and Salzman, 2002).
6. Provide clear examples of the type of information and the level of detail you want from people's diaries.
7. Try to avoid giving too many details of the study's purpose because participants inevitably focus their writing and even adjust their activities to emphasize thoughts, feelings, and behaviors they think would interest researchers.
8. Pilot test the fixed-response or open-ended format on a member of your targeted population who will not be part of your sample. You want to ensure that the diary method will provide the information you need to answer the research questions. You also want to learn about the difficulty of the tasks and what attrition rates you could expect. Based on the pre-test, you might pare down or expand the questions, rewrite certain items, change the recording period, or adjust the number of observations.
9. Because it takes a day or two for participants to become comfortable with the process, start participants on different days of the week. Otherwise, diaries may all have questionable data for the day on which all diaries began (Rieman, 1993).
10. Monitor and transcribe diary reports immediately to assess their quality and provide additional training and guidance to participants when necessary.

11. Use an open-response format for an initial diary study so that you will know which questions to ask when you later use a fixed-response format.

12. Include at least one open-response question in every fixed-response study so that participants can qualify an answer or address issues that go beyond those specified in the fixed-response questions.

13. Use fixed-response studies when a) you have a larger number of participants; b) you want to collect quantitative data; c) you have limited time for contact with participants; d) you have limited time for transcription; e) you have limited time for analysis.

14. Use the diary method in conjunction with other research designs to prevail over the disadvantages of both types of design.

Further Viewing

Hug Shirt videos
The Hug Shirt
http://video.google.com/videoplay?docid=-1602527082430538243&q=hug+shirt&ei=nB0bSIziBYu2qQL_9bjLAg&hl=en

Intimate communication
How to improve intimate communication
http://video.google.com/videoplay?docid=-8296045558768974506&q=intimate+communication&ei=8R4bSOmhFJGErgK20JTAAg&hl=en

Camera phone pictures
How to share photos with a mobile phone
http://video.google.com/videoplay?docid=-5215704502575482324&q=mobile+photo+sharing&ei=pSAbSIiaBJCqrgLX7fjNAg&hl=en

Sharing photos on the Web
http://video.google.com/videoplay?docid=2256660716983522608&ei=pSAbSIiaBJCqrgLX7fjNAg&hl=en

Diaries for Data Collection

Leysia Palen

My first use of diary studies as a data collection technique arose out of need to understand how a new technology—mobile telephony—was weaving its way into everyday life. In 1999, when I conducted the research described here with my colleague Marilyn Salzman, mobile phones were just beginning to be widely adopted in the United States. About half the population owned mobile phones, and the rate was rising. Some telephone companies employed people like me—human–computer interaction and human factors researchers—to design user-centered products and services for this new, expanding wireless market.

My engagement with the telephone company where I conducted this research was short term and occurred during my university's summer intersession. I was fortunate to work with the company's highly experienced human factors group, and saw it is a personal opportunity to learn how to conduct research that had immediate, practical implications. We also had hopes to publish results to the broader research community, and in the end, successfully published four articles about the work for those venues. In addition, the research study I helped lead spawned a second internal study that further bored in on specific business-related concerns we uncovered in the first study. The collaboration resulted in research that met both business and scholarly goals.

Upon my arrival, I had little personal experience with mobile phones myself, and so before I jumped into ongoing development projects, I decided that I needed to first understand, very simply, how people used mobile phones beyond what I imagined and casually observed. I was surprised when I found little empirical reporting on the behavioral aspects of this new phenomenon.

My colleagues and I decided to make understanding and describing mobile phone use a core research objective. Not only were we studying these issues for immediate business benefit, but we also appreciated that society was on the verge of undergoing a radical change in the ways we communicated and coordinated with one another. As researchers, we knew the window of time to capture and "see" these small but significant changes in behavior before they disappeared was short.

It made sense to focus on new users, then, not only to improve the phone providers' business goals of appealing and retaining new customers, but also because new users are most able to reflect on how using a technology does, or does not, change features of everyday life. In our research study, we cared about a variety of both practical business issues as well as further-reaching behavioral and societal issues, which included studying interactions with customer service, the comprehensibility of call plans, the usability of handset hardware and software features, and the evolution of new communication habits and attitudes.

These broad goals required an array of data collection methods to longitudinally describe mobile phone experiences of new users. We asked customers who had just placed a mobile phone order—but who had not yet received their handsets—to become participants in our six-week study. We planned to conduct three interviews over the time period: the first before they began using their phones, another after three weeks, and the last at the end of six weeks. We spent a good deal of time thinking about how we should account for the in-between periods, when the moment-to-moment events that gave rise to change and assimilation of the phone into everyday life were taking place. Participants allowed us to see their phone bills, so we were able to quantify call activity and change in that activity over the entire period. However, we needed more: we wanted a way to detect small changes in behavior and understanding without burdening participants to the point that they would drop out before the study period was completed.

If we had left this sort of inquiry to the interviews, our participations would have forgotten many of these transient changes in attitude and behavior. It was clear, in fact, that they did not realize how interesting their seemingly mundane experiences actually were, such as the first time they realized that they could turn the ringer off, or the first time they accidentally left their phones at home and discovered that they felt lost without them. All these seemingly small observations go to the specific issue of "domestication" of technology (Haddon, 2003), and we knew it would be critical to collect those transitory experiences when—or at least close to when—they happened. The challenge of how to do this was the genesis of our adaptation of the diary method. We turned to voice-mail as a familiar and easy way for participants to record a daily entry verbally, which in turn enabled us to retrieve the reports and contact our participants for further elaboration. We imagined that once a day would probably be sufficient to allow users to report on self-observations of new aspects of their phone use. We also limited diary participation to once a day so that we could encourage them to call in at a regular time from their home phones. This was a research design decision to limit our biasing of participants to carry and use their phones more often, as part of the requirement to call in to a voice-mail line for the study. Since the use of the mobile phone was itself the object of study, we had to be very careful about requiring mobile phone use.

The voice-mail diary was experimental. Some of our colleagues doubted its potential for effectiveness. Consequently, we decided to make participation in the voice-mail diary portion of our data collection optional so that we could ensure participation in other data collection activities for the full period. Indeed, by the end of the study, it was true that not all our participants made regular entries. It was also true that some participants left only very short entries, with little detail about their daily experiences (or non-experiences) with their phones. (We discuss a range of detailed suggestions born out of considered

lessons learned for implementing diary studies in Palen and Salzman, 2002.) Even so, it was clear that overall, the methodological experiment was successful. Most participants described some notable and insightful moments that were richly detailed. In addition, these diary entries allowed us to tailor the second and third interviews specifically to each participant, which in turn yielded better interview data. We were able to remind participants about things that happened in the preceding weeks that they had already forgotten—and they were often surprised and delighted by our recall and inclusion of those experiences into the other forms of data collection.

Such an approach was also the basis for developing **rapport** between participants and researchers, which in turn seemed to improve the nature and degree of participation in the study. Establishment of rapport was also enabled by the daily voice contact—even though brief and asynchronous—through the voice-mail diary. (We made it a point to regularly change the greeting with welcoming messages and with new information about what was coming up next in the research study logistics; participants reported that this helped them feel as though there was someone actively listening on the other end.) In the end, the team felt that the voice-mail diary studies produced good yield for very low cost on the part of both the participants and the researchers.

We employed variations on these techniques in later studies. We used a structured voice-mail diary in a follow-on study (also reported in Palen and Salzman, 2002). This implementation of the diary required participants to answer the same three specific questions every time they called in. This made reporting more systematic across the participant pool, which was a real benefit in analyzing the data, but overall, participation in this second study was lower than in the first (other execution differences highlighted the tradeoffs that are at stake in diary-based research design, also described at further length in the 2002 paper). Still in a later study by Palen and Hughes (2007), we combined both a similar end-of-the-day voice-mail diary study with an additional beeper-style experimental sampling method (ESM) technique to study how parents of young children used their phones for both work and home life. We had participants carry a small, custom-printed notebook with seven short questions asking about where they were, what they were doing, who was with them, and if they had their phones available. Participants were paged at arbitrary intervals at an average 1.5 hours apart during waking hours over the course of one week. Again, to avoid bias, we equipped participants with pagers instead of paging them over their phones.

My experiences with diary studies have been that they have yielded rich results, especially when put in combination with other forms of data collection. The entries themselves can provide good data—and can be qualitative, quantitative, or both, depending on the research design—and can beneficially inform other data collection instruments and techniques in the same study. It is also

safe to say that I have had small surprises in how diary studies turn out, and I have learned that every aspect—from medium, stimulus, incentive structure, and researcher involvement—is an important part of the research design, and can affect evenness, depth, and length of participation. With attention to these details paid, diary study techniques can be surprisingly engaging for both researchers and participants alike.

5 We Shall Act and Overcome, Together

Theoretical Perspective

Western filmmakers and photographers often focus on the miseries of people in the developing world. They take pictures of refugee camps in Darfur, AIDS victims in the slums of Kampala, Uganda, and war victims in the Congo. They also photograph the underclass in the United States, including refugees from Hurricane Katrina, drug addicts in Manhattan, and gang members in Los Angeles. They use cameras to show oppressed people's problems so more fortunate people can be informed, and with their new information, take action to help.

Zana Briski seemed to follow in the footsteps of such concerned documentary photographers when she went to photograph the red light district of Calcutta, India, in 1997. Upon arrival, however, the British-born photojournalist realized how difficult it would be to take pictures of the prostitutes and brothel owners. She says: "It's almost impossible to photograph in the red light district, everyone is terrified of the camera, and they are frightened of being found out. Everything is illegal, there is a whole separate society within itself, you just walk down that one lane and it's another world." The standard response to such a challenge is to first live within the sub-culture. Understand its members' lives. Gain people's trust. Then, begin to take pictures.

Briski, however, met the prostitutes' children and decided it would be better to help these children escape their fate of becoming prostitutes than to show how prostitutes struggle to survive. She gave the children cheap point-and-shoot cameras, set up weekly classes to teach them how to take pictures, obtained grants to fund her efforts, arranged to sell the children's photographs in Calcutta/New York galleries and an auction at Sotheby's, and helped some children enter a boarding school in Calcutta. The children loved taking pictures. They photographed a half-starved dog, kids playing cricket, pet rabbits, scenes inside their houses, and people out on Calcutta's streets.

Briski and a New York-based filmmaker, Ross Kauffman, videotaped these efforts at helping children for two years beginning in 2002. The resulting film, *Born Into Brothels*, won an Academy Award for Best Documentary Feature in 2004. In addition, Briski created a non-profit organization, Kids with Cameras,

which has raised $100,000 for tuition for children who appeared in the film. This money also helped build a school in India for other children of prostitutes.

In summary, Briski collaborated with the children. The children taught Briski about the Sonagachi, or "red light," community, and Briski helped the children pursue their education. The profits from the children's photography and *Born Into Brothels* were returned to the children and their community. As a result, Briski followed in the footsteps of Paulo Freire rather than the footsteps of documentary photographers.

Imagine if you wanted to conduct a research study that helped other people. If so, and if you wanted to draw upon your knowledge and skills as a visual communicator, then you might begin by studying the ideas of Paulo Freire.

Paulo Freire was a world leader in the struggle for the liberation of the poorest of the poor. He worked to help men and women overcome their sense of powerlessness and to act in their own behalf.

Freire taught and organized the urban poor for three years in the late 1950s in Recife, a city in the northeast of Brazil. Then, in the early 1960s, he became director of the University of Recife extension service, through which he helped thousands of peasants become literate. The literacy program motivated adult illiterates to want to learn to read and write because it connected literacy with participation in the political process. Freire and his co-workers gave peasants hope that they could start to have a say in the day-to-day decisions that affected their lives, such as issues related to land reform. As the poor increasingly valued literacy, they followed Freire's teachings and became less passive and fatalistic.

Brazilian military leaders and wealthy land-owners hated Freire's literacy program because it qualified peasants to vote, usually for land reform, and it also empowered peasants socially and politically. The elites, therefore, found Freire's methods outrageously radical. The military overthrew the Brazilian government in April 1964, and Freire was jailed for his "subversive" activities. He spent a total of seventy days in jail and then was exiled to Chile.

In Chile, Freire worked for adult education programs for a few years, but another coup led to a repressive regime, which exiled Freire. In 1969, he taught at Harvard University, where he saw students protesting America's wars in Southeast Asia. Freire realized that repression and exclusion of the powerless from economic and political life was not limited to developing countries. He extended his definition of the third world from a geographical concept to a political concept. During this period, Freire wrote his famous book, *Pedagogy of the Oppressed* (Freire, 1972).

Freire's ideas in this book, as well as several ideas from *Teachers as Cultural Workers* (Freire, 1997), form the theoretical framework for this chapter. One of Freire's ideas was to base education upon local people's life experiences rather than others', mainly colonialists' artificial experiences (Freire, 1997). Freire did not begin his literacy courses by teaching the alphabet or teaching how to spell words from a standard textbook. Instead, he spent time within communities, learning the words that would be meaningful and would evoke emotional responses. Freire called these words **generative words.** After local

people taught Freire which words to use to promote literacy, Freire wrote those words and drew pictures of what the words represented.

A second idea concerned the importance of dialogue. Freire invited groups to discuss "their" words and to feel they had power over their words. His work as an informal educator led him to believe education should not resemble a bank, with teachers making large deposits of knowledge, and students coming to withdraw the knowledge they need for life (Freire, 1997). When a teacher lectures, and students memorize, schools promote dependence upon authority. Moreover, schools can become tools used by parents, business, and the community to impose their values and beliefs upon students. Instead of following the "bank" model, teachers and students should engage in dialogue based on mutual respect. They should collaborate in order to build social capital and enhance their community.

Three, Freire used dialogue to promote conscientization. **Conscientization** means developing consciousness of social and political forces that limit people's potential. Freire believed subjugated people remain subjugated because they belong to a culture of silence (Freire, 1972). Their silence prevents them from actively transforming their society. Not only do they lack a voice, but, worse still, repressed people have also adopted the myths of their dominators. Because they have adopted these myths, the oppressed see themselves as the dominators see them—incompetent, lazy, and naturally inferior. The ruling group, therefore, does not need force to dominate other social groups; the subordinate groups have agreed to be subordinate.

Four, Freire believed dialogue should be followed by **praxis**, or putting an idea into practice. Dialogue may deepen knowledge, and conscientization may free people from a culture of silence, but people must then take the next step, which is action (Freire, 1972: 28).

Freire regarded reflection without action as sheer verbalism, or "armchair revolution." Along the same lines, he dismissed action without reflection as action for action's sake, or "pure activism" (Freire, 1972: 41). Neither is acceptable. Nor can there be a prior stage of reflection and a subsequent stage of action. Instead, action and reflection must take place at the same time.

In addition, Freire believed the reflection part of praxis, as well as the action part, must occur within groups, rather than at the individual level. To be effective, a group must talk and act together.

Five, Freire helped people achieve full humanization. **Humanization** is defined as recognizing our common humanity with our opponents. Freire believed we can become more human or less human (Crotty, 1998). When we exploit, oppress, or hurt others, we become less human. Moreover, as our victims suffer, they become less human. To become more human, we must move beyond the dichotomy of oppressors and oppressed; we must heal and improve our opponents.

To put these ideas into practice, disadvantaged people need help. Actually, they need to help themselves, as a group. Freire believed nobody liberates anybody else, and nobody liberates themselves by themselves (Freire, 1972).

People liberate themselves in fellowship with each other. An outside facilitator can provide assistance by:

1. Presenting the group's situation as a set of problems.
2. Showing that these problems are challenges.
3. Encouraging the group to remove itself from the situation and to reflect upon the situation.
4. Using the reflection/action process to help the group transform its situation.

Facilitators help a group in three ways. First, members of a group escape the web of myths that make their situation seem inevitable. Second, with a clearer view of reality, they gain hope for freedom. Third, with hope, they cast aside the culture of silence so they can transform their lives.

Goals

If you want to use Freire's ideas of generative words, dialogue, conscientization, praxis, and humanization, then you might conduct action research. With **action research**, investigators purposefully become part of the change process. They engage people in studying their own problems in order to solve those problems. They make reports for specific stakeholders who will use the results to make decisions, improve programs, and solve problems (Patton, 1990).

In fact, you would probably use a type of action research called **participatory action research** (**PAR**). PAR is an iterative process involving researchers and practitioners acting together for problem diagnosis, action intervention, and reflective learning (Avison et al., 1999). Six characteristics of PAR include:

1. Groups of community members take part in the research process, from identifying the problem to collecting data to analyzing the results and taking action.
2. They take action to improve the lives of the poorest of the poor—people living in urban slums; in remote, resource-poor rural areas; and in neighborhoods with high levels of unemployment or unregulated industries—by overcoming problems arising from marginalization, exploitation, racism, sexism, etc. (Kemmis and McTaggart, 2000).
3. Community members become empowered by recognizing and applying their own capabilities (Hall, 1981).
4. Community members and researchers adapt methods drawn from conventional research for use in new ways, in new contexts (Cornwall and Jewkes, 1995).
5. The researchers may be outsiders to the community, but they fight for change rather than remain detached from the community.
6. Community members and researchers emphasize the process more than the outcomes (Cornwall and Jewkes, 1995).

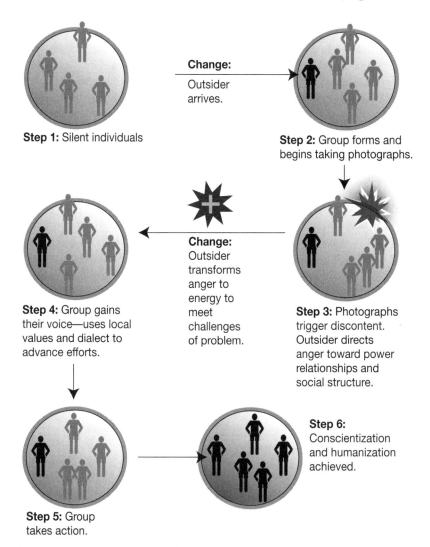

Figure 5.1 Model of Freire's ideas from *Pedagogy of the Oppressed*

Even though all PAR involves some type of collaboration between researchers and non-researchers, the type and amount of participation by community members vary quite a bit (Biggs, 1989). At the most basic level, you contract people to take part in your investigations. The next level of participation occurs when you ask groups for their opinions. At the third level, you work with local people, but you initiate, design, and manage the projects. Ideally, PAR occurs at the highest level of participation—the collegiate level—when you and stakeholders use different skills to work together as colleagues. Thus, you become facilitators of knowledge creation: stakeholders discover

their own understandings, analyze their situation, and design their own solutions. Eventually, you become redundant and unnecessary.

Ironically, when researchers and community fully collaborate, some institutional review boards (IRBs) may view PAR more as social activism and community development than as social research (Kemmis and McTaggart, 2000). University researchers, however, continue to engage in PAR because they want to give as much as they receive. Too often, researchers take advantage of a group's time, resources, and goodwill, but they bring little or no direct benefit to the community with their work. PAR strategies have also arisen out of scholars' awareness that universities have contributed to individual-oriented rather than group-oriented solutions. Even worse, universities have helped foster dependency rather than enhance interdependence among citizens.

For action research, therefore, your goal would be to empower a specific community. **Empowerment** is the process whereby people gain control of their lives by developing participatory skills. Empowered people can interpret for themselves the agendas of those with political, economic, and social power. They can then make use of these other people's agendas to develop their own realistic solutions for improving their lives.

Research Questions

Not all qualitative research designs begin with research questions. Sometimes researchers simply talk with community members, and after analyzing the situation together, they jointly decide upon a focus for the research project.

Brief Description

When researchers want to empower a specific community, they sometimes launch a Photovoice project. **Photovoice** is a research design that combines visual images, the "photo" part of the design's name, with group discussion, the "voice" part. Instead of being the subjects of photographs, videos, or films, people photograph their community's assets and liabilities. Then, as a group, people identify which of the photographs most accurately show their concerns. The group then shares stories about their photographs, including why they were taken, what they mean to the individual photographer, and what they are supposed to show. With the help of a facilitator, the group then identifies central issues that they want to target for action. Finally, the group of people, the facilitator, and community leaders take action.

Caroline Wang, an assistant professor in the Department of Health Behavior and Health Education at the University of Michigan, and **Mary Ann Burris**, research associate of the School of Oriental and African Studies at the University of London, created the first Photovoice project (Wang and Burris, 1994) when they helped raise the consciousness of rural Chinese women about their status in a male-dominated society. Wang and Burris empowered these

women to change their social status so that the Chinese women could improve their economic status, which would improve their reproductive health.

Units of Analysis

Since the goal is to empower a specific community, your unit of analysis would be comments on the community's strengths and weaknesses from group discussions.

In a Photovoice project, a facilitator uses the group's photographs of the community's strengths and weaknesses in order to generate discussions. In a Photovoice project in a Hispanic community within the United States, for example, people might talk about the support of schools (free health care, reduced lunches) and churches (free English classes) as well as idle men (no capital to start a business and no jobs).

Sampling

In order to obtain an adequate quantity of your units of analysis—comments on a community's strengths and weaknesses—you need to draw a sample of at least ten members of the community.

Photovoice researchers generally use volunteers, rather than a probability or purposeful sample. They are trying to find enough volunteers willing to invest the necessary time and energy.

An exception to this rule, however, occurred in Michigan, where the W.K. Kellogg Foundation financed a Photovoice project in order to improve education and economic outcomes within seven distressed neighborhoods (Foster-Fishman et al., 2005). In Battle Creek, local leaders identified potential participants in seven neighborhoods by contacting families, briefly describing the study, and inviting participation. The leaders also advertised in community newsletters and distributed flyers at neighborhood events. To maximize the project's impact, leaders created a diverse group, with old and young, males and females, rich and poor, Caucasian and other ethnicities.

You can try to generate interest in your Photovoice project by describing potential social changes that may result from the project, but you must be careful to not raise false hopes. If groups' achievements do not match their high expectations, they may leave the project feeling less empowered than when they began. Ideally, you should interview potential participants, not so much to exclude people, as to convey expectations for project involvement. All those who decide to join the project should be required to sign a contract outlining their responsibilities and providing you with their consent.

Methods

In order to empower a specific community, you could use the Photovoice method. This section explains how to a) obtain IRB approval; b) secure

Figure 5.2 Flow chart for a Photovoice study

funding; c) hire and train advisors; d) recruit policy-makers; e) conduct training; f) take pictures; g) discuss issues as a group; h) implement policies; and i) conduct an evaluation.

Obtaining IRB Approval

The university's Institutional Review Board may be reluctant to approve a non-traditional research design such as a Photovoice project, which involves photography, consciousness raising, and action.

A problem with photography is that it denies anonymity. Readers of the final research report can often identify participants by their photographs, so participants lose some ethical protection. Researchers, therefore, must be sure to get signed releases for photographs that will be displayed or published.

Community members, however, not professional photographers, take the pictures, and sometimes they photograph problems in their communities. Community members, especially children, might feel they do not have authority to ask their subjects to sign consent forms. As a result, community members may only photograph inanimate objects. In the *Born into Brothels* documentary, for example, the children seldom photographed adults; instead, they usually took pictures of each other.

Consciousness raising can agitate people and may cause emotional harm. To deal with this problem, you may hire a trained group facilitator, who might also be a therapist, to take care of the participants' emotional well-being. The facilitator attends all group sessions and responds to phone messages twenty-four hours a day. You should also remind participants they can withdraw at any time if they become uncomfortable. If participants withdraw, they can keep their pictures or they continue to let the group use the pictures.

Taking collective political action can also anger people who prefer the status quo. For example, if students at a school become empowered to make improvements in the quality of food at lunch, the current food providers would, logically, feel threatened. Therefore, Photovoice should attempt to anticipate if someone in the community would stand to lose from a change that

resulted from the project. In Calcutta, for example, the mothers believed they would lose significant income if their children chose to pursue an education rather than work as prostitutes.

Securing the Funding

Photovoice projects may require funds for cameras, exhibit-related costs, rent for a space for training, and a stipend for a group facilitator. Some projects also pay groups for attending training sessions and/or they give them a small, weekly stipend. Ideally, groups could apply for small mini-grants to put their ideas into practice and improve their community. In fact, several Photovoice projects have been funded, especially since 2004. Most of the funding comes from grants from health organizations, such as the National Cancer Institute or from foundations, such as the W. K. Kellogg Foundation.

People working in health fields have had some success finding institutions to pay for expenses. Carlson, Engebretson, and Chamberlain (2006) were supported by the National Cancer Institute; Lopez and collaborators (2005) were sponsored by the Susan G. Kornen Breast Cancer Foundation; Strack, Magill, and McDonagh (2004) were funded by the Centers for Disease Control and Prevention; Wang and Pies (2004) by the Contra Costa Health Services.

Foundations have supported some Photovoice projects. The W.K. Kellogg Foundation supported three projects: Nowell and others (2006); Foster-Fishman and others (2005); and Streng and others (2004). The Soros Foundation supported Lykes' work in Guatemala (1997; 2003). The Charles Stewart Mott Foundation supported Wang and Redwood-Jones' work (2001) in Flint, Michigan. The Ford Foundation supported Wang's Photovoice project in Yunnan, China (Wang, 1999; Wang and Burris, 1997; Wang et al., 1998; Wang, Burris, and Ping, 1996).

Other researchers pieced together funding from a variety of photography-related sources. Frohmann (2005), for example, was funded by Helix Camera, Gamma Photo and Digital Imaging Labs, HammerMill Paper Company, Studio ERA2, and Calumet Photographic, as well as several university-based institutions. Another group of researchers was funded by research councils in the countries where they conducted Photovoice projects (Mitchell et al., 2005).

Hiring and Training Advisors

If no researchers live in the community, then one or two people who know the community's history should be hired as part-time advisors. This kind of alliance enables researchers and advisors to capitalize on each other's areas of expertise. Neighborhood-based advisors can help develop linkages to existing community resources, while university scholars can obtain outside resources and serve as catalysts throughout the project's implementation. Such collaboration increases the likelihood that scholarly research will be channeled into action and converted into policy changes.

Recruiting Policy-makers

The team of researchers and advisors should establish relationships with community leaders. In the United States, appropriate leaders include city council members, journalists, physicians, religious leaders, business people, and teachers. When such leaders work together with Photovoice participants, they can improve the community.

You may recruit policy-makers at the beginning of a Photovoice project by asking them to serve on an ad hoc advisory board. If you cannot form a board, you should continually inform policy-makers about the project so policy-makers will feel involved. You should also seek publicity for the project.

In Briski's case, she may have had greater success convincing the mothers to let the children go to school if she had enlisted the aid of community leaders, who may have known better how to approach the mothers. They may have helped the families work together to find a community-wide solution to the problem. In addition, leaders may also have found a way to reduce the families' dependence on Briski for solving future financial problems. Ideally, these leaders would be accountable to the community and openly committed to social change.

Conducting Photovoice Training

Photovoice requires a substantial investment of time and effort. An orientation session, therefore, should give people the information they need to decide whether they wish to participate in the project. During the orientation, you should also strive to develop rapport and trust among investigators and participants. You may use team-building exercises to build enthusiasm for changing a community.

Photovoice resembles narrative approaches to inquiry (Foster-Fishman et al., 2005). Both consider the stories people tell about their lives as a useful way to understand the meaning and significance of their social realities. Early in the training session, therefore, you should explain that the purpose of a story arc is to show the change in a character or situation. For example, a character experiences a tragic fall from grace, or a character goes from a situation of weakness to one of strength. Have participants tell stories about themselves or people they know so they can become familiar with storytelling before the Photovoice project begins.

Before you give groups instructions on how to use their cameras, you should discuss legal issues such as where people can take pictures and issues related to privacy.

In the United States, you can photograph in most public places and on much publicly owned property. You can take pictures on streets, sidewalks, parks, zoos, train stations, bus stations, and on university campuses. You can also photograph private areas visible to the public, such as porches and lawns. Restrictions apply to public schools and government buildings, and you need permission to photograph any medical facility.

Privacy means the right to be left alone. Although the U.S. Constitution does not explicitly grant us a right of privacy, some commonly recognized legal principles of privacy have evolved through the years. For example, you cannot take pictures without permission in private places, such as a person's home or dorm room. Nor should you use a hidden camera in order to take pictures.

As a Photovoice photographer, you may be concerned about taking pictures that make someone look bad. In general, however, you should not worry, because this branch of privacy law primarily concerns attaching libelous captions to photographs. You can legally photograph problems in your community. You just cannot photograph something that is not a problem and then attach a caption that claims a problem exists, because then you would place a person in a "false light." You would make the person look bad without cause.

A similar problem occurs when you take a truthful but embarrassing photograph. You cannot take a picture that would be highly offensive to a reasonable person unless the picture is of legitimate concern to the public. Of course, community problems would meet this criterion.

In addition to legal issues, you should also discuss ethics, which involves deciding the right thing to do. One type of ethical problem involves setting up or "staging" pictures. According to the National Press Photographers Association (NPPA) Code of Ethics: "While photographing subjects do not intentionally contribute to, alter, or seek to alter or influence events." The Code also states: "Do not manipulate images or add or alter sound in any way that can mislead viewers or misrepresent subjects." In other words, even if you know drug users frequently discard empty packages of drugs at a particular street corner, you should not add anything to that area in order to take a picture that shows the problem.

Another potential ethical worry for Photovoice photographers concerns stereotypes and prejudices. The NPPA Code of Ethics states: "Be complete and provide context when photographing or recording subjects. Avoid stereotyping individuals and groups. Recognize and work to avoid presenting one's own biases in the work." For example, you may be upset about how people (ab)use an empty lot in your community. You may think Hispanics (or substitute any other group of people) just dump their trash (or substitute another problem) on that lot. Therefore, you wait to photograph the lot until you see a Hispanic person dumping trash.

During training, the research team should also discuss the following questions:

1. What is an acceptable way to approach someone to take his or her picture?
2. Should someone take pictures of other people without their knowledge?
3. How can a photograph lie?
4. Can a photograph be accurate, but unfair?
5. Can it harm a person?

After discussing such legal and ethical issues, you may begin the camera instruction. You need to show people who are unfamiliar with photography how to use a camera. Although a camera might have auto-white balance, auto-exposure, auto-focus, auto-ISO, auto-advance, etc., the equipment still requires a well-timed press of the shutter release and good framing. The following are some general tips.

One, show people how a wide-angle view sets the scene; how a medium shot tells the story; and how close-ups add drama (Kobre, 2008). People can either walk toward, or away from, their subject to change their angle of view, or they can use the lens zoom feature. Two, explain that cameras have a delay between the moment that you press the shutter release and the moment that the camera actually takes a picture. With inexpensive digital cameras, the marked delay can hamper shooting candid pictures. Three, show people how to hold their cameras steady so that their pictures will not be blurred. Four, help people to notice both the subject and the background so unwanted background elements will not distract viewers from noticing the primary subject.

In addition to showing people how to use a camera, you need to give them tips on how to use the built-in flash. One, show people how they can use flash at different shutter speeds. When people do not use flash, the shutter speed controls whether moving subjects will appear sharp or blurry in the final image. With flash, however, the light is so quick that it will stop movement; flash can even stop a speeding bullet. When people take flash pictures, therefore, they change shutter speeds to control the level of the light in the background, where the flash does not reach. A slow shutter speed means the available light will appear bright, while a fast shutter speed means that the background will appear dark—maybe completely black. Two, explain how people can avoid problems with flash pictures. For example, to avoid having a dark shadow appear on the wall behind a person, you can move the person away from the wall. To avoid reflections in someone's glasses, you can position the flash at an angle to the reflective surface.

After learning about their cameras and flash units, participants can then practice taking pictures of each other while they role play. You should also explain the logistics for processing the film if groups use disposable cameras. If they use digital cameras, explain the process for deleting unwanted pictures and for transferring pictures to a computer.

People also need to know how to answer people's questions about the project. Before leaving the training session with a camera, the group might want to develop written material, such as a brochure, that describes the goals of the Photovoice project. This brochure should also explain who is participating in the project, how photos will be used, and whom to contact for more information. Participants can give these brochures to anyone who asks questions or expresses interest in their work.

Taking Pictures

Photovoice projects generally begin with two descriptive questions: What do you value about the community? What do you think needs improvement? Participants have the option to use photography, videography, drawings, or other visual representation, in order to show the things they value and the things that need improvement.

Discussing Issues as a Group

After completing their picture taking, people select their favorite photographs, which you print. To use Freire's language, each picture becomes a **trigger**—a concrete physical representation of an identified issue. Like generative words, these photographs are meaningful and they evoke emotions because they come from people's real-life experiences.

Then each person uses his or her photographs to tell a story. These stories are part of Freire's dialogical process.

The facilitator then uses these stories to develop the group's consciousness of limiting social and political forces. For photographs depicting strengths, the facilitator asks how those strengths came to be, in what ways they impacted people, and what relevance, if any, they held in promoting positive change. By contrast, for photographs depicting things in need of change, the facilitator asks why the problem existed, how it impacted people, and how it could be changed. A facilitator might ask the following questions:

1. What is happening in this situation?
2. What does this have to do with health or social justice (or other topic)?
3. What circumstances have created this situation?
4. What can be done about this situation?
5. Who has the power to do something?

Facilitators develop critical thinking skills by moving discussion from the concrete and personal level to a more abstract level. They help groups recognize the root causes of their subservient place in society—the socioeconomic, political, cultural, and historical context of their lives.

Facilitators also work on an emotional level. Photovoice research starts with real issues, so emotions often surface during group discussions. Group members reveal past hurts, or feelings of relief at finally being valued. Facilitators allow such feelings to surface in a relatively safe environment. They then use members' emotional responses to build empathy with others and to motivate members to initiate programs to improve their lives.

Ultimately, the facilitator must perform a number of roles:

1. Encourage everyone to share a personal story, so people can see they are not alone.

2. Listen for, and name, the community's problem.
3. Address the emotional impact that occurs when real issues are discussed.
4. Ask how and why people's stories fit into a social–cultural context.
5. Help people think differently and act differently so they become empowered.

Implementing Policies

During the first Photovoice project, Wang and Burris (1994) explicitly placed the agency for social change in the hands of more powerful policy-makers. They did not expect Chinese women to act by themselves because in Chinese society women feel inferior to men, have little or no power even within the family unit, and can easily be targets of oppressive political repercussions. Peasant women could not initiate social action, so researchers involved out-siders to implement changes. For example, they called on township, county, and provincial leaders in the All-China Women's Federation, male cadres of the County Project office, as well as local anthropologists, Chinese university scholars, foreign technical advisors, donor agency program officers and other policy-makers at various levels of government (Wang et. al., 1998).

Scholars who have used Photovoice since Wang have also looked to policy-makers to take action. They generally invite local leaders and journalists to exhibitions of the groups' photographs. They hope leaders will learn about specific problems and then use their political power to find solutions.

Sometimes this strategy backfires because policy-makers become defensive about shortcomings documented in the photographs and they do not feel responsible for making improvements. In such situations, Photovoice groups could have had greater success if they had gained support from policy-makers early in the project rather than at the end. For example, Rutgers University students conducted a Photovoice project and displayed fifty photographs depicting a range of problems, such as students' use of alcohol and marijuana to relieve boredom (Goodhart et al., 2006). Rutgers students also showed pictures of junk food offered throughout the campus and of bare walls where condom vending machines used to be. They invited fifteen university officials to attend the exhibition and see the students' concerns. The students wanted officials to solve the problems, but the officials wanted the students to come up with specific solutions for their problems. Neither group ended up taking action. Perhaps, if the students had gotten officials to "buy into" the project from the beginning, Rutgers campus would be healthier.

Photovoice groups can take action themselves, of course. If so, they should embrace an incremental approach, beginning with short-term winnable goals and ending with long-term substantive changes.

A Photovoice project ends when the group helps itself and no longer needs outsiders, such as the research team or policy-makers. For example, one group developed an action plan to address the employment-seeking behavior of people living with HIV or AIDS, and the plan helped people get jobs

(Hergenrather, Rhodes, and Clark, 2006). In another example, middle school students living in a poor, crime- and drug-ridden neighborhood used Photovoice to launch a school clean-up project that will be maintained and sustained by the community in collaboration with city officials, businesses, and other local residents. They also co-developed a short-term career exploration program that assisted them in exploring educational and occupational goals (McIntyre, 2000). In a third example, a group organized a workshop that identified sixty ideas for community and economic projects (Cameron and Gibson, 2005). It also organized several "How-To Workshops." Then the group formed the Latrobe Valley Community Environment Gardens, and the local government gave it a large piece of land for a garden. Former welfare recipients began to work as managers, fund-raisers, publicists, and decision-makers in the project. Later the group launched three other projects: a Santa's Workshop to make large outdoor Christmas decorations; a community shed to provide tools, equipment, and a workspace for residents; and a one-day circus workshop, which received funding from the State Health Department. Finally, the group accomplished the project's ambitious objectives of raising employment and stimulating the local economy.

In all of these situations, groups moved to a higher level of consciousness from a lower level characterized by apathy, dependency thinking, and distrust of their neighbors. They acknowledged feelings of pain and anger; then they moved on to other kinds of enabling and creative emotions. Instead of thinking about things they could not do, groups recognized the things that they were already doing. They discovered strengths and capacities within themselves that had, until that time, gone unnoticed. In addition, Photovoice groups realized their community already had people assets and an active diverse economy. As a result, their sense of their own and others' capacities grew so they began to feel like capable, contributing citizens. Finally, some groups developed resources that led to collective actions to make their community a better place to live.

Evaluating Photovoice

Participants should be required to complete an exit survey that includes several open-ended questions inquiring about their participation in the study, their experience as photographers, and their overall experience within the group. Possible questions include:

1. What made you decide to participate in the project?
2. What was it like to be a Photovoice photographer?
3. What was it like to talk about your photos with other people from your group?
4. Did you find you were affected in any way by your participation in Photovoice? If so, how were you affected?
5. Did participating in Photovoice change the way you see your community? If so, in what ways?

In addition, your team can monitor the extent and quality of media coverage of the project. If the project includes exhibitions of groups' photographs, the team can assess audience attendance and feedback.

Data Analysis

After you have gained comments about the community's strengths and weaknesses, you need to use a connecting strategy to transform the group's talk into group action. **Connecting strategies** operate quite differently from coding strategies. Instead of fracturing an initial text into discrete segments and sorting the segments into categories, connecting analysis attempts to understand relationships among the different aspects of the text (Maxwell, 2005). Researchers use connecting strategies for the construction of profiles and vignettes, some types of discourse analysis and narrative analysis, and some case studies.

Throughout the Photovoice study, the facilitator helps members of the group to make connections: by connecting the community's problems with the forces that oppress the community; by connecting the community's assets with a plan of action; and then by helping the group to connect its mental and physical resources with the resources of community leaders.

Data Displays

When researchers conduct a Photovoice project, they might display the results of their analysis as a list of projects in progress and a list of completed community projects. Researchers would also include several photographs with written explanations about how such images triggered important group discussions.

Credibility, Transferability, and Dependability

When researchers use the Photovoice method, they seldom worry whether their findings are credible to the people they study because Photovoice researchers collaborate with the people they study. Researchers may, however, use interviews to measure people's changes in attitudes and researchers may observe changes in participants' behavior.

Photovoice researchers can, however, make their work more credible to readers by following these steps. One, they can describe the community's strengths and weaknesses, as well as its history, in detail. Two, they can connect their work in a particular community with relevant theories about social, economic, and political forces acting upon similar communities. Three, they can identify any areas of uncertainty or disagreement that arose during the Photovoice project. For example, did everyone agree with the group's discussion of photographs? Did some people resist the facilitator's efforts at conscientization? Did community leaders refuse to "buy into" the group's

Making and exchanging projects:
- Fixing old bikes
- Lawn mowing for elderly people
- Sharing garden tools
- Furniture exchange
- Book binding

Environmental projects:
- Fixing gardens for elderly people
- Backyard seed banks for native plants
- Recycling demolition materials
- Garden produce exchange
- Revegetation projects

Cultural projects:
- Internet cafe for youth in small towns
- Music festivals
- Art and beautification projects
- Youth newspaper
- Street parties

Ideas for specific workshops:
- How to set up a community garden
- Cooperatives—how do they work
- How to set up a community toolshed
- Communication and networking workshop

Figure 5.3 Data display for a Photovoice study

Source: Cameron and Gibson (2005)

action plan? Were some community members dissatisfied with the results, and if so, why?

Photovoice researchers seldom worry about transferability. They focus on the special character of each community. In the course of their work, they may learn about problems that they had previously encountered in other communities, but they seldom try to apply what had worked before to a new situation.

Nor do Photovoice researchers worry about dependability because if problems vary from community to community, then their tools for addressing those problems cannot be used in a consistent manner. Instead, Photovoice researchers focus on flexibility and adaptability. They use whatever works rather than general measurement tools.

Critics of PAR worry that if researchers share control over the research process with inexperienced community members, then researchers compromise the integrity of their work. On the other hand, one could use ethical and pragmatic reasons in order to argue that all researchers should give participants a role in the research process.

Internet

Researchers using the Photovoice method have embraced the Internet as a way to let people know about their projects. For example, a charity in England called PhotoVoice uses the Web to inform readers about the fifteen projects it has conducted in twelve countries since 1999 (Photovoice.org). The site says

the charity has benefited 1,000 people, including street children, orphans, the homeless, HIV/AIDS affected individuals, and other special-need groups living in Afghanistan, Bangladesh, Cambodia, Sri Lanka, Vietnam, and the Democratic Republic of Congo. The site also sells prints and books from past projects.

A similar site explains how to conduct a Photovoice project and provides links to many projects conducted by Caroline Wang and her collaborators (Photovoice.com). Other organizations, such as the Nature Conservancy, Boston University's Center for Psychiatric Rehabilitation and dozens of others, use the Internet to promote Photovoice projects.

If groups create a website for their project, they can offer more people the opportunity to compare, contrast, and question their images. Web users could offer suggestions and, ideally, become involved in community projects.

Advantages and Disadvantages

Photovoice projects have several advantages over other types of research design.

1. You have the satisfaction of seeing how your work benefits people who need help rather than working with people who may not need assistance or people who may not benefit directly from the research.
2. You work with people from different socioeconomic, educational, and cultural characteristics rather than with college students or other people like yourself. Not only does collaborating with different types of people make the research more interesting, it makes the results more valid.
3. You work with groups rather than individuals. Working with groups breaks researchers' habits of measuring everything at the individual level.
4. Participants learn from the research process because they collaborate in the research process. Too often researchers must keep participants in the dark so that researchers can obtain unbiased measurements.
5. Participants benefit directly from the research rather than simply receiving token compensation as their part of the research bargain. Too often researchers put the needs of the research community over the immediate needs of the general public.
6. Participants can often see their photographs in public exhibitions rather than (or in addition to) reading the results of research in refereed journal articles. Too often the subjects of research never learn the results of the work in which they played a crucial role, although they should and so should their communities.

Photovoice projects have several disadvantages over other research designs.

1. You may receive less recognition from your peers than if you conducted experiments, surveys, or case studies. Critics believe Photovoice confuses social activism and community development with research. Supporters,

however, consider Photovoice a type of indigenous ethnographic research that goes from describing to understanding to action. Along the same lines, researchers conducting Photovoice and other PAR projects seldom have two articles in refereed journals each year. Success, however, can be defined by the way a community benefits from Photovoice and by one's satisfaction in helping.

2. Your group may feel less, rather than more, empowered if everyone spends six months or more on a Photovoice project without tangible results.

Ethical Issues

Photovoice researchers, like visual ethnographers, must be particularly concerned about harm to participants. Some community members may become upset and try to stop participants from taking pictures that reveal problems, such as poverty or violence. They may even hurt participants who want to show these problems to others outside the community (Lykes, 1997). To reduce the likelihood of this occurring, researchers should train participants in how to handle such situations. Because group discussions require sharing inner thoughts and feelings, people may feel vulnerable. To deal with such feelings, facilitators should carefully create a feeling of trust within the group and establish rules of confidentiality for the sessions. Because Photovoice projects lead to action by participants, actions others may dislike, participants may suffer from public criticism and isolation. Enlisting the aid of community leaders can help with this problem.

Photovoice researchers and visual ethnographers also share a concern about privacy that can only be resolved with informed consent by everyone involved in the project. For example, in the first session, investigators should thoroughly inform group members about the project and have them sign a contract. During the picture-taking stage, group members should explain the project to each person they photograph and then get these people to sign a photo release form. During the discussion stage, everything said should remain confidential. If someone discloses a serious problem, however, you have a responsibility to either help that person or get an outsider to help. Tell people, therefore, that you may feel obligated to make such information accessible to others, but that you would discuss this with them before taking any action (Morrow, 2001). At the end of the project, investigators should ask group members for permission to include excerpts and images in their research reports. If researchers plan to add excerpts or images to a website, they must talk about how worldwide distribution may impact people's lives.

In addition to harm and privacy, power imbalance remains an ethical issue in Photovoice projects because although you collaborate with a group, you seldom share power equally. To mitigate any power imbalance, you must constantly remain aware of your own power in the research process and do your best to balance your "voice" with participants' voices (Arafeh and McLaughlin, 2002).

You should discuss who owns research materials. Researchers generally return all the photographs to the participant-photographers, who may want to use the photographs for publicity, fundraising, or other purposes. They also give prints to the people who appear in the photographs.

Resources

Photovoice projects take a lot of time. Collaborating with a group of people with varying interests and little or no research skills can take a long time. Continuing a project until action takes place requires even more time. In order to complete the project and see tangible results, the research team should expect to invest several months. This requires that everyone be committed to the goals of the program and excited to participate in each step of its implementation. Some scholars have reported a high rate of attrition in their projects. They speculate that people drop out because they had wanted to learn photography more than they had wanted to improve their community.

Researchers need money for disposable cameras or inexpensive digital cameras, a facilitator, and even though their work will benefit the community, they may also pay people for participating in their project. Researchers will also need some seed money for starting community improvement projects, so they should make every effort to obtain funding from local policy-makers or outside funding organizations. Getting funded once, however, is not enough, because Photovoice projects may lack local sustainability without continued outside funding.

Advice

1. Be patient and allow groups to set the pace for their projects.
2. Hire a consultant from the community or invest time to get to know the community well and to establish trust.
3. Hire a facilitator who can lead discussions about empowerment.
4. Seek funding from organizations that wish to improve marginalized communities.
5. Obtain informed consent from everyone involved in the project.
6. Recruit a diverse and motivated group of participants.
7. Involve policy-makers at the beginning of the project.
8. Set small goals at first and celebrate every success—large or small.

Further Viewing

Photovoice projects
Social action research—cross dressers
http://video.google.com/videoplay?docid=7220369129674303587&q=action+research&ei=OiQbSNSDGY6IrQKog7m2Ag&hl=en

Photovoice project in Honduras
http://video.google.com/videoplay?docid=5710486622725665706&q=
photovoice&ei=rSEbSKakDIS4rgKY3sjGAg&hl=en

Paulo Freire
Paulo Freire biography
http://video.google.com/videoplay?docid=-6531064980346869775&q=
paulo+freire&ei=PiMbSMTMJZOqrgLnq4G_Ag&hl=en

Photovoice Project in a Refugee Camp in Uganda

Eric Green

As a doctoral candidate at the University of South Carolina, I approached Keith Kenney about serving as a member of my dissertation committee because of his background in photojournalism and his knowledge of Photovoice. I was planning to incorporate a Photovoice project into my dissertation fieldwork in Northern Uganda, and I knew Keith would be able to provide good advice.

Wary of psychologists who might be inclined to test or survey people to death, Keith used our first meeting to impress upon me the importance of participatory action research, community empowerment, and ethics. Unbeknownst to either of us, his field of participatory documentary photography and my field of community psychology overlapped to a surprising degree in a respect for community empowerment through participatory action research.

The setting for my fieldwork was Gulu District, Northern Uganda. In 2004, the United Nations labeled Northern Uganda the "biggest neglected humanitarian emergency in the world." More than twenty years of fighting between the Government of Uganda and the rebel group, the Lord's Resistance Army (LRA), have resulted in thousands of deaths, injuries, and abductions, in addition to the displacement (often forced by the government) of more than 90 percent of the northern population.

However, a defacto peace came about following a Cessation of Hostilities Agreement signed by delegates from the government and the LRA in August 2006. As a result of this agreement and improvements in the security situation, an estimated 230,000 of the more than 1.4 million internally displaced persons (IDPs) living in squalid camps returned home in 2006. Many more continued to resettle in 2007 as peace talks continued. As a community psychologist, I was interested in studying this transition. In developing the research proposal, the Photovoice method seemed to be a good complement to other methods of inquiry (e.g., household surveys and in-depth interviews) and a mechanism for involving members of the community in data collection, interpretation, and advocacy.

I began my work in Northern Uganda in February 2007. Arriving in the country with a relatively small research budget of a few thousand dollars from my department and two university fellowships, I traveled by bus to Gulu, the north's largest town and economic capital. I reviewed data on estimated movement trends from a local U.N. office and identified Opit, a camp for displaced persons, as a microcosm of the unfolding situation.

I visited Opit and confirmed that people were moving to decongestion camps initiated by the government, smaller camp-like settings initiated by community members, and pre-displacement villages (or "home-home" as one agency came to call it). Others were staying put. After a few weeks, and almost by chance,

I connected with AVSI, an Italian NGO with more than twenty-five years of experience working in Uganda (www.avsi.org). AVSI was planning to open a new field base in Opit, so I decided to move there and immerse myself in the local context.

The Photovoice project began with help from a visiting friend who, being a middle school teacher, was invited to teach classes at several schools in Opit. Over the course of a few weeks we cultivated relationships with three schools: one always located on camp-land and never displaced, one displaced to the camp but now returned to its village location, and one displaced to the camp where it remains today. The headteachers appreciated her work and liked the participatory nature of the proposed Photovoice project.

After a few weeks of instruction in English (an official language in Uganda that is incorporated into primary education), journaling, and basic photography, we randomly selected two boys and two girls from each school to invite to participate in a Photovoice project. We made the selection process as transparent as possible to avoid suspicion and hurt feelings. Each student was given a highly cherished notebook with a unique ID number and we selected the students using a random number generator.

Our official program began with an opening reception for students, teachers, and parents. Careful to avoid anything too elaborate, we printed paper invitations and asked local friends to prepare a small meal for our guests. We used this reception as an opportunity to inform participants what they should and, maybe more importantly, what they should not expect from this project; it was our informed consent process. In a setting where the majority of the population is illiterate, asking parents to sign a consent form would have been impractical and insensitive. The IRB at my university accepted this necessary modification to normal procedure.

While this reception provided a mechanism for establishing informed consent, an important aspect of research in its own right, it represented something else for the participants. It was an opportunity for the parents and teachers to formally express support and thanks, a typical component of events large and small in Acholi society. After finishing the meal and listening to my description of the project, various attendees, starting with one of the headteachers, offered unprepared remarks about why this project was important. As someone who eschews formality on most occasions, I was ultimately glad that I did not interrupt this process. Knowing your context is critically important. But we missed something, more on that in a moment.

As the project got under way, we found that many of the students struggled to express themselves creatively in journaling assignments. This observation, at least initially, was true for most students regardless of proficiency in spoken and written English. It signaled a challenge we would face throughout the project: How to connect with the students while asking them to think and communicate in ways they had not previously been asked to think and communicate.

Our efforts to address this challenge would have been futile without the help of Jimmy, a young former teacher from the community who was unemployed and eager to join the project. As a former teacher, Jimmy was able to liaise with school officials, guide the students through assignments, and help me interact with all involved.

Jimmy was primarily responsible for supervising the students on each photo outing. Each week we would develop open-ended assignments, such as "What is it like to be a member of your community?", and Jimmy would accompany each school's group on two outings. While allowing me to do other research activities, this arrangement also precluded any temptation on my part to nudge the students into telling any one particular story.

Prior to each outing, I would ensure that both of our cameras—point-and-shoot digital cameras (5MP and 10MP)—were charged and at full memory capacity. Because of security concerns, Jimmy would return the cameras at the end of each day. I downloaded the images to my computer, backed everything up on an external hard drive, and recharged the cameras for the next day.

At first, the images were very uniform. The students stood straight up and pointed the camera directly ahead of them, capturing whatever they could. To my surprise, however, there were very few images of other children. My experience as an outsider with a camera was that it was next to impossible to take any photos in the camp without twenty excited children and a few curious adults in the viewfinder. But it was different for the students. They were able to move around more easily and capture candid moments, as in Figure 5.4.

This might have been because of their smaller stature and the fact they were members of the community and attracted less interest. Jimmy, typically moving with the students, could have also been a deterrent of the behavior I experienced.

Because the students were able to capture candid moments, we had discussions early on about the power of photography and the need to know when not to take a photo. While there were no specific reasons to be concerned about their safety, we did take precautions to reduce the chance that the students would face any problems resulting from their participation. In addition to legal and ethical discussions, we also reacted to the students' initial images with lessons and encouragement to try something new. If they stood up to take one photo, we told them to sit down to take the next and to lie down to take the next. The results were amazing.

We discussed these results at the end of each week. On Thursdays or Fridays I would rejoin Jimmy and the students to review their images and facilitate a group discussion. The hour-long sessions typically started with a slideshow of the week's images in Google's Picasa, the software I used to organize the images on my laptop. Though I had images I wanted to know more about, I asked the students to identify photos to discuss. I found that this process became easier

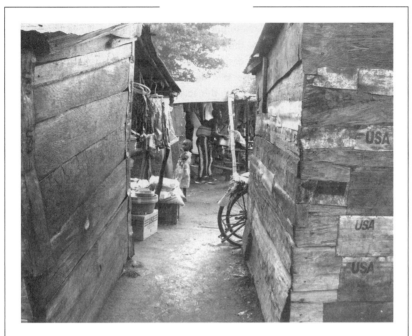

Figure 5.4 Peering into the market

Figure 5.5 Finding beauty in unexpected places

for all of us as time progressed, but we often struggled to move from the concrete and personal level to the abstract and general or emotional level. For example, in describing an image of the school library, students might have labeled the scene as a library and described the function of the library rather than discussing more abstract ideas like the scarcity of printed materials and the impact on their ability to learn.

However, some discussions provided great insight into the students' perception of their community. Figure 5.6 is a good example. Attempting to model how to talk about the images in a group, I commented that I liked this photo because it depicted a typical scene in Opit. I said the image was great because the cropping and the blurring of the men in the background gave a sense of anonymity while capturing the feeling of what it is like to walk down the main road.

The students agreed, but did not share my appreciation of the photo. From their perspective, the "typical" scene this image depicted was pervasive poverty. The men in the background—idle, jobless, poor. The man in the foreground—shoeless, a sign of poverty.

While I hope to continue working with these students over time as they transition into new stages of life and possibly new surroundings, I am turning my attention from data collection to data display and analysis. Not an expert in photography myself, I am finding myself venturing into new territory talking

Figure 5.6 A new perspective

with gallery owners and exhibitors. I am also working to prepare the images for display, a process that requires technical skills that I do not possess. The challenge now is linking up with the right people to raise awareness about this project.

I view this as a crucial part of our social change effort. For things to change, people need to know this story. One vehicle for raising awareness will be a website created for this project: www.displacedcommunities.org. It will ultimately include images and information about the photographers.

With this project we are seeking to impact several levels of life in Opit. At the individual level, we want to use these images to directly improve the lives of the participants. Among all of the transitions these children are experiencing, they are at the age where, with funding, they would normally transition from primary school (tuition free—with some general fees for all students) to secondary school (largely fee-based). Few students are in a financial position to make this transition. We are trying to change this by using their work to generate funds.

We are also seeking direct improvements for their schools. As I write this, I am preparing for a return trip to Opit. One way we will celebrate our success is to recognize each group's work with a permanent display of images for the schools. Donations to the project will also enable us to present each school with one XO Laptop created by the One Laptop Per Child project. These machines are equipped with a suite of creativity programs, including audio, photo, and video hardware, that will allow students and teachers to continue documenting life and expressing themselves creatively.

Finally, we are also seeking broader social change for the community and the region. Awareness is a good start, but it is not enough. Real change requires the participation of community stakeholders—the missing component I mentioned earlier. We should have recognized this and recruited local community leaders, district officials, and members of the humanitarian aid community to join the project from the beginning. While we can still engage these groups to address the issues the students highlighted, it is always easier to do so when all parties have a sense of commitment and participation.

6 Working for Two Universities 5,000 Miles Apart

Theoretical Perspective

At the New York World's Fair, which ran from 1964 to 1965, AT&T introduced the **Picturephone**, which is a phone that sends audio and video signals. AT&T predicted the video telephone would replace the voice telephone by the 1970s, but it was wrong. Its Picturephone service had 500 subscribers at its peak, and the service faded away by 1974 (Video Phones, 2000). One of the (many) problems was that people felt self-conscious "about being a TV character" (Jeffrey, 1998).

Fast forward to spring of 2008, when people use Skype. **Skype** is a software program that allows users to make calls over the Internet to other Skype users free of charge. It also includes instant messaging, file transfer, and videoconferencing.

Skype now offers DVD quality "picturephone" service over the Internet. Skype 3.8 provides users with a large image size (640×480 pixels) and a video rate of 30 fps (frames per second) rather than the 15 fps available previously. With the faster rate, you can move around quickly without seeing annoying artifacts or a "blur" effect on the video. These problems have occurred in the past when the camera or the software could not keep up with the motion. After you pay for a Webcam, computer, and a fast Internet connection, Skype is free. In 1964, however, Picturephone prices ranged from $16 to $27 for a three-minute call between special booths AT&T set up in New York, Washington, and Chicago (Video Phones, 2000). Adjusted for inflation, by 2008 the call would cost $107 to $181.

People can use Skype or another videoconferencing system at home or at work. They might use it at home to talk with, and see, family and friends who live elsewhere or who are traveling elsewhere. For example, half my family lives in Brazil and my wife and I only fly there once every two years. Telephone calls are relatively cheap if you keep it short, but who wants to quickly end a conversation full of family news? With Skype, we can talk for an hour and not worry about costs.

Businesses also use videoconferencing to bring people at different sites together for a conversation. They also use a number of systems, ranging from

desktop applications with Webcams, to mobile systems for connecting site to site, to dedicated videoconferencing rooms.

Even though time and air ticket costs for travel have increased, and videoconferencing costs have decreased, businesses have not embraced videoconferencing. A questionnaire completed by 4,532 Hewlett-Packard employees found 68 percent had not taken part in a videoconference in the last three years, and only 3 percent were frequent users (Hirsh, Sellen, and Brokopp, 2005). Employees indicated that the main benefits were the ability to: a) see people they had never met before; b) see facial expressions and gestures; and c) follow conversations with multiple participants more easily. The main problems were: a) the high overhead of setting up and planning videoconferencing meetings; b) a lack of a widespread base of users; c) perception that videoconference technology did not add value over existing communication tools; and d) quality and reliability issues. In theory, however, businesses should use videoconferencing in order to support the three Cs: connection, communication, and collaboration.

Collaboration requires a sense of presence over distance. Researchers have broken down presence into three categories: person space, task space, and shared reference space (Baecker et al., 2008). **Person space** is the video-mediated space that shows you my face and that gives indications of my mood, my personality, my trustworthiness, and other visually expressed attributes. This is the part of presence that is most often supported with videoconferencing. **Task space** is the video-shared space around the drawing, written document, whiteboard, or other artifacts we are meeting about. Few videoconferencing systems have a smooth integration of task space with person space. **Reference space** is the superimposition of one's physical presence on the shared task space. Video-mediated reference space is what enables you to gesture and point, and is what enables me to anticipate your next action because I can maintain a peripheral awareness of what you are doing. Shared reference space is very difficult to achieve.

In the education world, videoconferencing is having an impact on students as well as teachers. It enables students from diverse communities and backgrounds to share information and ideas with one another. Teachers in geographically isolated or economically disadvantaged locations can use this technology to pool resources and teach courses (such as foreign languages) which could not otherwise be offered. Faculty members can take advantage of videoconferencing in several ways. One, they can keep in touch with their classes while away for a week at a conference. Two, they can bring into a class a guest lecturer from another institution. Three, they can collaborate with colleagues at other institutions on a regular basis without loss of time because of travel. Four, they can participate in a thesis defense at another institution.

Or faculty members can chair thesis committees. Imagine you frequently see a particular professor, called Tom, because you visit his office for advice on your research. Now imagine that Tom takes another job at a university 5,000 miles away. Not a different job, but an additional job. Since Tom remains a faculty

member at your university, he can continue to teach, supervise research, and counsel students. He just moved his office—a great distance! Of course, you could e-mail Tom a draft of a chapter, and he could return it with comments, but the distance might hurt your ability to have an enjoyable, successful thesis experience. Would technologies that support visual information improve your communication with Tom and other members of your thesis committee? In other words, can seeing the other people and their environment help you to overcome the problem of distance?

Imagine if you wanted to conduct a research study that would answer such questions. To begin, I suggest that you study the research about non-verbal communication. **Non-verbal communication** is commonly described as exchanging messages using means other than spoken or written words. Non-verbal communication scholars, however, avoid a simplistic verbal–non-verbal classification. They prefer to think of communication as a continuum from non-verbal to verbal. They also believe that much communication includes both verbal and non-verbal signals (Knapp and Hall, 2006).

Non-verbal communication research showed the importance of facial expressions, gestures, and gaze in conversational situations (Knapp and Hall, 2006). Scholars assumed similar non-verbal cues would also be important for videoconferencing. Therefore, they designed video systems to present the head and shoulders of co-participants.

Before I explain why scholars were wrong when they assumed non-verbal cues would be important for videoconferencing, let me explain why they could have been right. Based upon non-verbal communication research, video showing others' faces and surroundings should improve connection, communication, and collaboration for six reasons.

One reason is that video allows us to see others' emotional reactions to messages. We get this information by studying others' facial expressions, eye gazes, head nods, gestures, and body positions. Of these non-verbal signals, people learn the most from facial expressions. They consider this visual information very valuable. In fact, if facial expression conflicts with verbal information, then people tend to trust the visual information (Short, Williams, and Christie, 1976).

Two, video improves communication because it allows us to see whether others are paying attention. We get this information by studying others' eye gazes, head nods, and body positions. For example, when people pay attention, they make eye contact with the speaker, nod their heads in agreement or disagreement, and they often lean forward.

Three, visual information improves communication because it allows us to know when it's our turn to talk. We get this information by studying others' eye gazes and gestures. For example, people might look at you for feedback or they may raise their hand in order to indicate they have something to say.

Four, video improves communication and connection because it allows us to see others' general appearance. We get this information by studying people's

skin color, hairstyle, facial features, height, weight, clothing, jewelry, or tattoos. From these appearance cues, people believe they can learn things such as others' background, character, personality, talents, and likely future behavior (Knapp and Hall, 2006). In fact, people can judge others' age, sex, and socio-economic status more accurately from clothing than from others' attitudes or beliefs (Knapp and Hall, 2006).

Five, visual information improves communication and collaboration because it helps us to establish common ground. Also known as mutual knowledge, **common ground** refers to knowledge that the people share in common and that they know they share. In order to find common ground, people coordinate the content and process of communication (Clark and Brennan, 1991). In a conversation, people coordinate the content of communication by knowing each other's personal histories, by remembering their previous conversations, and by studying non-verbal signals. People coordinate the process of communication by looking for verbal and visual signs of understanding. People also look for evidence that they have been misheard or misunderstood. If they detect signals of misunderstanding, people revise their assumptions about what common ground they share and they say something to repair the misunderstanding.

Participants in a conversation establish common ground on the fly from whatever verbal and visual cues they have at the moment. The fewer cues they have, the harder they work in constructing common ground, and the more likely misinterpretations will occur. These misinterpretations in turn require more work to repair, and if people believe repair work requires too much effort, they talk with someone else. On the other hand, with a video channel, people can establish common ground better, which makes communication easier, which makes their cooperative work more productive (Olson and Olson, 2000).

Six, video improves communication and collaboration because it allows us to see the other person's surroundings. Previously, we have been looking at people's faces. Now we look at the task space, including books, drawings, and furniture in the person's environment.

In summary, past researchers believed that by adding video, we could make the communication experience richer, more realistic, and more like face-to-face (FtF) encounters; therefore, connection, communication, and collaboration would improve. Researchers over the past decade or so, however, have shown that this hypothesis is too simplistic.

The addition of a video channel only seems to benefit two types of tasks. One type of task involves elements of emotion (such as conflict, bargaining, or negotiation), but, even in such cases, the evidence is not strong (Short, Williams, and Christie, 1976). Two, video has been shown to help support people's understanding of the broad membership of a group in a meeting, and the general attentiveness and activities of people in a distributed group (Sellen and Harper, 1997). However, in such cases, high-quality video is largely unnecessary (Hirsh, Sellen, and Brokopp, 2005).

Two theories explain why video may not improve communication: social information processing theory and hyperpersonal interaction theory, both written by Joseph Walther.

In the **Social Information Processing theory** (**SIP**), Walther (1992) suggests the absence of non-verbal cues does not harm social interactions. Instead, people adapt to computer-mediated communication (CMC) by either a) writing about their characteristics, attitudes, and emotions; or b) interpreting such information from contextual and stylistic cues. For example, people can use emoticons to convey simple emotions. From their writing and other cues, people make assumptions about each other and then they test those assumptions. Over time, people refine their knowledge of each other and build healthy social relationships (Walther, 1996).

Walther's **Hyperpersonal Interaction theory** (1996) goes even further. It suggests computer-mediated communication can foster better interpersonal relationships than traditional FtF communication. Since people cannot see non-verbal cues, they can create more idealized self-presentations. In addition, they tend to assume the other person has similar admirable qualities. As a result, intimacy increases. Research has shown that these results remain true even for groups with geographically dispersed and culturally diverse partners who had never met FtF.

Goals

With this chapter's theoretical perspective, you could choose to believe that video improves communication between people in different locations, or you could believe that video does not improve communication. To clarify the issue, you could conduct a basic research study. Your goal could be to learn whether video can overcome the problem of distance with Tom, the chair of your virtual thesis committee.

A **virtual thesis committee** is a committee that helps graduate students compete in the academic marketplace by using communications technology to link a student with faculty members who have special skills but who live in different parts of the world. A virtual thesis committee resembles a **virtual team**, defined as a temporary, geographically dispersed group of people with a common interest, who communicate and coordinate their work through communication technology (Ahuja and Carley, 1998). Many businesses now include virtual teams in order to a) link employees with special skills who live in different parts of the world; b) increase productivity and lower costs by reducing travel; and c) compete in a marketplace that requires inter-organizational cooperation.

Two other types of research would also apply to the study of a virtual thesis committee: applied, and evaluation. You could conduct an applied research study in order to help virtual thesis/team leaders to effectively introduce new communication technologies. On the other hand, you could conduct evaluation research in order to gauge the effectiveness of using video-mediated

communication for a virtual thesis committee. **Evaluation research** assesses the processes and outcomes of a specific solution to a problem or a planned change.

Evaluation researchers conduct two types of studies: summative and formative (Patton, 1990). **Summative evaluations** render an overall judgment about the effectiveness of a program, policy, or product in order to judge the effectiveness of the idea itself. For example, your conclusion might be that thesis committees in communication programs can include distant members if they follow certain procedures when using communication and collaboration tools. On the other hand, **formative evaluations** only focus on a specific context and they do not generalize beyond a particular setting. For example, you might conclude thesis committees in the communication program at University A can use communication technology to collaborate with a professor working at University B.

Research Questions

If scholars believe visual information can improve technology-mediated communication, then they might pursue these additional questions:

1. How does video affect the ability to build trust among people with cultural, gender, and age differences? How does video affect the ability to build cohesion? Does it matter if the group has a common history? Does it matter if the group thinks it will work together again in the future?
2. How does video affect communication among members of big teams and small teams? How does video affect performance of various tasks by big and small teams?
3. How can visual information from video be used to accomplish different tasks? Which tasks require the use of video more than other tasks?
4. How does the use of video affect the time required to make decisions? How does video affect the quality of a team's decisions?
5. How does the addition of video affect the overall amount, speed, and quality of communication within a virtual team?
6. Does the virtual team shape the use of video, or does the technology itself seem to shape the dynamics of the virtual team?
7. How do people use visual information to converse? Do people prefer to see other people's facial expressions and gestures, or do they prefer to see the overall space and its objects?
8. Do people use visual information to help decide when it's their turn to speak?
9. How does a phone call compare with a video glance in terms of initiating conversations with a remotely located person? How does a phone call compare with a continuous open video link to another person's office?
10. How does visual information among virtual team members affect outputs such as performance and satisfaction?

Brief Description

The ideal method for studying virtual thesis committees would be case studies. **Case study research** investigates an individual, event, social activity, group, or organization in its natural setting with multiple methods of data collection. Researchers use interviews, observations, diaries, archival documents, and questionnaires in order to gather information about the case. Researchers generally use case studies when they want to study how the introduction of a new technology will affect a group of people or an organization (Yin, 2003). Researchers also use case studies to generate theory when scrutiny of a topic has just begun.

With a case study, you also collect comprehensive information about the case's context. The **context of the case** may be broadly conceptualized, such as large historical, social, and political issues; or it may be narrowly conceptualized, such as the physical location and time period in which the study occurred. When studying a virtual thesis committee, for example, context considerations might include: a) the number of college faculty members who serve on thesis committees; b) their prior usage of collaborative software and technology; c) their general attitudes toward innovation; and d) whether the college has a collective or individual culture.

After analyzing the data, you write a report in the form of a story. Using lots of quotations, you tell how the virtual team communicated and collaborated. If you choose your sources well, collect sufficient raw data, and make sound assertions, then you can provide readers with a vicarious experience of working with a virtual thesis committee.

Units of Analysis

Since the goal is to gauge the effectiveness of using video-mediated communication for a virtual thesis committee, and since you are conducting a case study, your unit of analysis would be a virtual thesis committee. In other chapters, the "case" is a community (Ch. 5), an organization (Ch. 7), and a focus group (Ch. 8).

In order to clearly define the case of case study research, try answering these four questions: who, what, where, and when. For a virtual thesis committee, the "who" might consist of a student and four faculty members, one of whom chairs the committee. You may, however, wish to include additional people in the case. For example, you might include the department's staff person, who controls the paper trail for theses, and you might include the graduate director, who settles any disputes that arise during the thesis project. The "what" might consist of all the written, oral, and visual messages exchanged among members within the case. The "where" might include the chair's office, where most of the student–faculty interaction occurs, and the remote faculty member's office, where virtual meetings will occur. The "when," or time boundaries, might begin before the proposal has been written, when everyone feels uncomfortable

with the technology, and end after the thesis has been successfully defended, or later still, when the college discusses the feasibility of using additional virtual thesis committees.

Sampling

After defining the case and its boundaries, you next decide whether to study a single case or multiple cases. You could study a single virtual thesis committee if it met at least one of these three conditions: a) it promises to be revelatory (never observed before); b) it is unique in some way; or c) it qualifies as a typical case (Yin, 2003). On the other hand, you should study multiple virtual thesis committees if you want to apply **replication logic**, which is defined as recreating a study's significant finding by conducting additional studies. You either duplicate the original conditions, or you alter one or two conditions considered irrelevant to the original finding in order to see whether the same finding occurs. Replications establish the robustness and generalizability of the original finding.

If you want to conduct multiple case studies in order to build theory, you would not determine the number of cases in advance of collecting data. Instead, you would conduct the first case and, based on its results, you would then change the hypothesis slightly and predict different results. A hypothesis generally includes two variables: an **independent variable** and a **dependent variable**. The independent variable is assumed to cause the dependent variable. If, after changing the independent variable, you got different results, then you would conduct a third case. You would again change the independent variable and predict different results. If your prediction came true, you would need to continue adding cases until you could no longer think of variables that might affect the results of the virtual thesis committee. In other words, you achieved **theoretical saturation**, defined as seeing the same thing over and over again, with no new properties, dimensions, or relationships emerging during analysis. In practice, however, time and money may dictate when data collection ends. As a general rule of thumb, try to conduct at least four cases if you want to generate theory (Eisenhardt, 1989).

Case study researchers use multiple cases for three types of studies: pre-post studies, patchwork studies, and comparative studies (Jensen and Rodgers, 2001). For **pre-post studies** you investigate something, such as a communication technology, before and after it becomes part of the case. For **patchwork studies**, you perform a within-case synthesis of the results of several studies of one particular thing, such as a virtual thesis committee. For **comparative studies**, you integrate the results of several studies about different things (virtual thesis committees), all of which share some important characteristic. For example, you could investigate all virtual thesis committees chaired by a particular professor in order to make generalizations about that professor's process of supervising graduate work.

After deciding on a single case or multiple cases, you need to establish a rationale for your purposeful sampling strategy. If you study a single case, then ask knowledgeable people about potential cases. If you study multiple cases, then collect limited documentation about each candidate, but do not invest much time and effort. Make your final decision based on a predefined set of operational criteria for determining the most qualified cases.

Whether you select one or more cases, do not consider a case in which you have a vested interest. It may seem advantageous to have easy access and intimate knowledge of a case, but the negatives outweigh the positives. One problem occurs if your expectations cause you to be biased in your collection or analysis of data. Another problem occurs if individuals withhold information, slant information toward what they want you to hear, or provide you with politically risky knowledge that you feel compelled to report to others.

Methods

This section explains: a) why case study researchers commonly use multiple investigators; b) how to train those investigators; c) what a protocol might look like; d) how to conduct a pilot study; e) considerations when collecting documentary data; and f) the value of triangulation.

This section does not explain how to gain access to a social group, how to fit into the group, how to minimize reactivity, and how to maximize reflectivity, because these topics will be covered in the method section of Chapter 7. This section also does not explain which skills you need to conduct interviews, how to prepare good questions, and how to conduct an interview, because these topics were covered in Chapter 2.

Multiple Investigators

Case study researchers commonly use multiple investigators for three reasons (Eisenhardt, 1989). First, multiple investigators often have complementary insights that add to the richness of the data. Their different perspectives also increase the likelihood of capitalizing on any novel insights that may be in the data. Second, using multiple investigators can enhance readers' confidence in the findings if their data and insights agree. Third, multiple investigators can more easily collect data from multiple sites. A virtual thesis committee investigator would find it challenging to travel back-and-forth amongst committee members who live 5,000 miles apart.

Researchers have two strategies for using multiple investigators (Eisenhardt, 1989). One, they may ask the entire team to visit the same site to intensively collect data. This way the team conducts its work quickly, and researchers obtain different perspectives on the site. A variation on this tactic gives individuals on the team unique roles. This also increases the chances that investigators will view case evidence in divergent ways. In the second strategy, researchers create multiple research teams and then assign each team to cover

some case sites but not others. Later, a sole investigator visits another team's site. This investigator has neither met the informants nor become immersed in case details, so he or she can bring a different and possibly more objective eye to the evidence.

Training Investigators

If researchers use multiple investigators, then each one must be able to independently follow all the procedures for collecting data. Perhaps more importantly, each investigator must also be willing to adapt these standard procedures *when* unanticipated events inevitably occur.

To enable each investigator to work independently, researchers conduct a training seminar. Typically, during a week of readings and discussions, investigators will learn all phases of the case study investigation, the theoretical issues that led to the case study design, and case study methods (Yin, 2003). Trainers want all investigators to understand the basic concepts, terminology, and issues relevant to the study. According to Robert Yin, president of an applied research and social science firm that has completed hundreds of case studies, each investigator should know (Yin, 2003):

1. Why the study is being done.
2. What evidence is being sought.
3. What variations can be anticipated and what should be done if such variations occur.
4. What would constitute supportive or contrary evidence for every research question.

In addition to teaching investigators, researchers also conduct a training seminar in order to uncover problems that might arise during the real-life studies (Yin, 2003). For example, some investigators may not share the ideology of the project's sponsors or they may be incompatible with other team members. Finally, the training might disclose unrealistic time deadlines or unrealistic expectations regarding available resources.

Protocol

A **protocol** is defined as a standardized agenda for the researcher's line of inquiry. It contains the instruments for logging information as well as the procedures for using these instruments. An interview protocol, for example, helps researchers organize their thoughts by including topics that need to be covered during the interview, information about starting and ending the interview, and a reminder to thank the participant. An observation protocol may include one column for descriptive notes and another for reflective notes. Yin (2003) recommends that a case study protocol include at least the following sections:

1. An overview, which covers background information about the project, the substantive issues being investigated, and the relevant readings about the issues.
2. Field procedures, which consist of presentation of credentials, access to the sites, and general sources of information.
3. Data collection procedures, which involve the names of sites to be visited as well as the sites' contact persons. This section also tells investigators how to prepare for a site visit.
4. Questions to keep in mind when collecting data as well as potential sources of information for answering each question.

Conducting a Pilot Study

When selecting the pilot case, researchers primarily consider convenience, access, and geographic proximity. A suitable pilot site would allow for a less structured and more prolonged relationship to develop between the participants and the investigators than might occur in the real sites. Investigators could try different observation techniques and various lines of questioning at the pilot site. Based on these results, researchers may then adjust the research design. The pilot study can be so important that researchers will devote more resources to this phase of the research than to the actual cases (Yin, 2003).

Considerations When Collecting Documentary Data

Researchers who use case studies to learn about virtual teams would probably use some of the following methods for collecting data. One, they may interview members at the beginning and ending of the study as well as at critical times in between in order to identify changes at those times. Two, they may observe a virtual team in order to understand how the team's social and cultural structure evolved during its adaptation to the communication technology. Three, they may ask members to complete a short questionnaire every week in order to learn the percentage of time they had collaborated with each other and how they rated their ability to accomplish their objectives. Four, they may conduct a content analysis of the e-mail exchanges among members in order to learn who used e-mail, for what purpose, how often, and with what consequences. Five, they may inspect documents from the organization in order to learn about its policies. Six, they may ask participants to write a paper analyzing one or two critical incidents during their time on a virtual team. Rather than repeating information about interviews, ethnographies, and content analyses, this section briefly explains how researchers collect data from documents, archival records, and physical artifacts.

Paper documents remain critical to the functioning of individuals, groups, and organizations even though we live in a world of electronic messages. Researchers want to study announcements, administrative proposals, progress reports, and stories disseminated by the media because they reveal a group's

events and processes. Documents indicate: a) what an organization produces (inventory list); b) how it certifies actions (policy statements); c) how it categorizes events or people (membership lists); d) how it codifies procedures or policies (manuals); e) in what ways it informs members (newsletters and stockholder reports); f) how it explains past or future actions (memos); and g) how it tracks its own activities (minutes of meetings) (Lindlof and Taylor, 2002).

Researchers also want access to personal documents, such as letters, diaries, notes, and scrapbooks, in order to gain insights in people's personal beliefs, identities, relationships, and communicative styles (Lindlof and Taylor, 2002).

Documents may have limited significance by themselves, but they become valuable when researchers relate documents to other evidence. For example, researchers can use documents to support their interviews and observations. In addition, they can use documents to reconstruct past events or ongoing processes that they cannot observe directly.

A similar source of evidence—archival records—includes organizational maps, lists of names, survey results, calendars, and telephone listings. In addition to seeking the group's records, allot time for using local libraries and visual archives, which can give a historical perspective on a contemporary issue.

Physical or cultural artifacts provide a third source of evidence. An organization's technological devices, uniforms, badges, objects of play, and furnishings can have important symbolic meanings for members of an organization as well as visitors. In addition, photographs, videos, films, paintings, and décor can reveal people's perspectives. You may also want to visit exhibitions of photographs in nearby schools, clubs, bars, and town halls. When informants accompany you on a photo tour, they may tell stories about the local areas and residents depicted in the pictures.

As you study these and other types of documents, remember that someone created every document for a specific purpose and a specific audience. Photographs, for example, serve the interests of the photographers who made the photos, the patrons who commissioned the work, the entrepreneurs who published the product and the audiences who consumed the finished work (Schwartz, 1996). With photographs and other documents, you should ask this series of questions: Why is this document here? Who produced it? What was its intended use? What is not here for examination? Answers to these questions must be fully considered when interpreting the usefulness and accuracy of visual or written records.

In addition to worrying about documents' original purposes and audiences, researchers should remember that documents are often either incomplete or inaccurate. For example, documents may selectively reveal only the positive sides of a program or organization.

Archives present special challenges because someone has removed visual and written documents from their original contexts and then classified them in a new manner. The archive's classification system essentially throws away the

meaning an image had to its makers and users; it then replaces this original meaning with a new one, which then becomes permanent (Sekula, 1986). As a result, researchers can no longer perceive what the archive has transformed and erased (Schwartz, 1996).

Value of Triangulation

Case study researchers often use triangulation, which means they deliberately seek evidence from different sources, methods, and investigators. They then compare these results in order to obtain a more complete and contextual understanding of the program, group, or organization being studied.

To compare data sources, researchers may: a) compare what people say in public with what they say in private; b) check for the consistency of what people say about the same thing over time; c) compare the perspectives of people with different roles—staff, administrators, clients, fund raisers, and people outside the program or organization (Patton, 1990). Similarly, field observations can be compared if they occur in the same setting and in similar time frames.

Researchers also compare findings obtained from qualitative methods, such as ethnography, interviewing, and the analysis of documents and artifacts, with evidence from quantitative methods, such as surveys. Researchers using triangulation assume that the weaknesses in each single method will be compensated by the counter-balancing strengths of another (Jick, 1979). They also assume that multiple and independent measures do not share the same weaknesses or potential for bias. Triangulation, therefore, exploits the assets and neutralizes the liabilities of any one method.

Researchers also compare the results from multiple investigators in order to overcome the biases or shortcomings of a lone investigator. They may deploy several interviewers or observers in the same field setting in order to take advantage of their distinct, but overlapping, competencies (Lindlof and Taylor, 2002). For similar reasons, researchers may use multiple analysts after the data has been collected.

Researchers using different sources, methods, and investigators should not expect their findings to automatically come together to produce a single, totally consistent picture of the program or organization. Indeed, if results from past research hold true, then researchers ought to expect initial conflicts in findings, especially from qualitative and quantitative data (Patton, 1990). Researchers can then employ one of two strategies. One, they can then give somewhat more credibility to data collected from what they believe were the more reliable and valid sources or methods. Two, they can weigh all of the evidence equally.

Data Analysis

Once the raw data have been accumulated from fieldwork, interview transcripts, diaries, and documents, you may feel overwhelmed. To overcome this feeling, you should pull together this rich information and organize it into

a database. To build a database, write a literal summary of the raw e-mails, sort out redundancies, fit parts together that belong together, and organize all of the information either chronologically and/or topically (Patton, 1990). In principle, other investigators could review this database of evidence and create their own, independent analyses.

For the second step in the analysis process you can conduct a case analysis meeting (Miles and Huberman, 1994). At a **case analysis meeting**, the person with the most knowledge of the case meets with one or two others to summarize the case's current status. A series of questions guides the meeting, and someone takes notes on the answers. Sample questions include:

- What are the main themes in the case?
- What is puzzling or unexpected about recent case events?
- How do you explain what is going on?
- What are some alternative explanations?
- What are the next steps for data collection?
- What additional analyses do we need of existing data to understand the case better?

As the case's main investigator answers these questions, colleagues adopt a tone of friendly skepticism in order to ask for clarification and concrete illustrations.

After the meeting, someone writes a summary of the case in the form of a chronological or thematic narrative. This narrative allows anyone to review the entire case quickly and to track the overall flow of events. Ideally, you would connect the narrative's summary points to the database's full texts.

Analysis of a Single Case

If you used a single case to test a hypothesis, then you can use an analytic technique called **pattern matching**. With this technique, you act like a detective, but instead of assembling clues to solve a crime, you study variables in order to create a hypothesis that explains the case. Then you check whether your detective hypothesis matches the original hypothesis, which came before you started collecting data. If so, then the patterns match and you have confidence in the validity of your results (Yin, 1981).

The first step in pattern matching is to identify variables that you might be able to use to create a hypothesis that will solve the "case." Variables may come from your research questions, previous research studies, your overall impressions, a review of the case's events, or the analysis papers that you (hopefully) had asked members to write about their time on the virtual thesis committee.

If you have trouble identifying useful variables, then try to understand the case from multiple perspectives. You might first try to understand team members' perspectives by studying their analysis papers. When studying these

analysis papers, look for critical incidents that occurred during the case. Then try to understand how each incident developed by studying the e-mail and chat records of team members. The e-mail and chat records provide a second perspective on the virtual thesis committee. You can get a third perspective on the data—your own perspective—by writing a memo about your original observations and your subsequent interpretations of those observations.

After defining the variables, review the case in order to collect evidence for refining each variable and for creating operational measures of each variable. You accomplish these goals by constantly comparing the data with a variable until everything converges on a single, well-defined variable.

With these refined variables, you create one or more hypotheses that seem to explain the dynamics of the case and its outcomes. You then need to review the case a second time. On this review, refine your one or more hypotheses by systematically comparing it with the case's evidence.

If you have one hypothesis, you compare this hypothesis with the original hypothesis, which you created before collecting and analyzing the data. If you have multiple hypotheses, you need to decide which one best explains the case. You can make this decision by constantly comparing your hypotheses with the data and then judging the strength and consistency of each hypothesis (Eisenhardt, 1989). In addition, check if your new, data-driven hypothesis matches results from previous research studies. Linking your study with the literature helps build theory because it ties together similarities in phenomena that had not been associated with each other. The resulting theory has stronger internal validity and wider generalizability.

A famous example of a case study with multiple hypotheses is Graham Allison and Philip Zelikow's study of the 1962 Cuban missile crisis (Allison and Zelikow, 1999). As the founding case study of the John F. Kennedy School of Government at Harvard University, the book revolutionized the field of international relations. In the book, Allison creates three competing but complementary theories about how the United States and Soviet Union had acted in the crisis. The governments acted as a) rationale actors; they set goals, evaluated their utility, and picked the one with the highest payoff; b) complex bureaucracies; or c) politically motivated groups of persons. Allison then compares the ability of each theory to explain some of the crisis' important events, such as a) the Soviet Union originally placed offensive, not defensive, missiles in Cuba; b) the United States responded with a blockage, not an air strike or invasion; and c) the Soviet Union eventually withdrew the missiles. The prevailing rational expectations theory did not match the events as well as the other two theories.

Analysis of Multiple Cases

If you used multiple cases instead of a single case, begin the process of analysis by studying each case independently of the others. By gaining a rich familiarity

with the variables and patterns of each case, your cross-case comparison will proceed quicker and smoother.

To make a cross-case comparison, you must get beyond your initial impressions of the cases' similarities and differences. To do this, Eisenhardt (1989) suggests several tactics. One, you can select variables and then look for within-case and cross-case differences. For example, the success of one virtual thesis committee might have been based on the frequent use of visual information to establish common ground. If so, then compare that committee's use of visual information with how often other committees used visual information. Two, you can select pairs of cases and then list the similarities and differences between each pair. As a result of these forced comparisons, you may discover new variables that can help explain the cases. Three, you can divide the data by sources. For example, compare the interview results in all the cases; then compare the observation results, e-mail results, and document results. This tactic exploits the unique insights possible from different types of data collection. When evidence from two data collection methods agrees, then the findings are strengthened. When the evidence conflicts, you can reconcile the evidence through deeper probing of the differences, or you may have exposed a spurious pattern or biased analysis.

After you have used these tactics to create a hypothesis, you need to test the hypothesis for the multiple cases. When testing the hypothesis, do not use an aggregate of all cases (Eisenhardt, 1989). Instead, match the hypothesis with the evidence for each case. Cases that confirm hypotheses enhance confidence in the validity of the relationship between variables. Cases that disconfirm the hypotheses provide an opportunity to refine and extend the theory.

Data Displays

Once you have analyzed a case, you could create a **case dynamics matrix**, which is a display of the forces that cause changes as well as the resulting outcomes. It displays problems and their resolutions in a way that will help readers understand why specific things happened the way they did (Miles and Huberman, 1994). For example, you might want to understand how adding video improves connection, communication, and collaboration on a virtual thesis committee.

Credibility, Transferability, and Dependability

In order to build credibility, case study researchers often triangulate their sources of information and methods for collecting data. They also use multiple investigators and analysts.

Case researchers can try to generalize the results of a particular case to other similar cases by creating a thick description of the case and its context. For a study of a virtual thesis committee, they should tell a story about how committee members operated in the beginning, what obstacles they encountered,

and how they overcame these problems. To help readers understand the contexts, researchers should describe the type, size, and goals of the graduate program. They should describe the particular technologies they used and people's familiarities with those technologies. They should also describe the thesis topic and methodology as well as the amount of interaction between the student and the faculty members. Overall, case researchers' story should include enough detail and effective quotations that readers could have a vicarious experience of the virtual committee.

Even better than generalizing to other cases, however, case study researchers should generalize a case's findings to theory. When researchers conduct experiments, they never select a "representative" experiment. Instead, if the experiment's findings support their hypothesis, they assume the hypothesis will explain similar phenomena too.

In order to ensure dependability, case study researchers should keep their database of case study evidence separate from their interpretation. Readers will trust a researcher's integrity and fairness if they can not only read a convincing narrative of the case, but also believe someone could access the complete database and perhaps tell a different story. In addition, researchers should present extensive sequences from the original conversations, observations, and/or documents, followed by detailed commentary, so that readers can judge for themselves whether the research made sound assertions, neither over- nor under-interpreting (Berg, 2007). Case researcher can also ensure dependability by including their protocols in their reports so that other researchers could repeat their work, if they desired.

Internet

Researchers have begun to use the case study method to study communication on the Internet. For example, at the start of the U.S.-led invasion of Iraq, three researchers (Nah, Veenstra, and Shah, 2006) investigated news consumption and political discussion among visitors to anti-war weblogs, discussion boards, and listservs. The researchers got 307 political dissenters to complete their Web-based survey. From the results, they learned that dissenters' use of Internet news contributed to both face-to-face and online discussion about the situation in Iraq. Those discussions then led to political participation.

Another case study focused on **YouTube**, a very popular website, which hosts many short videos. In January 2008, 79 million people used YouTube for 3 billion viewings (Yen, 2008). In April 2008, people could choose to watch any of its 84 million videos (YouTube). To study YouTube, Cheng, Dale, and Liu (2007) collected a database of 2.7 million videos in early 2007. In studying many characteristics of YouTube videos, they found the three most popular categories were Music (23 percent), Entertainment (18 percent), and Comedy (12 percent). The most common lengths of videos were 1 minute (20 percent) and 3–4 minutes (16 percent).

Advantages and Disadvantages

Researchers using a case-oriented approach consider the case as a whole entity. They look at associations, causes, and effects within one case. Only after understanding the individual case do researchers conduct a comparative analysis of a limited number of cases. Because researchers focus on the case, rather than variables, they can discover specific, concrete patterns (Miles and Huberman, 1994). With these patterns, researchers build theory.

Multiple case studies bring additional advantages. With multiple cases, researchers have greater confidence in their findings. In addition, they can use replication logic to build theory, extend theory, or to test competing theories.

The primary disadvantage of case studies is that their findings cannot be generalized to other cases, but only to theory.

Ethical Issues

Like other types of researchers, case study researchers worry about investigator bias. They worry their work may substantiate a preconceived position because they already understand the issues of the case before collecting data. To test for the presence of this bias, they can consider their degree of openness to contrary findings.

Resources

Since case study researchers try to understand a case and its context in great depth, they generally use multiple sources of information and multiple methods for collecting data. They may also use multiple investigators to collect data from multiple sites. As a result, case studies require more time and money than many research designs.

For a case study about a virtual thesis committee, in which members work in a media space with continuous video and audio connections, equipment resource demands would be high. In addition, the opportunities for unwanted interruptions of normal work would go up dramatically.

Advice

1. Use case studies for basic, applied, and evaluation research. Conduct case studies in order to understand how and why new technologies affect groups or organizations (Benbasat, Goldstein, and Mead, 1987).
2. Define the case as early as you can during a study. Think of the focus, or heart, of your case and build outward. To firm up the boundary, think of what you will not be studying.
3. Describe how you selected which cases to study. If a single case study, you should select a typical, unique, or revelatory case. Do not select cases because of easy access and availability.

4. When you have the choice and the resources, use multiple cases rather than single cases, even if you can only do a two-case study. Consider multiple cases as analogous to an experimental design with multiple replications. Both use literal and theoretical replications.

5. Use multiple methods, including interviews, observations, questionnaires, and documentary analysis. By triangulating the evidence, you strengthen the grounding of theory.

6. Provide details about the procedures for collecting data. This improves the study's dependability.

7. Collect data at several points in time. This provides a better understanding of how one incident or process may affect subsequent events.

8. Conduct in-case analyses before attempting a cross-case analysis.

9. Provide detailed descriptions of the case and its context. Include original data, quotations, and examples of how you analyzed the data.

10. Compare the results with the research literature. If the results agree, you can build credibility. If they disagree, you can better understand the transferability of your results.

Further Viewing

Skype video
Using Skype in the classroom
http://video.google.com/videoplay?docid=-8492817690922123697&q
=skype+video&ei=LSsbSK3qGYjkrQLwnLy_Ag&hl=en

Videoconferencing
http://video.google.com/videoplay?docid=-703507857064101546&q=
desktop+video+conferencing&ei=oiwbSLqxGYu2qQL_9bjLAg&hl=en

Using the Case Record and New Media to Study Schools

Rob Walker

There is no doubt that case studies can provide accounts that engage the reader. What makes them compelling is that, like good travelers' tales, case studies traverse an edge between what is familiar and what is beyond our immediate experience, providing a bridge between what we know and what we might risk doing next. (And, perhaps, what we will make sure to avoid.) Classic examples include Vivien Paley's book, *Wally's Stories* (Paley, 1981), which takes us into the thinking of a young child and Sherry Turkle's, *Life on the Screen* (Turkle, 1995), which investigates the relationships we have with computers.

Among the criticisms commonly made about case studies by researchers and academics is that these studies are unreliable as evidence and weak as a basis for generalization. Unlike measurement studies, they are too subjective we are told. As we are carried along by the narrative of the case, this directs us to ask:

- Can we trust the evidence we are given?
- If we repeated a study done by someone else, would we see the case differently?
- If we took this case as a model for a similar situation, would we find the same phenomena being enacted in the same way?

The answer to each question is probably not, probably so, and probably not. The critics have a strong argument.

But there are also many good reasons for pushing past the arguments and engaging with the method, for case studies can give us insights, empathy, and understanding of a kind we cannot easily reach by other methods. These research tools take us close up to what seems real, grapple with complexity, allow us to recognize elements of cases that may be very distant from our own experience but which take us some way to understanding them. Case studies are especially good at conveying the meanings the case has for those who are part of it.

So the response to the critics is to agree that case methods are flawed (as, in truth, are all research methods) but to ask instead what can be done to strengthen their claims to accuracy, authenticity, and understanding.

In the late 1970s, the curriculum innovator, Lawrence Stenhouse (1978), wrote a series of papers in which he suggested solutions to some of these problems of method. He did so, in part, because he was interested in encouraging teachers to research their own classrooms and he wanted such research to be taken seriously by the academic community as having some claim to truth. Too often, he thought, the writer had made selections, both consciously and

unconsciously, that undermined any claims the thesis might have as an accurate, fair, and truthful record and his proposal was that we should think in terms of three levels:

- Case data
- Case records
- Case studies.

You can think of case data as consisting of any kinds of empirical evidence you might collect as relevant to a case—documents, interviews, video, photos, samples of "found" material—letters, drawings, maps and plans, census data and other statistics, newspaper and magazine cuttings, and more. As research progresses this material may become refined, categorized and classified, organized around emerging themes or just dropped in files and boxes more or less at random. Taking historical research as a model, Stenhouse saw this as similar to making collections and slowly organizing them into an archive.

The case record is similar to an archive in that it is edited, organized, and (usually) thematic and periodic. It is a bit like the first rough-cut of a film, or the notes that will eventually form a novel. There is minimal interpretation by the author in the case record, and maximum coverage of relevant issues. The case record does not tell just one story, it should support divergent interpretations and different points of view: it should be unresolved.

To take the next step, the case study is a story that can be told disciplined by the evidence of the case record. It is not fanciful or fictional since the interpretations that are made can be checked (and perhaps challenged) against their sources in the case record.

A case record should provide a basis for sustaining several case studies, perhaps picking up different themes, drawing on different disciplines, or seeing the case from different perspectives. For example, in a primary school study, we asked several people each to conduct "guided tours" through the archive exploring particular ideas that were of interest to them (Walker and Smith, 1998). We had one tour about the idea of "the open classroom," one from the perspective of a feminist researcher, and another from a second language acquisition expert who worked in the area of multiculturalism. In a teaching context, this offers the possibility of using a single case record for multiple purposes—perhaps for students in education, social work, psychology, and architecture—and what we might ask them to produce is their own guided tour. Not an essay but a series of annotated links!

Initially the concept of the case record was that it was mostly text. Since, digital multimedia methods (digital cameras, video and audio recorders) have become available to ordinary users and new forms of case research are possible. Using simple and relatively cheap equipment, a single researcher can collect, edit,

and assemble a case record that includes a variety of forms of evidence and share this using any one of a variety of Web-based formats. Moreover, this need not be a closed archive; it can be updated, its users can interact with it and, maybe, in future it will react intelligently to user responses, perhaps in the manner of an expert system.

There are various contexts and settings within which this kind of development might be possible, but in my own work I have been interested in schools, and specifically in the design of new school buildings and the interrelation of design and pedagogy.

The architecture and design of educational buildings has a long history in which technology, pedagogy, and the instructional roles of teachers are intertwined. We know from experience that the spaces (actual and virtual) in which we learn and teach have an influence on what we learn and how we teach, but there is little systematic research that pins this down. These relationships are more complex than it might seem at first, but case records can help us understand better how these aspects connect in specific cases. In particular, this knowledge can prompt us to make changes for specific purposes, or to be aware why a class is not working as well as it might. In this sense, generalizations are probably less useful than practical knowledge.

The question is important because, while the conventional classroom has become almost taken for granted in our thinking, it is in fact an invention of the mid-nineteenth century that is closely related to the social, economic, and industrial changes of the time. As we move into new economic and social times (and as technologies transform almost all aspects of our lives), so the idea of the classroom is shifting, and with it what we assume teaching and learning to be.

In an attempt to document some of these changes (Walker and Lewis, 1998), I have assembled case records of two primary schools, both have novel design features, innovative pedagogies, and new approaches to curriculum. Both records provide a mix of evidence types (photos, video, audio, text), loosely organized and requiring the user to navigate the material independently. The schools are called Hathaway School and Wooranna Park.

One of the reasons I started doing this work came from using conventional case study accounts in teaching. Some students took to these studies readily, but for others they were not sure quite how to manage what they had learned from reading them. What they had learned required a degree of reflective and critical thinking that did not fit easily into conventional ideas of learning or into course assessment. Thinking about this I realized the most productive phase of learning in case studies comes at the point at which the record is interpreted and the case assembled, not so much at the point where the finished study is read. It was the author who was doing all the learning (and having all the fun) and the reader who was being left out. What I needed to do was to take the reader inside the process of writing the case. In case study research, I came to

believe, students need to be given access to the backstage of knowledge production if they are to understand the presentation of knowledge in papers, reports, books and journals (Walker, 2003).

Interestingly, it was only much later that I realized that there was a clear parallel here with what we observed in the classrooms, where teachers would take students behind the formal curriculum in order to investigate where knowledge came from. Knowledge was not so much received as won from the hard work of critical interpretation.

In his book on the Media Lab at MIT, Stewart Brand (1987) tells a story about a group of journalists who visit the Hennigan School in Jamaica Plain to quiz a group of students about the work they have been doing with computers. One reporter is quizzing a small child under the glare of TV lights and, not getting the answer she wants, says, "But isn't it just fun," meaning they are not really learning anything. The child hesitates and then says, "Yes it's fun. But it's hard fun."

So too with case study research.

7 Traditions are Group Efforts to Prevent the Unexpected

Theoretical Perspective

Lauren Greenfield has taken some amazing photographs. Have you seen the picture of a 15-year-old girl pressing her breasts together to create cleavage? It's on the cover of *Girl Culture* (Greenfield, 2002). Or how about the picture of two convertibles full of teenagers trying to be seen and trying to see others? It's on the cover of *Fast Forward: Growing Up in the Shadow of Hollywood* (Greenfield, 1997). Because of such pictures of youthful culture, *American Photo* magazine calls Greenfield one of the top twenty-five photojournalists and documentary photographers (*American Photo* staff, 2005). In 2006 she came out with a new book, *Thin* (Greenfield, 2006), and a documentary film with the same name was shown at the Sundance Film Festival in 2006.

Thin takes a look at residents of the Renfrew Center, a Florida treatment facility for women with eating disorders. We see pictures and read interviews and journal entries from twenty females who fear gaining weight to the extent that they suffer physically and psychologically. They avoid eating or purge. They cut themselves or attempt suicide. The book includes commentary by medical and sociological experts and an introduction by Greenfield. Greenfield's pictures, as usual, are intimate, almost uncomfortably intimate, because she's gained the trust of her subjects. The women have confidence that Greenfield will show their raw truths, but with respect.

Trust made the project possible. Greenfield says: "One of the biggest challenges of making this film was getting that access, especially in light of how delicate the eating disorder population is. These women have big issues around trust, and many of them are survivors of trauma. I was aware that we were going in there as image-makers, with women who already have body image issues and for whom the media can play a triggering role" (Gutoff, n.d.)

Greenfield is a great example of a multimedia storyteller. In addition to the book *Thin* and the film *Thin*, Greenfield has produced a DVD as well as a traveling exhibition, multimedia segments, and a lively forum on her new website.

Imagine if you wanted to conduct a research study about a group of people, such as the women undergoing treatment at Renfrew Center. If you wanted

to describe the group, you might, like Greenfield, want to use a camera and/or camcorder, and you might use research about organizational culture as your theoretical perspective.

Organizational culture is the personality of the organization. It is the combination of qualities that gives the organization—or group—its distinctive character and makes it interesting. Organization culture includes habitual patterns of behavior, thought, and emotions. It also includes the assumptions, values, and tangible symbols (artifacts) that an organization's members share amongst themselves and that they pass on to new members.

The concept of organization culture became popular in the 1980s when Japan's economy was soaring, and American executives worried the prevailing quantitative research was not explaining why American businesses were falling behind. Two seminal books—*Theory Z: How American Business Can Meet the Japanese Challenge* (Ouchi, 1981) and *The Art of Japanese Management: Applications for American Executives* (Pascale and Athos, 1982)—suggested Japanese business success could be attributed in large part to Japanese corporate culture. As a result, emphasis shifted from the functional and technical aspects of management to the interpersonal and symbolic aspects of management. To understand the soft side of organizations required qualitative studies of the symbolic aspects of organizational life.

This softer view of organizational culture built upon the work of anthropologists and sociologists who studied culture in groups and societies. Anthropologist Clifford Geertz, for example, explained culture by comparing it with a spider web (Geertz, 1973). Like spiders, we live within a web that surrounds us. Moreover, like webs, each organization's culture differs from others. For example, the culture of a large, for-profit corporation differs from that of a hospital, which differs from the culture of a university. In order to understand the organization, we must understand its web of culture (Schein, 1985).

Pacanowsky and O'Donnell-Trujillo (1982) drew upon Geertz's work when they created **Organizational Culture theory**. Their theory adopts the spider web metaphor and assumes that members of the organization build their unique web with symbols, such as stories, rituals, and logos, whenever they communicate and interact. Although easily sensed, the organization's culture may be difficult to "see" because it consists of so much tacit knowledge. **Tacit knowledge** resembles common sense. Tacit knowledge consists of largely taken-for-granted ideas relevant to a particular situation as well as deeply ingrained emotions related to physical survival. People do not usually talk about their tacit knowledge because it is so basic and pervasive. We learn about tacit knowledge by observing people's unconscious habits, their nods, silences, and humor.

Some aspects of culture are more visible than others. At the heart of a culture lies its fundamental assumptions, values, and behavioral norms. Moving outward from this core, we can see patterns of behavior as well as artifacts and symbols (Schein, 1985). Artifacts and symbols include everything we can see,

hear, or feel. We can observe them easily, but they have ambiguous meanings and may be difficult to interpret properly.

Dandridge, Mitroff, and Joyce (1980) describes three types of artifacts and symbols:

1. Verbal symbols, including myths, legends, stories, slogans, jokes, nick-names, and metaphors. **Myths** are dramatic narratives of imagined events, usually used to explain origins or transformations of something. Myths are also unquestioned beliefs about the practical benefits of certain techniques and behaviors that are not supported by demonstrated facts. **Legends** are handed-down narratives of some wonderful event that is based in history but has been embellished with fictional details.
2. Action symbols, which revolve around rites, rituals, ceremonials, parties, meals, recruitment efforts, orientation sessions, critical incidents, and a system for rewards and punishments. **Rites** are relatively elaborate, dramatic, planned sets of activities that consolidate various forms of cultural expressions into one event, which is carried out through social interactions, usually for the benefit of an audience. **Rituals** are standardized, detailed sets of techniques and behaviors that manage anxieties, but seldom produce intended consequences of practical importance. **Ceremonials** are systems of several rites connected with a single occasion or event.
3. Material symbols, including awards, furnishings, technologies, buildings, products, and services. Material symbols also include decorations, such as family photos and cartoons in offices, on office doors, and in hallways.

I will use my visual communication sequence at the University of South Carolina to explain Organizational Culture theory. In 2002, we began to create a visual communication sequence by simply moving people and courses to new locations. An advertising professor, a public relations professor, and two print journalism professors left their old sequences and joined a new sequence, called visual communications. We also moved existing courses, with their original course titles and descriptions, to the new visual communications sequence.

After these administrative moves, we began to create a culture for the visual communications sequence. We started by talking among ourselves and deciding upon our core values. What do we think students need to learn to become visual communicators? How should we teach the mixture of theory and hands-on skills? How will we evaluate their work? What jobs will they accept after graduation?

From our discussions, we decided to prefer breadth over depth, so we teach our students many ways to communicate visually rather than expect them to specialize in one area. We also emphasize breadth by ensuring that our students are visual communicators in an area of communications. For

example, in addition to their general education requirements and their visual communications courses, students must take at least three courses in advertising, public relations, print journalism, or electronic journalism. We plan to add an option: self-employed business people with a visual communications specialization.

We use several types of verbal symbols to create our culture. One, we gossip (gasp!), bitch (double-gasp!), and talk shop in sequence meetings. During these meetings, we build camaraderie, evaluate our recent efforts, and make plans for the future. Two, we have fun nicknames, such as "Men in Black." We had our picture taken one day when we all dressed in black shirts, wore dark shades, and put on appropriately serious expressions. Then we took another photo without the sunglasses or expressions. You can see the rollover pictures at www.jour.sc.edu/news/isite/viscom/index.html. Three, we tell stories about some graduates who got jobs in small, start-up companies as well as others who created their own companies. We also tell anecdotes about graduates who have written to thank us for all they learned, describing our teaching as right on target.

Action symbols become important when we have our annual party for graduating seniors. At these parties, students and alumni mix with faculty members. One recent graduate has a band, so the band plays music while we cook hamburgers, admire the students' portfolios, and enjoy an occasional adult beverage. At about the same time, the end of spring semester, we present a multimedia presentation at the annual school-wide awards ceremony. This service work allows us to share our culture with faculty, students, and their parents in all sequences.

We also create and maintain our organizational culture whenever we hire new faculty members. When the new hire arrives, we have a dinner to get to know each other. We assign the new person a mentor to ensure he or she will be successful in teaching, research, and service. We will explain the annual performance review process with its system of rewards (and lack of rewards). We talk in the hallways and around the coffee pot; we visit each other's offices and have meetings. In other words, we absorb the new hire into our culture.

People can see the material aspects of our culture all of the time. For example, twenty of my $16'' \times 20''$ photographs and dozens of student photos hang in a hallway outside the sequence director's office. We also have numerous display cases, where we hang excellent student work. Right now, you would see a) ten posters promoting travel to Jordan (Information Graphics course); b) magazine covers with a student's posterized self-portrait and teasers to inside content related to that student's interests (Advanced Graphic Design course); c) CD "album" covers for two local bands: Hootie and the Blowfish and Crossfade (Graphic Production course). Visitors might also notice the way we teach in our Apple Macintosh computer labs. They could also observe students using up-to-date Canon digital SLR cameras and Sony digital camcorders. They can see that our office doors remain open many hours throughout the week so that students and faculty members can drop by to chat.

Unfortunately, visitors would undoubtedly notice our "home," the windowless coliseum, which was originally built as a basketball arena.

Goals

You could use basic or applied research in order to study an organization's culture. For basic research, you might create an additional metaphor to describe organizational culture. Pacanowsky and O'Donnell-Trujillo use a web metaphor, and others compare an organization to a baseball team, club, academy, and fortress. You might also want to test one of the following theories about organizational culture: functionalist, structural-functionalist, ecological adaptationalist, historical-diffusionist, cognitive, structuralist, and mutual-equivalence structure.

You could conduct applied research for a company that wants to understand its culture and possibly change its culture. Nissan, for example, hired John Schouten and Jim McAlexander to conduct research on brand community amongst owners of its vehicles. Interestingly, Nissan insisted the finished product be video only, with no accompanying written material (Belk and Kozinets, 2005). According to Russell Belk and Robert Kozinets, companies that are attuned to the power and impact of video-based research are regularly requesting video reports (Belk and Kozinets, 2005).

You could also conduct applied research in order to create a case study for a business course. Harvard Business School, for example, is now producing and selling multimedia cases on CD-ROM. Their "Building Brand Community on the Harley-Davidson Posse Ride" case presents rich videographic data on the biker community and its communal gatherings (Belk and Kozinets, 2005). The multimedia case study, in essence, takes viewers along for a simulated posse experience.

You might also set a personal goal of visually describing the culture of an organization or a social group. What is it like to live in that group? How do they differ from people in your organization or neighborhood? How do they contribute to society?

Research Questions

Researchers of organizational culture strive to describe and interpret a cultural or social group. They would ask this type of questions (adapted from Dandridge, Mitroff, and Joyce, 1980):

1. Do certain kinds of organizations, such as banks, share similar logos, colors, metaphors, rituals, and office designs? What does "similar" mean?
2. Do certain individuals, such as naturally gregarious senior employees or supervisors, initiate a story or ritual more than others? If so, how do they do this?

3. What happens to symbols during violent upheaval or organizational change? For example, when photography programs switched from photo-chemical darkrooms to digital "darkrooms," did stories change? Were new heroes created? New slogans? Were fewer prints made and displayed?
4. Do contradictory symbols predict impending change? For example, if you see posters for newspaper internships at a school of journalism and mass communications, but you also see multimedia storytelling on a large HD television screen, then can you assume the school's culture is changing?
5. What effect does the surrounding culture have on the organization's symbols? For example, someone asked me to create a visual communication program at a Chinese university. How many American symbols would I bring, and how many new Chinese symbols would I need to discover?
6. What effect does the organization symbol system have on life in its community? For example, how does the University of South Carolina's culture affect the city of Columbia? Does UCLA's culture affect Los Angeles less or more?
7. Do professional symbols support or conflict with organizational symbols? For example, if a college has student chapters of the National Press Photographers Association, the Society of Newspaper Design, and the American Institute of Graphic Arts, then how do colleges integrate these symbols into their cultures?
8. How does the influence of management leadership compare with members' work experience in shaping organizational culture?

Brief Description

When researchers want to understand a group and its culture, they conduct an ethnographic study. **Ethnography** is the study of a cultural or social group based primarily on researchers' observations and interviews during a prolonged period of fieldwork. **Fieldwork** is defined as the practice of studying others at close quarters in order to gain an understanding of the everyday operations of a particular way of life as well as the meanings that members of that culture attribute to these everyday occurrences.

Researchers who use video and still cameras when they conduct fieldwork are called **visual ethnographers**. Like Lauren Greenfield, who told the story of women recovering at Renfrew Center, visual ethnographers observe—and use their cameras to record—people at their daily activities. A key part of the ethnographic method is to see firsthand what occurs. If they cannot observe firsthand, ethnographers ask informants and others for their recollections, points of view, and interpretations. They also analyze artifacts and documents in order to give viewers the experience of what it looks and feels like to be a member of a group or organization.

In the past, visual ethnography could have been described as a researcher using observation, interviews, and cameras to discover exotic communities in

isolated areas, and then interpreting and translating that culture. Visual ethnographers tried to provide a descriptive– explanatory–interpretive account of that community for scholarly readers and the general public in the form of a journal article, educational film, or televi-sion broadcast. In the past twenty years, however, visual ethnography has undergone major changes:

1. Instead of one researcher, now a team may be needed to collect data, especially if the final product appears as a hypermedia DVD or website.
2. Instead of primarily studying exotic distant communities, ethnographers now also study organizations within their own societies. Like exotic others, organization members engage in rituals, pass along corporate myths, and use arcane jargon (Gregory, 1983).
3. Instead of studying isolated communities, they recognize that communities lack clear geographical boundaries. Harley Davidson and Nissan drivers, for example, may gather together from all parts of the world in order to share an experience.
4. Instead of interpreting and translating other people's accounts, visual ethnographers now create a multi-voiced account that lets others "speak" directly to viewers.
5. Instead of creating an end product for a small group of scholars or the general public, their new target audience includes members of the social group they study.
6. Instead of writing their results, they use hypermedia, including video, photographs, audio recordings, etc.
7. Instead of distributing their work via a journal article or film, visual ethnographers use a CD-ROM, DVD, or website.

Units of Analysis

Since the goal is to visually describe a group's culture, and since your method is visual ethnography, your unit of analysis might be both ethnographic chunks from videos and photographs that you, as the researcher, produced. **Ethnographic chunks** consist of blocks of information with the same meaning. They often show interaction between people. For example, an ethnographic chunk might consist of a scene in a video that shows a Renfrew staff member helping residents to mount a scale backward so residents could not see their weight gain.

To identify an ethnographic chunk, analysts examine their videotapes and note when something new has happened. Later they try to identify the criteria they had spontaneously used to mark the chunk's beginning and ending. Sometimes they draw upon their own cultural knowledge to identify chunks. Other times they ask local experts to review the video and make suggestions.

Ethnographers often video or photograph ritual events because members of a group or organization perform such events again and again. If an

ethnographer has limited time for fieldwork and he or she misses a ritual event, another opportunity will occur. Moreover, ritual events often occur in public, so it is likely that ethnographers can observe them with minimal research effects (Trice and Beyer, 1984).

Sampling (or Deciding What to Photograph)

In order to obtain an adequate quantity of your units of analysis—ethnographic chunks of video and photographs—you need to draw a purposeful sample of 100 to 200 observations.

One, you can begin with an initial theory about the organization's culture and then let your photographic theory guide your picture taking. **Howard Becker**, a prominent sociologist who uses qualitative research, in particular visual sociology, to study social groups, emphasizes the importance of theory-guided work. Becker explains that a **photographic theory** is "a set of ideas with which you can make sense of a situation while you photograph it. The theory tells you when an image contains information of value, when it communicates something worth communicating. It furnishes the criteria by which worthwhile data and statements can be separated from those that contain nothing of value, that do not increase our knowledge of society" (Becker, 1974: 12).

Two, you can create **shooting scripts**, which are lists of research topics that guide you in a strategic and focused exploration of answers to research questions (Suchar, 1997). After shooting video or photographs, you analyze what you learned. You then use that knowledge to create the next day's shooting script.

Three, you may get lucky and have a **Click! experience**: a sudden, though minor, epiphany about the importance of an event (Adler and Adler, 1998). For example, as Greenfield photographed two women holding hands while eating a "fear" food—Pop Tart—she suddenly realized some residents were experiencing their first close relationships with other women. After having a Click! experience, reflect on how the surprise may change your initial theory. You should then try to find similar examples at other times and in other places. For example, once Greenfield realized that residents may not have had close friends outside Renfrew, she probably looked for other instances of bonding. She may also have looked for times when women did not bond.

A Click! experience resembles the **analytic induction** method of data collection because you explicitly take the unusual, or deviant, case as a starting point for testing or building theories. With this new case in mind, you return to the field and collect new data to test your revised thinking. If you again find a deviant case, you again revise your theory and collect new data. This process continues until there are no more unusual or deviant cases to account for.

Methods

In order to visually describe the organization of an organization or group, you could use the visual ethnography method. This section explains how to: a) gain access to a social group; b) fit into the group; c) minimize reactivity; d) maximize reflexivity; and e) shoot video that can be analyzed.

Gaining Access

You begin to gain access by contacting the **gatekeeper**, who is someone with the authority to control access to a site, or someone who manages the flow of information. You want to: a) provide a good **hook**, which is a story that attracts potential participants' initial interest by making your project sound interesting; b) explain the project so the gatekeeper feels informed and so that the gatekeeper can answer others' questions about the project; c) show that you are competent and trustworthy so the gatekeeper will be satisfied that the project will not waste people's time; d) explain why that particular site was chosen for study; e) explain what you will do at the site; f) estimate how long you will remain at the site; g) explain how—if at all—your presence will disrupt participants; h) tell how you will report the research results; i) describe the research bargain.

A **research bargain** is an agreement regarding what the gatekeeper and participants can expect from the researcher in return for their cooperation with the research. Visual ethnographers usually offer participants images. Susan Meiselas (2003), for example, took portraits of her community of strippers. For these portraits, she allowed the women to present themselves as they wished to be seen.

Some scholars, however, argue that the "giving something back" of a research bargain actually benefits the ethnographer, "who will feel ethically virtuous," and not the participants (Pink, 2007: 57).

People who object to giving something to participants suggest that you can collaborate with participants so they can achieve their own objectives as you work together. In one project, for example, a group of HIV-positive women collaborated with researchers to produce a set of videotapes that contained messages for their children. The researchers, of course, used the tapes for their research, while the women gave their families a video of memories before they died (Barnes, Taylor-Brown, and Weiner, 1997). When you write about your research, remember to tell your audience about the research bargain so it can decide how the bargain may have affected your project.

Greenfield had no problems with her gatekeepers. She writes: "The Renfrew Center never wavered in their cooperation or enthusiasm for the project. They understood my need for journalistic independence free from editorial influence or conditions. The staff taught me about the illness and daily life within the institution and guided me in gaining the trust of the residents, each of whom could choose whether or not to participate" (Greenfield, 2006: 13).

After getting gatekeepers' consent, you'll need to decide when to introduce a camera into the setting. Some visual ethnographers use the **can-opener approach**; they assume that people like to take pictures and to have their pictures taken, so by bringing out their cameras, visual ethnographers hope to establish rapport with participants (Collier and Collier, 1986). Others use the **softly-softly approach**, which means visual enthnographers first walk around with a camera without taking pictures; then they photograph safe subjects, such as buildings; and much later they begin serious work (Prosser and Schwartz, 1998: 121). In other situations, ethnographers prefer to spend some time chatting with each person before taking out a camera. You may let people try out your camera as you explain how you will take pictures (Pink, 2004a).

After letting people know you intend to take pictures, you need to obtain their permission to take their picture. Anyone who uses cameras to document people knows that the initial moments when they approach people and present themselves are crucial to the success of their picture taking. To build trust, you might show them the first few photographs or minutes of recorded video in order to reassure participants that your visual content and style of representation will be fair (Pink, 2004b). Visual anthropologist Sarah Pink reports that many enjoy participating in a visual ethnographic project and they learn new things about themselves, which motivates participants to recommend Pink to others so she can complete her study.

Building rapport is part of climbing the **access ladder**. You start at the bottom, seeing public, non-controversial events. Later you gain entry to more hidden, intimate, and controversial information (Neuman, 2003: 529). Bill Bamberger, for example, initially received a hostile reception when he arrived to take pictures only weeks after the announcement that the White Furniture factory would close. A cabinetmaker said, "When I first saw him with his camera, I considered him the enemy. I looked at him just like I did management, just one more vulture in here trying to pick the bones of the employees" (Bamberger and Davidson, 1998: 21). Over time, Bamberger gained the cabinetmaker's support.

For Greenfield, the access ladder was relatively short. She writes, "The residents came on board gradually and unpredictably—sometimes with enthusiasm, at other times with hesitation or apprehension, and at the best of times, unexpected openness and partnership" (Greenfield, 2006: 13). She remained open to the residents' moods, issues, and changes of heart toward the filming, she writes. She also shared her own goals, process, and needs with members of the community.

Fitting into the Group

To fit in, you should be empathetic. **Empathy** is defined as a sense of shared experience, including emotional and physical feelings, with someone else. Empathy does not necessarily mean agreement or approval. It means being

sensitive to the feelings, thoughts, and experiences of another. You lay aside your personal views and you enter into another's world without prejudice. Susan Meiselas (2003) took extraordinary measures to develop empathy with women who stripped at small-town carnivals in New England. One night, as she imitated their dancing on stage, she flashed the audience while wearing nothing but a trench coat. As a result, she had the same feelings of vulnerability as her subjects. She also gained the strippers' respect.

You can also demonstrate empathy by sharing relevant aspects of your identity with participants. Greenfield writes in the prologue to her book that she has strictly dieted, religiously exercised, and even tried purging a couple times (with little success) (Greenfield, 2006: 11). She probably told residents that she had been a chronic dieter during her teenage years. Greenfield, however, also kept some distance from the residents. You must balance your insider's perspective with your role as researcher, in other words, as an outsider, by viewing participants from multiple points of view simultaneously.

Minimizing Reactivity

Visual ethnographers neither try to elicit responses nor try to affect participants' actions, but they seldom achieve such goals because of reactivity. Reactivity occurs when people alter their behavior as they become aware that researchers are studying them. This problem appears in all research. For example, people guess at what researchers want when they complete surveys and participate in experiments. Reactivity particularly hurts photographers because people have the habit of posing for cameras.

Some visual ethnographers pretend reactivity does not exist. They convince themselves that people habituate themselves to the camera quite quickly, especially when they are intensely involved in what they are doing. As camera effects wear off, people tend to behave naturally in front of cameras, especially when photographers handle their cameras discreetly or when no one stands behind the tripod-mounted video cameras.

Another group not only acknowledges reactivity, but also embraces it as an important source of information in their research (Lomax and Casey, 1998). Since people respond to cameras and researchers, the two parties should negotiate the camera-based research process together. They should agree on what can and cannot be shown; when an appropriate event begins and ends, as well as who may or may not be included. Researchers can capture the negotiation process on video, which becomes a valuable source of information and insight.

Maximizing Reflexivity

Reflexivity is defined as sensitivity to a) the personal interests that researchers and others brought to the study; and b) how various thoughts, feelings, and

actions may have shaped the data. For example, researchers need to share with readers how their personal characteristics such as age, sex, social class, and professional status may have affected their work. Researchers should also tell readers how personal and emotional factors may have influenced their data collection or analysis. They should also tell readers about assumptions that caused them to formulate a set of questions in a particular way; how they sought answers to those questions in a particular way; and how they presented their findings in a particular way (Ruby, 1980). In other words, researchers should reveal potential biases.

Although some television journalists and documentary filmmakers try to remain **objective**, which means, accurate, fair, and impartial, many others realize that they are telling (hopefully compelling) stories and attempting to dramatically shape audience reactions. There is no such thing as a neutral image that is simply there as a fact, especially after the substantial winnowing that must take place in editing (Belk and Kozinets, 2005). Nor is the person with a camera a non-intrusive fly on the wall. Instead, the visual ethnographer is closer to being an artist and storyteller than to an objective scientist.

Greenfield practiced reflexivity because she thought about the theories that informed her picture taking. In her introduction to *Thin*, she explains her theory that eating disorders function as a coping mechanism "used to numb out intolerable emotional pain and experience a sense of control" (Greenfield, 2006: 12). She let readers know about her personal connections with dieting and purging. She also acted reflexively by putting the book into the larger context of her decade-long exploration of body image: "the way the female body has become a primary expression of identity for girls and women" (Greenfield, 2006: 11).

You can also deal with subjectivity by collaborating more fully with participants. Attempting to understand and represent their point of view makes the meaning of the final product inter-subjective rather than subjective, or ostensibly objective (Pink, 2006). Greenfield collaborated with the patients being treated at Renfrew Center. She writes, "For reasons practical and ethnical, the subjects were my collaborators, and when we had obstacles, roadblocks, questions, concerns, we had to work them out together to move forward" (Greenfield, 2006: 13).

Shooting Video That Can Be Analyzed

Ideally, you would capture all relevant aspects of events as they unfold, but you cannot know ahead of time what will emerge as relevant. You can, however, try to record a large area to show as much as possible. For example, you can use a wide-angle lens to have all participants in the picture and to have their whole bodies visible (Jordan and Henderson, 1995). You want to avoid close-ups of one person because a talking head does not show others who may be interacting with this key person.

Working with another photographer helps because in an unstaged group interaction, with people oriented in different directions, one camera cannot record everyone's words and gestures. You could also use two cameras when simultaneous and related activities occur.

In addition, keep the camera stationary for predictable action, so you can obtain a sustained view of the scene of interaction (Jordan and Henderson, 1995). When walking around to photograph different interactions, it is important to remember that the person behind the camera may be making moment-by-moment judgments, which may be questionable in retrospect. Moreover, a roving camera typically misses the all-important transitions. It also intrudes on the action. For example, when photographing a company picnic, you might be tempted to move from one group of people to another, trying to capture key moments on videotape. With this strategy, however, you will miss recording what people said when they first began congregating. You will also miss how they indicated a desire to break away and join a different group. Such transitions reveal as much about corporate culture, if not more, than the events that first caught your attention.

When you want to focus on a specific action as well as the background for that activity, try **pipping**—a procedure that allows two or more simultaneously recorded images to be merged and recorded onto the same tape (Jordan and Henderson, 1995). The secondary images appear as small insets in a less important region of the primary image. For example you might PIP a picture of a teacher's activities in the front of the classroom into a whole-classroom shot.

Since you need quality audio to study complex interactions, prepare carefully. Use wireless mikes so people can remain mobile. If you do not have a wireless mike, you can ask people to carry a small tape recorder on a string around their necks or in a pack on their waist in order to obtain great sound.

Data Analysis

After you have completed your fieldwork, you need to analyze your chunks of video and photographs. This section covers several steps, including: a) how you make content logs; b) how a group of researchers brainstorms about the transcripts; c) how you interpret the results of the brainstorming session; and d) how you review the findings with participants. It also covers useful foci for analysis, such as a) structure of activities; b) timing of activities; c) space of activities; d) artifacts and technologies of activities; and e) troubles related to activities.

Making Content Logs

After they shoot a day's worth of videotape, visual ethnographers create a **content log**, defined as a written description of what can be heard and seen on the videotape as well as when it appears on the videotape. Depending upon

what they need to answer their questions, visual ethnographers may simply create side-by-side columns with dialogue on the left and activities on the right; or they may consider it important to transcribe pauses, voice inflections, facial expressions, gestures, body movements, head nods, hand movements, etc.

Brainstorming About the Transcripts

Brainstorming is a problem-solving activity conducted by a group of people who spontaneously generate many creative ideas. During the activity, everyone accepts these without criticism. You should try to form a multi-disciplinary collaborative work group to brainstorm about transcripts of a project's tapes (Jordan and Henderson, 1995). This collaborative viewing neutralizes preconceived notions on the part of researchers. For example, if a researcher reviewed a videotape of 8 year olds in an English for Speakers of Other Languages (ESOL) class, (s)he might observe that one child disrupted the class. Another researcher might agree that the child had been talking inappropriately, but the researcher also noticed that the teacher had appeared to lose control of the class. Still another team member might have noticed that the teacher had been introducing a new and complex idea immediately before the disruption. As a result, the group generally produces a large number of such observations, which the primary investigator records for more extensive analysis later.

Interpreting the Results

After transcribing the brainstorming session, you have a number of potentially significant observations about the phenomena. You then try to assess which observations are indicative of general patterns, which are idiosyncratic, and which are due to some as yet unexplained cause. To make such decisions, you need to make additional observations of the same event and then check whether the proposed generalization holds true. This job is easier if you make a **collection tape**, which is a videotape with all instances of a particular person, event, or theme. By seeing one example after another, you can decide whether the pattern holds true across multiple sets of empirical observations. In other situations, you may not have sufficient examples to confirm a hypothesis, so you may need to return to the field and do more focused ethnographic fieldwork or more targeted videotaping.

Reviewing the Findings

After tentatively identifying patterns, invite organization members to participate in one of two types of viewing sessions (Jordan and Henderson, 1995). Sometimes you can use the tape to elicit specific information from informants about actions and events whose significance is unclear. This often proves more productive than returning to the field for additional data collection. Other

times, you can ask informants to stop the tape whenever anything strikes them as significant. This gives some idea of how participants partition the event— where they see significant segments as beginning and ending.

Analytic Focus: Structure of Activities

In order to analyze videotapes, you need to decide where to focus your attention. Jordan and Henderson (1995) recommend looking at the structure, timing, space, artifacts, and technologies of various activities. To use the structure of activities to analyze videotapes, you study the beginnings and endings of events because significant interactions tend to happen at these junctures. You also study the way people indicate shifts in an activity. For example, a committee chair may signal the transition from chitchat to discussion of agenda items by rustling papers or moving to the front of the room. If everyone understands this code, then this smooth transition indicates a coherent organizational culture.

Analytic Focus: Timing of Activities

You may also use timing of activities as a focus of analysis (Jordan and Henderson, 1995). Study the shape of an event—its high and low points as well as its relaxed and frenzied segments. Also look for the repetitive, routine aspects of a sequence of events. For example, you can study the way externally imposed deadlines affect workers' activities, the way technology drives work rhythms, and the way newcomers enter the flow of events. You can also study the breathing spaces between activities, when employees read a magazine, catch up on paper work, order food for later delivery, tell job-related war stories, etc. Such activities provide insight into an organization's time culture.

Analytic Focus: Space of Activities

Organizational cultures also vary in terms of their use of space. Ethnographers analyze video to study appropriate body distance, how far one's gestures can intrude into another's personal space, and how public spaces are used in contrast to private spaces. They also study how physical setups encourage or hinder certain kinds of interaction between people in the scene. For example, organizations where everyone works in an office differ from places where people work in cubicles. Ethnographers also consider to what extent participants can control the setting. For example, can employees rearrange the furniture?

Analytic Focus: Artifacts and Technologies of Activities

Artifacts and technologies set up a social field within which certain activities become very likely, others possible, and still others very improbable. You can analyze which objects and technologies support particular activities. You can

also analyze how these activities change as different objects and technologies are introduced. For example, how does the introduction of wi-fi change the way people interact in an organization? What happens when an organization removes a refrigerator that had been full of bottled water? Do teaching styles change when universities update their classrooms to make them "smart?" Do teacher–student interactions change?

Analytic Focus: Troubles Related to Activities

Ethnographers carefully analyze problems related to activities. When people break an unspoken rule, trouble often results. People may then apologize, assign blame or ignore the problem. Whatever their course of action, you gain insight into what the world looks like from somebody else's point of view. For example, if a patient being treated at the Renfrew Center refused to be weighed, you might learn whether the staff would move closer to intimidate the patient, verbally reason with him or her, appeal to peer pressure, or wait until the next day.

Data Displays

Researchers who conduct a visual ethnography display parts of their videos and a selection of their photographs on paper (articles and books) or on screens (films, videos, CD-ROMs, DVDs). Lauren Greenfield, for example, created the book and a documentary film, both called *Thin*.

Credibility, Transferability, and Dependability

When visual ethnographers use observation and interviews to collect their data, the amount of time they spent in the field becomes an indicator of their work's credibility. Credibility improves when the ethnographer has had adequate time to become thoroughly familiar with the organization or group under scrutiny and the participants have had adequate time to become accustomed to having the researcher around (Mays and Pope, 1995). The researchers, for example, should also have witnessed a wide enough range of activities at the study site to be able to draw conclusions about typical and atypical forms of behavior. Moreover, these observations should have been undertaken at different times.

Readers of ethnographies judge credibility by asking questions such as: a) How well does this analysis explain why people behave in the way they do? b) How comprehensible would this explanation be to a thoughtful participant in the setting? and c) How well does the explanation cohere with what we already know? (Mays and Pope, 1995). The ideal test for an ethnography, however, is whether the account would allow a reader to learn the rules and culture sufficiently well to be able to function competently in the research

setting (Mays and Pope, 1995). In other words, the report would enable someone else to have the same experience as the original observer and appreciate the truth of the account.

Ethnographic studies may lack transferability if researchers attempt to generalize the results from the one case to another rather than attempting to generalize the results from one organization or social group to a theory of organizational culture.

Dependability, or quality control, improves if visual ethnographers take these steps. One, they begin their work with clear research questions that match their research design. Two, visual ethnographers are reflexive and they explicitly describe their role and status at the site. Three, they collect data across a full range of appropriate settings, times, participants, etc. as suggested by the research questions. Four, researchers check the quality of their data for participant bias, deceit, and knowledge. Five, visual ethnographers can use a **peer reviewer**. This knowledgeable colleague provides support, plays devil's advocate, challenges the researcher's assumptions or asks hard questions about the methods and interpretations. Readers believe the study's results and conclusions because they know that a peer reviewer had provided assistance.

Greenfield did not photograph and write for a scholarly audience, yet she used five strategies for ensuring quality:

1. She used triangulation because she collected data from several independent sources, including her own photographs, interviews with patients both during treatment and after their release from Renfrew Center, calorie journals, and patients' diaries. In addition, experts wrote essays about the eating disorders.
2. She was reflexive about her potential biases and motivations.
3. She immersed herself into the project, spending six months taking thousands of photographs and writing captions that vividly described patients at Renfrew Center.
4. She collaborated with the patients on picture taking and interviewing.
5. Her 190-page book, *Thin*, provided a thick description of the Center. A **thick description** is a detailed description of specifics, as opposed to a summary or generalization. It reveals the intertwined layers of meaning that underlie what a particular person says and does, so it resembles the many strands of a cultural web. Thick description provides readers with the feeling that they have experienced or could experience the events described in the study. Photographs are an excellent means for providing thick description because they use vivid detail to transport readers into the situation or setting. Greenfield used hundreds of photographs and other visuals to describe the culture at Renfrew from the point of view of its patients.

Lauren Greenfield could have used five additional strategies:

1. She could have given copies of *Thin* to a group of patients and then conducted a focus group to learn if patients agreed with the book's explanations of what was happening at Renfrew Center.
2. She could have kept a diary of her experience photographing and interviewing patients at the Center. She could have then used her diary to write about how she made sense of the place.
3. She could have asked someone familiar with qualitative research to serve as a collaborative peer reviewer. In addition, an expert could have reviewed transcripts of the interviews and the entire file of photographs to comment upon her work.
4. She could have written an expanded essay with more analysis and included discussion of any negative cases encountered during her work. **Negative cases** are cases that do not fit within expected patterns. Either through the process of purposeful searching or by happenstance, you come across a case that seems contrary to the general pattern.
5. She could have put her work on a website and included multiple points of view, each of which may have represented partial truths, but which together provided readers with a grasp of the world of the social or cultural group (Goldman-Segall, 1995).

Internet

Ethnographers have embraced the Internet as a way of quickly and inexpensively distributing their work to everyone, anywhere. In the past, researchers had to send their work to publishers, who needed a year to get a journal article, book, or film to readers/viewers. Now ethnographers can produce a hypermedia product and distribute it instantly. Moreover, the authors may receive feedback via e-mail on the same day.

Ethnographers also use the Internet in order to obtain stories from multiple perspectives. In the past, books and films generally explained events from an individual's perspective. With digital media and cheap storage, however, websites can include descriptions of events from multiple points of view. In addition, well designed, hyperlinked websites make listening to multiple voices easier than reading a linear book or watching a film.

Ethnographers use the Internet to make their work more collaborative and more interactive. In the past, readers could write in the margins of books, but others rarely saw their comments. Now websites' interactive facilities allow participants and users to add their own material, post counter-opinions, and follow links to sites offering other resources (Murdock and Pink, 2005). In fact, a virtual discourse may occur among a community of readers, investigators, and the members of the community. For example, a reader about anorexia could view the visual ethnographer's work, but also connect with residents at the center that was investigated and with other visitors to the website.

Advantages and Disadvantages

Documentary-style visuals enhance ethnographies considerably. For example, although ethnographers write in order give readers the impression of being there, visual ethnographers can show more detail than even a trained observer report (Bate, 1997). Visual ethnographers also supplement this rich visual detail with natural sound and participants' voices. With a multi-sensory set of materials, the audience gains not only cognitive knowledge about something, but also a more emotional and resonant knowledge of the experience of something (Belk and Kozinets, 2005). Such visual and auditory impact is important in an age when book and newspaper reading are declining, and video and TV watching are increasing.

Video also permanently preserves this rich data. It allows investigators an unlimited number of viewings, which may lead to more and better insights. Moreover, video can be played in slow or accelerated motion, which might expose otherwise unseen patterns of movements. Video, therefore, puts researchers in closer contact with their data, which leads to better research about a group's culture or an organization's culture.

Visual ethnography also has some disadvantages compared to ethnography without a camera. The greatest, perhaps, is participants' reactions to cameras. Ethnographers without cameras can observe discreetly or blend in with participants, but members of groups or organizations become aware of ethnographers with cameras. Their awareness may then affect their behavior.

Ethical Issues

With visual recordings, researchers must make an extra effort to obtain true informed consent by explaining the kinds of problems that are likely to arise from public viewing of the images and how these problems can best be solved. People may become surprised and embarrassed by information disclosed on videotapes and in photographs. For example, participants may have consented to videotaping for research purposes because they did not anticipate ever becoming embarrassed by anything researchers might record on video. Moreover, they may have had a general awareness of what researchers actually videotaped and photographed, but they may not know enough about photography to anticipate how they will appear on film. When participants review the tapes and take a microscopic look at their interactions, they may feel their privacy has been invaded. They may also worry that supervisors will consider their behaviors inappropriate (Jordan and Henderson, 1995). For example, since no one had previously videotaped your teaching, you may never have realized how frequently you turn your back to some students. Without seeing video of your teaching, you never realized how students take advantage of such moments. Researchers, therefore, should warn participants that supervisors might use the video to indict the worker instead of realizing that certain objectionable activities are common to that type of work.

With ethnographies, you need to ensure that people are participating voluntarily. Sometimes ethnographers rely upon authorities to do their recruiting; a supervisor says something like, "Listen, we've got these nice people from X University here today and they want to shoot some video and talk with you a bit." In such circumstances, even when researchers tell people they are free to refuse and can stop the taping at any time, their subjects may feel compelled to participate (Jordan and Henderson, 1995).

Ethics are bound up with power relations between ethnographers, informants, sponsors, gatekeepers, governments, the media, and other institutions; therefore, you must be sensitive to the power difference between yourself and participants (Pink, 2007: 49). You should be especially concerned about the power of the images taken of vulnerable populations, such as minors younger than eighteen, the homeless, medical patients, prison inmates, and persons with physical or mental disabilities. You should protect such participants as you would wish to be protected if you were vulnerable. Participants with more power, such as politicians, corporate, and military leaders, have greater defense mechanisms to ward off your intrusions.

In fact, ethnographers seldom study wealthy, powerful people. Why? Maybe because wealthy, powerful people fear that others will be jealous of their success; maybe they fear people will criticize the way they became wealthy and powerful; maybe they value their privacy; or maybe they lack a need to be understood better by others. Of course, when wealthy, powerful groups deny access, and a curious public wants to learn about them, then paparazzi's pictures become especially valuable.

A potential ethical problem concerns researchers' responsibility to notify authorities of harmful or illegal activities. When you work in public places or institutions, you may unexpectedly discover secrets that prove embarrassing or threatening. The discovery may initially catch you off guard, unprepared to assess the situation or take action. Later, however, as you decide whether to report the secret or harmful/illegal activity, ask: What obligations do I have to the observed? (Albrecht, 1985). Greenfield, for example, photographed women smoking in their rooms, which was against Renfrew rules, but Greenfield and the women must have agreed this could be reported.

A more serious problem arose when a photographer documenting gang activity published incriminating photograph-caption combinations (Rodriguez, 1998). One caption, for example, reads: "Chivo counts his money the morning after a carjacking." Another reads: "Chivo turns a homegirl on to cocaine." In other words, you must be concerned about legal safety from lawsuits or arrests because the law does not provide unambiguous, clear protection for a field researcher or confidentiality of field data.

Resources

Visual ethnography requires lots of your time and energy. You must spend weeks, if not months or years, observing, photographing, and interviewing people in an organization or social culture. If you live near the social group or organization you plan to study, then you can collaborate with several co-investigators. You can train together, practicing how to collect data and discuss ethical practices. Some people can conduct fieldwork on weekends, while others can devote time during evenings or particular weekdays.

Visual ethnography also requires money. You need to support yourself during the time you live with a group of people to understand their views of themselves and others around them. You also need money to purchase and maintain camera equipment.

For visual ethnographies, you need photography skills. If you collaborate, then some people may use a still camera, while others might use a camcorder to record behaviors. People without photography experience may wish to conduct interviews, collect documents, or observe.

Visual ethnography requires great multi-tasking skills. As a photographer, you must do everything other fieldworkers do and also get good photographs or video. If you put too much energy into operating the camera, getting good light and quality sound, then perhaps your observations, note-taking, and interviewing will suffer. Likewise, if you emphasize the fieldwork, then your pictures will be mundane. To do both well, you either need to be two people or you need to be experienced in both photography and fieldwork because, in my mind, the visuals must have high aesthetic quality.

Advice

1. Gaining good access to a particular community or organization presents a major challenge for visual ethnographers. To get permission to record participants, you need to develop a good hook. To get permission from gatekeepers, you need to develop an explicit agreement. You also must decide when to introduce your camera and how to develop rapport.
2. As you fit into the group, try to balance your empathy for others and your need to remain objective.
3. Decide whether you will minimize reactivity, and how you will minimize it; or if you will embrace reactivity, and how you will embrace it.
4. Be aware of your biases and commit to being reflexive.
5. Choose a strategy for deciding what to photograph or videotape, such as using theory, searching for Click! experiences, or using analytic induction.
6. Match your analytic foci with your display of images.
7. Consider creating a hypermedia product so that multiple voices can be presented and so that viewers can interact with your work.
8. Use several of the nine strategies for ensuring the reliability and validity of your work.

9. In addition to using an informed consent form and deciding on your research bargain with participants, be aware of power relations with participants and take steps to avoid harming them. Decide whether you will share copyright with participants.

Further Viewing

Videos about Lauren Greenfield and *Thin*
From Lauren Greenfield's website, an intro
http://www.laurengreenfield.com/index.php?p=y6qzz990

From Lauren Greenfield's website, slideshow of image
http://www.laurengreenfield.com/index.php?p=VQTME4W6

From HBO, a multimedia piece and deleted scenes
http://www.hbo.com/docs/programs/thin/video.html

From MyspaceTV, a video by Lauren Greenfield
http://vids.myspace.com/index.cfm?fuseaction=vids.individual&videoid=
1946097768

From the TV program 20/20, January 16, 2008, a story about the Renfrew Center, Part 1
http://www.redlasso.com/ClipPlayer.aspx?id=1fc2851b-a14f-4515-99e1-
4fb9886ec8d2

From the TV program 20/20, January 16, 2008, a story about the Renfrew Center, Part 2
http://www.redlasso.com/ClipPlayer.aspx?id=866a9002-7597-47df-a9e9-
aa68ddb7f67b

The Long-form Documentary: The Space of Access and Objectivity

Craig Denton

Gaining access to a group and maintaining objectivity are tricky challenges for any documentarian. Keith Kenney's chapter on organizational culture provides valuable insights and ethnomethodological strategies, but each documentary project poses unique challenges, since the documentarian inevitably has to inter-act with individual people. In turn, each person—documentarian and subject—brings a history and a sense of self that coexist in the dynamic negotiation that creates the documentary.

While video documentaries usually require a team, still photographic documentaries often are the product of one seer. That can provide the documentarian an advantage in gaining access. Since participants worry about personal disclosure, an anxiety that is heightened when a group witnesses the exposure, when the documentarian works alone, disclosure is less threatening. Moreover, the sole practitioner can gain more trust when participants feel they only have to negotiate with one person.

But with that perceived level of trust and disclosure comes special challenges for the sole practitioner. Knowing that the process of documentary production is complex and extends beyond the initial, image-gathering stage, the unitary documentarian needs to be even more self-reflexive and continually examine personal motives and perceptions. Objectivity is more elusive, because there are fewer checks and balances that a group approach can provide. At most, the sole practitioner can offer a fluctuating objectivity, not a fixed point of perspective but a fluid locus within a personal experiential space.

How, then, can one person manage these challenges of access and objectivity in a documentary?

All access, of course, begins with informed consent. The photographic documentarian carefully explains the objectives of the documentary and identifies the likely uses of the photographs and any verbal text that will be generated by interviews. All participants need to agree to those future displays and places of representation, at least through oral agreement, if not legally stipulated on a release form or a vocal acquiescence on a recorded interview.

One trust-building technique for gaining and maintaining access is to offer participants the chance to review transcribed interviews. Some oral historians allow interviewees to change their responses, and even go so far as to say that interviewees "own" their recorded responses. Others just allow the inter-viewee to change factual errors arising from unintended misspeaking or mistakes in transcription.

The photographic documentarian can maintain access and strengthen trust during the image-gathering process by asking the participants to engage

in a photo elicitation exercise. Derived from projective interviewing techniques, the documentarian shows work prints to a group of participants and asks them to comment on accuracy, significant detail, and feelings generated by seeing themselves perform for the camera. When they see how they are being represented, that takes some of the mystery and anxiety out of the process.

So, while informed consent and providing access to transcripts and work prints can go a long way in establishing trust and gaining and maintaining access, they do not absolve the documentarian from considering the problem of fair representation of participants in the documentary. There is still the challenge of authorial control. Ultimately, the still photo documentarian creates a narrative that has a point of view. The final document is an expression that is protected by copyright, regardless of any ownership by an interviewee in a recorded transcript. When the documentarian exercises those rights, the subjects become vulnerable to the documentarian's creative decisions. The challenge is to maintain the fidelity of participant voices and clarify their visual representations as the narrative takes shape in the photographic documentary, a product that is spatially removed from the initial negotiations between the documentarian and the participants.

Long-form Documentary

In *Image Ethics* (Gross, Katz, and Ruby, 1988), Larry Gross maintains that all groups have a right to be seen. Because visual representation in the media has become the equivalent of existentialist being, if a group is not represented, it is symbolically annihilated. If a culture is one-dimensionally represented, the representation becomes a perpetuating stereotype. Compounding the problem is that some groups, usually socially marginalized groups, have no control over those visual representations. Decisions about their characterizations are made by media elites, typically the socially dominant class.

There is a flip side to this problem for documentarians. Sometimes, groups do not want media visibility. They prefer to live under the radar of public exposure for any number of legitimate reasons. But the documentarian knows that choosing no visibility can make them vulnerable, because they inevitably will become represented in an all-seeing world of visual communication, but that representation will be shaped and colored by the perceptions of others.

The typical newspaper story creates a different problem. In this model of storytelling, the journalist typically chooses two antagonistic voices, one representing each side of a position, and those voices battle it out on the page. The journalist exercises authority by choosing the voices and counterposing them as antagonists parrying and thrusting against each other in the same space. There is little room for other, moderating voices, so the journalistic form

becomes strident and perpetually contentious, and the fulcrum becomes invisible.

The long-form documentary, represented by the book, provides the documentarian with a way to avoid this over-simplification of narrative and high decibel abrasion. In the book, where space is less constricted, the documentarian can include multiple voices, whether they are individual voices or the collective voice of a group. When all communities in a narrative of larger and more complex scope get the chance to have their say in the long-form documentary, there is more overall objectivity because all voices can be heard. Each voice resides in its own space in the documentary. Because authorial control is more the all-seeing eye that does not intervene as one group tells its story, and does not intrude by inviting the antagonist to respond in that group's space, the process is fairer to the participants. More important, when a group knows that it will have its own space to tell or show its story in a photographic documentary, it is more likely to grant access to the documentarian. When all groups engage in storytelling, the documentarian and documentary benefit, because the multiplicity of voices and images creates the likelihood of greater accuracy.

Few cultures have not been exposed to media. Moreover, there are few groups who have not been visually represented in some medium, either fairly or unfairly. The days of media innocence, where a documentarian discovers a culture that has been lost to the modern world, are over. As audiences are becoming more sophisticated, so too are cultures becoming more wary of how they are represented. They want some control over their visual personas when they are asked to participate in a documentary. If they feel they are going to be powerless, they are savvy enough to know it would be wiser not to participate.

This makes the job of the contemporary documentarian even harder, because the documentarian needs access to people and groups to tell a story. In any documentary, the documentarian usually has a dramatic arc driving the production, and an individual plays a role as a particular character in that narrative or serves as an archetype. If an individual or group chooses not to participate, the documentarian sometimes can find another person or group to tell its story and serve in the role. But what happens if there are no other willing archetypes to tell the story?

In *Doing Documentary Work* (1998), Robert Coles talks about the "problem of place." First, there is the place where the initial interview is made or the photograph captured. Then there is the reflective place where the documentarian begins to edit copy and images. Next is the place of the fixed narrative, where a photographic documentary takes shape as a visual product. Finally, there is the published place where the documentary becomes public and enters the place of the audience. Each of these succeeding places takes the documentarian further away from the site of the first draft narrative.

The long-form documentary helps overcome some of the problems of place, because it expands the boundaries of place while minimizing the distance between the pictorial gathering site and the final representation. While the documentary becomes the place of the larger narrative, each group has its own place within that narrative, typically in a chapter. The chapter is a recognizable place, with beginning and ending pages. The chapter is a confined place, protected from intrusion.

By now, the reader should be asking himself or herself, "How can the documentarian give each individual or group their own space in the narrative, free from heavy editing oversight, without becoming the public relations agent for that group?" Indeed, there is that danger in this model of the long-form documentary.

But the group does not have the whole narrative to themselves. It is but one narrative node in the larger narrative. Even while their space in the narrative is controlled by their understanding of their story, their perspective, whether political, social, or economic, does not drive the point of view of the narrative. That resides elsewhere in the larger conglomeration of all voices and visual representations.

Another way for the documentarian to avoid being an unwitting PR practitioner is to come to the negotiations well-read and well-armed. It is critically important that the documentarian thoroughly research the history and political, social, and economic positions of the group or its representative before making initial contact. That way, when triangulation indicates that a certain person would be a good source, the documentarian is prepared. The key is asking the gatekeeper the right questions, and depending upon the responses, following them up with questions that expose the political thrust of the responses. If the participant is willing to be self-reflective and self-critical, willing to recognize that his or her group's ideology resides in a larger world of multiple ideologies, willing to acknowledge another's contrary positions, then the voice is a reflective, authentic one that warrants recording. If upon in-depth questioning of the source, he or she tacitly refuses to acknowledge the legitimacy of differences of opinion based on fact, then that person is eyeing the documentarian as a conduit for promoting individual or group political positions. In that case the potential source should not be used in the long-form documentary.

People of the West Desert: Finding Common Ground (Denton, 1999) and Bear River: Last Chance to Change Course (Denton, 2007)

Two of my books have been photographic documentaries for which I have also written the texts. They serve as exemplars of negotiating access and objectivity and trying to preserve the fidelity and authenticity of voices. Both books were based on the long-form model of organization.

People of the West Desert looks at the lives and lifestyles of people who live on what was the last frontier in the lower forty-eight states, in western Utah and eastern Nevada: a diverse culture of ranchers, farmers, prospectors, Native Americans, polygamists, constitutional separatists, religious fundamentalists practicing a united order economic plan, new age communitarians and dreamers looking for a second chance. They are a small but sophisticated group of people, due to a relatively high level of education. They were politically active during the MX missile controversy, and the opening of Great Basin National Park brought them media attention. Sometimes, they have been stereotyped as exotic because they live near U.S. Highway 50, often dubbed "The Loneliest Highway in America." Because of their experiences with national media, they are media savvy—and wary.

I had met members of an iconoclastic ranching family in Utah's West Desert by happenstance while working on an earlier landscape documentary, and they provided me with an overview of the culture. They identified the gatekeepers in the several cultures and suggested other good sources. I made my initial contacts from that information. In my introductory letter I said I was on the faculty of the University of Utah. That gave me some status and probably an aura of "scientific objectivity." I explained the reason for my documentary and my hopes for publishing outcomes: a photographic exhibit and perhaps a book. I said I was pursuing answers to several questions in the documentary:

1. What does the last frontier in the continental United States look like 100 years after the official closing of the frontier and on the cusp of the millennium?
2. How is democracy practiced on this last frontier? Does it follow the tenets of Jeffersonian democracy?
3. How does the surrounding land affect community formation and the practice of democracy?

Knowing the questions ahead of time and where I was heading allayed some anxieties. I also interviewed gatekeepers in the several communities and spent at least one day in each community before I began photographic work. I decided not to require a signed consent form because I did not want that legalism posing as a potential barrier to open communication. While consent forms supposedly protect both parties, they are more about protecting the documentarian.

I spent multiple sessions with several communities, especially those for which I knew my limited personal experience and world view might be an obstacle to understanding. For the Native Americans, the fundamentalist religious community, the constitutional separatists, and the New Age communitarians, I organized photo elicitation interviews. This gave me a greater understanding of their communities and a second layer of reflective comment. Typically, there were several people looking at the work prints during the sessions, and I said

that if there were unanimous agreement on whether or not a certain photograph should be included or excluded, I would follow that direction. If there was not unanimity, I said I reserved the right to make final choices. Seldom was there unanimity. Nevertheless, the photo elicitation process showed the communities what I was looking at and what would possibly be published.

I was not able to include one source because I felt he wanted to use me as a public relations agent for the organization he represented, the Utah Woolgrowers Association, a trade and political action group. While sheep ranching is a major cultural force in the area, and while I used some of the information he provided me as background, I could not publicize his voice or direct quotations, because when I questioned him regarding research I had done about damages caused by overgrazing, he refused to concede the legitimacy of an opposing viewpoint. I was able, though, to include sheep ranching in the documentary by articulating the voices of migrant New Zealand sheep shearers in the text. Then, I was able to expand the voice of ranching in general because two cattle ranchers were sufficiently self-reflexive in my interviews that I felt I could use them as ranching archetypes to add to that collective voice.

One person and one culture declined to become a part of the documentary. A miner with a valid permit to mine gold using a hydraulic process, which is hard on the land, agreed to talk and provide background, but he did not want to be identified. He was afraid his operation might be sabotaged by Earth First!, a radical environmental advocacy group. Respecting his wishes, I did not press the issue. I was able to weave the voices of prospectors into the narrative when two grizzled hard-rock miners agreed to participate.

I wanted to include a polygamous community in the documentary because their culture is a dominant player in the society. I received initial permission from a church patriarch to visit the outpost, but he wanted to clear it first with the people on site. But they declined to let me interview or photograph them, because they felt they had nothing to gain from exposure. Their refusal was unfortunate, because it left a hole in my book, a hole that wound up being filled by the vocal perceptions of people outside the polygamous community commenting on the practice of plural marriage and its social effects. I did not edit out all references to polygamy, though, because the model does not require guardianship or self-censorship. I could not protect the polygamist community from their choice to remain invisible.

Bear River is a documentary about water in the West, using a particular river as a way to talk about the issues. The river has been in the news because it carries the last sizable amount of surface water that can be used to slake the thirst of a rapidly growing area. To tap into those water rights, dams will have to be built, which is a politically, socially, and economically charged topic.

This documentary required a lot of background research into the science of

rivers: geomorphology, hydrology, and ecology. I interviewed a lot of earth scientists, and documentaries that have a science-based component can be difficult for documentarians, because typically they are generalists and often do not have the required pedigree in science to read the literature, let alone interview scientists. So, I had to get their voices right, not only because the science-based description of the river had to be correct, but also because their professional reputations were at stake if I attributed a false fact to them because of my ignorance of the data and what it meant.

They were ready to talk to a fellow academic, even though I come from the humanities rather than the sciences. But before I felt comfortable interviewing them, I knew I needed to steep myself in the scientific literature. I spent a winter on sabbatical doing basic research before I began the interviews. In my initial query letters to them explaining the objective of my documentary, I was able to refer to my earlier *People of the West Desert* documentary as an example of how I apply the long-form model of a documentary. While *Bear River: Last Chance to Change Course* attempts to retain the voice of the river, I also wanted to tell the stories of the various communities—farmers, hydropower generators, biologists, hydrologists, suburban water developers, recreationists, therapists, teachers, and conservationists—that have a stake in the river and its water. Some of them were scientists. Most were people who interacted with the river in a more general, non-scientific fashion, although several of them represented water-user organizations or stakeholder associations.

I received informed consent from all my target archetypes. Again, I did not use a written consent form. But I did use another kind of consent tactic that I had not used in *People of the West Desert*. Because so many of the voices in the book were going to be scientists, I decided to let them read the draft chapters in which they appeared to make sure that I did not attribute erroneous information to them. In my letters I included this common language:

> As you know, I taped our interview, so the direct quotes are literal transcriptions. What I'm looking for is help with factual information. If there is an error of fact in the chapter, or if there is new or additional information that could be added that would aid clarification and veracity, I'd like to incorporate that in the text.
>
> Please understand that this isn't an invitation to edit the chapter to your perspective. This chapter is but one of many in the book. There are several points that I'm making regarding the Bear River, and this chapter is weaved into a larger fabric composed of multiple stories and points of view, as well as geomorphic, hydrologic, ecologic and historical background. I reserve the right to make the ultimate interpretations and decide upon the perspective that I think best pieces together the complex narratives that are the Bear River.

Because I gave this opportunity to the scientists, I felt it only fair to make the same offer of editorial preview to the other participants in the documentary.

I was concerned that this consent tactic could open up a can of worms. Surprisingly, it did not. A few scientists offered clarified wording in my explanation of hydrologic or geomorphic processes, but for the most part, I got it right. I also was surprised by the responses of stakeholders who were official spokespersons for their stakeholder groups. The general manager of a water wholesaler that would receive Bear River water did not cringe when I used quotations from our interview where he said that water problems in the West ultimately are tied to unsustainable population growth. The president of the largest canal company on the river agreed that exercising senior water rights sometimes creates real hardship on junior water users. The president of the Utah Trappers Association felt that I had been fair in representing his avocation in text and photographs, even though trapping is a touchy subject in an increasingly urban West where newcomers look at harvesting wildlife with some disgust.

Oddly, one ranching family objected to their representation, even though it was quite positive. At the time of our first interview, the family was feeling besieged by pressures from several directions, some from environmentalists, but mostly from increasingly global commodities markets. In the response to my draft chapter, one of the members of the ranching family objected to how she sounded harsh in her comments regarding environmentalists. That was awkward for her, because the family was negotiating with The Nature Conservancy to create a permanent conservation easement across some of their ranchland. However, the direct quote chastising environmentalists was plainly legible on the tape, and I said I could not edit out that comment because of her current situation. From reading and other interviews, I knew that the feeling she articulated was one that some ranchers have of environmentalists. That mutual antagonism of ranchers and environmentalists in the West is an ongoing problem, and it was an issue that needed to be a part of the documentary. But upon reflection, I sensed that her comment was really made in the context of larger problems and pressures facing ranchers and farmers feeling pinched by an economy that does not support the family farm. So, in the final text I negotiated the meaning of her remarks by placing them within that larger, economic context so that it did not seem like she was singling out environmentalists as the seat of all their problems. After all, they were committed conservationists themselves. Suggesting otherwise would mischaracterize them. Enlarging the context of her remarks, I felt, was more fair and truer to her feelings. I felt I could make this change to amplify the fidelity of her voice without compromising my authorial control.

The long-form documentary is not a perfect vehicle for narratives, a space free of constraints that guarantees access, objectivity, and a regime of truth.

Inevitably, compromises are part of the process of creation. But constructive compromise that recognizes the rights of both parties is the crux of negotiation, and an ethically based documentary willingly engages that process. The documentarian creates the long-form narrative from multiple voices and images. The more authentic those voices, the more resonant the tone, and the more crisply focused the picture.

8 That Story's Ridiculous; Look, Here's What Happened

Theoretical Perspective

The case was a tabloid editor's dream. It had celebrities (the Kennedy family), death (beating with a golf club), and sexual desire (of one 15 year old for another). I am telling you about this case, however, because of the prosecution's visual persuasion.

On October 30, 1975, Martha Moxley, a 15-year-old girl from a gated community in Greenwich, Connecticut, was beaten to death with a golf club (*Connecticut v. Skakel*). Michael Skakel, also 15, a cousin of Robert F. Kennedy, Jr. and Martha's neighbor, was charged with her murder. When the trial began twenty-seven years later, there was no eyewitness and no direct physical evidence linking Skakel to the killing. The prosecution team, therefore, had to tie together an array of circumstantial evidence to try to convince a jury of Skakel's guilt. The team's success depended on many factors, including the investigators' work, the team's diligent preparation for the trial, and the prosecutor's oratorical skills (Carney and Feigenson, 2004).

The prosecution team also effectively used visual persuasion technologies (Carney and Feigenson, 2004). It used a customized interactive multimedia presentation system to display all of its demonstrative evidence throughout the trial, including photographs of the neighborhood and crime scene, diagrams of the locations at which evidence had been found, and an audiotape of a telephone interview Skakel had given to a journalist in the late 1990s. In the closing argument's most dramatic moment, jurors looked at a large screen; read the word "panic" from the transcript; heard Skakel say "panic"; and simultaneously saw a photograph of Martha's lifeless body (Carney and Feigenson, 2004).

Using the multimedia CD-ROM improved the conduct of the trial at least four ways, according to Brian Carney, a former prosecutor whose consulting firm created the technology, and Neil Feigenson, a professor of law (Carney and Feigenson, 2004). First, each piece of demonstrative evidence was presented immediately rather than passed from one juror to the next. Second, information was displayed on a large screen, which allowed people to focus on the testimony's substance. Third, presenters could use a laser pointer to indicate the relevant part of the image on the screen. Fourth, having all visual, audio, and textual information available on demand enabled the prosecution to either support or contradict information from the witness stand with the

medium best suited for the job. In other words, the prosecutors used visual communication to clarify the evidence, to captivate the jury, and to convince the decision-makers (Carney and Feigenson, 2004). Skakel was convicted on June 2, 2002, and received a sentence of twenty years to life in prison. He continues to fight his conviction.

In another high-profile case, the prosecution team used eighteen colorful, three-dimensional computer images to clarify, captivate, and convince. On November 25, 2006, five police officers fired fifty bullets at a 23-year-old New York City black man as he left a Queens strip club. One of the bullets killed Sean Bell as he left his bachelor's party in order to return home in order to get some sleep before his wedding later that day. Two detectives were charged with first-degree and second-degree manslaughter, and a third detective was charged with reckless endangerment. The detectives waived their right to a jury, so a judge decided the case.

Prosecutors used the three-D images to create a virtual reality display to argue that the detectives had fired carelessly. A **virtual reality** display is a digitally constructed world in which users may see, hear, move about, and interact with simulated objects and persons, creating a heightened sense of being in a real place, among real things. The display included separate red, green, and blue lines that depicted the estimated paths of each shot. It also showed that some bullets landed as far as a block from where the police shot Bell. According to a *New York Times* reporter, the display resembled a video game, but it also gave spectators the same street-level vantage point that the detectives may have had (Eligon, 2008). On April 25, 2008, Justice Cooperman acquitted all three men of all the charges.

Virtual reality displays can be viewed on the electronic monitors that pervade modern courtrooms. On these screens jurors and judges also watch video depositions, distant witnesses, as well as all manner of evidentiary exhibits. Jurors even watch movies made for closing argument (*Standard Chartered PLC v. Price Waterhouse*, 1989). In addition, lawyers show: a) "day in the life" documentaries of accident victims for personal injury lawsuits (Sherwin, Feigenson, and Spiesel, 2007); b) computer animations and simulations to illustrate expert witness reconstructions of crimes and accidents (Sherwin, Feigenson, and Spiesel, 2007); c) video montages as a form of legal argumentation (*Standard Chartered PLC v. Price Waterhouse*, 1989); d) video previews for pressuring opposing counsel into making a favorable settlement (Tarantino, 2004); e) video montages of murder victims' lives for victim-impact evidence in sentencing proceedings (*Hicks v. Arkansas*, 1997; *Salazar v. Texas*, 2002); and f) digitally enhanced photographs with Photoshop overlays in order to clarify forensic evidence (*State v. Swinton*, 2004).

Imagine if you wanted to conduct a research study about how attorneys use visuals in trials to persuade juries and judges. If so, you would draw upon a theoretical perspective based on visual persuasion.

In the next few pages I paraphrase and augment a set of insights into visual persuasion that was compiled by Sherwin, Feigenson, and Spiesel (2007). Their concepts come from a variety of disciplines, including neurobiology, narrative

studies, and visual media studies. If you combine these ideas with my thoughts about visual symbol systems from Chapter 3, and my points about how video improves communication from Chapter 6, then you can see the outline of a developing theory of visual communication.

Neurobiology and Psychology of Vision

From neurobiology we can learn why pictures both resemble and differ from other texts. When you look at a page of written text, your brain sorts out discrete bits of information (letters, words) and assembles that information into a coherent idea. When you look out the window, your brain also sorts and assembles bits of information into a coherent view. When viewing reality (and realistic pictures), however, your brain processes the information quicker than when viewing words. Why? Because in order to survive in prehistoric times, humans had to immediately react by fighting or fleeing. Humans, therefore, developed the ability to rapidly sort visual information and to register its emotional significance. Humans have not had an equivalent evolutionary need for processing words quickly; therefore, slower, more conscious processing occurs with words.

As a result of these biological and psychological influences, pictures differ from words in at least seven ways.

One, pictures tend to have a greater impact because they tend to be more vivid. Information is **vivid information** to the extent that it is emotionally interesting; concrete (great detail); and close to its referent in a sensory, temporal, or spatial way. As a result a) people pay more attention to vivid information; b) they remember the information; c) they use the information more often (Bell and Loftus, 1985).

Two, visual displays can convey more information than words alone, so they can enable viewers to understand more. For example, graphs and diagrams can show relationships between data that would remain obscure if the data appeared in a table or in a written description (Tufte, 1983, 1990, 1997). Similarly, animations and simulations can represent with clarity and precision small but legally significant changes within a given time period (Dunn, Salovey, and Feigenson, 2006). **Animation** is the process of filming still images in sequence to give the illusion of movement when the images are projected. **Simulations** involve the input, calculation, and manipulation of the rules of physics—for example, the effects of acceleration, gravity, and friction. While animations involve illustration, simulations involve both computation and illustration.

Three, photo-realistic pictures tend to arouse cognitive and emotional responses similar to those aroused by the real thing. We see a person, place or thing in a picture; we care about that person, place or thing, so we get excited, scared, sad, or happy. Similarly, visuals enable us to experience empathy by enabling us to step into the shoes of others and to experience vicariously what we have not experienced directly (Eisner, 1997).

Researchers have used mock trials to test pictures' emotional impact. For example, one group of jurors saw gruesome photos, and another group did not

see any photos. The group that saw gruesome photos reported emotional distress and physical reactions, including greater anger at the defendant. They convicted subjects at a significantly higher rate than the group that did not see photographic evidence (Bright and Goodman-Delahunty, 2006).

Pictures' ability to elicit emotions contributes to their "hidden" power. Although the photographs had obviously affected the mock jurors, the jurors did not think that photographs should affect their judgment and they did not think the photographs had affected their judgment. In fact, the mock jurors considered their levels of impartiality to be moderately high.

Four, much of a picture's meaning can be grasped all at once. It takes a lot less time and mental effort to see a picture than to read a thousand words (Kosslyn, 1994). This quick, overall viewing helps people's understanding because it allows people to apprehend the context as well as the subject (Pink, 2005). Quick, overall viewing hurts, however, because people can rush to the conclusion that they understand the picture and what it represents.

Five, when people view photo-realistic pictures, they tend to accept what they see as credible evidence. Moreover, people trust moving pictures even more than still pictures. People viewing films and videos tend to forego critical thinking. They focus on the picture immediately before their eyes and they have no time to reflect on the pictures that had gone by (Barry, 1997). As a result, moving pictures tend to generate less counter-argument.

Six, some of a pictures' meaning always remains implicit, or "unspoken," so pictures seem more ambiguous than the words in a scientific report (Eisner, 1997). Pictures' ambiguous meanings would present two problems if you wanted to send and receive clear messages. One, viewers would need to work harder to interpret pictures' meanings. Two, senders could not be sure that the receivers correctly interpreted their message. On the other hand, in some circumstances, people prefer messages with ambiguous meanings. For example, many advertisements and artworks intentionally have multiple meanings. Such pictures help us a) tolerate ambiguity (Goel, 1995); b) experience surprise (Eisner, 2002); c) use our intuition (Eisner, 2002); and d) conceive of imaginative possibilities (Eisner, 2002).

Seven, pictures, more than words, convey meaning through associational logic that operates in large part at a subconscious, emotional level (Martin and Williams, 1990). People may believe they use inductive and deductive reasoning to make decisions, but often they simply react to a picture's emotional impact and to its associations with other images, thoughts, and feelings. People's later conscious cognitive processing rationalizes their initial, quick judgment. Moreover, their initial picture-based conclusion sticks because people seldom subject their early decisions to critical scrutiny (Haidt, 2001).

Narrative Studies

For as long as people have been around, they have told stories. They use stories to share information, cultural values, and experiences with others. They like

stories because viewers and listeners can assimilate the details more easily than if the same information appeared in serial lists. Moreover, people find stories more compelling than lists (Gershon and Page, 2001).

Powerful litigators tell effective stories. They often convert legal discourse into a story form in order to first help jurors organize and make sense of the evidence. They also use stories to convince jurors whom to reward and whom to punish (Stachenfeld and Nicholson, 1996).

But what is a story? Amsterdam and Bruner (2000: 113–114) offer what they call a "bare-bones" definition of a **narrative**:

> A narrative can purport to be either a fiction or a real account of events; it does not have to specify which. It needs a cast of human-like characters, beings capable of willing their own actions, forming intentions, holding beliefs, having feelings. It also needs a plot with a beginning, middle, and end, in which particular characters are involved in particular events. The unfolding of the plot requires (implicitly or explicitly): 1) an initial steady state grounded in the legitimate ordinariness of things; 2) that gets disrupted by a trouble consisting of circumstances attributable to human agency or susceptible to change by human intervention; 3) in turn evoking efforts at redress or transformation, which succeed or fail; 4) so that the old steady state is restored or a new (transformed) steady state is created; 5) and the story concludes by drawing the then-and-there of the tale that has been told into the here-and-now of the telling through some *coda* — say, for example, Aesop's characteristic moral of the story.

Every trial includes two contrasting stories: one from the prosecution team and the other from the defense team. For example, prosecutor Marcia Clark told a whodunit mystery story in the O.J. Simpson double murder trial. Clark wanted jurors to believe each piece of evidence was like a piece of a jigsaw puzzle. When all of the pieces fit together, jurors could see the murderer's picture. During her summation, as she rattled off each clue, jurors saw yet another picture fragment of Simpson's face click into place on a large screen. Clark told of Simpson's opportunity to kill (click), his motive (click), the victim's blood on his socks and glove (click), the blood trail that he left at the scene (click). Finally, the familiar face of O.J. Simpson appeared; mystery solved (Sherwin, 2004). Johnny Cochran, of course, told a different story. He wanted jurors to believe they were leading a heroic quest against "genocidal racism" by the state. Cochran said, "If you don't stop it (i.e., the state's cover-up) then who? Do you think the police department is going to do it? . . . You police the police through your verdict" (Sherwin, 2004).

After closing arguments, jurors create their own story of what happened. They base their story upon the facts and arguments they heard during the trial, the guiding rules given by the court, their own personal experiences and beliefs, and the interactive discussion among all the jurors (Gabriel, 2008). Expectations conditioned by popular culture also shape stories. For example,

crime shows such as *CSI* and *Law & Order*, which move from present to past and back again, have conditioned jurors to non-chronological stories (Gabriel, 2008).

Visual Media Studies

Professional storytellers used to entertain a crowd of people gathered in a village square and they still do in a few locations, such as Marrakech, Morocco. Today, however, the mass media, especially television and movies, have become the world's storytellers. Legal storytellers, therefore, must have a sophisticated understanding of such media in order to grasp how people think about truth, law, and justice. Only then can they effectively tell their story before a particular jury (Meyer, 2001). In fact, lawyers follow in the footsteps of advertisers and politicians by learning how to: a) get the message out; b) tailor its content to a medium; c) spin the image; d) edit the bite; e) impress the viewer (Sherwin, 2004).

Not only did TV and movies supersede griots, bards, puppeteers, and wandering storytellers, but these media also changed the way people tell stories. Mass media rely more upon visuals to trigger associations than on words to tell a linear story. Moreover, instead of representing something in the real world, mass media visuals and sounds often refer to *other* visuals and sounds, which then trigger thoughts and feelings. For example, the prosecution in *Maxus Corp. v. Kidder, Peabody & Co.* used a popular TV show and associative logic to damage a witness's credibility. In this case, Maxus Corporation accused the investment firm Kidder, Peabody & Co. of insider trading. Kidder's executive, Martin Siegel, was deposed during discovery, and under the threat of criminal prosecution, he took the Fifth Amendment more than 600 times. To take advantage of his evasiveness, Maxus' lawyers displayed an empty three-by-three grid that resembled a graphic from *Hollywood Squares*. Like the TV show's opening sequence, a picture of a person's face would fill a square, then another picture would appear, and another, until all nine squares were filled. In the trial, however, Siegel's picture appeared in a box each time a prosecutor asked a different question. When the ninth and final image of Siegel became visible, the audio from Siegel's responses to each of the nine questions played in unison: "On the advice of counsel, I respectfully decline to answer on the grounds of my privileges against self-incrimination" (Sherwin, Feigenson, and Spiesel, 2007).

Aside from the shift from words to visuals, another significant change concerns the growing, media-generated difficulty of clearly demarcating fiction and reality. It is hard to know where the documentary ends and the docudrama begins, or where the photograph ends and the Photoshopped illustration begins. The problem becomes worse with time. In our memories, information from real sources and from fictional sources becomes mixed together. In that situation, our default mode—credulity—kicks in, and when we lack the inclination to undertake critical analysis, we believe the fact–fiction story.

Fact and fiction, information and entertainment, worked hand in hand in a civil dispute involving an accounting firm, Price Waterhouse, and a bank, Standard Chartered. In arguing their case, the bank's lawyers used a visual montage showing a broad range of visual images, but the central image, the *Titanic*, remained on the screen throughout. The bank's attorneys wanted to make the point that being the largest accounting firm (or the largest ship at the time) is no guarantee against carelessness and disaster. Price Waterhouse's attorneys objected to the indiscriminate mingling of documentary images and feature film images of the *Titanic*; but the judge overruled their objections; and later the judge's ruling was reversed on appeal (Sherwin, Feigenson, and Spiesel, 2007).

Not only has a mixture of fiction and non-fiction visual media become a major source of our knowledge, but now we can also interact with these visuals. Increasingly, prospective jurors come to court with the expectation that they should be able to seek out and interact with information rather than passively receive it. Moreover, lawyers cater to such expectations.

Attorneys used a complex virtual reality system, for example, for the Bloody Sunday Tribunal, established in 1998 to re-examine the facts of the 1972 killing of thirteen Northern Irish citizens by British soldiers in the streets of Derry. Interacting with computer-generated views of various locations in Derry, witnesses could revisit scenes from any angle and draw arrows on the screen to describe the events they recalled. In some instances the VR system enabled the Tribunal to confirm that witnesses could have seen what they remembered seeing, given the layout of the city and the witnesses' locations at the time (Sherwin, Feigenson, and Spiesel, 2007).

Goals

Pre-trial jury research falls into the applied research category. Jury researchers want to understand jurors' state of mind, including their value beliefs, legal knowledge, and expectations. Jury researchers also want to learn how jurors will react to evidence, arguments, and key themes during the trial. Attorneys then use this information to create the most persuasive stories for their opening statements and closing arguments.

Research Questions

When planning jury trial research, Richard Gabriel, an expert on pre-trial research and presentation strategies, recommends starting at the end and working your way backward. He suggests asking these questions (Gabriel, 2008):

1. What information do jurors need to construct a cohesive story to justify the desired verdict?

2. What do jurors need to hear to overcome any weaknesses in the case?
3. What story sequence will jurors need to follow in order to overcome weaknesses in the case?
4. When will jurors respond weakly, or not at all, to strong evidence? When will they need some context to understand the evidence?
5. How do jurors re-define the key jury instructions or key terms in the case? In addition, where do they get lost and how would they like witnesses and lawyers to clarify these problems?
6. What do jurors need, on a psychological and emotional level, to feel content with their decisions? Will they react better to a scholarly approach or an indignant, combative approach?
7. What kind of jury would be best for the case? What life experiences, personality, attitudes, and demographics would favor the plaintiff or defendant?

Brief Description

When pre-trial researchers want to learn how jurors might regard their case, they often conduct focus groups. A **focus group** is a research technique that collects data through a moderator-led group discussion "focused" on a particular set of questions or a topic (Morgan, 1996).

Pre-trial researchers want to learn jurors' concerns so they can directly respond to those concerns. Researchers also want to identify areas of potential confusion so they can break complex arguments down into easy-to-understand yet highly compelling analogies, metaphors, stories. In summary, researchers use focus groups to discover what jurors want to hear, and how and when they want to hear it.

Two points about focus groups deserve emphasis. One, the interaction occurs among group members rather than between the moderator and the group. Because they interact with each other, participants give valid answers rather than socially correct responses (Bender and Ewbank, 1994). Two, the moderator limits the discussion to a few issues and concerns. A narrowly focused discussion encourages participants to give specific, detailed answers, which should contribute to new knowledge.

A focus group generally consists of five to ten people, who meet one time for a discussion. Standard focus groups typically last one to two hours, but trial focus groups take longer—perhaps four hours—depending upon how heated the discussions get. Ideas from a focus group may be consistent or inconsistent; the group need not reach a consensus or solve a problem.

Units of Analysis

Since the goal is to learn how visuals can help tell a persuasive story, and since your method is to conduct focus groups, your unit of analysis might

be opinions about visuals that were collectively developed by a focus group. Do not assume that individuals held these opinions before the group was formed, and do not assume the entire group holds these opinions; instead, assume the opinions were jointly constructed during a particular group meeting (Smithson, 2000).

Sampling

In order to obtain an adequate quantity of your units of analysis—opinions about visuals—you need to draw three to five purposeful samples of six to nine people. You want people who can comfortably talk about their ideas and feelings with a group of others.

Jury researchers do not care about participants' race, age, gender, occupation, etc. because research has established that such demographic factors fail to relate in any meaningful way with jury verdicts (Singer, 1996). Only value beliefs and life experiences correlate with how jurors will actually judge the case. **Value beliefs** are the basic beliefs, ideas, assumptions, and attitudes people hold most central to their personalities. Jury researchers want to recruit people who possess value beliefs that run directly counter to the value beliefs that underlie their client's case because such contrarians will likely uncover and spotlight the case's problem areas.

Jury researchers use several strategies to find participants. One, they may place advertisements in newspapers or on the Internet. For example, if attorneys defend a drunk driver and they want focus group members with opposing value beliefs, jury researchers could use this ad: "Tired of drunk drivers endangering others? Want to participate in valuable research concerning this issue?" On the other hand, if attorneys prosecute a drunk driver, then jury researchers could use this ad: "Tired of the government intruding into your personal business? Want to participate in valuable research concerning this issue?" Two, focus group researchers may recruit people from other events or meetings, such as people from MADD (Mothers Against Drunk Drivers). Three, they may use temporary employment agencies. Although jury pools predominantly have fully employed jurors, and temp agencies send underemployed people, the benefits (quick and easy) might outweigh the limitations.

Focus group researchers should not, however, ask people they know. Friends may either share researchers' value beliefs or they may know who (prosecution or defense) had hired the researchers, and then friends may try to "support" the researchers' side of the case.

Once you have identified participants, then you need to get them to attend the focus group. You should make attending easy and comfortable. After an initial personal contact, send a personalized follow-up letter. Make a reminder phone contact right before the meeting. Also, offer participants either a financial incentive, such as $50, or a non-financial incentive, such as a gift of chocolates. Even if you follow these suggestions, however, you should expect

several no-shows, so focus group researchers recommend over-recruiting by 10 to 25 percent.

Focus group researchers provide conflicting advice about the homogeneity or heterogeneity of a group. Some argue that using similar participants facilitates discussions and affords easier comparisons across groups. Others argue that such segmentation allows for fewer contrasting opinions within a group and it necessitates a greater number of focus groups. I say let the fur fly. Let a group of outspoken people with contrasting value beliefs generate a lively discussion. Encourage a "spirit of contradiction" (Billig, 1996), so arguments and counter-arguments will be elaborated and co-constructed by the participants.

Methods

In order to determine how visuals can tell a persuasive story to a jury, you could conduct focus groups. This section explains a) choosing the quantity and type of groups; b) choosing the setting and atmosphere; c) creating the question guide; d) recording the discussion; and e) moderating the discussion.

Choosing the Quantity and Type of Groups

No researcher would be satisfied with one focus group. Some researchers may use fifty or more groups. Most of the time, however, people start with four to six groups. Then they quickly determine if additional groups might yield supplemental information or if the groups they have already conducted have produced all the useful information.

For trials, researchers conduct one series of focus groups early in the trial planning process—at least ninety days before discovery ends (Singer, 1996). With these focus groups, researchers learn what experiences and concerns jurors bring to the case. Based upon this information, researchers can decide whether to add witnesses or pieces of evidence in order to properly educate jurors about the case. Researchers may also conduct a second series immediately before trial. These focus groups help determine how jurors will perceive demonstrative exhibits, testimony, and opening statements.

According to Gabriel (2008), trial researchers may conduct one or more of the following types of focus groups in order to prepare for trial: a) comprehensive; b) opposing case; c) advocacy; d) values; e) story development; and f) visuals-demonstrative evidence.

A comprehensive focus group aims to assess jurors' pre-existing comprehension of complex case issues. The moderator begins by asking the group about its basic opinions and definitions related to the case's key issues. Then the moderator presents legal points likely to be made by the prosecution and defense. The moderator then asks which aspects cause confusion. The group brainstorms ideas to help clarify these problem areas and makes recommendations for graphics. The research team uses this information to discover

how to describe the case, issues, and law in a way that jurors will understand and embrace.

An opposing case focus group poses issues, laws, and arguments from the opposition's point of view. The moderator asks members about the opposition case's strengths. Focus group members then explain what they need to hear from your side in order to minimize the opposition's strengths. The research team uses this information to choose words, phrases, and definitions that will inoculate jurors against the opposition's tactics.

In an advocacy focus group, members themselves play the role of the attorney for your case. The moderator gives them a brief neutral overview of the matter, the opposition's strongest points, and an outline of the possible arguments in support of your case. Focus group participants then rank your arguments according to strength and impact. They also create the strongest counter-arguments possible. Finally, members use their own words to create the best presentation for your case. The results tell researchers how jurors might weigh evidence and arguments in your case. The results also suggest the best sequencing for your arguments.

A values focus group assesses community opinion and sentiment about the case's general issues, but not about the specific facts of the particular case that will be tried. The moderator initially asks participants about their basic beliefs; for example, in general, do they favor landlords or renters in disputes about deposits. The group then discusses whatever it finds important or compelling about the issue. With this information, the research team can gauge how resistant jurors might be to persuasion. The team can then develop a theme to frame the case in the most appealing way.

A story development focus group identifies the best storyline to thread through each phase of the trial. The moderator provides members with minimal case facts from both sides. Members then create story lines as they see fit, stopping when they need additional information to fill in the gaps of the story they want to tell. The research team uses this information to develop opening statements and closing arguments.

A visuals/demonstrative evidence group gauges juror reactions to demonstrative evidence and various types of visual displays. The moderator shows your key pieces of evidence and visual displays as well as the same number of pieces of evidence and visual displays for the other side. The focus group explains how it weighs the evidence and visuals. It also notes any points of confusion about the evidence or displays. With this information, the research team decides if it needs to adjust its story and how.

Choosing the Setting and Atmosphere

The proper physical setting can encourage respondents to openly share their opinions (Basch, 1987). Choose a neutral location, such as a hotel suite, and not an office (especially a law office), which can be intimidating (Singer, 1996). Place chairs around a table so participants can sit close together. Provide

refreshments to make the experience as pleasant as possible. Keep the room free from interruptions.

Creating the Question Guide

Moderators attempt to get the group talking on a more-or-less focused topic. Sometimes they use a consistent set of pre-determined questions; other times moderators generate new questions based upon the group's earlier discussion. Standardization offers the advantage of facilitating comparison across focus groups, but standardization also forces moderators to work with whatever questions researchers chose prior to beginning the focus groups. As a compromise, moderators could divide each focus group into two phases. In the first phase, they would allow the discussion to flow naturally, but in the second phase, moderators would use the pre-determined questions. Of course, moderators could also do the reverse: start with standardized questions and then let new questions emerge from the discussion. Moderators have an additional option: they could ask participants to look over three to five alternative definitions, pieces of evidence, visual displays, arguments, stories, etc. Moderators then ask participants to talk about the advantages and disadvantages of each. Participants then select the one that they like the best and explain why.

Recording the Discussion

Recording a focus group presents three challenges (Sim, 1998). One, data need to be collected not only on what participants say, but also on how they interact with one another. Two, quotations need to be attributed accurately to individuals. Three, the recording process should not interfere with, or detract from, the group's discussion. To meet these challenges, focus group researchers use digital audio equipment rather than video camcorders, which seem too obtrusive. They place a microphone in the middle of the table and they place the recorder on a nearby chair. Researchers ask an assistant moderator to take notes during the discussion. This assistant writes about non-verbal communication and indicates who speaks when. Of course, researchers must obtain participants' consent to record the focus group.

Moderating the Discussion

The moderator performs many tasks in a focus group, including: a) creating a non-threatening, supportive climate that encourages all group members to share their views; b) interjecting probing comments, transitional questions, and summaries without interfering too brusquely with dialogue among participants; c) covering important topics and questions in the prepared outline while relying on judgment to pursue other lines of questioning if they seem more revealing; d) presenting questions in an unbiased way and being sensitive to

possible effects of vocal inclinations, facial expressions, and other non-verbal behavior; e) remaining non-judgmental—verbally and non-verbally—to participants' responses; f) encouraging involvement among all members, which may require drawing out shy participants and politely directing attention away from dominating participants; and g) determining how group members feel about ideas or feelings that others expressed (Basch, 1987).

To be successful, moderators must respect participants. They must believe the participants have wisdom no matter what their level of education, experience, or background. Indeed, participants may have limited knowledge on the topic, hold opposing values to that of the researchers, or seem to have fuzzy logic, but moderators listen attentively with sensitivity, trying to understand members' perspectives.

The moderator begins the focus group discussion by welcoming participants and providing an overview of the topic. He or she explains the ground rules, which means the moderator explains how to ensure the discussion goes smoothly. The moderator then reaffirms there are no right or wrong answers, explains confidentiality, discusses taping of the sessions, and asks the first question.

During the focus group, the moderator encourages participants to ask each other questions, exchange anecdotes, and comment on other's points of view (Kitzinger, 1995). Especially when participants share some common frame of reference, they can challenge each other's ideas and motives in a pointed fashion. As a result of this give and take of discussion, participants may modify their opinions, or at least their statements about their opinions.

A moderator may initially let participants talk as much or little as they desire, but as time goes on, he or she often intervenes more forcefully. For example, the moderator may urge debate to continue beyond the stage it might otherwise have ended, challenge people's taken-for-granted reality, and encourage participants to discuss the inconsistencies within the group.

Following each group, members of the research team conduct a debriefing. They identify issues that may affect analysis, such as domineering or quiet members, discuss what went well and what did not, and suggest possible modification to the interview guide.

Data Analysis

After you have conducted your focus groups, you need to identify your units of analysis—opinions about visuals—and then use a connecting strategy to analyze those opinions. From the interaction within a focus group you must determine how the focus group uses the visuals to understand the evidence. Attorneys can then use your analysis to tell a story that will overcome obstacles to their desired verdict.

If researchers selected a homogenous group of people for a focus group, then participants may initially establish some common ground because they share a profession, background, or certain experiences. On the other hand,

if the focus group, like a jury, includes a wide variety of people, then partici-
pants must find another way to establish common ground (Hyden and
Bulow, 2003). The moderator's initial questions can get the group started.
Participants, however, usually have no preconceived ideas about how to act in
a focus group. They must decide together how they want to talk about the
case and accomplish their goals. Researchers observe how some people initially
toss out spontaneous ideas; others challenge their ideas; the original speakers
then qualify their assertions; others join in the conversation and express their
personal experiences; new arguments arise; and consensus is reached, or not.
Jury researchers care about this decision-making process. They want to know
how the group co-constructs a narrative together so they can prepare for their
trials.

You can also use the following twelve questions to analyze the data
generated by the group's discussion (Stevens, 1996: 172):

1. How closely did the group adhere to the issues presented for discussion?
2. Why, how, and when were related issues brought up?
3. What statements seemed to evoke conflict?
4. What were the contradictions in the discussion?
5. What common experiences were expressed?
6. Were alliances formed among group members?
7. Was a particular member or viewpoint silenced?
8. Was a particular view dominant?
9. How did the group resolve disagreements?
10. What topics produced consensus?
11. Whose interests were being represented in the group?
12. How were emotions handled?

Data Displays

Researchers who conduct focus groups, especial trial researchers, might display
their analyses as a vignette. A **vignette** is a focused description of a series of
events, with a narrative structure; it is often limited to a few key actors in a
bounded space and a brief time span (Miles and Huberman, 1994). In other
words, a vignette is a brief story.

You can create a vignette for each of several focus groups. Then you might
convene a final focus group and ask its members which vignette seems most
persuasive and why.

In addition to a vignette, you might also present a few sequences of
comments from the group's discussion. In general, avoid presenting quotations
from one individual at a time, because such a display gives the impression that
individual viewpoints can be isolated from the context in which they were
expressed.

Credibility, Transferability, and Dependability

When the goal is basic research, researchers use focus groups in conjunction with other data collection methods because, by themselves, focus group findings lack the necessary credibility, dependability, and transferability. Focus groups aim "not to infer but to understand, not to generalize but to determine the range, not to make statements about the population but to provide insights into how people perceived a situation" (Krueger, 1994: 3). When the goal is applied research, however, a series of three to five focus groups are quite adequate.

You can, however, take some steps to ensure credibility. For example, your final report could include answers to the following questions: How many groups were conducted and what were their sizes? Was a standardized set of questions and procedures applied to all focus groups? If not, which questions were asked for which groups? What was the basis for segmenting participants into different groups? How were participants located and recruited? How much structure did the moderator impose? How many moderators were used? What was their training and qualifications?

In addition to answering these questions, you can check for rival explanations. You may be heavily invested in a particular interpretation of the findings and may lack the self-discipline to draw a different conclusion. If so, then develop alternative interpretations of the focus group and ask a member of the group, a peer researcher, or an auditor to evaluate the different interpretations.

To increase dependability, have two or more researchers analyze the data independently and then analyze it again as a team. Use the same moderator for all of the focus groups because differences in moderator experience and interviewing style may affect the flow, texture, and content of focus group interviews. In addition, provide the same conditions or environment with each group and prepare transcripts promptly.

To improve transferability, use a sequence of direct quotes when presenting findings. In addition, describe the relevant background data of the group's members.

Internet

Focus group researchers increasingly use the Internet as a way to collect data. The main benefits of virtual focus groups, like e-interviews, include lower cost, no travel expenses, automatic capture of the discussion data, and the ability to reach remote populations for participation.

Some researchers have compared the results from a face-to-face (FtF) focus group and a computer-based focus group. Underhill and Olmsted (2003), for example, found similar quantity and quality of information in both conditions. Schneider and colleagues (2002), however, found online participants contributed briefer comments than FtF participants. In their study, participants

in four online and four FtF focus groups discussed their opinions about several health-related websites. All participants and the moderator were online in the chat room simultaneously. They typed their comments over the course of the session, and a running transcript of these comments was continuously visible to all participants. Moloney and colleagues (2003) noted some additional disadvantages of online focus groups. They found participants had trouble understanding each other. They also learned that moderators had difficulty encouraging participation and maintaining control of the group process.

Advantages and Disadvantages

Focus groups offer participants some advantages over interviews and other research designs.

1. Participants find focus groups more stimulating than interviews (Kidd and Parshall, 2000).
2. Participants may feel empowered because they play an active role in data collection and analysis (Sim, 1998).
3. Participants can provide mutual support. In a cohesive focus group, participants may freely express ideas and feelings that they might hesitate to share with people from the mainstream culture (Sim, 1998). In addition, group dynamics can allow for a shift from personal, self-blaming psychological explanations, such as "I'm stupid not to have understood" to the exploration of structural solutions, such as "If we've all felt confused about what we've been told, maybe having a leaflet would help" (Kitzinger, 1995).

Focus groups also offer researchers some advantages because participants talk among themselves rather than to an interviewer.

1. You gain insights into the way group members suppress some information and encourage other contributions to the discussion. This helps you understand group norms and the process of building common knowledge (Kitzinger, 1995).
2. You hear jokes, anecdotes, teasing, and arguing, which can tell you as much, if not more, about what people know or experience than reasoned responses to direct questions (Kitzinger, 1995).
3. You can explore the arguments people use against each other and which ones can effectively change people's minds. This information, in particular, helps attorneys prepare for trial.
4. You can document how facts and stories operate in practice (Kitzinger, 1995).
5. You can analyze how particular forms of speech facilitate or inhibit peer communication, clarify or confuse the issues (Kitzinger, 1995).

6. You can use the conflict between participants in order to clarify why people believe what they do (Kitzinger, 1995).
7. You can examine the questions that people ask one another in order to reveal their underlying assumptions and theoretical frameworks (Kitzinger, 1995).
8. You can ask participants to compare their attitudes and experiences and why they hold those views, which may be better than aggregating data from interviews (Morgan, 1996).

Focus groups have some disadvantages compared to other means for collecting data.

1. The group itself affects the data; for example, participants with dissenting points of view may feel too uncomfortable to express their ideas.
2. Your moderator affects the data because he or she asks the questions and controls the discussion.
3. You affect the results because your analysis of conflicting messages from a group's discussion requires interpretation, and this interpretation may be more subjective than objective. Focus group findings often support researchers' preconceptions.

Ethical Issues

Focus groups can present two ethical problems. One concerns confidentiality. Typically, social science researchers give participants assurances of confidentiality, but with focus groups, researchers cannot ensure that participants themselves will adhere to stipulations of confidentiality. The other problem concerns participants' over-disclosure of information during discussions of sensitive topics. Social science researchers must insure that participants in their studies experience no physical or psychological harm.

Resources

You should plan on paying for the following: room hire, snacks, incentives, transcriptions, and a highly trained moderator. Trial researchers may conduct a focus group for about the same price as a deposition.

Advice

1. Think about the final report when selecting your sample. What type of people do you want to be able to say something about?
2. Balance the number of focus groups and the size of groups with the resources available.
3. Select useful questions for the moderator. Is this a "nice-to-know" or a "need-to-know" question? What would you do with this information if you had it?

4. Make complex questions visual. If you have a difficult question, write it on a flip chart before the group begins and have the moderator flip to it when he or she gets to that question in the discussion. The visual cue helps people understand and remember the complex question.

5. Show that you care by interacting informally before and after the focus group. Ask how participants are doing and lean forward as you listen. Remember their names. Ask about family members or events in their lives.

6. Be alert during the discussion; ensure participants answer the question the moderator asked.

7. Remind the moderator to think past, present, and future. Think about what has already been discussed, what is currently being said, and what still needs to be covered.

8. When participants ask questions in the focus group, ask yourself: "Is this really a question? Do I need to give an answer?" If the question is indeed a question, you could invite someone else to answer the question. Another strategy is to postpone the answer. If the question is about a factual matter, then just answer it.

9. Find a skillful moderator because he or she will exert a powerful influence on the quality of your data.

Do not expect focus groups to reveal the strength of participants' views; focus groups can only review the nature and range of views.

Further Viewing

Multimedia about Sean Bell

John Eligon, a reporter for the *New York Times*, discusses the verdict in the Sean Bell shooting and the scene outside the courthouse (video)
http://video.on.nytimes.com/index.jsp?fr_story=d842aa38665e612af3b708
64e4a933b770aee796&scp=1&sq=sean+bell&st=m

In Queens, reactions to the not guilty verdict in the death of Sean Bell range from anger to disappointment about the justice system (video)
http://video.on.nytimes.com/index.jsp?fr_story=087005f1ef4935206448d4
60d2d50cdbedb53606&scp=2&sq=sean+bell&st=m

The acquittal of three New York police detectives who killed Sean Bell in a hail of fifty bullets prompted calls for calm from New York Mayor Michael Bloomberg, angry promises of protests by those speaking for the Bell family, and expressions of relief by the detectives (slide show)
http://www.nytimes.com/slideshow/2008/04/25/nyregion/20080425
BELL_index.html?scp=3&sq=sean+bell&st=m

Three detectives were found not guilty in the November 2006 shooting death of Sean Bell in Queens and the headquarters of Zimbabwe's opposition party was raided by police (slide show)
http://www.nytimes.com/slideshow/2008/04/25/nytfrontpage/2008042 5POD_index.html?scp=4&sq=sean+bell&st=m

Bell protestors block traffic across city (slide show)
http://www.nytimes.com/slideshow/2008/05/07/nyregion/0507-BELLPROTEST_index.html

An overview of the Sean Bell trial proceedings summarizing the testimonies of each witness and reviewing the events the night of the shooting (interactive feature)
http://www.nytimes.com/interactive/2008/04/24/nyregion/20080424_ BELL_GRAPHIC.html?scp=5&sq=sean+bell&st=m

A fatal police shooting in Queens (graphic)
http://www.nytimes.com/2006/11/27/nyregion/20061129_SHOOTIN G_GRAPHIC.html

Analyzing Focus Groups

Lars-Christer Hydén

Since it was introduced as a concept almost twenty-five years ago, "burnout" has attained a lot of interest from researchers, mass media, the general public, and certain professional groups.

In the late 1990s one of my master's students—Pia Bülow—was interested in investigating the way various professional groups conceived of and talked about burnout. She set up three focus groups consisting of teachers, social workers, and medical doctors and asked them to talk about "burnout."

Pia Bülow used the material she collected in order to write her master's thesis. Some years later she became a doctoral student with me as her supervisor. We then together started to look closer at the focus group material she had collected.

One thing we discovered was that the participants in the focus groups talked about burnout not only in many different ways but also in many capacities or roles. Sometimes the focus group members spoke as professionals; at other times as colleagues from the same work place or as individuals talking in what could be called a biographical mode. This fact seemed significant.

Pia Bülow and I wanted to understand more about the way speakers position themselves in relation to their own utterances. They may for instance be just lending a physical voice to some words or a story someone else has made up; or they may be the actual author of the utterance or the story. Alternatively, speakers can relate to the utterance as spoken from a private, personal point of view; or as a professional, giving voice to their views as experts. Or, speakers may simply act as a member of the focus group, trying to facilitate communication and having a good time.

We started by looking at the ways the group members tried to create a "group we," something shared that the members could refer to as common. We found that group members were careful to signal to the other members in what role or capacity they were contributing to the general discussion in the group. We also found that discussion in the focus group was a continuing adding of new ideas, arguments, reflections, and stories to a growing common ground (Hydén and Bülow, 2003).

How did we analyze the focus groups?

We started by transcribing the talk in the focus groups. We used what sometimes is called a multilayered transcription. This means that you start with a straightforward textual rendering of the talk organized by turns. Later you may want to look closer at certain parts of the talk and then make a re-transcription that also includes prosodic information, overlap, interruptions, etc. From the start we included pauses in our transcription and we also timed the pauses

(which is quite simple if you have your recordings on a computer and use an audio program for playing the files; most audio programs have a graph capability which helps you measure pauses).

In order to get an overview of the three different focus groups, we counted the number of turns in every focus group conversation manually; we counted the number of words in every turn (we used the word count in Microsoft Word); we also counted the number of turns and words used by every participant. Finally we counted the number of pauses and the total length of pauses in every focus group (see tables in Hydén and Bülow, 2003).

We then entered the numbers into Microsoft Excel and compared the different groups in order to see if we could find any significant differences. In this way we could observe that in one of the groups there was a lot of inter-action between the participants, while in the other groups the number of turns were fewer. We found the groups with fewer turns also had a higher number of pauses and that the total length of these was quite substantial. As a result, we could make some statements about the organization of the talk in the various focus groups.

Because we were interested in the way the participants established a common ground we thought one way to investigate this would be to look at specific parts of the group discussions. We chose to look more closely at the beginnings of the group discussions. We were especially interested in the ways that the participants interpreted the task given to them by the moderator.

We quickly noticed that the participants used different strategies starting the discussions. In one group the participants started by defining their task in professional terms, while in the two other groups the participants started a more general and abstract discussion. The group that started with a professional perspective on their common task easily defined a common ground for their further discussions while the others groups had to struggle for a longer period of time in order to find their common ground.

A second aspect of the common ground concerned the ways that participants marked their contribution to the discussions. Some participants would say for instance, "As a *doctor* I think that . . ." or someone else would say "*Personally I* think that" That is, the participants shifted foot when speaking and indicated this by a shift in either pronouns ("we," "I") or social categories (for instance "doctor") used.

We went through our material and found a lot of such footing. Speakers were careful to indicate to others in the group whether they were talking as private persons or as representatives of a profession or even speaking on behalf of the professional collective. We found this interesting because the meaning that the participants gave to their various contributions and the way these were interpreted by others shifted depending on *who* was talking (Hydén and Bülow, 2003).

This way of analyzing focus groups is time consuming. At the same time it lets you look closely at the various ways that discussions are organized and how participants create meaning. So even if for practical reasons you are unable to spend much time on transcribing and in-depth analysis, it is probably important to notice some of the details we pointed out in listening to recorded focus group discussions because they will have consequences for your interpretation of the total material.

Later on we used some of these ideas in a research project about patients with Chronic Fatigue Syndrome (CFS). We studied patients with CFS meeting in groups in order to share their illness experiences. Quite often they met with some medical expert attending and giving information. We published several studies from this project (Bülow and Hydén, 2003; Bülow, 2004). In one of these, Pia Bülow (2004) showed that sharing stories of suffering was one important way in these groups of creating a common ground and to confirm experiences and suffering that had an ambiguous status in medicine.

9 Everything You Wanted to Know, but Were Powerless to Ask

David Weintraub

Theoretical Perspective

When I teach photography, I ask my students a series of questions. How many of you have taken an English literature course? All hands go up. So what did you learn? With some prompting, my students tell me they learned how to analyze short stories, poems, plays, and novels. Next I ask: How many of you have taken a course on analyzing visual images? Perhaps a few, if any, hands rise. Then, I pose this question: How many short stories, poems, plays, and novels do you read in an average day? And, of course, the final question: How many visual images do you encounter in an average day?

The point I am trying to get across to my students is this: even though we supposedly live in a visual age, many of us are ill prepared to analyze, or think critically about, visual images.

This chapter looks at a qualitative research method called **discourse analysis**. Discourse analysis is a method researchers can use to study photographs and their accompanying written texts. Originally designed to study spoken dialog between individuals, discourse analysis has been modified to apply to other forms of communication, including written text and photographs. This expansion of discourse analysis has come about, in part, because visual images have gradually taken over more and more of the functions traditionally performed by language alone—or what one researcher calls "the displacement of the linguistic by the visual" (Iedema, 2003: 33).

When viewing photographs in everyday life, we almost never encounter these visuals (other than snapshots and family photos) without accompanying written texts. For example, the text might be the headline, caption, and article that accompany the photographs in magazine layout. Or the written text might be the catalog for a museum exhibition and the captions on the museum walls.

When photographs and written text are designed to work together, as in these examples, we can call the combination a **discourse**. For our purposes, a discourse can be defined as a combination of photographs and written texts that convey information-knowledge and create a particular version of reality. In other words, a magazine article about global warming—photographs, captions, headlines, and written text—presents a discourse about an

environmental problem. And it is this combination of photographs and written text that is the subject of a discourse analysis.

Here is another way to think about this: for a discourse analysis, photographs never stand alone; they are always links in a chain of meaning, along with other associated photographs and associated written texts (Aiello and Thurlow, 2006: 148).

Whereas some other forms of photographic analysis are primarily concerned with explicating the content of individual photographs, discourse analysis tries to discover how photographs and their accompanying written texts construct particular versions of reality for their viewers. In other words, how do photographs and accompanying written texts construct meaning? One of the premises of discourse analysis is that photographs perform this construction in combination with written texts. This premise sets discourse analysis apart from some other forms of visual analysis, such as compositional analysis and content analysis, which generally treat photographs as individual, isolated entities.

Discourse analysis evolved within various theories and academic disciplines, including Marxism, psychoanalysis, anthropology, linguistics, literary criticism, and film theory, among others. Discourse analysis is therefore a highly interdisciplinary method. This fact both enables and requires you to cast a wide net, both in terms of the problems and topics you wish to study and in terms of the resources you bring to bear on the analysis.

Discourse analysis also embraces a concept called **intertextuality**. Intertextuality simply means that no single element of a discourse (photograph, caption, headline, written text), and indeed no discourse itself, exists in a vacuum (Edgar and Sedgwick, 1999: 197–198).

When audience members encounter photographs and their accompanying written texts, it is likely they will interpret the information based on more than just the current items they are viewing and reading. Instead, they will probably relate the photographs and written texts to other photographs and written texts in the same publication (other articles and advertisements, for example); to other photographs and written texts about related subjects that they have seen in other contexts (newsmagazines, television documentaries); and even to unrelated images and written texts (films and novels, for example) that, somehow, resonate with the current items under consideration.

Thus, the discourse analyst must ask if any or all of these potential directly or peripherally related texts can shine a revealing light on the discourse under study.

Discourse analysis is one of a number of methods that have been used to study photographs. These methods can be divided into two broad categories, depending on how photography is conceived. On the one hand, photography can be conceived as an art form, like painting and drawing. As an art form, photography's goal is to express the artist's personal vision. On the other hand, photography can be conceived as a communication medium. In this case, photography's goal is to describe or construct a particular version of reality.

The saying "A picture is worth 1,000 words" has become such a cliché that we tend to dismiss the sentiment behind it. But many scholars acknowledge that photographs are at least as powerful as words in terms of constructing particular versions of reality, with their ability "to highlight certain aspects of reality while hiding others" and "to evoke emotions that do not translate easily into linguistic form" (Seppänen and Väliverronen, 2003: 59). Also, photographs demand attention in a way that written text alone does not: "It is always possible to skip the text, but it is difficult not to see the photograph" (Seppänen and Väliverronen, 2003: 82).

Here is another way to look at these two different conceptions of photography: What questions are you most interested in asking about photographs? Are you concerned with photographs as the product of an individual artist who is trying to express a personal vision? Or do you see photographs (in combination with other photographs and written texts) as part of a discourse that can only be understood within specific contexts?

If the first question interests you more than the second, you are probably going to find more satisfaction in pursuing an art-history or an aesthetic analysis of photographs. But if you find the second question more provocative and interesting, then you will probably find discourse analysis a useful tool.

Discourse analysis places great importance on context—discourses do not take place in a vacuum but rather are part of the culture and society that produce them (Dijk, 1985: 5–6). Discourse analysis of photographs is based on the premise that the meaning, or communicative power, of visual images resides not solely within the images themselves, but also within the context of how and why the images were produced and distributed (Aiello and Thurlow, 2006: 151). This is because there is generally no personal link or contact between the producer and the viewer of an image. In other words, the photographer is not able to explain to the viewer what he or she intended to communicate (Kress & van Leeuwen, 1999). Thus the viewer, to derive the most meaning from the image, must take into account not only what the image shows, but also 1) the circumstances under which it was made, and 2) the situation in which it is being viewed.

When photography was first invented, the main critical questions asked about it involved the nature of the medium itself: Is photography an art form or merely a mechanical reproduction of reality? In the late nineteenth and early twentieth centuries, however, photography slowly gained acceptance as an art form, largely because it developed its own aesthetic, a cadre of highly skilled practitioners, and specific venues of exhibition and publication. Photography was seen less as a mirror of the real world and more as an expression of a particular (and peculiar) photographic vision. And like other art forms, photography could express the concerns, feelings, and emotions of the photographer.

But photographs also began to appear outside the world of art. Thanks to the development of the halftone reproduction process in the late nineteenth century, newspapers and magazines began to use photographs to convey

information to their readers. Soon, social reformers began to use photographs to portray the plight of immigrants crowding into the slums of New York City, while from America's rapidly developing frontier, photographs brought back messages of Manifest Destiny and pleas to preserve the grandeur of the Western wilderness.

The communicative power of photography, whether to portray facts or feelings, raised critical questions that came to dominate discussions of the medium during the latter part of the twentieth century. Photography was now seen as a form of discourse, on a par with written texts and films in terms of its power to construct particular versions of reality and to have those versions accepted as "true."

The word "discourse" itself has been used in a variety of ways. Originally, it was associated with human speech and various types of formal statements, such as sermons, treatises, and dissertations. In the 1970s, Michel Foucault, Jean-François Lyotard, and other philosophers began using the word to mean a body of knowledge with well-defined rules. These rules included what types of statements can and cannot be made and who gets to make them (Ashcroft, Griffiths, and Tiffin, 1998: 70–73; Edgar and Sedgwick, 1999: 116–119). Discourse, then, is a way to organize experience and create certain social realities. In the words of one scholar, discourses do not reflect social realities but, in fact, produce the realities (Pennycook, 1994: 131).

This organization of experience and the creation of social reality give people a way to think about themselves and their relationships with others. This dynamic process of identity formation among individuals and groups is, for Foucault, driven by **power**. Power in this sense is not coercion or oppression; rather, for modern democracies, it is the glue that holds everyday social relationships together. But power is important for another reason: power gets to determine what is, and is not, accepted as knowledge (Edgar and Sedgwick, 1999: 304–305).

Discourse analysis, then, is interested in the relationship between power and knowledge. This is because power and knowledge are linked through discourse. For example, every academic field has its own particular body of knowledge and specific ways of speaking and writing about that knowledge. These ways of speaking and writing establish the discourse for that particular field. Those who possess knowledge get to define the discourse, and this gives them power.

But the relationship also works the other way: those with power get to define the discourse, and this allows them to determine what counts as knowledge. Thus, knowledge leads to power—those with knowledge can define the boundaries and the rules of the discourse, and thus wield power. But power also leads to knowledge—those with power can define the boundaries and the rules of the discourse, allowing them to determine what is considered knowledge.

Because it involves the relationship between power and knowledge, discourse analysis is interested in **ideology**. Ideology can be defined as the shared

beliefs and values that allow a society to function (Jaworski and Coupland, 1999: 496). In other words, if people in a society share common beliefs and values about what should and should not be done, this constitutes an ideology. Some conceptions of ideology link it to the process that enables certain individuals or groups to gain and/or maintain power in society. In these conceptions, ideology tries to get people to "believe in something as opposed to simply believing something" (Kates and Shaw-Garlock, 1999: 38).

The diffusion of ideology throughout a society is accomplished by what Louis Althusser called "a system . . . of representations," including images, myths, ideas, and concepts (Althusser, 1997: 231)—in other words, a discourse. Because we will return to ideology many times in this chapter, it is important to have a clear understanding of the term, and especially the elements Althusser says make up ideological discourse—images, myths, ideas, and concepts.

By image, Althusser meant **mental image**, which exists in an individual's mind. It can be a real memory, an imagined idea, or an abstract concept. Myths are strongly held beliefs that may or may not be true. Ideas and concepts are the frameworks people use to organize experience and put events into context. In order to understand the meaning of the words—images, myths, ideas, concepts—as used here, try this thought experiment. Think of the American war on terrorism and write down the first twenty things that come to mind. Did you put September 11, 2001, on your list, after seeing a mental picture of the World Trade Center? That is an example of an image.

What about Osama Bin Laden, Saddam Hussein, or suicide bombers? They have become myths—cartoon-like figures representing absolute evil. America's military power, which you might also have listed, is also mythic—based on memories of previous wars and an optimistic faith in technology to solve problems.

The larger conflict in the Middle East, including Israel's relations with its neighbors, the tension between Islam and the West, and the role oil plays in politics—all of these can be thought of as ideas and concepts. Through this thought experiment—which you can repeat for many different topics—you should be able to see how the discourse about terrorism, for Americans at least, consists of a standard repertoire of images, myths, and ideas, and concepts.

Ideology, therefore, is a system of shared beliefs and values diffused throughout society by a discourse consisting of images, myths, ideas, and concepts. Ideology becomes powerful when the discourse used to represent it is embraced by a majority of people in the society. Therefore, ideology and power are related through discourse: discourse is what gives ideology its power.

We might visualize the relationship between ideology, power, and discourse thus:

Ideology ◄────► Discourse ◄────► Power

In modern democracies, power is wielded for the most part not through coercion but through compliance (Cameron et al., 1999: 142). In other words, people agree to obey laws and respect authority not because they are forced to do so, but because they embrace the discourse and hence the ideology. Those with political and economic power generally control the means for defining and disseminating discourses, such as the mass media. Thus these holders of power get to promote certain ideologies, which help them retain and expand their power. This appears to be a self-perpetuating cycle: political and economic power enables certain people and institutions to control discourse, which in turn leads to more political and economic power (Aiello and Thurlow, 2006: 160).

For example, democracy as an ideology maintains that the best system of government is representative, where people get to choose their leaders in free and fair elections. The discourse about democracy usually involves words such as freedom, liberty, individual rights, and participation. Since these appear to be desirable social values, it would be hard to argue against the ideology of democracy—even if there were other options to choose from. Ideology is what makes particular ideas, opinions, and attitudes seem normal, ordinary, and inevitable.

This interest in ideology leads directly to the two theoretical pillars of discourse analysis:

1. An authoritative discourse will be the most ideological, because it involves the strongest claims of power and knowledge; thus it is most worth analyzing.
2. Discourse must always be analyzed in context, in order to reveal its social and therefore ideological foundations.

Research Questions

As you can see, discourse analysis is a way to investigate issues of truth, power, and the social construction of reality—philosophical issues that often remain hidden in our day-to-day encounter with photographs and written texts. Discourse analysis is a way to bring these issues to the forefront of the discussion.

Now, let us consider another aspect of discourse analysis: it is ideally suited to discourses that present themselves as authoritative. An **authoritative discourse** is one that makes a claim to truth—this is the way things really are. For example, mass-media coverage of an important issue is an appropriate topic for a discourse analysis, because in this case we would probably be dealing with some form of journalism, such as newspapers, magazines, television news, or a documentary film. And journalism, as an enterprise, depends for its success and survival, on its claim of truth. Just think of Walter Cronkite's famous signoff for the CBS Evening News—"And that's the way it is"—or the motto of the *New York Times*—"All the news that's fit to print."

For example, in a study of British television news, Stuart Allan argues that, rather than simply reflecting reality, journalists present specific, or preferred, versions of reality. Through the standard routines of journalism, these preferred versions of reality are perceived by the audience as "natural, obvious or commonsensical" (Allan, 1998: 105–106). Ideology, as you will remember, works by making particular ideas, opinions, and attitudes seem normal, ordinary, and inevitable—or, in Allan's words, "natural, obvious or commonsensical." Thus Allan links journalism with ideology: what is presented by journalists to their audience as a reflection of reality is, in fact, "an ideological construction of realities" (p. 108). In this way, the discourse of journalists is accepted, at least by many audience members, as "authoritative, credible and factual" (p. 107).

Journalism supports this authoritative claim of truth with various indicators, such as objectivity, balance, and fairness. Photographs, especially the kinds of images used in photojournalism, support their authoritative claim of truth through the notion of realism (Clarke, 2005: 209). This is the age-old (mis)-conception that the camera never lies, that it faithfully records the scene as it really is.

Today, many scholars of photography find the notion of realism problematic. They believe a photograph, as much as a written text, is a product of a specific set of circumstances. Rather than reflecting the world "in a mirror-like, more or less realistic fashion," photographs are created "for particular purposes" and are products of "particular social domains" (Clarke, 2005: 219). Photographs, thus, never merely reflect reality. Instead, they reflect "issues of power, politics and practices of representation"—in other words, the circumstances under which they are produced and distributed (Seppänen and Väliverronen, 2003: 60).

So, to summarize, a discourse analysis would be useful if you were trying to understand how the mass media uses photographs and accompanying written texts to represent important social, political, cultural, or economic issues.

Here are some of the types of questions a discourse analysis might ask:

1. What social reality has the discourse constructed?
2. How are photographs, in combination with written text, used to portray the social reality being constructed as authoritative?
3. What ideologies are being represented by this authoritative discourse?
4. What power relationships are being established, maintained, or perhaps subverted by the discourse?
5. How do these power relationships determine which aspects of the issues portrayed in the photographs and their accompanying written texts are being accentuated, and which are being ignored or dismissed?

Here is a fine example. In the 1950s, *Life* magazine certainly claimed to be an authoritative, trustworthy voice and was accepted as such by many of its millions of readers. In her book Life's *America*, Wendy Kozol explains how *Life*

in the 1950s constructed a particular version of America through a series of photo-essays on American families (Kozol, 1994). Kozol was interested in describing the "ideological power" behind the family photo-essays, rather than writing a history of the magazine or an aesthetic critique of its contents (p. ix). In doing so, Kozol hoped to reveal something about the "power relations that structure the social worlds depicted in *Life*," and the powerful issues of race, class, gender, and ethnicity lurking beneath the surface of *Life*'s tranquil, homogenous 1950s America (p. ix). Her conclusion? That through its photo essays, *Life* made certain values—especially domesticity, consumerism, and anticommunism—seem "normal and commonplace" for America (p. 183). In other words, *Life*'s discourse was ideological.

Here are some other examples from actual research projects to help you understand the nature of research questions in discourse analysis. You'll notice many of the questions begin with "how" or "what." This is because discourse analysis is particularly interested in the social construction of reality: what version of events is being presented, and how that version is constructed as authoritative and therefore true.

In a 2004 dissertation, "Collective Memory, the Media, and the Social Construction of Postmodern War" (Fisher, 2004), Benjamin F. Fisher asks the following questions:

1. How do the collective memories of WWII and Vietnam shape American's discourse about modern wars?
2. What roles do recent movies, AP photos, and newsmagazine stories about war play in determining the meaning of war for Americans?
3. What effect do the myths Americans hold about themselves and their enemies have on their perception of history?

Through his discourse analysis, Fisher determined that Americans' collective memory of World War II and Vietnam plays a large role in determining current attitudes toward modern wars. This memory is not historically accurate, but instead depends on cultural and ethnically biased myths that Americans hold about themselves and their enemies. Rather than use past wars as a way to understand present conflicts, Americans rely on their myth-influenced memory and hence misunderstand modern warfare and its participants.

Here are five other examples of research questions selected from various academic journal articles:

1. How were the photographs of prisoner abuse/war crimes at Abu Ghraib used to trivialize the policies and behaviors of U.S. officials and absolve the U.S. public of its failure to condemn (and halt) the torture? (Tétreault, 2006).
2. How did newsmagazine photographs of the 1991 Gulf War, the 2001 invasion of Afghanistan, and the 2003 invasion of Iraq construct a portrayal of American technological power and reinforce the myth of

American supremacy—all in the guise of objective, truthful reporting? (Griffin, 2004).

3. How have giant image banks such as Corbis and Getty Images changed the way photographs are used in publications around the world? (Machin, 2004).

4. How is the concept of biodiversity represented in newspaper photographs and their accompanying written texts? (Seppänen and Väliverronen, 2003).

5. What is the relationship between "idealized tourism marketing materials" for East African safaris and the actual experiences of vacationers? (Norton, 1996).

As you can see, these "how" and "what" questions are concerned primarily with the construction of reality. For example, in the Abu Ghraib article, Mary Ann Tétreault was interested in the sexually demeaning nature of the photographs and the message they sent about the events that took place in the prison. She concluded that the Abu Ghraib photos helped transform an instance of war crimes and torture into the sexual escapades of a few rogue soldiers. Thus the events were portrayed as isolated, deviant, and not part of a larger pattern of willful disregard for international law. Hence blame for the events was shifted from the U.S. government—and ultimately the U.S. public—to individuals; and thus the ideology of America as a defender of human rights was preserved.

In his study of newsmagazine photographs, Michael Griffin examined a common premise—that photojournalism is a highly factual form of reporting, showing events as they really happened. In the case of the two Iraq wars and also the U.S. invasion of Afghanistan, Griffin found that, in fact, this was not the case. Instead, at least as shown in *Time, Newsweek*, and *U.S. News & World Report*, the photographs focused less on the day-to-day reality of the wars and more on American military might in all its technological glory. This shift of focus mirrored the viewpoint of the U.S. government and the military, which were both trying to project an image of American supremacy. Rather than providing an independent lens through which to view events, newsmagazine photographs of these wars created for their viewer a reality that was in keeping with an ideology promulgated by the government and the military.

Brief Description

Discourse analysis involves three steps:

1. Describe the content of the photographs and the accompanying texts.
2. Analyze the context for the production and reception of the photographs and the accompanying texts.
3. Explain how the photographs and accompanying texts construct a particular social reality.

Describe Content

1. Provide a rich description of each photograph's content, including: subjects (human/non-human), composition, camera position/camera angle, tonality/color, look and gesture, and size relationships of subjects to each other and to the viewer.
2. Provide a thorough description of accompanying text, including headline, caption, and article. Does the caption merely restate what is going on in the photograph? Does it elaborate and add new information? Is the information consistent with, or contradictory to, the information in the photo?

Analyze Context

1. Analyze details of production, distribution (publication, for example), and reception (viewing) of the photograph.
2. Analyze details of the historical, social, and cultural situations surrounding the photograph's production/distribution/reception.

Explain Construction

1. Explain what social reality is being constructed by the photograph, in combination with other accompanying photographs and texts (including headlines, captions, and articles).
2. Explain the ideologies created, exemplified, reinforced, or contradicted by the photographs and accompanying texts.

Units of Analysis

Rather than looking at individual photographs or isolated passages of written text, discourse analysis uses larger units of analysis. Using an analogy from linguistic discourse analysis, the researcher is interested not in words or sentences but in the "structure of the entire conversation" (Lacity and Janson, 1994: 147). This choice of larger units of analysis allows the researcher to draw conclusions about the social relationships between the parties involved in the discourse—relationships that would not emerge through a study merely of words or sentences (Lacity and Janson, 1994: 147).

Because discourse analysis is interested in how photographs do their communicative work, it is crucial to look at how the photographs are presented to the viewer. Photographs are almost always accompanied by various forms of written text—headlines, caption, articles—and these should be considered as part of the discourse to be analyzed. From the examples given earlier in this chapter, it is clear that discourse analysis is most useful when applied to bodies of work—groups of photographs and written texts that are related in some way. What form can these relationships take?

Two relationships that might be useful to consider are thematic and temporal. For example, photographs and texts are related thematically if they share the same topic or subject matter. For example, many scholars have analyzed the Farm Security Administration photographs of rural poverty taken in the United States during the 1930s by a variety of photographers. Others have looked at war photography, wildlife photography, and photography to document human-rights abuses. What links these studies is their interest in the topic or subject matter, not the individual photographers, publications, or time periods—these may range widely.

On the other hand, photographs and texts are related temporally if they share the same time period of production. When Kozol wrote her book on *Life* magazine, she was interested in a particular time period, the 1950s. This was an era of great transformations in American life—the atomic age, the Cold War, America's emergence as a superpower, the rise of suburbia, and the beginning of television, to name a few. All of these transformations impacted the American family during that time, and *Life* during that era championed a particular view of family life. Evidently, this era especially interested Kozol, and thus she made it the focus of her study.

Other relationships are also possible. For example, you might choose to analyze the work of a single photographer, as Sharon E. Dean did in her dissertation on the Western landscape images of Andrew A. Forbes, who worked during the late nineteenth and early twentieth centuries (Dean, 2002). Or you might explore a particular genre of photography, such as the photo-essay or wildlife photography (Brower, 2005; Hansom, 1999). Whichever path you choose, remember discourse analysis is most useful when it is applied to bodies of work that present themselves as authoritative.

Sampling

Because discourse analysis is best suited to studying bodies of work that present an authoritative version of reality, it is not surprising to find a high percentage of discourse analyses that concentrate on the mass media, specifically on journalism and documentary photo-essays. Archives and museum collections devoted to the work of a single photographer or a unified theme also present appropriate opportunities for discourse analysis. Again, the emphasis is on a body of work that is authoritative—does this archive or collection represent the definitive statement of what a single photographer or group of photographers was trying to achieve?

Because discourse analysis is a qualitative, rather than a quantitative, method, it is impractical to attempt to analyze a huge mass of material. On the other hand, a discourse analysis of a single magazine article with two or three photographs probably will not tell you much about what you want to know. In order to find the right balance between too much material and too little, you should use purposive sampling and look for the most vivid and relevant examples that will enable you to answer your research questions.

Remember, you are not interested in obtaining a statistically representative sample from a population—the goal is to amass enough evidence from the most instructive examples of the discourse you are interested in analyzing to make your case beyond a reasonable doubt.

For example, when studying how giant image banks have impacted the use of photographs around the world, scholar David Machin did not attempt a comprehensive review of all images in the image banks, because this would have been impossible. Nor did he select a random sample of images. Rather he used a purposive sample of photographs of women from a single agency, Getty Images, as a "representative example" of the changing nature of photographic use in publications (Machin, 2004: 317).

In a study of how newspaper photographs represent the concept of biodiversity, Janne Seppänen and Esa Väliverronen used a keyword search to retrieve newspaper articles from 1990 to 1997. They then winnowed the 168 retrieved articles to sixty-nine whose main subject was biodiversity. Of these, forty-two were illustrated, and thirty-one had main illustrations that were photographic. The articles were then grouped into three categories by theme: nature, nature and humans, and humans. For their discourse analysis, Seppänen and Väliverronen picked three articles, one from each category, and wrote what amounted to three extended essays, full of rich descriptions of the images and text (Seppänen and Väliverronen, 2003). Notice how different this sampling method is from ones traditionally used in quantitative analysis, which would either analyze an entire population of newspaper articles or a random sample.

One scholar suggests following these four steps before starting any discourse analysis: 1) deciding, 2) locating, 3) collecting, and 4) tracking (Clarke, 2005: 223). First, you must decide which are the most appropriate types of materials you will need to answer your research questions. Second, you must locate these materials—in archives, in libraries, on the Internet, etc. Third, you must collect the materials in a form you can work with, such as photocopies, scans, PDFs, downloaded image files, etc. Finally, you must track all the materials and their sources—otherwise, your project may dissolve in a hopeless mass of untraceable data. Collecting and tracking visual materials will probably be the most labor-intensive and time-consuming parts of your research project; these activities can be "fussy, obsessive, and tedious tasks" (Clarke, 2005: 223).

Methods

Discourse analysis involves providing a rich description of content; analyzing the historical, social, and cultural contexts of production and reception; and explaining what social reality is being constructed and how.

Here is a detailed, step-by-step plan that will help you conduct a discourse analysis.

Content

The first task is to provide a rich description of the photographs and their accompanying written texts. This means looking closely at the photographs, headlines, captions, and articles, and describing exactly what you see and read. Some of the things to look for are as follows.

Subjects

Provide a thorough description of all the subjects in the photographs. These can be both human and non-human—animals, landscape features, buildings, machines.

Composition

How is space used within the photograph? Where are the subjects placed? Is there empty space (also called negative space), and if so, what part of the image does it occupy? Are there lines, shapes, and repeating patterns that you notice?

Camera Position and Camera Angle

Camera position determines the visual perspective, which gives the image its sense of depth—whether the image seems to have a great deal of space from foreground to background (called "expanded space"), or very little space (called "compressed space"). Camera angle, on the other hand, determines whether we are viewing the scene from eye level, from above, from below, straight on, or obliquely. Both camera position and camera angle tell us, the viewer, where we are physically in relation to the scene being photographed. This may also translate into how we feel, psychologically, about the scene. Are the subjects far away, and hence of little importance, or do they appear close up and intimate? Do we look down on the scene from an omniscient, all-seeing viewpoint, or do the subjects tower over, and therefore dominate, us?

Tonality and Color

Tonality and color can set the mood of a photograph. Tonality means the overall brightness of the image, or the brightness of specific areas within it. What is the predominant tonality—dark or light? Are certain subjects rendered in certain tonalities, such as hidden in shadow or bathed in light. This can be a clue as to which subjects the photographer wanted viewers to consider most important. Colors have culturally constructed meanings; for example, in many cultures, green stands for nature, red for blood and passion, and white for purity. Are the colors in the photograph used to transmit these or other meanings?

Look and Gesture

Where people are looking and gesturing in a photograph provides clues about their relationships with each other and with the photographer. When a subject is looking directly into the camera, this often makes the viewer feel as if he or she is being directly looked at or addressed in some way. This can take the form of a welcome, a challenge, a question, or a demand for some sort of action. If the subject is looking away from the camera, this may send a different message. For example, the subject may simply be unaware of the camera, or may choose not to acknowledge it. The relationship between two or more subjects can sometimes be determined by whether and how they look at each other. Gesture can reinforce look—if a subject is both looking at and gesturing toward the camera, the effect is more intense. Gesture can also direct the viewer's attention to or away from some other aspect of the image.

Size Relationships

Size relationships of subjects to each other and to the viewer are often clues to their social relationships. The taller a subject appears in an image, the more powerful he or she seems, in relation both to us and to the other subjects. The closer a subject is, especially if the subject fills the frame, the more intimate the connection between subject and viewer.

Headline, Caption, and Article

Provide a thorough description of accompanying text, including headline and caption, and a concise summary of any story or article included with the photographs.

Caption Details

Does the caption merely restate what is going on in the photograph; does it elaborate and add new information; is the information consistent with, or contradictory to, the information in the photo?

Context

Now it is time to analyze the context in which the photographs and their accompanying texts were produced, distributed, and received. This will help give your analysis an appropriate historical, social, and cultural framework.

Production Context

To analyze the production context, it is necessary to find out why and for whom the photographs and their accompanying written texts were made. What

was the purpose of creating these images—for example, were they made as news photographs, social-documentary images, historical records, or scientific illustrations? Was the photographer working freelance or on assignment? If these were assigned photographs, who assigned them and for what purpose? Did the photographer and writer collaborate, or were the photographs used to illustrate a written text in which the photographer played no part? What role did the photographer play, if any, in writing the headlines and captions?

Distribution Context

How did the photographs and their accompanying written texts reach an audience? Before the Internet, most photojournalism reached an audience through magazines, newspapers, books, and, occasionally, museum and gallery exhibitions. Other types of photography, such as social-documentary, relied on lecture presentations, specialized magazines, books, and exhibitions.

Reception Context

In order to analyze the reception context, you must examine the historical, social, and cultural environment in which the photographs and their accompanying written texts were received and understood by an audience. In other words, what impact did these images and words have on—and how were they likely to be interpreted by—their intended audience? For example, travel photographs today are commonplace, but during the early days of photography in the mid-nineteenth century they represented magical glimpses of exotic people and places. So today, we might view a travel photograph and think about our next vacation. But in the mid-nineteenth century, which was also the Age of Imperialism, people viewing travel photographs probably thought about the glories of empire and the otherness of the natives.

Construction

Finally, it is necessary to explain how the photographs and accompanying written texts construct a particular social reality for the viewer. In order to do this, you will need to explain the ideologies created, exemplified, reinforced, or contradicted by the photographs and accompanying texts.

As we saw earlier in this chapter, ideology is a system of shared beliefs and values diffused throughout society by images, myths, ideas, and concepts. Ideology is powerful because it represents particular beliefs and values as normal, ordinary, and inevitable. Ideology is thus, for the most part, unseen and unacknowledged—for example, most Americans go through their daily lives never questioning the basic premises of social life, such as the value of hard work, the benefits of a two-parent, heterosexual family, the importance of obeying the law, and so forth.

Photographs, for their part, are powerful vehicles for representing ideology, because they are generally perceived as being realistic and thus essentially authoritative and truthful. Photographs are especially effective at conveying images, myths, ideas, and concepts—the things that diffuse ideology throughout society. Therefore, it is important to pay close attention to images, myths, ideas, and concepts at this stage in your research.

Images

The relationship between images and photographs seems obvious; after all, most photographs are usually visual representations of what the photographer or camera "saw" at a particular moment in time; in other words, what was in front of the lens at the instant the shutter was released. What is less obvious is the power of photographs, along with their accompanying written texts, to fix in the public's imagination the defining image or set of images that represents a person, place, or event. Consider how certain people—politicians or celebrities, for example—are forever associated with their photographic images: Nixon giving the victory sign as he left the White House in disgrace, or President Bush on an aircraft carrier in 2003 declaring "mission accomplished" in Iraq. Places and events, too, can be represented by a single photographic image—for example, a picture of the Eiffel Tower represents Paris; the napalmed girl represents the Vietnam War, and so on. For your discourse analysis, however, you must probe these types of associations further, to discover how they contribute to promoting a particular construction of reality, and also to learn what ideologies are being represented.

Myths

If photographs can create defining images of people, places, and events, they can also contribute to the formation of myths. Myths are nothing more than stories that have an especially strong hold on the public's imagination. These stories often concern socially important goals and values, and they are frequently used to transmit messages about the way things ought to be in society. Myths tend to simplify information that may in fact be complex or even contradictory. For example, it is a standard American myth that, through hard work and a positive outlook, everyone in society has a chance to get ahead, and even to become president. Many people believe this myth, even though they would probably acknowledge that, statistically speaking, the odds are stacked against members of the lower classes in society and in favor of the wealthy and the powerful. Photographs contribute to myth-making by presenting oversimplified and idealized versions of reality, and also by emphasizing socially desirable norms and values. This myth-making becomes especially evident during times of crisis and social upheaval, when complex issues are often reduced to simplistic formulas, such as "us against them," "good versus evil," etc. For example, during wars, photographs and their accompanying written

texts are often used to demonize one side and glorify the other—our troops are shown as noble, self-sacrificing heroes, whereas the enemy's are portrayed as wicked, deceitful, and without regard for human life. Thus it is important to see beneath the surface representation to understand what myths are being created and promoted.

Ideas and Concepts

Many of the photographs people encounter in daily life, if you leave out news photographs for the moment, are used to represent ideas and concepts. In fact, many photographers devote their careers to creating images that can be used by advertising and corporate clients to illustrate ideas and concepts. For example, a photograph of a harried executive dashing through an airport, laptop in one hand, cell phone in the other, can be used to illustrate the pace of modern business, the benefits of technology, the stress of being a busy executive, and so on. For more examples of photographs that illustrate ideas and concepts, visit the website of a stock photo agency such as Corbis (http://pro.corbis.com) and search for "patriotism," "family," "success," or any other keywords you can think of. In addition to giving you a better idea of how photographs illustrate ideas and concepts, the examples will probably stimulate your thinking about how ideology is represented by the way the ideas and concepts are illustrated. In other words, which versions of patriotism, family, and success—or any other keywords you choose—are being promoted, and how do photographs accomplish this?

Data Analysis

You will certainly need to devise some useful method for keeping track of your data. Many qualitative researchers use a process called **memoing,** which is a systematic and organized form of note-taking (see, for example, Clarke, 2005: 224–228). Memos, which are your detailed, written notes, allow you to keep track of your findings. You will almost certainly need to keep memos for each image and its accompanying written text. Perhaps you will find it helpful to have separate memos for your content, context, and construction findings.

For example, you might have a content memo for each photograph and its accompanying written text. In this memo, you would include the rich descriptions of the image, along with answers to the other pertinent questions listed under Content, above. Similarly, you might have a context memo and a construction memo for each photograph and its accompanying written text.

Just as quantitative researchers often use coding as a way of extracting useful data from their samples, you will use memoing to extract the data you need from photographs and their accompanying written texts for your discourse analysis.

The end product of a discourse analysis is an extended essay that integrates the results of your content, context, and construction findings. This is where

you must bring to bear all your skills as a writer, in order to create a convincing story. In fact, it is helpful to think of a discourse analysis as telling a story, building your narrative piece by piece, providing a richness of description but also a clarity of explanation, focusing on the heart of the matter and winnowing out unnecessary details. Like any good story, your discourse analysis needs to captivate your readers from the start. One effective way to do this is to explain what captivated you about the material you have chosen to analyze. Why did this particular topic speak to you in a way others did not? What led you to your particular research questions, and how did you select the material to analyze?

Then you need to hold your readers' attention as you move step by step through the analysis process—describing the photographs and their accompanying texts; setting them in their appropriate historical, social, and cultural contexts; and explaining what social reality is being constructed for the audience.

Finally, you must make a convincing case for your conclusions, whatever they may be. Here the weight of evidence is helpful, as you construct your argument logically and carefully. Discourse analysis requires you delve into ideology, as you attempt to explain the particular social reality being constructed by the photographs and their accompanying texts. But this does not mean forcing all your evidence into a rigid mold. If there are exceptions that point to different realities, or alternative interpretations of your material, by all means say so. Your analysis will be richer and more persuasive if the reader understands that you approached your material with an open mind.

As an example of an actual discourse analysis, consider how Kozol, in her book *Life's America* (1994), handles the integration of her findings, and how she pays careful attention to each step of the method—she describes the content, analyzes the context, and explains what reality is being constructed for the audience.

Kozol begins her first chapter with a rich description of a photograph, the January 7, 1957, cover of *Life*, which featured Richard Nixon and two young girls in white dresses—the first of several dozen she analyzes in her book. She makes the point that this is an ordinary photograph, similar to many others that readers of *Life* might have seen over the years. She then provides the appropriate historical, social, and cultural contexts for understanding the photograph and its accompanying texts. Nixon, as vice president, was frequently photographed as a goodwill ambassador for the Eisenhower administration. The costumes in the photograph are for a passion play, a post-Christmas Catholic ritual. Kozol now turns to the photograph's caption and the accompanying story: we learn the young girls are Hungarian refugees, and the photograph was taken in a relocation center. She reminds her readers of the 1956 Hungarian uprising and U.S. efforts to alleviate the refugee crisis—events that would have been familiar to *Life* readers.

Kozol goes on to discuss the ideological struggle between American democracy and Soviet communism, and says that cultural values, such as

domesticity and consumerism—key elements of 1950s American life—often get linked with political issues. She goes on to describe the power of realistic photography, the kind of photojournalism omnipresent in *Life* pages, to make specific political and cultural values seem normal and natural. In other words, *Life* photographs are doing ideological work.

In the space of a few pages, Kozol has taken her readers from the consideration of a single *Life* photograph to an understanding of the ideological messages *Life* photos and stories conveyed during the 1950s. And she did that by integrating her findings into a cogent, coherent, and compelling story.

Data Displays

If you find it helpful, you can present a summary of your findings in table form, as shown in Table 9.1. Each row would be a separate item of the discourse you are analyzing. The example given here is based on the first chapter of Wendy Kozol's book, Life*'s America*. This might also be a useful way to keep track of your findings as you conduct your research.

Table 9.1 Summary of content, context, construction, and ideology

Photograph	Content	Context	Construction	Ideology
Nixon with girls	Intimate, casual, celebration, family photo, father figure	Cold War, Hungarian refugee crisis, pageant play (Catholic ritual)	United States as bastion of anticommunism, haven for refugees	American supremacy over Soviet communism; value of domesticity and consumerism

Credibility, Transferability, and Dependability

The most important tasks of a discourse analysis are a) to explain how photographs and their accompanying written texts construct a particular reality, and b) to illuminate the relationship between ideology and the particular reality being constructed. Thus the standards for the quality of your conclusion require that your analysis be judged on how well it tackles the twin problems of construction of reality and ideology. Unlike quantitative analysis, which uses statistical measures of reliability and validity, qualitative analysis relies heavily on "the strength of the analytical arguments used to defend the interpretation" —in other words, on the researcher's ability to persuade and convince his or her audience (Lacity and Janson, 1994: 146).

A successful discourse analysis, then, is one that presents convincing evidence that shows how a particular reality is being constructed and what ideology is being represented in this construction. In order to evaluate the success of your research project, people reading your results must have a clear picture of how

those results were obtained. It is not enough to simply state that this group of photographs and texts constructs this particular reality. Instead, you must walk the readers step by step through the process you used to determine what reality was being constructed.

In terms of ideology, you must demonstrate a sophisticated understanding of the historical, social, and cultural contexts in which the photographs and their accompanying written texts were produced, distributed, and received. This understanding, combined with a weight of evidence, will help convince your readers that, indeed, you are correct when you say the discourse under study establishes, reinforces, or perhaps even undermines a particular ideology.

In order to apply this process of evaluation in practice, consider again Kozol's book on *Life* magazine in the 1950s. We have already seen how Kozol plays close attention to each image and its accompanying texts, building up her analysis layer by layer, enriching her story with more details and more evidence. Throughout her book, Kozol clearly shows the reality being constructed for *Life*'s readers and the relationship of this constructed reality to the ideologies that dominated Cold War America—anticommunism, market-driven consumerism, and domesticity.

Clearly, Kozol's analysis of *Life* photo-essays from the 1950s goes well beyond a mere description of the photographs and their accompanying written texts, and also well beyond historically based speculations on what these combinations of words and pictures might have meant to readers of the magazine at the time. Instead, Kozol examines the role played by *Life* magazine in 1950s America and the particular ideology represented in its pages. Kozol showed her readers how *Life* photo-essays, through their subject matter and narrative structure, transformed specific social and political values—anticommunism, consumerism, and domesticity, for example—into universal, unchallengeable norms that seemed to emanate from America's democratic soil itself. Kozol's book, then, represents a high-quality, successful discourse analysis.

Internet

The Web presents fascinating, if potentially frustrating, opportunities for discourse analysis. On the one hand, the availability of hyperlinks, whereby a Web user can follow a path of his or her own choosing through cyberspace, seems to embody the concepts of discourse and intertextuality—in other words, a conversation that can involve subject matter from many related spheres of interest. On the other hand, Web content is often ephemeral, changing from day to day and sometimes from moment to moment. Thus, unlike with a magazine or a newspaper, easily locating an archive of researchable materials on the Web can be difficult.

Fortunately for researchers, the issue of archiving Web-based information is being addressed. For example, the website Internet Archive (www.archive.org /index.php) has a "Wayback Machine" that allows you to search its digital library for Web pages of many organizations, which are organized by date.

Thus, if you were trying to do a discourse analysis of Web-based content from the past ten years or so, you might be able to find what you need in the Internet Archive. The Internet Archive claims to have more than twenty-five million unique, text-searchable Web pages from more than 1,500 sites.

For his 2003 master's thesis from Florida Atlantic University, Mark Kattoura compared how Exxon Mobil and Greenpeace USA treated the environmental issue of global warming on their websites (Kattoura, 2003). Specifically, Kattoura looked at what he called "competing claims" (Kattoura, 2003: 37). In other words, how did each organization use its website to try to construct a particular social reality vis-à-vis global warming by presenting itself in the best possible environmental light? Kattoura found that whereas Greenpeace used its website to portray Exxon Mobil as "dominating nature" for the sake of profit, Exxon Mobil used its site to disassociate itself from business practices that most people would consider harmful to the natural world (Kattoura, 2003: 37, 87).

Thus, contrasting discourses about global warming were presented on each organization's website. Greenpeace USA used its site to convince the public that burning fossil fuels is the primary cause of global warming and that negative consequences will result from such warming. Exxon Mobil, not surprisingly, used its site to promote itself as a conscientious corporate citizen, while at the same time casting doubt on the scientific consensus surrounding global warming. Lost in the debate, according to Kattoura, are ordinary citizens, who have little, if any, way to evaluate the competing discourses (Kattoura, 2003: 90).

Advantages and Disadvantages

Discourse analysis has several advantages:

1. Discourse analysis shines light on an often-hidden aspect of communication: How do photographs and their accompanying written texts construct particular versions of reality for their viewers?
2. Discourse analysis illuminates the role of ideology—the accepted beliefs and practices of everyday life—in determining, to a large extent, which version of reality people believe. Because photographs have been considered (for a long time and by many people) to be merely faithful representations of reality, it is enlightening to discover that they are, in fact, ideologically driven and do ideological work.
3. Discourse analysis examines the contexts in which the photographs and their accompanying written texts are produced, distributed, and received; these play a large role in determining meaning.
4. Discourse analysis investigates the role photographs play as powerful tools for promoting ideology—for making a specific reality seem normal, ordinary, and inevitable.
5. Discourse analysis allows the researcher to work across disciplines, drawing on the strengths of each, and the chance to include in the analysis other

discourses which might be helpful and instructive in interpreting the particular photographs and texts being studied.

Although discourse analysis is a powerful tool for studying photographs and their accompanying texts, the method does have a few disadvantages:

1. Discourse analysis is highly dependant on the skill of the researcher. Because it is an interdisciplinary method, discourse analysis requires a working familiarity with a variety of research methods drawn from different academic disciplines. For example, in order to provide a rich description of the images themselves, the researcher must be well versed in compositional analysis, which is a method used by art historians. To provide an analysis of the context in which the photographs and their accompanying written texts were produced, distributed, and received, the researcher must delve into the fields of history and sociology, weaving in information gleaned from secondary sources.
2. Discourse analysis requires a researcher who is able to understand and explain complex philosophical issues, such as ideology, power, and knowledge.
3. Discourse analysis may tempt the researcher to provide a "one size fits all" answer to questions of ideology—capitalism or imperialism cannot always be the answers to the variety of subtle, nuanced questions raised by a meaningful discourse analysis.

Ethical Issues

There are no ethical issues that arise from discourse analysis.

Resources

Discourse analysis is a labor-intensive, time-consuming process. It requires amassing a large quantity of primary and secondary sources, it may involve travel to archives and other sites, and it will certainly draw on all your skills as a researcher.

As we learned earlier, before beginning a discourse analysis, the researcher must decide which materials are most appropriate, locate these materials, collect them in a useable form, and methodically keep track of them.

In terms of deciding on and locating your materials, are you going to look at a specific time span, a thematic grouping, or a specific number of publications? In this Internet era, you may be able to find what you need with the click of your mouse. Chances are, however, that you will need to spend time in libraries and archives—especially to see what secondary sources are available to help you put the material you are studying in its appropriate historical, social, and cultural contexts. Collecting and tracking your sources, both primary and secondary, will also involve large amounts of time and energy.

But these steps are only the beginning. Now comes the difficult but exciting work of actually going through your material—photograph by photograph, headline by headline, caption by caption, article by article—and teasing out the content, context, and construction. Finally, you must put your findings into a cogent, coherent, and compelling narrative, supporting your claims with convincing evidence.

Advice

The following summary of the points made in this chapter will help you understand the purpose and method of discourse analysis:

1. Discourse analysis tries to discover how photographs and their accompanying written texts construct particular versions of reality for their viewers.
2. Discourse analysis is useful for studying mass-media coverage of important social, political, cultural, or economic issues.
3. Discourse must always be analyzed in context, in order to reveal its social and therefore ideological foundations.
4. An authoritative discourse will be the most ideological, because it involves the strongest claims of power and knowledge; thus it is most worth analyzing.
5. Research questions for a discourse analysis often begin with "what" or "how". This is because discourse analysis is particularly interested in the social construction of reality: what version of events is being presented, and how is that version constructed as authoritative and therefore "true."
6. Discourse analysis involves three steps:
 a) Describe the content of the photographs and the accompanying texts.
 b) Analyze the context for the production, distribution, and reception of the photographs and the accompanying texts.
 c) Explain how the photographs and accompanying texts construct a particular social reality.
7. Locate the most vivid and relevant examples which will enable you to answer your research questions.
8. Integrate your content, context, and construction findings into a cogent, coherent, and compelling story.
9. Discourse analysis is a labor-intensive, time-consuming process.

Life Magazine Photographs

Wendy Kozol

In the 1980s, when I began my research on *Life* magazine, the United States was struggling with an extended period of economic instability, anxieties about American status abroad after Vietnam, and ongoing social justice activism around race, gender, and sexuality. In response, a newly emergent New Right coalition that championed conservative social politics sought a return to traditional family values as the way to restore American political and social dominance. Importantly, "family values" referenced an idealized portrait of the white, middle-class nuclear family consisting of female housewives and male breadwinners. President Ronald Reagan's election in 1980, based on a campaign linking patriotism to family values, was a huge boost for the New Right. Despite the fact that fewer than 15 percent of Americans lived within this model by the 1980s, the call for a return to traditional family values resonated powerfully with many Americans.

Feminist historians have challenged this call for a return to tradition, arguing that the nuclear family model is a fairly recent development that emerged in Western societies with the rise of industrialization. More specifically, Reagan's nostalgic "family values" invoked an ideal that emerged in the post-World War II years. Knowing that this was a period of heightened focus on domesticity, I became interested in how Americans in the 1940s and 1950s came to associate this visual ideal of the family with nationalist sentiments about citizenship and U.S. global power.

In order to answer this question, I turned to the most influential site of visual news in the post-war period, *Life* magazine (television news did not become significant in American culture until the early 1960s). *Life* was a weekly magazine that described itself as a family magazine, imagined its readership to be the family unit, and routinely depicted families in various sections of each issue. I focused on the news section, "The Week's Events," because I wanted to understand the politics of the family portrait in the context of photojournalism. In rejecting reflection theory (that news photographs simply represent reality, or truth), I argued that *Life*'s photo-essays selectively portrayed white, middle-class families as representative of the nation coping with inflation, the threat of communism, or other pressing social issues of the day. Far from dismissing families as irrelevant, or a side note to the important work that the news was doing, I argued that these pictures were central to *Life*'s depiction of complex political, economic, and social concerns.

I faced several methodological challenges in this project. First, and foremost, was the amount of material. Fifty-two issues per year times fifteen years of the post-war period were too many issues to examine. Rather than rely on random sampling, I conducted a study of every issue in the months of October and May,

using a purposive sampling technique in which I looked for all news photo-essays that included pictures of families. I based this methodological claim on the presumption that the magazine would have a fairly consistent and sustained message from issue to issue, month to month, so that by selecting two months each year for fifteen years, I could chart larger trends over time.

Identifying trends is one important way to ensure that you do not make unsupportable claims based on a small sample or idiosyncratic images. Thus, from my research, I could argue that family pictures in "The Week's Events" section formed a collective text (rather than individual statements by individual photographers) that made important statements about how *Life* wanted readers to imagine the nation and its citizens. As anticipated, pictures of white, middle-class families who upheld dominant gender norms promoted these ideals as representative of the nation.

A related methodological challenge, though, was that not all news photo-essays that featured families conformed to the ideal I had identified. Instead, I encountered photo-essays that seemed to contradict or problematize these social ideals. Images of families who did not fit the convention I expected turned out to be crucial in developing a more nuanced understanding of how ideology operates. As much as *Life* tried to maintain a consistent message, the magazine was also committed to an ideology of news objectivity, which meant that it covered a wide variety of subjects. Along with tremendous economic prosperity and the growth of the middle class in this period, labor unrest, immigration, the rise of the civil rights movement, and other social contestations challenged the very ideals the magazine promoted. Pictures of non-normative families also performed a representative role, but here it was to serve as representative of social problems. Textual and visual strategies ensured that families of color, working-class families, and immigrant families never served as representatives of the nation. Hence, while families consistently appeared, it is important to consider how race, class, citizenship, and other factors that distinguished some families from the norm shaped claims of representative status and national ideals.

Life certainly was not the first visual medium to turn to the family as representative of national ideals. Thus, another methodological challenge was to address how and why family ideals were meaningful to producers of popular culture and their audiences in the post-war period. Here, I took an interdisciplinary approach to incorporate historical context into the study in order to understand how family portraits mobilized particular Cold War ideologies. Beyond the historical factors addressed in the photo-essay itself, I sought to understand the significance of news reporting in relation to post-war social, political, and economic currents. Historical context is a crucial means through which we can avoid making claims of universality; in other words, family pictures in *Life* during the Cold War may look similar to family pictures in other periods but historical context is important to understanding their significance for their readers.

10 Sex on TV: A Content *Interpretive* Analysis

Theoretical Perspective

Miley Cyrus was the center of a quasi-scandal in early May 2008 because a) Annie Leibovitz photographed her in a suggestively wrapped bed sheet for the June issue of *Vanity Fair*; b) Miley is 15 years old; and c) Miley stars in the Disney Channel's *Hannah Montana* show. Some people think Leibovitz and *Vanity Fair* manipulated a 15 year old in order to sell magazines. There may be some truth in this idea because the magazine's website racked up 1.8 million unique visitors and 17 million page views the day after the story broke (Kafka, 2008). Other people refuse to believe Miley was exploited. They note that Miley and her parents and/or minders were on the set all day; they saw the digital photos; they considered the pictures beautiful and natural portraits. Some people see Miley as a youthful role model for three million viewers, ages six to fourteen, of *Hannah Montana*. Others see Miley as a press-savvy celebrity, who signed a seven-figure book deal and who works for a franchise expected to generate $1 billion in 2008 (Barnes, 2008).

The real issue in this scandal is the sexualization of girls. According to the American Psychological Association, **sexualization** occurs when any of the following conditions are present:

1. A person's value comes only from his or her sexual appeal or behavior to the exclusion of other characteristics.
2. A person is held to a standard that equates physical attractiveness (narrowly defined) with being sexy.
3. A person is sexually objectified—that is, made into something for others' sexual use, rather than seen as a person who can make decisions and act independently.
4. Sexuality is inappropriately imposed upon a person.

I am not very knowledgeable about Miley, but from what I know about photography, I believe that Miley, Annie Leibovitz, and *Vanity Fair* are "guilty" of sexualization by this definition because they made Miley look sexy when they could have just made her look physically attractive.

Causes of Sexuality

We divide the potential influences on humans into two large groups—nature and nurture. The "nurture" part includes influences from our family, friends, teachers, coaches, religious leaders, employers, and so on. These people both create our culture and they are affected by our culture. I think of **culture** as common sense; it is the large, vague, changing system of attitudes and behaviors that affect a social group.

The people who create and edit the content for mass media have a great impact upon our culture. The mass media, themselves, distribute that content widely. A huge audience then consumes that content. If we do not experience something directly, or hear about it from someone, then we learn about it from music videos, music lyrics, movies, television programs, cartoons, animation, newspapers, magazines, books, sports media, video/computer games, Internet, and advertising.

Sexualization, therefore, results from contact with the media, interpersonal communication, or direct experience. Up to a certain age, adolescents lack direct experience with their sexualization, so the early cause of sexualization must be media or communication with people.

Let us consider interpersonal communication first. Parents seldom tell their children about sexuality because both parents and children are too embarrassed. Children seldom ask their parents about sexuality because they think their parents will just tell them to wait and not to have sex (Winerip, 2008). Sex education teachers must not be communicating clearly. During the past decade, the federal government spent $1 billion on abstinence-only sex education, but in 2005, 63 percent of high school seniors said they had had intercourse (Winerip, 2007). Nor does religion matter much. Religious attendance, religious beliefs, and children's perceptions of their clergy's view of sex have minimal influence (Brown, Halpern, and L'Engle, 2005). That leaves peers. But if a teen matures sexually faster than her peers, then who talks with her?

The answer is media. In 2003, David Buckingham reported that two-thirds of young people turn to the media when they want to learn about sex (Buckingham, 2003).

Of the media, television plays an especially important role in adolescents' lives, and television provides lots of information about sexuality. In 2002, more than 83 percent of television programs watched frequently by adolescents included sexual content (Kunkel et al., 2003). These programs show how to be sexual, why we have sex, whom to have it with, and what is the appropriate sequence of activities (Ward, 1995). Television also creates the impression that people always think about and talk about sex (Collins et al., 2004).

On the other hand, sometimes TV does portray sexual risk and responsibilities, so TV can be a healthy sex educator, teaching valuable lessons to adolescent audiences by modeling responsible behavior or pointing out the consequences that can result from careless sexual activity. In fact, teenagers say

they learn from TV how to say no to a sexual situation and learn about how to talk to a partner about safer sex (Collins et al., 2003).

Television producers can also defend themselves by claiming they simply deliver already-existing cultural values. Moreover, girls are wise enough to choose and interpret the media in their lives, with increasing independence as they mature from girlhood to late adolescence (Rubin, 2002; Steele, 1999).

Effects of Sexualization

Researchers study how exposure to media messages that sexualize girls can lead to girls' dissatisfaction with their bodies, lower self-esteem, and depression. Sexualization can also lead to a belief that physical appearance rather than academic or extracurricular achievement is the best path to power and acceptance. As a result, girls do not care as much about math and may drop out of higher-level mathematics in high school (APA Task Force, 2007). Girls may also not care as much about physical activity and sports because they are overly concerned about the appearance of their bodies. As a result, girls are "kept in their place as objects of sexual attraction and beauty" (APA Task Force, 2007: 22).

Researchers commonly use three theories to explain why television plays a critical role in educating youth about sex (and violence): cultivation theory, Social Modeling theory, and Social Schema theory.

Cultivation Theory

In the late 1960s, an outraged public wanted to know what was causing the civil unrest that lead to assassinations of Dr. Martin Luther King, Jr. and Bobby Kennedy. The American government responded by funding research to learn to whether television could be blamed for that period's violence. **George Gerbner**, dean of the Annenberg School for Communication at the University of Pennsylvania, and **Larry Gross**, director of the Annenberg School for Communication at the University of Southern California, used some of that funding to create cultivation theory.

Cultivation theory claims television makes specific, measurable contributions to viewers' conceptions of reality. To test those claims, researchers conduct large-scale content analyses of television programming. Then they survey some people who are heavy viewers of TV and others who are light viewers. From the content analyses, cultivation researchers find that more violence and sex occur on television than in real life. From the surveys, they find that heavy viewers of TV hold beliefs that resemble TV more than reality-based facts. Cultivation researchers conclude, therefore, that heavy viewers "cultivate" or adopt, TV-like views of the world.

Social Modeling Theory

Albert Bandura, Professor at Stanford University, had a different explanation for violence in American society. He thought people learned aggressive behavior by watching others behave aggressively and then imitating their behavior. Bandura based his social modeling theory upon 1960s experiments of children with a Bobo doll, which is an inflatable toy about the size of a prepubescent child. In these studies, a child would be placed in a room with various toys, including the Bobo doll, and an adult "model." Sometimes the adult hit the Bobo doll; other times the adult played with TinkerToys. Later, researchers moved the child to a new room with new toys. The children then consistently modeled whichever adult behavior they had seen. The **Social Modeling theory**, therefore, states that through observation people learn which behaviors are appropriate and inappropriate. They may not imitate these behaviors immediately, but instead store this knowledge and apply it when they believe they could use the behavior.

The idea of modeling aggressive behavior may also apply to modeling sexual behavior that has been viewed on TV programs. In other words, girls learn from TV about women's expected roles in the world and they strive to meet these TV-based expectations because doing so brings specific rewards. When women (on TV) deviate from their roles, however, they can encounter denigration, punishment, and even violence (on TV). Girls, therefore, learn to maintain their roles, for example, if you see attractive, powerful characters similar to yourself, and they have unprotected sex without negative repercussions, then you may do the same. A Fetish scent advert provides another example. It implies women do not really mean no when they say it, that women are only teasing when they resist men's advances. The advert's copy reads: "Apply generously to your neck so he can smell the scent as you shake your head 'no.'" The advert implies, "he'll understand that you don't really mean it and he can respond to the scent like any other animal." According to the theory, viewers may store this information for later, when they become involved sexually.

Social Schema Theory

Researchers also use **Social Schema theory** to explain media's role in the sexual socialization of youth. According to this theory, many attitudes operate, at least in part, on an unconscious level. For example, from TV people may develop gender stereotypes. Then, a short time later, these media stereotypes may activate a schema due to the processes of salience and priming. **Schemas** are cognitive representations—or expectations—of something. They are organized in memory in an associative network. Similar schemas are clustered together, and when a particular schema is activated, related schemas may be activated as well. When a schema is activated, it becomes more accessible, which means people can use it quickly in a particular situation. **Salience** is the degree to which a particular social object stands out relative to other social

objects in a situation. The higher the salience of an object the more likely that object's schemas will be made accessible. **Priming** refers to any experience immediately prior to a situation. When a schema has been primed, it becomes more accessible.

For example, someone warns you that John is a real "player"; then you will recall stereotypes about gender roles and make certain assumptions about John's character. Moreover, hearing that John is a "player," will "prime," or call to mind, related concepts. For example, "players" make you think of "chauvinists," which make you think of your uncle, which makes you think about his messy divorce, which makes you think you do not want to date John.

Priming may also have longer-term effects. If particular schemas are frequently activated—"players–chauvinists–uncle–divorce"—then these schemas are always in the front of your mind. Because these are readily accessible, these schemas will probably influence your judgments about men regardless of the particular situation and the particular guy. On the other hand, if you have had great success dating a certain type of guy, say visual communication majors, then positive schemas will be frequently activated, and with each activation, you will become increasingly "biased" toward dating visual communication majors.

Goals

Researchers trying to test these three theoretical perspectives would conduct basic research to learn the nature of sexual information on television. Their specific goals would depend upon which theoretical perspective they adopted. For example, cultivation theory states that heavy TV viewers adopt TV-like views of the world, so to test this perspective, they would want to understand television's general depiction of sexual behavior. Social Modeling theory states that people learn which behaviors are appropriate and inappropriate by observing others. To test this perspective, researchers would want to study characters with which adolescent audiences identify and how their behaviors are rewarded and punished. Social Schema theory states that people's schemas become more accessible due to the processes of salience and priming. To test this perspective, researchers would want to discover which schemas of sexual behavior appear most frequently on TV. They would also want to create a network display showing how other concepts relate to the central schema.

Research Questions

To learn the nature of sexual information on television, you could investigate the following questions:

1. What themes of sexual behavior are conveyed by TV programs commonly watched by youth? Which themes apply to a male sexual role and which to a female sexual role?

2. What types of sexual behavior are shown on TV? Did the sexual behavior have a recreational orientation, a relationship/marital orientation, or a procreational orientation?

3. Which of the sexual behaviors were considered positive or appropriate by characters on TV? Which were considered negative or inappropriate? What were the consequences of these behaviors? Which of these positive or negative behaviors were rewarded? Which were punished?

4. Which of the themes and types of sexual behavior were verbalized? Which were shown? Which were implied?

5. What was the tone of the sexual interactions—heavily dramatic, moderately dramatic, or light-hearted and playful?

6. Which sexual behaviors were planned?

7. What were participants' motivations for sexual behaviors?

8. What were the outcomes of sexual behaviors?

9. To what extent do TV programs encourage the sexual double standard? Are women rewarded or punished for being sexual? How about men?

10. Do male characters on TV programs admire "players?" To what extent? Why? How about female characters?

Brief Description

Researchers generally use content analysis when they want to learn about content distributed by mass media, including messages about sexual behavior that adolescents receive when they watch television programs (Lombard, Snyder-Duch, and Bracken, 2002). **Content analysis** is an objective, systematic, and quantitative method of describing the content of texts (Kassarjian, 1977). This chapter discusses three types of content analysis: traditional, interpretive, and reception-based.

Traditional content analysis involves several tasks. One, you view the TV programs several times in order to notice interesting things that could develop into a theory or that could help answer pre-determined research questions. In this case, you want to notice the way sexual behavior is shown and talked about. Two, you make a list of the interesting things you noticed—call them themes—and add to the list any themes you discovered from reviewing the literature about sexual behavior depicted in the media. Three, you divide the TV programs into smaller units, such as scenes. Four, you then decide which scenes are relevant to answer your research questions. In this case, you select scenes concerning sexual behavior. Five, as you collect the scenes of sexual behavior, you begin to sort them according to their theme. This process is like working on a jigsaw puzzle where you start by sorting the pieces of the puzzle (scenes) into groups (themes) (Seidel, 1998). Some of the pieces fit easily into groups, but others will be more difficult to categorize. In any case, sorting makes it easier to solve the puzzle. Scenes, however, are not like jigsaw pieces because they are not precut. You have to determine when a scene begins and ends. Six, you think about your groups of themes about sexual behavior. You

want to make some type of sense out of these groups. You want to find patterns and relationships. You want to make discoveries. In other words, you start to fit the puzzle pieces together to form small portions of the overall picture. This thinking process can take a while. It involves trial and error, as well as frustration. Seven, you join the patterns you discovered into a theoretical model. Unlike building a jigsaw puzzle, however, you cannot refer to a picture that shows the puzzle's solution. You'll need to create a model as you go along.

This content analysis process becomes more challenging when the texts include visual information because visual information requires more interpretation than written information. With visuals, meaning is often implied rather than stated directly. In addition, the message-maker uses symbols, metaphors, and other figures of speech, so people need a lot of cultural context to understand the intended messages. Television scenes showing sexual behavior, for example, often require extensive cultural knowledge to decide whether or not a glance was flirtatious. Even within a culture, people may interpret scenes differently. Older viewers, fearing youth's sexual behavior, may see signs of sex everywhere and interpret the glance as flirtatious. On the other hand, younger viewers may view the glance as normal, without special meaning.

In order to address such problems, researchers use two variants of traditional content analysis: interpretive content analysis and reception-based content analysis. **Interpretive content analysis** differs from content analysis in that analysts work collaboratively, rather than independently, in order to improve their ability to make valid coding judgments. They let reviewers see a random sample of their texts along with the texts' coding results and, if necessary, they give reviewers a justification of why they obtained those results. **Reception-based content analysis** differs from content analysis because analysts believe that meanings exist in people more than they exist in texts. They ask members of the message's target audience to interpret and code the study's texts.

Units of Analysis

Since the goal is to learn the nature of sexual information on TV, and your method is content analysis, your unit of analysis might be a character, a scene, or a shot. A **scene** is defined as a section of a film or video, usually made up of a number of shots, which is unified by time, setting, and characters. It ends when time, setting, or characters shift in a way that extensively interrupts the flow of action. A scene also ends whenever a commercial interrupts the story. A **shot** is the pictorial material between two cuts, and **cuts** are instantaneous transitions. You make a cut by splicing two shots together without a fade or dissolve. Shots can typically be identified by a change in the camera direction or the angle of view. When a camera looks at the same scene from different angles, or looks at different regions of a scene from the same angle, viewers see different shots. Researchers often use a shot to analyze the formal features of TV programs. Formal features include camera angles, camera or lens movement, lighting, scale (shot distance), subject movement within a shot, and

framing; as well as editing techniques, such as duration of shots and transitions between shots.

Sampling

In order to obtain an adequate quantity of your units of analysis—characters, scenes, or shots—you need to draw a probability sample of TV programs with at least eighty instances in which the character, scene, or shot refers to sexual behavior.

Your population consists of television programs watched by adolescents. You could find a list of such programs or you could develop your own list. To develop a list, you might mail a media-use survey to a sample of youth. This survey could cover frequency of use and involvement with television. You should next consider how much your population of TV programs varies. Television programs, for example, have different genres, and you may want to ensure that your sample includes equal numbers of comedies and dramas. Based upon your survey results and your need to divide the population into different groups, or strata, you could draw a random sample of episodes.

You next need to watch these episodes and determine whether at least eighty instances of characters, scenes, or shots refer to sexual behavior. If a scene is your unit of analysis, you might only study scenes with verbal and visual interactions of a sexual nature. If a shot is your unit of analysis, you might only study shots with a **sexual reference**, which is defined as a depiction of dialogue or behavior that involved sexuality, sexual suggestiveness, sexual activities, or sexual relationships. If your sample lacks eighty instances of sexual behavior, then you will need to add TV programs to your sample.

Methods

In order to learn the nature of sexual information on TV, you could conduct a content analysis or a variation of a content analysis study, such as interpretive content analysis and reception-based content analysis. This section explains how to: a) develop categories inductively; b) develop categories from prior understanding; c) sort content into categories for the three types of analysis; d) identify scripts (frames); and e) measure intercoder agreement for the three types of analysis.

Developing Categories Inductively

Researchers use two general ways to develop categories: an inductive approach and a prior understanding approach. The inductive approach means that researchers examine their texts, visuals, and sounds to notice interesting things related to their theory and research questions. Ryan and Bernard (2003) suggest three ways to inductively identify themes that appear in media content. One, you can look for topics that occur and reoccur. When people talk, for

example, they frequently circle through the same set of ideas. On television news programs, an anchor states a story's theme; then a reporter uses the theme to explain an event, and then a video shows the theme. The more the same idea occurs in a text, the more likely it is a theme.

Two, you can search for similarities and differences by making systematic comparisons across units of data. I explained this constant comparison method in Chapter 2.

Three, you can cut and sort. After initially marking up texts with different colored pens (use transcripts of TV programs), identify quotes or expressions that seem somehow important and then arrange these quotes/expressions into piles of things that go together. For example, you might cut out each quote, with some context, and paste it on a small index card. On the back of each card, write down who said the quote and where it appeared in the text. Randomly distribute the cards on a big table and then sort them into piles of similar quotes. Name each pile and you have created the themes.

For a variation on the cut-and-sort method (Ryan and Bernard, 2003), ask several team members to try to independently sort the quotes into the named piles. When they have difficulty, they may add additional piles (themes). Ask the team members to talk aloud as they sort the quotations and record their thinking process to learn about the criteria they used to sort the quotes. Moreover, since team members do not know where the quotes came from, they will be less biased in how they group the quotes.

The prior understanding approach means that researchers a) adopt pre-existing categories from other people's similar research studies; b) use common-sense ideas; or c) use their values and personal experiences.

Developing Categories from Prior Understanding

Constas (1992) offers at least five means to create categories. One, you can ask viewers of your study's media content to identify categories. Two, you may use a panel of experts from outside your study. Three, you can rely on logic and reasoning, ensuring that categories reflect some sort of functional consistency or hierarchical relationship. Four, you can look at what is missing within your initial group of categories and create a new category to ensure you have a mutually exclusive and exhaustive set. Five, you may create categories after coding has begun because during coding you discovered that too many units of analysis were being placed in the "other" category. Of course, you must then re-code content to take into consideration this newly created category.

You can also take advantage of the most common way to develop categories from prior understanding: use the literature. To understand the nature and extent of sexual information on TV, you could adopt themes from Ward's study (1995) of sexuality on TV programs. The most common themes in his sample were: a) men value and select women based on their physical appearance; b) women are attracted to specific types of men; c) sexual/romantic relations are a competition; and d) maintaining a relationship is serious and

often involves pain and conflict. If you wanted to code visual depictions of sexual behavior, you could borrow Heintz-Knowles' categories (1996) from her study of daytime soap operas. The most frequently sexual activities other than intercourse were a) flirting; b) intimate dancing; c) romantic touch/embrace; d) modest kiss; and—the most common behavior—e) passionate kiss.

Sorting Content into Categories: Traditional Content Analysis

Traditional content analysts generally code messages' **manifest content**, defined as the most obvious and straightforward meanings. They try not to interpret a sender's intended meanings or a receiver's perceived meanings. Traditional content analysts want to simply code what was said, which they implicitly believe is the same as what coders think was said (Ahuvia, 2001). Traditional content analysts imply that they do the important work of measuring things objectively and systematically, while interpretive content analysts make subjective interpretations, and reception-based researchers use viewers, who make personal, untrained decisions about what was said. Traditional content analysts consider the work of others less scientific and less important.

To code manifest content, traditional content analysts create a codebook, which includes the instructions that enable coders to sort content into themes or categories. A good guidebook includes a full definition of each theme/category, guidelines for when to assign a unit of media content to a theme/category, guidelines for when a theme/category does not represent a scene, and examples of scenes that have been sorted into themes/categories. The following is a better-than-normal definition of a category:

> Physical suggestiveness was defined as sexually suggestive actions or sexually suggestive exposure of one's body. In contrast to Erotic Touching (defined below), which involves one character touching another, physical suggestiveness applies only when one partner is not touching another. For physical suggestiveness, the camera shot was used as the unit of analysis. This means, for example, if five strippers were on the screen simultaneously "bumping and grinding," this would count as one instance of physical suggestiveness. But if one stripper were shown on the screen in five different camera shots, this would count as five instances. The most common instances of physical suggestion were breast shots and derriere shots—referred to in the industry as "T and A shots."
>
> (Lowry and Shidler, 1993)

Coding occurs in three steps. First, coders independently segment the same media texts into characters, scenes, or shots. Second, they determine which units include sexual behavior. Third, they sort these units according to the study's themes/categories.

For training, researchers explain the codebook and the three steps for coding the media. Researchers and coders then watch texts that resemble, but are not part of, the texts that will be analyzed to answer the research questions. Coders then code these sample texts, and researchers calculate coders' agreement on coding decisions. If coders disagree, then researchers discuss these problems with coders in order to clarify the codebook. Researchers may revise the codebook many times during the training period in order to provide increased clarification for coders. Coders then use the revised codebook to re-code the trial texts. Researchers again check intercoder agreement to ensure that the new definitions and guidelines have resolved all problems.

Sorting Content into Themes: Interpretive and Reception-based Content Analysis

Although visuals may seem easy to "read," they are difficult because we lack the equivalent of both a dictionary and a rules of grammar for visuals. Moreover, visuals often are loaded with **latent content**, which refers to a text's subtler meanings.

For example, imagine all of the non-verbal communication involved with flirting (Knapp and Hall, 2006). Women, who flirt more than men, use three types of eye gaze: a) a room-encompassing glance; b) a short, darting glance at a specific guy; c) a fixed gaze of at least three seconds at "the one." In addition, they smile at the man, and they laugh and giggle in response to his comments. Additional non-verbal flirting behavior includes: a) tossing their head and stroking their hair; b) grooming, primping, and adjusting their clothes; c) caressing objects such as keys or a glass; and d) seemingly accidentally touching the guy, who, by now, should have gotten the message.

Visual interpretation of subtle behavior occurs through a reasoning process called **abduction**, defined as inference to the best explanation (Moriarty, 1996). Abduction entails considering all possible theoretical explanations for the data, forming hypotheses for each possible explanation, checking them by examining data, and pursuing the most plausible explanation. Many important kinds of intellectual tasks, including medical diagnosis, scientific discovery, and legal reasoning have been characterized as abduction.

To understand abduction, think of Sherlock Holmes or one of your favorite detectives. Holmes begins by discarding any preconceived ideas (theory) about what had happened. He simply observes everything around him. He then assembles these observations along with information filed in his memory to make an educated guess about what happened. The more clues he has available, of course, the more likely he will have an "aha" moment and solve the case. Holmes succeeds where others fail because he observes more clues than Watson and he has developed his ability to unconsciously "connect the dots." This same abductive reasoning process occurs, just as unconsciously, but more quickly, when you look at an unfamiliar visual and attempt to determine what it means.

The more interpretation that coding requires, the less likely that adequate coding rules can be written because the amount of training for coders would be prohibitive. Moreover, coders need to interpret latent content within a particular theoretical perspective. With interpretive and reception-based content analysis, therefore, coders can rely on neither codebooks nor training. Instead, they rely on themselves. They realize that they need to train themselves and other researchers to become more like Sherlock Holmes rather than spend time creating codebooks and then letting inexperienced people do their coding.

Interpretive content analysts work collaboratively to improve their ability to interpret texts. They care less about agreement and more about making valid coding judgments. They realize that a group working together has more theoretical sensitivity than any member working alone (Ahuvia, 2001).

Reception-based content analysts realize that meanings exist in people as much as they exist in texts, so people may understand the same text in different ways. They do not care if researchers have more theoretical sensitivity and could do a "better" job of coding. They believe that the natural readers' understanding of the text should be used as the basis for coding (Ahuvia, 2001). Reception-based content analysts select coders who are representative of the target audience (youth) and ask them to interpret the study's texts. A perfectly representative sample of youth may not be possible to obtain, but they believe that even an imperfect sample of youth would be a step in the right direction.

All three types of content analysts offer good advice. The best choice for you, however, depends upon your purpose and research questions. Since this chapter concerns the nature and extent of sexual information that media convey to youth, youth's interpretations should trump both scientists' objective judgments and researchers' skills for abductive reasoning.

Identifying Scripts (Frames)

Instead of analyzing small units of analysis, such as a shot or scene, some researchers look for the presence of larger scripts, which other researchers call frames. The **Heterosexual Script** (Kim et al., 2007), for example, is the blueprint for socially sanctioned romantic and sexual encounters. It recognizes that sexuality carries different meanings and consequences for boys and girls. The script includes three major elements: a) a sexual double standard, stating that it is more desirable and appropriate for boys to accumulate sexual experience than it is for girls; b) courtship strategies, stating that boys use active and powerful ways to attract women, while girls use submissive and alluring ways to attract men; and c) attitudes toward commitment, suggesting that women more than men seek commitment in romantic and sexual relationships. In a study of TV programs popular among adolescents, Kim et al. (2007) found an average of fifteen references to the Heterosexual Script per hour.

To measure the presence of the Heterosexual Script, the researchers used a combination of deductive and inductive processes in order to create complementary themes, which reflected specific elements of the Heterosexual Script mentioned earlier. During the coding, one coder watched a program, identified themes whenever they occurred, and wrote a specific description of the content that fitted a theme. A second coder then watched the same episode and verified the first coder's decisions.

Traditional Content Analysts Measure Intercoder Agreement

Whether researchers collect data by interviewing, observing, conducting experiments, or coding content, they want to ensure that their methods are reliable, which means consistent. Traditional content analysts base reliability upon intercoder agreement, or percent of agreement for coding decisions. To calculate percent agreement, divide the number of coding agreements by the total number of coding decisions. Thus, if in a particular study, two judges make a total of 1,000 decisions each and they agree on 870 of them, then they agree 87 percent of the time. Researchers then apply a correction formula to take account of the fact that some fraction of agreement will always occur by chance (Ryan and Bernard, 2003). The amount of that fraction depends on the number of coders and the number of choices each coder needs to make. For example, if two people code themes as either present or absent and they agree one hundred times out of one hundred decisions, then reporting 100 percent agreement would be overstating the reliability of their coding because they would have agreed 25 percent of the time by chance alone. Researchers commonly use a formula, such as Holsti's method, Scott's Pi, Cohen's Kappa, or Krippendorf's Alpha in order to test for chance agreements (Lombard, Synder-Duch, and Bracken, 2002).

Interpretive Content Analysts Use Public Justifiability

Interpretive content analysts substitute **public justifiability** for intercoder agreement (Ahuvia, 2001). To achieve public justifiability, interpretive researchers let reviewers of their work see a random sample of their texts along with the texts' coding results and, if necessary, a justification of why the researchers obtained those results. In this way, reviewers can directly assess the quality of interpretive researchers' coding. Moreover, by sending a random sample of texts, researchers avoid a natural inclination to cherry pick the clearest coding examples for submission.

Public justifiability is just as scientifically legitimate as intercoder agreement, if not more. In traditional content analysis, coders, who are often graduate students, are trained to follow coding rules, so intercoder agreement measures inexperienced coders' ability to consistently apply these rules. In interpretive content analysis, on the other hand, a team of experienced researchers uses

their intuition to jointly interpret the texts' meaning, and then reviewers interpret a sample of the same texts, so this type of "intercoder agreement" really measures the agreement between two sets of qualified coders.

Actually, the researchers' interpretations may not be identical to reviewers' interpretations. They can differ as long as the peer reviewers ensure that the media texts justify the researchers' interpretations. With interpretive and reception-based content analysis, researchers realize that no one "correct" interpretation can exist.

Reception-based Content Analysts Welcome Disagreements as Important Data

Since reception-based content analysts do not use coding rules, they do not expect different readers to agree on a text's meaning, and they cannot use intercoder agreement as a measure of reliability. They could measure reliability, however, by asking a sample of coders to wait a month and then re-code the same TV programs and movies. They could then compare the two sets of coding decisions in the same way that traditional content analysts compare two people's coding decisions.

Although they cannot use intercoder agreement to measure reliability, reception-based content analysts want to learn when viewers disagree about the meaning of a scene. They particularly want to identify patterns of disagreements because such findings may generate new, interesting research possibilities. For example, in a reception-based content analysis, male viewers may believe that 75 percent of female characters dressed in a highly suggestive manner, and that 50 percent of the scenes focused on sex. Female viewers, on the other hand, may think that 25 percent of female characters dressed in a highly suggestive manner, and that 25 percent of the scenes focused on sex. Reception-based content analysts expect such disagreements about the meaning of a text because they do not believe in the myth of one correct interpretation, but they will want to understand why males and females disagree. After talking to male and female coders, they may form new hypotheses, such as "Males think about sex more than females, so they see sexual behavior in more scenes than females."

Reception-based content analysis studies also differ from the other two types of studies because the researchers use many more coders; they may ask hundreds of people to interpret scenes of sexual behavior. In fact, reception-based studies use so many coders, they resemble a combination of a content analysis and a small survey. For example, reception-based researchers could post some TV and movie scenes on the Web and then e-mail a representative sample of people, ask them to view the scenes, and then respond to a few questions about the scenes' meaning.

Data Analysis

Traditional Content Analysis

After coders have coded the sample of media content, researchers need to reduce this data. To do this, traditional content analysts generally use **descriptive statistics**, defined as statistics for summarizing, tabulating, organizing, and graphing data for the purpose of describing a sample. They reduce their data by counting the number of scenes assigned to each theme/category. Researchers generally convert these numbers to percentages. They and their readers generally assume that the most common themes/categories are also the most important ones.

Using numbers and percentages to reduce the data may not be sufficient for complex variables. Instead, researchers may need to create an **index**, which is defined as a combination of several separate measures of a concept. Each measure provides some indication of the variable, and when combined, the index provides a measure with a greater range of variation. For example, to create an index to represent "voice," Mullen (1999) combined four measurements of the vocal tone of the president. The president's voice could be scored as sarcastic or friendly, irritated or soothing, pessimistic or optimistic, and loud or soft. Coders scored 1 for each instance of negative adjectives; 3 for positives, and 2 when they could not decide if the president's voice was positive or negative. By combining the four measures together, Mullen ended with an index that ranged from a score of 4 to 12. This index number allows greater variation than any of the four underlying measurements, which could only range from 1 to 3.

Many traditional content analysts end their analyses after reporting numbers and percentages for each theme/category. If they want to do more than describe content, such as test hypotheses, then they need to measure the relationship between variables in a hypothesis. They need to determine whether the increase of one variable affects the increase (or decrease) of the other variable.

Traditional content analysts generally conduct a **bivariate analysis**, which is an analysis of two variables simultaneously in order to determine the relationship between the variables. For their bivariate analysis, they may use a **chi square test**, defined as a statistical test of significance for comparing observed frequencies with expected frequencies (Babbie, 1983). If they match, then the two variables are unrelated. On the other hand, if they differ, then a relationship exists. To understand how chi square tests work, follow these steps for a hypothetical study of stereotypes on TV programs.

One, you would select a random sample of one hundred characters from TV programs. Let us say your sample includes forty African-Americans and sixty Caucasians.

Two, you would then code each character as stereotyped or not stereotyped. Let us say you find that 30 percent of all the characters in your sample are stereotyped. If 30 percent of all characters were stereotyped, then you would expect 30 percent of the African-American characters would be stereotyped

and 30 percent of the Caucasian characters would be stereotyped. If you do the math, you will find that 30 percent of forty is twelve; therefore, you would expect twelve African-American characters to be stereotyped. Since 30 percent of sixty is eighteen, you would expect eighteen Caucasian characters to be stereotyped.

Three, you check to see how many African-Americans were actually stereotyped. Let us say your previous coding efforts determined that twenty African-American characters and ten Caucasians were stereotyped.

Four, you either use your math skills to calculate a chi square value, or, more likely, you use software to obtain the number, which in this case is 12.7.

Five, you then compare this value (12.7) with a table of critical values of chi square found in a quantitative methods textbook. If you read the table properly, you will learn that a random sample with a chi square value of 12.7 would appear less in less than 0.1 percent of all samples. Since it is so unlikely that your results arise from sampling error, you can conclude that, indeed, TV programs stereotype African-American characters more than Caucasian characters.

Table 10.1 Chi square analysis

1. *Expected cell frequencies*	*African-American*	*Caucasian*	*Total*
Stereotyped	28	42	70
Not stereotyped	12	18	30
Total	40	60	100

2. *Observed cell frequencies*	*African-American*	*Caucasian*	*Total*
Stereotyped	20	50	70
Not stereotyped	20	10	30
Total	40	60	100

3. *(Observed − expected) ÷ expected*	*African-American*	*Caucasian*	
Stereotyped	2.29	1.52	$\chi^2 = 12.70$
Not stereotyped	5.33	3.56	$p < .001$

Interpretive and Reception-based Content Analysis

Researchers using interpretive content analysis and reception-based content analysis also need to analyze their results, but they do not use statistics. Instead, they interpret patterns they find in their themes (Morgan, 1993).

Pattern codes are explanatory or inferential codes that identify an emergent explanation of the data (Miles and Huberman, 1994). The codes pull together a lot of material into more meaningful and parsimonious components of analysis. When pattern codes revolve around themes, they resemble scripts

(frames) such as the Heterosexual Script discussed earlier. Pattern codes may also revolve around causes–explanations from a researcher's interpretation of the data or from characters on the TV program. For example, a male character may exclaim: "I need you so much." A female character may say: "I really shouldn't." As a result, the researcher might be reminded of something Billy Crystal once said: "Women need a reason to have sex. Men just need a place."

Data Displays

Quantitative content analysts use a table showing frequencies, percentages, and statistical indicators to display their final results. Interpretive and reception-based content analysts may map their pattern codes. They may create a network display to see how the various components interconnect.

Credibility, Transferability, and Dependability

Traditional Content Analysis

Traditional content analysts take five steps to ensure that they developed and used their categories properly (Kolbe and Burnett, 1991). One, they describe the study's rules and procedures, including operational definitions of categories. Two, they train their coders. Three, they pre-test categories either in coder-training sessions or before coding began. Four, they use coders other than themselves. Five, they ensure that each coder made autonomous judgments.

Like all quantitative researchers, traditional content analysts strive for internal and external validity. **Internal validity** refers to the extent to which scientific observations and measurements authentically represent some reality. This presents problems for quantitative content analysts. Analysts break TV stories into small units and then code each unit separately according to theoretically defined categories. Regular TV viewers, however, do not normally view or interpret communication that way. They concentrate on the general meanings (Graber, 1988). **External validity** refers to the generalization of research findings, either from a sample to a larger population or to settings and populations other than those studied. Quantitative content analysts use **statistical significance** tests, such as a chi square test, to indicate the probability that any association found between the two variables within a sample will hold true for the entire population.

Qualitative Content Analysis

Spiggle (1994) suggests usefulness, innovation, integration, resonance, and adequacy to evaluate interpretive studies. A study is useful when it furthers inquiry in one of two ways. Researchers make connections between their work and the central issues, problems, and debates in the field; or researchers can

show how their concepts and frameworks can transfer to other research settings and other fields. A study is innovative if the concepts and frameworks provide new and creative ways of looking at behavior. A study is integrative if it offers a holistic framework that goes beyond the identification of common themes or categories. Rather than report the frequencies of several categories and sub-categories, the framework should unite the data. A study resonates if it enlightens us about similar and even dissimilar things. A study is adequate if we can trust the concepts and frameworks because the researchers provided sufficient evidence for us to assess the way the data were used to create those concepts and frameworks.

Internet

Researchers who conduct content analysis studies frequently study Web-based content. By the year 2000, McMillan was able to review nineteen content analysis studies of the Web (McMillan, 2000). She lists the studies' a) purposes and questions; b) sampling frames, sampling selection methods, and sample sizes; c) context units and coding units; d) number of coders, training of coders, and reliability; and e) summary of findings. McMillan also provides useful recommendations for anyone wanting to analyze Web content.

Two other scholars had a similar article published in the same year. Weare and Lin (2000) analyze methodological issues related to the Web's global reach, interactivity, decentralization, hyperlinked structure, and multimedia format. For example, they studied the difficulties of drawing a representative sample, and they explained how to create sampling frames based on Internet addresses, search engines, collector sites, and popular sites. They also studied the challenges of dividing Web content into units of analysis, since the non-linear nature of the Web obscures the boundaries and context of messages. They also suggest methodological improvements for future research.

Advantages and Disadvantages

Traditional content analysis has several advantages over other research designs:

1. You can study virtually any form of communication, including books, poems, songs, paintings, letters, and photographs.
2. You can view this content repeatedly.
3. You can study it unobtrusively, without affecting the data (**non-reactive**).
4. You can study content from the past and present.

Content analysts, however, also acknowledge some disadvantages.

1. You may, wrongly, associate frequency of content with significance of content. For example, frequently appearing clichés, such as the academic expert in front of rows of books, appear in the media because

photographers can take such images easily and because audiences can quickly recognize these clichés; their frequency does signal their significance.

2. You may use content categories—roles depicted, settings shown, gender and age of represented participants—without relating them to any particular theoretical perspective.

Fortunately, some additional disadvantages of traditional content analysis disappear when researchers use interpretive or reception-based content analysis. One, traditional content analysts often use simplistic categories in order to gain high reliability, or they use categories that require interpretation, and intercoder agreement suffers. Interpretive content analysts resolve this problem by allowing coders to use abductive reasoning and by using public justifiability as a reliability measure. Reception-based content analysts resolve this problem by also allowing coders to use their intuitive reasoning skills, and they treat differences in intercoder agreement as important findings rather than as a problem. Two, fragmenting the content effectively de-contextualizes messages, so quantitative content analysts cannot properly appreciate how people naturally experience the symbolic character of communication. Both interpretive and reception-based analysts resolve this problem by encouraging coders to use observations (clues) from the entire program or movie, and even from their past experiences, in order to interpret scenes. Three, with traditional and interpretive content analysis, the different ways people interpret the same text—photographs, TV stories, etc.—must be ignored in order to achieve reliability. Reception-based content analysis, of course, resolves this problem by asking different types of natural viewers to interpret texts.

Ethical Issues

You should report the coder's experience, training, and perspective, and any connections the coder may have to the people, program, or topic studied. In fact, you should report any personal and professional information that may have affected data collection, analysis, and interpretation, either negatively or positively (Patton, 1990).

Resources

You need neither a large staff nor special equipment to conduct a content analysis study. For a traditional study, you can train fellow students to conduct the coding, input data, and create frequency distributions.

Interpretive and reception-based content analysis studies, however, require more resources. You either need some coders who have experience with the theoretical framework and the topics being investigated, or you need to recruit numerous coders who are members of the target audience for your content.

Advice

1. Use traditional content analysis when you expect people to agree about the meaning of texts, or when coding categories are based on denotative meanings. Use reception-based content analysis when coding categories include connotative meanings and intercoder agreement is unlikely, or if you want to measure audiences' interpretations. Use interpretive content analysis when coding categories include connotative meanings, or when reception-based content analysis is not practical.

2. Use different types of people (male and female; old and young) as coders for traditional content analysis. Take advantage of a collaborative team of researchers as coders for interpretive content analysis, and use a representative sample of coders based upon your theoretical framework for reception-based content analysis.

3. Use clearly written coding rules for traditional content analysis; explain abductive reasoning to coders for interpretive content analysis; and let coders use their own intuitive ideas for coding in reception-based content analysis.

4. Use intercoder agreement for measuring reliability in traditional content analysis; public justifiability for interpretive content analysis; and treat the level of consensus about the meaning of texts as a research finding in reception-based content analysis.

5. Become familiar with research about how people watch TV programs and movies because it may give you ideas for developing categories. Also use inductive procedures to develop themes/categories.

6. Use indexes to measure variables at the ordinal level rather than nominal level.

7. Assign primary responsibility to one person for creating, updating, and revising a codebook. This will ensure that the codebook is consistent and it will minimize ambiguities arising from differences in vocabulary and writing styles (MacQueen et al., 1998).

8. Create a codebook that someone can learn to use within a few hours. For the most part, coders can reasonably handle thirty to forty codes at one time. If the codebook contans more than forty codes, the coding process needs to be done in stages (MacQueen et al., 1998).

9. When defining codes, do not assume that anything is obvious. Always state specifically what the code should and should not capture. This includes defining common abbreviations.

10. Accept the fact that text will need to be recoded as the codebook is refined. Recoding should not be viewed as a step back. It is always indicative of forward movement in the analysis (MacQueen et al., 1998).

Further Viewing

Videos about Miley Cyrus

The View women give their opinions on the Miley Cyrus photos
http://www.redlasso.com/ClipPlayer.aspx?id=48b050b0-e211-4496-9950-9e3f9145db2d

Miley Cyrus gets a call from Hilary Duff!
http://video.google.com/videosearch?q=miley%20cyrus&gbv=2&hl=en&ndsp=18&ie=UTF-8&sa=N&tab=iv

Miley Cyrus: *Vanity Fair* shoot
http://www.youtube.com/watch?v=3keEzdkCjW4

Composite Variables

Lawrence J. Mullen

One of the more interesting things about visual content analysis is the study of complex concepts and coming up with visual indicators for them. The concept I studied was "contentiousness" and I was interested in how this concept was manifested in television news about the president of the United States, who was Bill Clinton at the time. One can easily find dictionary definitions of the word, but what does contentiousness look like? How do you know it when you see it?

There is no single thing that you can point to and say, "there's an example of contentiousness." Rather, the concept can only be understood as a composite of several visual components. In my study I developed three cumulative variables, or composites which I developed through my literature review of related topics to measure contentiousness. Without rehashing the article itself, each of these composite variables tried to measure visual manifestations of contentiousness in a different way. The variables that formed each composite were the visual indicators of contentiousness. The literature that examined the visual aspects of political communication uncovered several variables that related to the contentiousness concept I was interested in. For example non-verbal contentiousness included measures of facial displays and body language the president displayed in the news imagery that was recorded from off-air television broadcasts. Measurements of his eyebrows, lips, arms, and overall body position were included in this composite variable, which could have a value from three to thirteen, with higher numbers indicating a greater degree of visual contentiousness.

The most important thing about the composite variables was to establish intercoder reliability for each variable making up the composite. The trick was to make the indicators of contentiousness as concrete as possible and to operationalize the indicators in a simple, clear way. The way to achieve this is through the creation of good coding rules and measuring each variable with only two or three attributes. Thus, the variables tend to be primarily nominal and ordinal level. For example, the visual aspects of the president's face were measured for contentiousness (from the non-verbal composite measure above) and one such variable had coders view the eyebrows of the president if they could see them in the shot. Coders indicated if his brows were either furrowed, or not furrowed. A furrowed brow is a non-verbal indicator of tension on a person's face which may indicate a level of contentiousness. The coding rules stated, "If it looks like his brow is noticeably wrinkled, tight, lowered, or tense, then mark the space by 'yes' (1). Otherwise, mark the space by 'no' (0)." So, if the coders could not tell if the president's eyebrows were furrowed or not, they would indicate "no." This measure was then tested for intercoder reliability

using one of the several standard statistics used to measure this form of reliability. The statistics indicated that intercoder reliability was good, so this variable was combined with the other non-verbal variables of the president's perceived contentiousness.

Content Analysis Isn't

Aaron Ahuvia

Content analysis is not really content analysis. That is to say, as it is conventionally practiced, it is not really an analysis of content per se. Visual communications do of course have content. They have paint on a canvas, ink on a page, pixels on a computer screen. But in conventional practice, this actual content is not measured or analyzed. Rather, a person is assigned to rate or code the content, and it is this coder's interpretation of the content which is quantified and analyzed. This is not a minor technicality. It goes to the heart of the methods used and is the basis for the methods presented in this chapter.

While our more philosophically oriented colleagues in English and Philosophy departments long ago abandoned the idea that a text had a single, simple meaning, the more practice-oriented disciplines of communications, marketing and the like, maintained earlier models of content analysis because they often seemed to work well enough for the task at hand. This was especially true if the task at hand was specifically chosen not to exceed the limitations of the methodology. Unfortunately, the limitations of the methodology often meant a severe dumbing down of the interpretive process so that only simply coded meanings could be analyzed. So called "latent content" analysis was an attempt to avoid this and code more complex content, but it rarely worked well and frequently the coding rules needed to carry it off distorted as much as they illuminated.

At the risk of sounding like a libratory postmodernist, I hope that the reader finds the methods here freeing. In this case, it is the freedom to address how visual or other texts are actually interpreted by the people who create or receive them. But as with all forms of freedom, it also brings a complexity, and this complexity can make the research and writing process more difficult. Presenting visual texts in all their complexity is rarely useful for social scientists. We correctly search for a simplified model of reality that can be remembered by our readers and usefully applied. The trick then, in applying the techniques described in this chapter, is to avoid the twin problems of so much simplicity that you take your reader for a simpleton, or so much nuance that the details become an aggravating nuisance.

Glossary

Abduction Inference to the best explanation. Abduction entails considering all possible theoretical explanations for the data, forming hypotheses for each possible explanation, checking them by examining data, and pursuing the most plausible explanation. Many important kinds of intellectual tasks, including medical diagnosis, scientific discovery, and legal reasoning have been characterized as abduction.

Access ladder Idea that a field researcher may only be able to learn about public, uncontroversial events at first, but with time and effort, may gain entry to more hidden, intimate, and controversial information and thoughts.

Action research (see also participatory action research) It aims at solving specific problems within a program, organization, or community. Action researchers purposefully become part of the change process. They engage people in studying their own problems in order to solve those problems. They make reports for specific stakeholders who then use the results to make decisions and improve programs.

Analytic generalization (see also naturalistic generalization) Judgment about the extent to which one study's findings can be used as a guide to what might occur in another situation. To make this judgment, compare the study's results to the previously developed theory. If the results support that theory and they do *not* support an equally plausible, rival theory, then the results can be generalized.

Analytic induction It explicitly takes the unusual, or deviant, case as a starting point for testing or building theories. With this new case in mind, researchers return to the field and collect new data to test their revised thinking. If they again find a deviant case, they again revise their theory and collect new data. This process continues until there are no more unusual or deviant cases to account for.

Animation (see also simulations and virtual reality) This process of filming still images in sequence gives the illusion of movement when the images are projected. In a legal context, animations are usually created from eyewitness accounts as well as from actual data from the scene. Animations can assist a judge or jury in quickly forming an understanding of a particular event,

possibly more vividly than if the people were merely shown a series of photos and had the event described to them.

Anonymity (see also confidentiality) Participants remain nameless and they cannot be identified in visual representations.

Applied research (see also action research, basic research, and evaluation research) Purpose is to inform action, enhance decision-making, and apply knowledge to solve problems. Applied research is judged by its usefulness in making actions more effective and by its practical utility to decision-makers, policy-makers and others who try to improve the world.

Auditor (see also peer reviewer) An independent scholar who systematically compares the researcher's data reduction and analysis process to a set of norms or standards for that practice and issues a professional opinion.

Authoritative discourse One that makes a claim to truth—this is the way things really are.

Autodriving (see also elicitation) The visual stimuli *drive* the questions, and participants respond by explaining the visuals.

Basic research (see also action research, applied research, and evaluation research) People conduct basic research to generate or test theory and to discover knowledge for its own sake. Basic researchers publish their reports in scholarly journals.

Becker, Howard A prominent sociologist who uses qualitative research, in particular visual sociology, to study social groups.

Bias (opposite of objective) This occurs when researchers bring a personal interest to the study. They should either acknowledge how their backgrounds and professional experiences may influence the collection and analysis of data, or they need to design their studies to reduce such subjectivities.

Bivariate analysis An analysis of two variables simultaneously in order to determine the relationship between them.

Born into Brothels This American documentary film concerns the children of prostitutes in Calcutta's red-light district. It won the Academy Award for Documentary Feature in 2004.

Bracketing (also known as defocusing) Setting aside, as much as humanly possible, past assumptions, preconceived ideas, and personal experiences in order to best understand the experiences of the study's participants.

Brain hemispheres The brain is divided into a left and right hemisphere, and each hemisphere processes different types of information in different ways. Whereas the left hemisphere processes information sequentially, the right does so simultaneously. The left hemisphere is more analytical, verbal, and logical; while the right is more holistic, imagistic, and intuitive.

Brainstorming A problem-solving activity conducted by a group of people who spontaneously generate many creative ideas. During the activity, everyone accepts these ideas without criticism.

Briski, Zana This photographer, filmmaker, and activist wrote and directed *Born into Brothels* with Ross Kauffman.

Burris, Mary Ann A research associate of the School of Oriental and African Studies at the University of London who created the first Photovoice project with Caroline Wang.

Can-opener approach (see also softly-softly approach) Researchers carry and show off their cameras in order to help establish rapport with participants. This approach assumes that people like both to take pictures and to have their pictures taken.

Case analysis meeting At this meeting, the person with the most knowledge of the case meets with one or two others to summarize the case's current status. A series of questions guides the meeting, and someone takes notes on answers to questions.

Case dynamics matrix A display of the forces that cause changes as well as the resulting outcomes. It displays problems and their resolutions in a way that will help readers understand why specific things happened the way they did.

Case study research The investigation of an individual, event, social activity, group, or organization in its natural setting with multiple methods of data collection.

Categorizing means a) organizing the data set; b) immersing yourself in the data; c) dividing the data into relevant chunks (units of analysis); d) creating categories that you can use to answer your research questions; e) assigning (coding) those chunks to different categories; f) interpreting the results of coding; and g) searching for alternative interpretations.

Ceremonials (see also rites) Systems of several rites connected with a single occasion or event.

Chi square test A statistical test of significance for comparing observed frequencies with expected frequencies. It can be used to either *describe* a sample or to *make inferences* from a sample to a population.

Click! experience A sudden, though minor, epiphany about the importance of an event.

Coding (see also connecting analysis) A process for analyzing data. Researchers begin by dividing their data into chunks. Then they create a system for categorizing the various chunks. Researchers assign each relevant chunk to a category and then they integrate the category results to form, expand, or verify theory.

Cognitive map It displays a person's beliefs about a particular topic as well as the relationships among the beliefs. Researchers commonly add descriptive text to the map.

Collection tape On videotape, someone assembles all instances of a particular person, event, or theme.

Commitment Both partners think of their relationship as ongoing for an indefinite period of time. They share a common journey, including the costs and rewards.

Common ground (also known as mutual knowledge) Knowledge that the people share in common and that they know they share. In order to find

common ground, people coordinate the content and process of communication.

Communication A social process. Communication is social because it involves interactions between people. Communication is a process because it consists of an ongoing series of exchanges. In these exchanges, one person uses symbols to intentionally send a message; then others interpret the message's meaning and respond.

Comparative studies (see also patchwork studies and pre-post studies) You integrate the results of several studies about *different* things, all of which share some important characteristic.

Composite measure Several indicators of a variable are combined into a single measurement, usually represented by a number.

Computer-mediated communication (CMC) A process of human communication via computers. People create, exchange, and interpret information in formats such as instant messages, e-mails, and chat rooms.

Confidentiality (see also anonymity) Information about participants is private and should only be revealed with their consent.

Connecting strategies (see also coding) Like coding, it is a process for analyzing data. Instead of fracturing the initial text into discrete segments and re-sorting it into categories, however, connecting analysis attempts to identify the relationships that connect statements and events into a coherent whole.

Conscientization A process whereby people learn about social and political forces in order to become liberated from oppression. They find their voice, and by speaking out, they transform their living conditions.

Constant comparative method A procedure for developing coding categories. Researchers identify incidents, events, and activities; then they constantly compare this information to an emerging category in order to develop and saturate the category. They later combine categories into a theoretical explanation of what happened.

Constitutive rules (see also regulative rules) They determine how behavior should be interpreted within a given context. We can understand another person's intention because the constitutive rules tell us what certain types of behavior mean.

Content analysis (see also interpretive content analysis and reception-based content analysis) An objective, systematic, and quantitative method of describing the content of texts.

Content log A written description of what can be heard and seen on the videotape as well as when it appears on the videotape.

Context of the case It may be broadly conceptualized, such as large historical, social, political issues; or it may be narrowly conceptualized, such as the physical location and the time period in which the study occurred.

Convenience sampling (see also probability sampling and purposeful sampling) It is fast, inexpensive, and opportune. It is probably the most common sampling strategy as well as the least desirable because it is neither purposeful nor strategic.

Coordinated Management of Meaning theory Communication is successful when two people attempt to make sense out of the sequencing of messages in their conversation and they have sufficient resources available for the process of coordination. Resources include the stories, symbols, memories, and concepts that people use to make their world meaningful.

Credibility (see also internal validity) Qualitative researchers' equivalent to internal validity. A study is credible when researchers present such faithful descriptions or interpretations of a human experience that the people having that experience would immediately recognize it as their own. In addition, after reading the report, other researchers and readers can recognize the experience when confronted with it.

Criterion sampling This means that researchers include people in their sample when a person has experienced the key phenomenon (or criterion); researchers exclude everyone that has not experienced the phenomenon (or criterion). For example, the criterion might be "received a photo message." If so, then everyone who receives a photo message becomes part of the sample.

Cube Comparison Test It requires participants to mentally rotate a line drawing of a three-dimensional cube. Each test item presents a) two views of a cube with letters and numbers printed on its sides; and b) four pictures of the same cube after it has been rotated in various ways. Participants must decide which of the four pictures of the cube that had been rotated best matches the original two views of the cube.

Cultivation theory It claims that television affects viewers' conceptions of reality. To test those claims, researchers ask heavy viewers of TV and light viewers about their attitudes toward various social issues. From correlations between TV viewing and people's survey responses, cultivation researchers conclude that heavy viewers "cultivate" or adopt, TV-like views of reality.

Culture I think of culture as common sense; it is the large, vague, changing system of attitudes and behaviors that affect a social group.

Cuts Instantaneous transitions. You make a cut by splicing two shots together without a fade or dissolve.

Data analysis This consists of examining, categorizing, tabulating, or otherwise recombining evidence in order to address the study's initial research questions.

Data displays Visual formats that compress and organize data so that viewers and researchers can draw valid conclusions about the data.

Data units (see also ethnographic chunk) Blocks of information with the same meaning; they might take up several pages or they could be as short as a phrase.

Denotative/connotative meanings These two related concepts refer to the production and interpretation of meaning at different expressive levels. Denotation refers to the primary, blunt, obvious meaning of sign or text. Connotation is the secondary, nuanced, implied meaning of a sign or text.

Dependability (see also reliability) Qualitative researchers' equivalent to reliability. Other researchers can clearly follow the reasoning used by the study's investigator. In addition, they can arrive at a similar conclusion given a similar situation.

Dependent variable/independent variable A hypothesis generally includes two variables: an independent variable and a dependent variable. The independent variable is assumed to *cause* the dependent variable.

Description (see also thick description) It uses words and visuals to create a mental image of an event, scene, experience, sensation, or emotion. It does not include judgments about whether what occurred was good or bad, appropriate or inappropriate, or any other interpretive judgments. A description simply illustrates what occurred.

Descriptive statistics Statistics for summarizing, tabulating, organizing, and graphing data for the purpose of describing a sample of individuals that have been measured or observed.

Discourse Photographs and written text that work together. For example, a magazine article about global warming—photographs, captions, head-lines, and written text—presents a discourse about an environmental problem.

Discourse analysis A method researchers can use to study photographs and their accompanying written texts. Originally designed to study spoken dialogue between individuals, it has been modified to apply to other forms of communication. This expansion of discourse analysis has come about, in part, because visual images have gradually taken over more of the functions traditionally performed by language alone.

Draw-and-tell Instead of observing children or talking to them, researchers ask children to draw. Then they can ask children to talk about their drawings.

Elicitation (see also autodriving) This occurs when researchers show visuals to participants, who then explain the images, as well as what is missing in the photographs.

Empathy A sense of shared thoughts, feelings, and experiences with someone else. Empathy does not necessarily mean agreement or approval. It means being sensitive to others. People lay aside their personal views and enter into another's world without prejudice.

Empowerment Process whereby people gain control of their lives by developing participatory skills. Empowered people can interpret for themselves the agendas of those with political, economic, and social power. They can then make use of these other people's agendas to develop their own realistic solutions for improving their lives.

Ethnographic chunk (see also data unit) A type of data unit because it consists of a block of information with the same meaning. For example, an ethnographic chunk might consist of a scene in a video that shows coherent interaction within an event.

Ethnography (see also fieldwork) The study of a cultural or social group based

primarily on researchers' observations and interviews during a prolonged period of fieldwork.

Evaluation research (see also action research, applied research, and basic research) It assesses the processes and outcomes of a specific solution to a problem or a planned change. Summative evaluations render an overall judgment about the effectiveness of a program, policy, or product in order to say that the *idea itself* is or is not effective. Formative evaluations, on the other hand, are limited entirely to a focus on a specific context.

External validity (see also transferability) It occurs when selection biases, effects of pre-testing subjects, and effects of being in a study have not produced conditions that differ from conditions in the natural world. Moreover, the subjects are representative of larger populations and tests are representative of other tests. The study's findings, therefore, are generalizable.

Facebook.com A social networking website with 70 million members. Today users can join networks organized by city, workplace, school, and region to connect and interact with other people. People can also add friends and send them messages, and update their personal profile to notify friends about themselves.

Fieldwork (see also ethnography) The practice of studying others at close quarters in order to gain an understanding of the everyday operations of a particular way of life as well as the meanings that members of that culture attribute to these everyday occurrences.

Flickr A popular photo and video sharing website because its organization tools allow images to be tagged and browsed easily. As of November 2007, Flickr hosts more than two billion images.

Focus group A research technique that collects data through group discussion on a topic determined by the researcher. A moderator encourages participants to talk to one another, ask questions, exchange anecdotes, and comment on each other's experiences and points of view. The discussion is "focused" on a particular set of questions or a topic.

Formative evaluations (see also summative evaluations) They only focus on a specific context and do not generalize beyond a particular setting.

Freire, Paulo A world leader in the struggle for the liberation of the poorest of the poor. He worked to help men and women overcome their sense of powerlessness and to act to improve their social and economic conditions. He used concepts such as generative words, conscientization, praxis, and humanization to promote adult literacy.

Frequency distribution An organized display that shows how often each different piece of data occurs.

Gardner, Howard A psychologist based at the Harvard Graduate School of Education who laid out the theory of multiple intelligences in *Frames of Mind* (1983).

Gatekeeper Either someone with the authority to control access to a site, or someone who manages the flow of information.

Generative words These words are meaningful to local people and they evoke emotional responses, which will lead to conscientization and action.

Gerbner, George The former dean of the Annenberg School for Communication at the University of Pennsylvania who helped create cultivation theory.

Gestalt Completion Test This requires participants to use mental imagery to assemble pieces into a whole object. The test-maker deletes parts from a black-and-white picture. The participant mentally puts the pieces together to identify the object.

Goffman, Erving Author of *The Presentation of Self in Everyday Life* (1959), which provides the theoretical framework for the study of impression management. Using a theater metaphor, Goffman compares people's everyday self-presentations to stage acting. Instead of following a script, however, people decide by themselves how to perform in a front stage area for a particular audience. Then people withdraw backstage, where they can put aside their onstage role, check their appearance, and reapply make-up.

Greenfield, Lauren One of the top twenty-five photojournalists and documentary photographers. She earns a living by selling photographs via the VII Photo Agency, shooting magazine assignments, creating books of her photographs, and producing documentary films.

Gross, Larry The former director of the Annenberg School for Communication at the University of Southern California who helped create cultivation theory.

Heterosexual Script The blueprint for socially sanctioned romantic and sexual encounters. It recognizes that sexuality carries different meanings and consequences for boys and girls. The script includes three major elements: a) a sexual double standard, stating that it is more desirable and appropriate for boys to accumulate sexual experience than it is for girls; b) courtship strategies, stating that boys use active and powerful ways to attract women, while girls use submissive and alluring ways to attract men; and c) attitudes toward commitment, suggesting that women more than men seek commitment in romantic and sexual relationships.

Hoarding Instead of simply leaving diary entries blank, as a sign that they had forgotten to write in their diaries, participants would later "catch up" and fill in all of their missing entries.

Hook A story that attracts potential participants' initial interest by making your project sound interesting.

Hug Shirt This shirt has sensors that record the strength of your touch as you give yourself a hug. The Hug Shirt also records your skin warmth, heartbeat rate, and the amount of time you hug yourself.

Humanities researchers (see also social science researchers and natural science researchers) They study people, but they do not use scientific methods. Instead they use analytic or critical methods to understand how culture influences people and how people influence culture. Humanities include

the fields of history, law, literature, languages, philosophy, religion, the performing arts, and the visual arts.

Humanization The recognition of the common humanity of everyone, including our opponents.

Hyperpersonal Interaction theory It suggests that computer mediated communication can foster *better* interpersonal relationships than traditional face-to-face communication because fewer non-verbal cues are available. Without these visual cues, message senders can create more idealized self-presentations. In addition, they tend to assume the other person has similar admirable qualities. As a result, intimacy increases.

Identity A persistent understanding of one's physical, psychological, and social self.

Ideology The shared beliefs and values that allow a society to function. In other words, if people in a society share common beliefs and values about what should and should not be done, this constitutes an ideology.

Impression management (self-presentation) People's efforts to both define themselves and control information that others have about themselves in order to influence others' opinions.

Independence The absence of a statistical relationship between two data points or two variables. In other words, knowing the value on one data point/variable provides no information about the values that will be found on another data point/variable. There is no association.

Independent variable (see dependent variable/independent variable)

Index A number that combines two or more measurements of something. For example, the heat index combines measurements of temperature and humidity.

Informed consent It ensures that people not only agree and consent to participating in the research of their own free choice, without pressure or influence, but that they are fully informed about what it is they are consenting to.

Institutional Review Board (IRB) A committee at U.S. colleges, hospitals, and research institutes that is required by federal law to ensure that research involving humans is conducted in a responsible, ethical manner.

Intelligence According to Howard Gardner, it is a biological and psychological potential to solve problems or to fabricate products. Each intelligence is like a separate information-processing device, or you can imagine each intelligence as a separate mental organ.

Intercoder agreement The percentage of agreement between several coders coding the same communications material. To measure agreement between coders, they divide the number of coding agreements by the total number of coding decisions.

Internal validity (see also credibility) The findings of a study are characteristic of the variables being studied and not of the investigative procedure itself.

Interpersonal Process Model of Intimacy Intimacy begins when a speaker

discloses personally relevant thoughts and feelings to a listener. The listener then *responds* by conveying that he or she understands the speaker's message, accepts or validates the speaker, and feels positively toward the speaker.

Interpretive content analysis (see also content analysis and reception-based content analysis) This differs from content analysis in that analysts work collaboratively, rather than independently, in order to improve their ability to make valid coding judgments. They let reviewers see a random sample of their texts along with the texts' coding results and, if necessary, a justification of why they obtained those results.

Intertextuality No single element of a discourse (photograph, caption, headline, written text), and indeed no discourse itself, exists in a vacuum.

Intimacy A feeling (often momentary) that results when a speaker discloses personally relevant thoughts and feelings to a listener; and the listener then responds by conveying that he or she understands the speaker's message, accepts or validates the speaker, and feels positively toward the speaker.

Latent content (see also manifest content) Texts have latent and manifest content. Latent content is a text's subtler meanings, which coders may interpret differently.

Legends Handed-down narratives of some wonderful event that is based in history but has been embellished with fictional details.

Likert scale It includes five choices: strongly agree, agree, neutral, disagree, and strongly disagree. Researchers measure the direction and intensity of people's responses to various statements with a Likert scale.

Manifest content (see also latent content) A text's most obvious and straight-forward meanings.

Matrix displays (see also network displays) They show how two lists—set up as rows and columns—intersect.

Media Practice Model It explains how media affect people's—especially teenagers'—self-identities.

Member checking Participants look at a researcher's data and interpretations so that they can confirm the credibility of the information and the overall explanation–theory of the situation. Without the benefit of member checking, observers are forced to rely more exclusively on their own perceptions.

Memoing A systematic and organized form of note-taking. Memos are the researcher's record of thoughts, questions, interpretations, and directions for further data collection. Researchers use memos to remember important details and nuggets of insight when they write their reports months later. Researchers also find memos useful for trying out analytic ideas and working out the logic of the emergent findings.

Mental image It exists in an individual's mind. It can be a real memory, an imagined idea, or an abstract concept.

Mental Rotations Test It resembles the Cube Comparison Test, but requires greater spatial imagery skills. Instead of matching cubes, participants

must match complex three-dimensional objects. Participants study the original drawing and compare it with three similar shapes that have been rotated.

Metaphors They involve comparing two things via their similarities and ignoring their differences. As partial abstractions of concrete things, metaphors play an immense and central role in the development of theory

Miner interviewer (see also traveler interviewer) Someone who tries to unearth valuable knowledge that is waiting in the person's interior.

Minnesota Paper Form Board Test A more difficult variation of the Gestalt Completion Test. Participants view five pieces, some or all of which can be put together to create an object in outline form. The participants must indicate which of the pieces, when fitted together, would create the object.

MMS (multimedia messaging service) A standard for mobile phone messaging services that allows one to send and receive not only textual messages, but also pictures, video-clips and recorded sound files, within certain size limits. The MMS phone represents a new kind of mobile media, combining the qualities of the digital camera, the Internet, the voice recorder, and the mobile telephone.

Multiple Intelligences theory People do not have one intelligence. They have a mixture of seven intelligences: linguistic, musical, logical-mathematical, spatial, bodily-kinesthetic, interpersonal, and intrapersonal. Because people's multiple intelligences are not connected, people can be "smart" in one, but not the other six intelligences. Each person develops a unique intelligence profile based upon his or her raw patterning abilities and life experiences.

Myths Dramatic narratives of imagined events, usually used to explain origins or transformations of something. Myths are also unquestioned beliefs about the practical benefits of certain techniques and behaviors that are not supported by demonstrated facts.

Narrative (story) It needs a cast of people capable of willing their own actions. It also needs a plot with a beginning, middle, and end. The unfolding of the plot requires: 1) an initial steady state; 2) that gets disrupted by a problem; 3) that characters try to overcome; 4) so that the old steady state is restored or a new steady state is created; 5) and the story concludes with some coda, such as Aesop's moral of the story.

Natural science researchers (see also social science researchers and humanities researchers) They use experiments and other quantitative methods to study the rules of nature. They accurately observe and objectively measure things that they can see.

Naturalistic generalization (see also analytic generalization) This rests on personal experience; you understand how things are in one case and you expect them to be similar in other cases.

Negative cases (disconfirming evidence) Cases that do not fit within expected patterns. Researchers come across a case that seems contrary to the general

pattern either through the process of purposeful searching or by happenstance. The fact that researchers searched and probably found disconfirming evidence gives them confidence in the overall credibility of their research.

Network displays (see also matrix displays) They show collections of nodes (points) connected by links (lines).

Neutrality You react neither favorably nor unfavorably to participants' responses, but you appreciate their willingness to share their ideas and feelings with you.

No Child Left Behind Act of 2001 A controversial United States federal law that strives to improve the performance of U.S. primary and secondary schools by increasing the standards of accountability for states, school districts, and schools. It also provides parents more flexibility in choosing which schools their children will attend. Additionally, it promotes an increased focus on reading/language arts, writing, and math. Students are also tested once in science in grades 3–5, 6–9, and 10–11.

Non-reactive (see also reactivity) The people being studied do not react to researchers or to the study.

Non-verbal communication Commonly described as exchanging messages using means other than spoken or written words. Non-verbal communication scholars, however, avoid a simplistic verbal–non-verbal classification. They prefer to think of communication as a continuum from non-verbal to verbal. They also believe that much communication includes both verbal and non-verbal signals.

Objective (opposite of bias) It means to be accurate, fair, and impartial in both the data collection process and the analysis process.

Organizational culture The personality of the organization. Similar to the way you would get a feeling for someone's personality, you can tell the culture of an organization by looking at: a) members' behavior; b) what they brag about; c) what members wear, etc. Organizational culture comprises the assumptions, values, and tangible symbols that an organization's members share amongst themselves and that they pass on to new members.

Organizational Culture theory It adopts the spider web metaphor and assumes that members of the organization build their web with symbols, such as stories, rituals, and logos, whenever they communicate. Like a spider web, each organizational culture is unique.

Paper Folding Test Each item shows successive drawings of two or three folds made in a square sheet of paper. The final drawing shows a hole being punched in the folded paper. The participant must select which of the five drawings shows how the punched sheet would appear when fully opened.

Participatory action research (PAR) (see also action research) People join researchers for problem diagnosis and action intervention.

Patchwork studies (see also comparative studies and pre-post studies) You perform a within-case synthesis of the results of several studies of *one particular* thing, such as a virtual thesis committee.

Pattern codes Explanatory or inferential codes that suggest an explanation of the data. They pull together a lot of material into more meaningful and parsimonious components of analysis.

Pattern matching With this technique, you act like a detective, but instead of assembling clues to solve a crime, you study variables in order to create a hypothesis that explains the case. Then you check whether your detective hypothesis matches the original hypothesis, which came before you started collecting data. If so, then the patterns match and you have confidence in the validity of your results.

PDA (personal digital assistant) A type of hand-held computer, also known as a palmtop computer. PDAs can be used as a calculator, clock, calendar, address book, video recorder, media player, phone, keyboard, and GPS.

Peer reviewer (see also auditor) A knowledgeable colleague who provides support, plays devil's advocate, challenges the researcher's assumptions, or asks hard questions about the methods and interpretations. Readers believe the study's results and conclusions because they know that a peer reviewer has provided assistance.

Person space (see also task space and reference space) The video-mediated space that shows you my face and that gives indications of my mood, my personality, my trustworthiness, etc.

Photographic theory The ideas you use to make sense of a situation while you photograph it. These ideas help you decide what is worth photographing and what can be ignored because it will not increase our knowledge of society.

Photovoice This research design combines visual images (the photo element) with group discussion (the voice element) in order to empower people to take action.

Picasso, Pablo A Spanish painter best known for founding the Cubist movement.

Picturephone (see also Skype) A phone that sends audio and video signals. AT&T first introduced the picturephone at the 1964–65 New York World's Fair.

Pipping This procedure allows two or more simultaneously recorded images to be merged and recorded onto the same tape.

Power For Foucault, power is not coercion or oppression; rather, it is the glue that holds everyday social relationships together. In addition, power gets to determine what is, and is not, accepted as knowledge.

Praxis Putting an idea or lesson into practice; we can shape the conditions of our existence because we are not controlled by fate.

Pre-post studies (see also comparative studies and patchwork studies) You investigate something, such as a communication technology, before and after it becomes part of the case.

Priming It occurs when a familiar thought, feeling, or experience triggers a schema to be more accessible.

Privacy The right to be left alone. Although the U.S. Constitution does

not explicitly grant us a right of privacy, some commonly recognized legal principles of privacy have evolved through the years. For example, you cannot take pictures without permission in private places, such as a person's home or dorm room. Nor should you use a hidden camera in order to take pictures.

Probability sampling (see also convenience sampling and purposeful sampling) First, quantitative researchers determine how the population varies and whether those variations might affect their findings. Second, they divide their population into the relevant groups. Third, quantitative researchers randomly select cases from each group to ensure that their sample represents the population. Fourth, they collect data about the sample. Fifth, they use statistical methods to determine whether what they learned from the sample should hold true for the population.

Protocol A researcher's standardized procedures for collecting data. It contains the instruments for logging information as well as the general rules to be followed in using these instruments.

Public justifiability Researchers let reviewers of their work see a random sample of their texts along with the texts' coding results and, if necessary, a justification of why the researchers obtained those results. In this way, reviewers can directly assess the quality of interpretive researchers' coding.

Purposeful sampling (see also convenience sampling and probability sampling) Qualitative researchers deliberately—not randomly—select individuals, settings, or activities; and they make their selections to obtain the best information to answer the research questions—not to represent the population. Qualitative researchers deliberately select cases to obtain the richest possible data because they will generalize from their data to their variables—not from their cases to their population.

Qualitative research Research that focuses on the meanings and interpretation of social phenomena and social processes in the particular contexts in which they occur.

Quantitative research Research that focuses on numerical data. The initial data collection may produce numerical values, or non-numerical values may subsequently be converted to numbers as part of the analysis process.

Rapport Mutual understanding, respect, and trust; neither party judges the other.

Reactivity (see also non-reactive) The influence of the researcher on the setting or individuals studied. It occurs if people alter their behavior when they become aware that researchers are studying them.

Reception-based content analysis (see also content analysis and interpretive content analysis) It differs from content analysis because analysts believe that meanings exist in people more than they exist in texts. They ask members of the message's target audience to interpret and code the study's texts.

Reference space (see also person space and task space) The superimposition of one's physical presence on the shared task space. Video-mediated

reference space is what enables you to gesture and point, and is what enables me to anticipate your next action because I can maintain a peripheral awareness of what you are doing.

Reflexivity It involves sensitivity to a) the personal interests that researchers and others brought to the study; and b) how various thoughts, feelings, and actions may have shaped the data.

Regulative rules (see also constitutive rules) They dictate what happens next in a conversation. We know how to behave in a conversation because the regulative rules tell us how to begin communicating, take turns while communicating, and later stop communicating.

Reliability (see also dependability) This refers to the consistency, stability, and dependability of a test. Investigators get comparable results every time they give the tests to comparable subjects because they have developed consistent habits in giving the test and scoring its results. They have managed to minimize the errors and biases in the testing procedures.

Replication logic The recreation of a study's significant finding by conducting additional studies. You either duplicate the original conditions or you alter one or two conditions considered irrelevant to the original finding in order to see whether the same finding occurs. Replications establish the robustness and generalizability of the original finding.

Research It means to investigate. Scholars may use the scientific method to investigate a phenomenon or they may use some other method, such as an analytic, critical, historical, or legal method, but their goal is to advance human understanding. Their forms of data collection and analysis are open to invention, and a critical community judges the value of their efforts.

Research bargain (reciprocity; giving something back) The agreement regarding what participants can expect from the researcher in return for their cooperation with the research.

Research design A plan for how the investigation will be conducted. As a plan, a research design deals with four problems: what questions to study, what information is relevant, how to collect that information, and how to analyze the information. A research design, therefore, enables you to link the investigation's research questions with its conclusions.

Rich data Detailed and varied information that provides a full and revealing picture of issues of central importance to the study's goals and research questions.

Rites Relatively elaborate, dramatic, planned sets of activities that consolidate various forms of cultural expressions into one event, which is carried out through social interactions, usually for the benefit of an audience on special occasions.

Ritual model of communication (see also transmission model of communication) It emphasizes emotions and connection more than information. People care less about a message's content than that communication took place and connected people.

Rituals Standardized, detailed sets of techniques and behaviors that manage anxieties, but seldom produce consequences of practical importance.

Salience The degree to which a particular social object stands out relative to others in a particular situation. The higher the salience of an object the more likely that object's schemas will be made accessible.

Scene A section of a film or video. It consists of a number of shots with the same time, setting, and characters. It ends when an aspect of the story shifts in a way that extensively interrupts the flow of action. A scene also ends whenever a commercial interrupts the story.

Schema This cognitive representation—or expectation—of something is part of our memory network. When a schema is activated, it becomes more accessible, which means people can use it quickly in a particular situation. Moreover, similar schemas are clustered together in our memory network, and when a particular schema is activated, related schemas may be activated as well.

Semi-structured data Researchers provide prompts that partly limit the range of suitable responses. Participants follow researchers' prompts, and researchers can code this information more quickly than unstructured data.

Sexual reference A depiction of dialogue or behavior that involved sexuality, sexual suggestiveness, sexual activities, or sexual relationships.

Sexualization It occurs when any of the following conditions are present:

1. A person's value comes only from his or her sexual appeal or behavior.
2. A person equates physical attractiveness with being sexy.
3. A person is made into a thing for others' sexual use.
4. A person has sexuality inappropriately imposed upon him or her.

Shooting scripts Lists of research topics that guide photographers in their strategic and focused exploration of answers to research questions.

Shot This pictorial material between two cuts can typically be identified by a change in the camera direction or the angle of view. The shot is the equivalent of a word, phrase, sentence, or a paragraph in a written text.

Simulations (see also animation and virtual reality) They involve the input, calculation, and manipulation of rules of physics, such as the effects of acceleration, gravity, friction, atmospheric pressure, water flow, etc. While animations involve illustration, simulations involve both computation and illustration.

Skype (see also picturephone) A software program that allows users to make calls over the Internet to other Skype users free of charge. It also includes instant messaging, file transfer, and video conferencing.

Snowball sampling process (see also purposeful sampling) It is used to find people who can provide rich data. The process begins by asking knowledgeable people: "Who knows a lot about what I'm researching? Who should I talk with?" These people tell you about others, who then suggest other people to interview.

Snowy Pictures Test It measures "speed of closure," or the ability to look at different pieces of shapes, quickly put them together, and see an object.

Social Information Processing theory This suggests that the social meaning of interactions is *not* harmed by the absence of non-verbal cues. Instead, people adapt to computer-mediated communication by either a) saturating verbal messages with information about conversational participants' characteristics, attitudes, and emotions; or b) interpreting these characteristics, attitudes, and emotions from contextual and stylistic cues.

Social Modeling theory Through observation, people learn which behaviors are appropriate and inappropriate. They may not imitate these behaviors immediately, but instead store this knowledge and apply it when they believe they could use the behavior.

Social presence A subjective sense of being with others even though people are separated. If we stay in frequent contact with personal photographs, then we can feel as if we are sharing experiences. As a result, the "missing" person almost seems present.

Social Schema theory People's schemas become more accessible due to the processes of salience and priming.

Social science researchers (see also natural science researchers and humanities researchers) They study people, not nature. They use interviews, observations, analysis of documents, and other qualitative methods to interpret the meaning of people's lives. Some of the things they study, such as thoughts and feelings, cannot easily be observed or measured.

Softly-softly approach (see also can-opener approach) Visual ethnographers first walk around with a camera without taking pictures; then they photograph safe subjects, such as buildings; and much later they begin their true work of photographing people's activities.

Solicited diaries Participants produce an account of their thoughts and actions over a period of time in order to comply with the researcher's request for this information. Their contents are negotiated between researcher and participants, so participants' writing generally reflects an awareness of what the researcher wants to read.

Spatial imagery The representation of the spatial relations between parts of an object, the location of objects in space, and their movements.

Spatial intelligence This ability to represent the spatial world internally in your mind is also known as visual-spatial intelligence and visual intelligence. Some chess players, for example, can recall all the moves from previous games; sailors can visualize a route across the ocean; and sculptors can anticipate how a beautiful form will emerge from a block of stone.

Statistical significance A finding derived from a sample is deemed statistically significant if it is calculated that there is an acceptably low chance that it could have emerged by chance. These estimations are expressed as probability statements.

Structured data (see also semi-structured data and unstructured data) It

means that researchers determine the possible answers to a question or the points on a scale. Participants mark their choice, and researchers can quickly conduct a quantitative analysis of the results.

Summative evaluations (see also formative evaluations) They render an overall judgment about the effectiveness of a program, policy, or product in order to judge the effectiveness of the *idea itself.*

Symbol Something that a person uses to intentionally represent something other than itself.

Tacit knowledge It resembles common sense. Tacit knowledge consists of largely taken-for-granted ideas relevant to a particular situation as well as deeply ingrained emotions related to physical survival. People do not usually talk about their tacit knowledge because it is so basic and pervasive. We learn about tacit knowledge by observing people's unconscious habits, their nods, silences, and humor.

Task space (see also person space and reference space) The video-shared space around the drawing, written document, whiteboard, or other artifacts that we are meeting about.

Themes The fundamental concepts researchers are trying to describe in order to answer their research questions and to build theory. Themes appear in texts, paintings, sounds, and movies.

Theoretical perspective A general explanation of what is going on with the people, events, and settings you plan to study.

Theoretical saturation This means seeing the same thing over and over again, with no new properties, dimensions, or relationships emerging during analysis.

Theory A general, and more or less comprehensive, set of statements that explains some phenomenon. Each statement includes at least two variables, as well as a description of the relationship between those variables.

Thick description (see also description) This detailed description of specifics reveals the intertwined layers of meaning that underlie what a particular person says and does, so it resembles the many strands of a cultural web. Thick description provides readers with the feeling that they have experienced, or could experience, the events described in the study.

Transferability (see also external validity) Qualitative researchers' equivalent to external validity. It concerns the range and limitations of the findings beyond the context in which the study was done. To ensure transferability, qualitative researchers collect rich data and then generalize from their data to their variables.

Transmission model of communication (see also ritual model of communication) It emphasizes the purposeful exchange of explicit ideas and information across time and space. For example, advertisers send messages, not because they want to become your friends, but in order to persuade you to buy a good or service. Researchers who adopt this model primarily study how communicators influence a message's content, and how content affects audiences' attitudes and behavior.

Traveler interviewer (see also miner interviewer) Someone who roams freely without a structured list of questions.

Triangulation Researchers deliberately seek evidence from different sources, methods, and investigators. They then compare these results in order to obtain a more complete and contextual understanding of the individual, group, or organization being studied.

Trigger A concrete physical representation of an identified issue, which groups use to help them project their emotional, social, and cultural responses in a focused manner.

Unstructured data (see also semi-structured data and structured data) It means that researchers provide questions that cannot be answered with a "yes" or "no" or simple piece of information. Participants write whatever they wish, and researchers code the information.

Validity (see also external validity and internal validity) It means that the research instruments and tests measure what they were intended to measure.

Value beliefs (see also opinion) The basic beliefs, ideas, assumptions, and attitudes that people hold most central to their personalities.

Vignette A focused description of a series of events, with a narrative structure; it is often limited to a few key actors in a bounded space and a brief time span.

Virtual reality (see also animation and simulations) Digitally constructed worlds in which users may see, hear, move about, and interact with simulated objects and persons, creating a heightened and even compelling sense of being in a real place, among real things.

Virtual team A temporary, geographically dispersed group of people with a common interest, who communicate and coordinate their work through communication technology.

Virtual thesis committee A committee that helps graduate students to compete in an increasingly global marketplace of academia by using communications technology to link a student with faculty members who have special skills but who live in different parts of the world.

Visual communication (see also visual display and visuals) A social process in which people exchange messages that include visuals. Visual communication differs from visual display.

Visual communication research designs You can use visual communication research designs to study visuals that were created by participants or researchers. You can also use visual communication research designs to study participant-created visuals and researcher-created visuals.

Visual conversation This occurs when people send a photographic message, rather than a voice or text message, because they think a visual is more efficient and/or effective than voice or text.

Visual display This is when one person uses visuals to express ideas or feelings, but that person does not particularly care who sees the visuals, when they see the visuals, or whether they respond to the visuals. Creators of the visuals, however, hope their audience will understand at least some of their intended meaning.

Visual ethnographers (see also ethnography) Ethnographers who use video and still cameras as well as participant observation, interviewing, historical reconstruction, and the analysis of artifacts and documents when they conduct fieldwork.

Visual imagery A representation of the visual appearance of an object, such as its shape, size, color, or brightness.

Visuals They include drawings, paintings, photographs, videos, films, computer graphics, animations, and virtual reality displays. Visuals do not include sculpture and architecture, which belong to the plastic arts. Nor do visuals include the performing arts, such as music, theater, and dance.

Vivid information It is emotionally interesting; concrete; and close to its referent in a sensory, temporal, or spatial way. As a result a) people pay more attention to vivid information; b) they remember the information; c) they are more likely to make use of it.

Wang, Caroline Professor in the Department of Health Behavior and Health Education at the University of Michigan who helped develop Photovoice.

Wikipedia.org A free, open-content encyclopedia project.

Winfrey, Oprah This host of the highest-rated talk show in television history is also an influential book critic, an Academy Award-nominated actress, and a magazine publisher. She has been ranked the richest African-American of the twentieth century and the most philanthropic African-American of all time.

YouTube A very popular website, which hosts many short videos. In January 2008, 79 million people watched 3 billion videos. In April 2008, people could choose to watch any of its 84 million videos.

References

Abel, Jackie and Elizabeth H. Stokoe. "Broadcasting the Royal Role: Constructing Culturally Situated Identities in the Princess Diana *Panorama* Interview." *British Journal of Social Psychology* 40 (2001): 417–435.

Adler, Patricia A. and Peter Adler. "Observational Techniques." In *Collecting and Interpreting Qualitative Materials*, edited by N. K. Denzin and Y. S. Lincoln. Thousand Oaks, CA: Sage, 1998.

Ahuja, Manju K. and Kathleen M. Carley. "Network Structure in Virtual Organizations." *Organization Science* 10 (1998): 741–757.

Ahuvia, Aaron. "Traditional, Interpretive, and Reception Based Content Analyses: Improving the Ability of Content Analysis to Address Issues of Pragmatic and Theoretical Concern." *Social Indicators Research* 54 (2001): 129–172.

Aiello, Giorgia and Crispin Thurlow. "Symbolic Capitals: Visual Discourse and Intercultural Exchange in the European Capital of Culture Scheme." *Language and Intercultural Communication* 6 (2006): 148–162.

Akerlind, Gerlese S. "Variation and Commonality in Phenomenographic Research Methods." *Higher Education Research & Development* 24 (2005): 321–334.

Albrecht, Gary L. "Videotape Safaris: Entering the Field with a Camera." *Qualitative Sociology* 8 (1985): 325–344.

Allan, Stuart. "News from Nowhere: Televisual News Discourse and the Construction of Hegemony." In *Approaches to Media Discourse*, edited by Allan Bell and Peter Garnet. Oxford: Blackwell, 1998.

Alliger, George M. and Kevin J. Williams. "Using Signal-Contingent Experience Sampling Methodology to Study Work in the Field: A Discussion and Illustration Examining Task Perceptions and Mood." *Personnel Psychology* 46 (1993): 525–549.

Allison, Graham T. and Philip Zelikow. *Essence of Decision: Explaining the Cuban Missile Crisis*, 2nd edn. New York: Addison Wesley Longman, 1999.

Althusser, Louis. *For Marx*, translated by Ben Brewster. London: Verso, 1997.

American Photo staff. "The 100 Most Important People in Photography, 2005." *American Photo*, May/June 2005.

Amsterdam, Anthony G. and Jerome Bruner. *Minding the Law: How Courts Rely on Storytelling, and How Their Stories Change the Ways We Understand the Law—and Ourselves*. Cambridge, MA: Harvard University Press, 2000.

Aoki, Paul M., Margaret H. Szymanski, and Allison Woodruff. "Turning from Image Sharing to Experience Sharing." Ubicomp 2005 Workshop on Pervasive Image Capture and Sharing (2005). Available at: http://www.spasojevic.org/pics/PICS/pics05-aoki.pdf. Last accessed May 30, 2008.

APA Task Force on the Sexualization of Girls. *Report of the APA Task Force on the Sexualization of Girls* (2007). Available at: www.apa.org/pi/wpo/sexualization. html. Last accessed May 30, 2008.

Arafeh, Susan and Mary McLaughlin. *Legal and Ethical Issues in the Use of Video in Education Research.* Working Paper No. 2002–01. Washington, DC: US Department of Education, National Center for Education Statistics, 2002.

Ashcroft, William, Gareth Griffiths, and Helen Tiffin (eds.). *Key Concepts in Post-Colonial Studies.* London and New York: Routledge, 1998.

Ashworth, Peter and Ursula Lucas. "Achieving Empathy and Engagement: A Practical Approach to the Design, Conduct and Reporting of Phenomenographic Research." *Studies in Higher Education* 25 (2000): 295–308.

Auchard, Eric. "Flickr to Map the World's Latest Photo Hotspots." Reuters (November 19, 2007). Available at: http://www.reuters.com/article/technology News/idUSHO94233920071119. Last accessed May 30, 2008.

Avison, David et al. "Action Research." *Communication of the ACM* 42 (1999): 94–97.

Babbie, Earl. *The Practice of Social Research*, 3rd edn. Belmont, CA: Wadsworth, 1983.

Backett-Milburn, Kathryn and Linda McKie. "A Critical Appraisal of the Draw and Write Technique." *Health Education Research* 14 (1999): 387–398.

Baecker, Ron et al. "Media Spaces: Past Visions, Current Realities, Future Promise." Conference on Human Factors in Computing Systems (2008). Available at: http:// portal.acm.org/citation.cfm?id=1358660. Last accessed May 30, 2008.

Balakrishna, Kanya. "Facebook Becomes Tool for Employers." *Yale Daily News*, February 21, 2006.

Bamberger, Bill and Cathy N. Davidson. *Closing: The Life and Death of an American Factory.* New York: W. W. Norton, 1998.

Bampton, Roberta and Christopher J. Cowton. "The E-interview." *Forum: Qualitative Social Research* 3 (2002). Available at: http://www.qualitative-research.net/fqs-texte/2-02/2-02bamptoncowton-e.htm. Last accessed May 30, 2008.

Barnes, Brooks. "Revealing Photo Threatens a Major Disney Franchise." *New York Times*, April 28, 2008. Available at: http://www.nytimes.com/2008/04/28/ business/media/28hannah.html?_r=1&oref=slogin. Last accessed May 30, 2008.

Barnes, Deborah B., S. Taylor-Brown, and L. Weiner. "'I Didn't Leave Y'all on Purpose': HIV-infected Mothers' Videotaped Legacies for Their Children." *Qualitative Sociology* 20 (1997): 7–32.

Barrett, Lisa F. and Daniel J. Barrett. "An Introduction to Computerized Experience Sampling in Psychology." *Social Science Computer Review* 19 (2001): 175–185.

Barry, Anne Marie Seward. *Visual Intelligence: Perception, Image, and Manipulation in Visual Communication:* Albany: State University of New York, 1997.

Basch, Charles E. "Focus Group Interview: An Underutilized Research Technique for Improving Theory and Practice in Health Education." *Health Education Quarterly* 14 (1987): 411–448.

Bate, S. P. "Whatever Happened to Organizational Anthropology? A Review of the Field of Organizational Ethnography and Anthropological Studies." *Human Relations* 50 (1997): 1147–1175.

Baxter, Jamie and John Eyles. "Evaluating Qualitative Research in Social Geography: Establishing 'Rigour' in Interview Analysis." *Transactions of the Institute of British Geographers* 22 (1997): 505–525.

Becker, Howard S. "Photography and Sociology." *Studies in the Anthropology of Communication* 1 (1974): 3–26.

Becker, Howard S. *Tricks of the Trade: How to Think about Your Research While You're Doing It*. Chicago: University of Chicago Press, 1998.

Belk, Russell W. and Robert V. Kozinets. "Videography in Marketing and Consumer Research." *Qualitative Market Research* 8 (2005): 128–141.

Bell, Brad E. and Elizabeth F. Loftus. "Vivid Persuasion in the Courtroom." *Journal of Personality Assessment* 49 (1985): 659–664.

Benbasat, Izak, David K. Goldstein, and Melissa Mead. "The Case Research Strategy in Studies of Information Systems." *MIS Quarterly* 11 (1987): 369–386.

Bender, Deborah E. and Douglas Ewbank. "The Focus Group as a Tool for Health Research: Issues in Design and Analysis." *Health Transition Review* 4 (1994): 63–79.

Berg, Bruce L. *Qualitative Research Methods for the Social Sciences*, 6th edn. Boston, MA: Pearson, 2007.

Bernard, H. Russell et al. "The Problem of Informant Accuracy: The Validity of Retrospective Data." *Annual Review of Anthropology* 13 (1984): 495–517.

"Best Inventions 2006." *Time Magazine*. Available at: http://www.time.com/time/2006/techguide/bestinventions/inventions/clothing3.html. Last accessed May 30, 2008.

Biggs, S. D. "Resource-poor Farmer Participation in Research: A Synthesis of Experiences from National Agricultural Research." *OFCOR-Comparative Study* 3 (1989): 1–4.

Billig, Michael. *Arguing and Thinking: A Rhetorical Approach to Social Psychology*, 2nd edn. Cambridge: Cambridge University Press, 1996.

Blajenkova, Olessia, Maria Kozhevnikov, and Michael A. Motes. "Object-Spatial Imagery: A New Self-report Imagery Questionnaire." *Applied Cognitive Psychology* 20 (2006): 239–263.

Bolger, Nial, Angelina Davis, and Eshkol Rafaeli. "Diary Methods: Capturing Life as it is Lived." *Annual Review of Psychology* 54 (2003): 579–616.

Brand, Stewart. *The Media Lab: Inventing the Future at MIT*. New York: Viking, 1987.

Brandt, Joel, Noah Weiss, and Scott R. Klemmer. "txt 4 l8r: Lowering the Burden for Diary Studies Under Mobile Conditions." *Conference on Human Factors in Computing Systems* (2007). Available at: http://portal.acm.org/citation.cfm?id=1240866.1240998. Last accessed May 30, 2008.

Bright, David A. and Jane Goodman-Delahunty. "Gruesome Evidence and Emotion: Anger, Blame, and Jury Decision-Making." *Law and Human Behavior* 30 (2006): 183–202.

Brinkman, Svend and Steinar Kvale. "Confronting the Ethics of Qualitative Research." *Journal of Constructivist Psychology* 18 (2005): 157–181

Broadbent, Elizabeth et al. "A Picture of Health—Myocardial Infarction Patients' Drawings of Their Hearts and Subsequent Disability: A Longitudinal Study." *Journal of Psychosomatic Research* 57 (2004): 583–587.

Brower, Matthew Francis. "Animal Traces: Early North American Wildlife Photography." Ph.D. dissertation, University of Rochester, 2005.

Brown, Jane D., Carolyn T. Halpern, and Kelly L. L'Engle. "Mass Media as a Sexual Super Peer for Early Maturing Girls." *Journal of Adolescent Health* 36 (2005): 420–427.

Buckingham, David. "Media Education and the End of the Critical Consumer." *Harvard Educational Review* 73 (2003): 309–328.

Bülow, P. H. "Sharing Experiences of Contested Illness by Storytelling." *Discourse & Society* 15 (2004): 33–53.

Bülow, P. and L. C. Hydén. "Patient School as a Way of Creating Meaning in a Contested Illness: The Case of CFS." *Health* 7 (2003): 227–249.

Burns, Edward. *Gertrude Stein on Picasso*. New York: Liveright, 1970.

Cameron, Deborah et al. "Power/Knowledge: The Politics of Social Science." In *The Discourse Reader*, edited by Adam Jaworski and Nikolas Coupland. London and New York: Routledge, 1999.

Cameron, Jenny and Katherine Gibson. "Participatory Action Research in a Post-structuralist Vein." *Geoforum* 36 (2005): 315–331.

Carey, James. *Communication as Culture*. New York: Routledge, 1988.

Carlson, Elizabeth D., Joan Engebretson, and Robert M. Chamberlain. "Photovoice as a Social Process of Critical Consciousness." *Qualitative Health Research* 16 (2006): 836–852.

Carney, Brian and Neal Feigenson. "Visual Persuasion in the Michael Skakel Trial: Enhancing Advocacy through Interactive Media Presentations." *Criminal Justice* 19 (2004): 22–35.

Carter, Scott and Jennifer Mankoff. "When Participants Do the Capturing: The Role of Media in Diary Studies." *Conference on Human Factors in Computing Systems* (2005): 899–908. Available at: http://portal.acm.org/citation.cfm?id=1054972. 1055098. Last accessed May 30, 2008.

Cassidy, John. "Me Media: How Hanging Out on the Internet Became Big Business." *The New Yorker*, May 15, 2006.

Chen, Peter and S. M. Hinton. "Realtime Interviewing Using the World Wide Web." *Sociological Research Online* 12 (1999). Available at: http://eprints.unimelb.edu.au /archive/00000210/01/realtime.pdf. Last accessed May 30, 2008.

Cheng, Xu, Cameron Dale, and Jiangchuan Liu. "Understanding the Characteristics of Internet Short Video Sharing: YouTube as a Case Study." Preprint (2007). Available at: http://arxiv.org/pdf/0707.3670. Last accessed May 30, 2008.

Clark, Herbert H. and Susan E. Brennan. "Grounding in Communication." In *Perspectives on Socially Shared Cognition*, edited by L. Resnick, J. M. Levine, and S. D. Teasley. Washington, DC: APA, 1991.

Clarke, Adele E. *Situational Analysis: Grounded Theory after the Postmodern Turn*. Thousand Oaks, CA: Sage, 2005.

Coles, Robert. *Doing Documentary Work*. New York: Oxford University Press, 1998.

Collier, John and Malcolm Collier. *Visual Anthropology: Photography as a Research Method*. Albuquerque: University of New Mexico Press, 1986.

Collins, Rebecca L. et al. "Entertainment Television as a Healthy Sex Educator: The Impact of Condom-Efficacy Information in an Episode of *Friends*." *Pediatrics* 112 (2003): 1115–1121.

Collins, Rebecca L. et al. "Watching Sex on Television Predicts Adolescent Initiation of Sexual Behavior." *Pediatrics* 114 (2004): e280–e289.

Consolvo, Sunny and Miriam Walker. "Using the Experience Sampling Method to Evaluate Ubicomp Applications." *Pervasive Computing*, April–June 2003: 24–31.

Consolvo, Sunny et al. "Location Disclosure to Social Relations: Why, When, & What People Want to Share." *Conference on Human Factors in Computing Systems* (2005): 81–90. Available at: http://www2.seattle.intel-research.net/publications/ pubs/chi05-locDisSocRel-proceedings.pdf. Last accessed May 30, 2008.

Constas, Mark A. "Qualitative Analysis as a Public Event: The Documentation of Category Development Procedures." *American Educational Research Journal* 29 (1992): 253–266.

Cornwall, Andrea and Rachel Jewkes. "What Is Participatory Research?" *Social Sciences in Medicine* 41 (1995): 1667–1676.

Counts, Scott and Eric Fellheimer. "Supporting Social Presence Through Lightweight Photo Sharing on and off the Desktop." *Conference on Human Factors in Computing Systems* (2004): 599–606. Available at: http://portal.acm.org/citation. cfm?id=985768. Last accessed May 30, 2008.

Cranford, James A. et al. "A Procedure for Evaluating Sensitivity to Within-person Change: Can Mood Measures in Diary Studies Detect Change Reliably?" *Personality and Social Psychology Bulletin* 32 (2006): 917–929.

Creswell, John W. *Educational Research: Planning, Conducting, and Evaluating Quantitative and Qualitative Research.* Upper Saddle River, NJ: Pearson Education, 2002.

Creswell, John W. *Research Design: Qualitative, Quantitative, and Mixed Methods Approaches*, 2nd edn. Thousand Oaks, CA: Sage, 2003.

Crichton, Susan and Shelley Kinash. "Virtual Ethnography: Interactive Interviewing Online as Method." *Canadian Journal of Learning and Technology* 29 (2003). Available at: http://www.cjlt.ca/content/vol29.2/cjlt29-2_art-5.html. Last accessed May 30, 2008.

Cross, Katherine, Allison Kabel, and Cathy Lysack. "Images of Self and Spinal Cord Injury: Exploring Drawing as a Visual Method in Disability Research." *Visual Studies* 21 (2006): 183–193.

Crotty, Michael. *The Foundations of Social Research: Meaning and Perspective in the Research Process.* London: Sage, 1998.

Dandridge, Thomas C., Ian Mitroff, and William F. Joyce. "Organizational Symbolism: A Topic to Expand Organizational Analysis." *Academy of Management Review* 5 (1980): 77–82.

Dean, Sharon Ellen. "Vision, Social Change, and the American West: The Photographs of Andrew A. Forbes (1862–1921)." Ph.D. dissertation, New School University, 2002.

DeLoache, Judy S. "Becoming Symbol-minded." *Trends in Cognitive Sciences* 8 (2004): 66–70.

Denton, Craig. *People of the West Desert: Finding Common Ground.* Logan: Utah State University Press, 1999.

Denton, Craig. *Bear River: Last Chance to Change Course.* Logan: Utah State University Press, 2007.

Dijk, Teun A. van. "Introduction: Discourse Analysis in (Mass) Communication Research." In *Discourse and Communication: New Approaches to the Analysis of Mass Media Discourse and Communication,* edited by Teun A. van Dijk. Berlin and New York: W. de Gruyter, 1985.

Driessnack, Martha. "Draw-and-tell Conversations with Children about Fear." *Qualitative Health Research* 16 (2006): 1414–1435.

Dunn, Meghan A., Peter Salovey, and Neal Feigenson. "The Jury Persuaded (and Not): Computer Animation in the Courtroom." *Law & Policy* 28 (2006): 228–248.

Edgar, Andrew and Peter Sedgwick (eds.). *Key Concepts in Cultural Theory.* London and New York: Routledge, 1999.

Eisenhardt, Kathleen M. "Building Theories from Case Study Research." *Academy of Management Review* 14 (1989): 532–550.

Eisner, Elliot W. "The Promise and Perils of Alternative Forms of Data Representation." *Educational Researcher* 26 (1997): 4–10.

Eisner, Elliot W. *The Arts and the Creation of Mind*. New Haven, CT: Yale University Press, 2002.

Eligon, John. "Of 50 Bullets, Focus Falls on 3 Strays." *New York Times*, March 29, 2008. Available at: http://www.nytimes.com/2008/03/29/nyregion/29bell.html?scp=1&sq=%22illustrations%20resembled%20a%20video%20game%22&st=cse. Last accessed May 30, 2008.

Elliot, H. "The Use of Diaries in Sociological Research on Health Experience." *Sociological Research Online* 2 (1997). Available at: http://ideas.repec.org/a/sro/srosro/1996-36-1.html. Last accessed May 30, 2008.

Ellison, Nicole B., Rebecca D. Heino, and Jennifer L. Gibbs. "Managing Impressions Online: Self-presentation Processes in the Online Dating Environment." *Journal of Computer-Mediated Communication* 11 (2006): 415–441.

Fisher, Benjamin F. "Collective Memory, the Media, and the Social Construction of Postmodern War." Ph.D. dissertation, Rutgers The State University of New Jersey, 2004.

Foster-Fishman, Pennie et al. "Using Methods that Matter: The Impact of Reflection, Dialogue, and Voice." *American Journal of Community Psychology* 36 (2005): 275–291.

Freire, Paulo. *Pedagogy of the Oppressed*. Harmondsworth: Penguin, 1972.

Freire, Paulo. *Teachers as Cultural Workers: Letters to Those Who Dare Teach*. Boulder, CO: Westview, 1997.

Frohmann, Lisa. "The Framing Safety Project: Photographs and Narratives by Battered Women." *Violence Against Women* 11 (2005): 1396–1419.

Fury, Gail, Elizabeth A. Carlson, and L. Alan Stroufe. "Children's Representations of Attachment Relationships in Family Drawings." *Child Development* 68 (1997): 1154–1164.

Gabhainn, Saoirse N. and Cecily Kelleher. "The Sensitivity of the Draw and Write Technique." *Health Education* 102 (2002): 68–75.

Gabriel, Richard. "Making the Most of Focus Group and Mock Trial Research." *The Practical Litigator*, January, 2008. Available at: http://files.ali-aba.org/thumbs/datastorage/lacidoirep/articles/PLIT0801-Gabriel_thumb.pdf. Last accessed May 30, 2008.

Gardner, Howard. *Art, Mind, and Brain*. New York: Basic Books, 1982.

Gardner, Howard. *Frames of Mind: The Theory of Multiple Intelligences*. New York: Basic Books, 1983.

Gardner, Howard. *Creating Minds*. New York: Basic Books, 1993.

Gauntlett, David. "Using Creative Visual Research Methods to Understand Media Audiences." *MedienPadagogik* (2005). Available at: www.medienpaed.com/04-1/gauntlett04-1.pdf. Last accessed May 30, 2008.

Gedo, Mary M. *Art as Autobiography*. Chicago: University of Chicago Press, 1980.

Geertz, Clifford. *The Interpretation of Cultures*. New York: Basic Books, 1973.

Gershon, Nahum and Ward Page. "What Storytelling Can Do for Information Visualization." *Communications of the ACM* 44 (2001): 31–37.

Gibbs, Jennifer L., Nicole B. Ellison, and Rebecca D. Heino. "Self-presentation in Online Personals." *Communication Research* 33 (2006): 152–177.

Glaser, Barney G. and Anselm L. Strauss. *The Discovery of Grounded Theory: Strategies for Qualitative Research*. Chicago: Aldine, 1967.

Goel, Vinod. *Sketches of Thought*. Cambridge, MA: MIT Press, 1995.

Goffman, Erving. *The Presentation of Self in Everyday Life*. New York: Doubleday, 1959.

Goldman-Segall, Ricki. "Configurational Validity: A Proposal for Analyzing Ethnographic Multimedia Narratives." *Journal of Educational Multimedia and Hypermedia* 4 (1995): 163–182.

Gonzalez-Rivera, Milagritos and Jose A. Bauermeister. "Children's Attitudes Toward People with AIDS in Puerto Rico: Exploring Stigma Through Drawings and Stories." *Qualitative Health Research* 17 (2007): 250–263.

Goodhart, Fern W. et al. "A View Through a Different Lens: Photovoice as a Tool for Student Advocacy." *Journal of American College Health* 55 (2006): 53–56.

Graber, Doris A. *Processing the News*, 2nd edn. New York: Longman, 1988.

Green, Amie S. et al. "Paper or Plastic? Data Equivalence in Paper and Electronic Diaries." *Psychological Methods* 11 (2006): 87–105.

Greenfield, Lauren. *Fast Forward: Growing Up in the Shadow of Hollywood*. New York: Knopf, 1997.

Greenfield, Lauren. *Girl Culture*. New York: Chronicle Books, 2002.

Greenfield, Lauren. *Thin*. New York: Melcher Media, 2006.

Gregory, Kathleen L. "Native-view Paradigms: Multiple Cultures and Culture Conflicts in Organizations." *Administrative Science Quarterly* 28 (1983): 359–376.

Griffin, Michael. "Picturing America's 'War on Terrorism' in Afghanistan and Iraq." *Journalism* 5 (2004): 381–402.

Gross, Larry, John Stuart Katz, and Jay Ruby. *Image Ethics: The Moral Rights of Subjects in Photographs, Film, and Television*. New York: Oxford Unversity Press, 1988.

Guest, Greg, Arwen Bunce, and Laura Johnson. "How Many Interviews Are Enough? An Experiment with Data Saturation and Variability." *Field Methods* 18 (2006): 59–82.

Gutoff, Bija. "Lauren Greenfield: Storyteller." Available at: http://www.apple.com/pro/profiles/greenfield/. Last accessed May 30, 2008.

Haddon, Leslie. "Domestication and Mobile Telephony." In *Machines that Become Us: The Social Context of Personal Communication Technology*, edited by J. Katz. New Brunswick, Canada: Transaction Publishers, 2003.

Haidt, Jonathan. "The Emotional Dog and Its Rational Tail: A Social Intuitionist Approach to Moral Judgment." *Psychological Review* 108 (2001): 814–834.

Hall, Budd, L. "Participatory Research, Popular Knowledge and Power: A Personal Reflection." *Convergence* 14 (1981): 6–19.

Hansom, Paul. "All Consuming Modernism: The Photo-Essay and American Historical Consciousness." Ph.D. dissertation, University of Southern California, 1999.

Heintz-Knowles, Katharine E. "Sexual Activity on Daytime Soap Operas: A Content Analysis of Five Weeks of Television." Menlo Park, CA: Henry J. Kaiser Family Foundation, 1996.

Henderson, Kathryn. "Flexible Sketches and Inflexible Data Bases: Visual Communication, Conscription Devices, and Boundary Objects in Design Engineering." *Science, Technology, & Human Values* 16 (1991): 448–473.

Hergenrather, Kenneth C., Scott D. Rhodes, and Glenn Clark. "Windows to Work: Exploring Employment-seeking Behaviors of Persons with HIV/AIDS Through Photovoice." *AIDS Education and Prevention* 18 (2006): 243–258.

Hirsh, Sandra, Abigail Sellen, and Nancy Brokopp. "Why HP People Do and Don't Use Videoconferencing Systems." Unpublished document (2005). Available at: http://research.microsoft.com/users/Cambridge/asellen/publications/why%20Hp%20people%2004.pdf. Last accessed May 30, 2008.

Hormuth, Stefan E. "The Sampling of Experiences *in situ*." *Journal of Personality* 54 (1986): 262–293.

Howard, Steve et al. "Negotiating Presence-in-Absence: Contact, Content and Context." *Conference on Human Factors in Computing Systems* (2006). Available at: http://portal.acm.org/citation.cfm?id=1124906. Last accessed May 30, 2008.

Hycner, Richard H. "Some Guidelines for the Phenomenological Analysis of Interview Data." *Human Studies* 8 (1985): 279–303.

Hydén, L. C. and P. H. Bülow. "Who's Talking: Drawing Conclusions from Focus Groups—Some Methodological Considerations." *International Journal of Social Research Methodology* 6 (2003): 305–321.

Iedema, Rick. "Multimodality, Resemiotization: Extending the Analysis of Discourse as Multi-Semiotic Practice." *Visual Communication* 2 (2003): 29–57.

Ito, Mizuko. "Intimate Visual Co-presence" (2005). Available at: http://www.spasojevic.org/pics/PICS/ito.ubicomp05.pdf. Last accessed May 30, 2008.

Jaworski, Adam and Nikolas Coupland. "Editors' Introduction to Part Six." In *The Discourse Reader,* edited by Adam Jaworski and Nikolas Coupland. London and New York: Routledge, 1999.

Jeffrey, Phillip. "Videoteleconferencing: Why Is It Disadvantageous for Group Collaboration?" Unpublished manuscript (1998). Available at: http://www.ece. ubc.ca/~phillipj/papers/videoteleconferencing.pdf. Last accessed May 30, 2008.

Jensen, Jason L. and Robert Rodgers. "Cumulating the Intellectual Gold of Case Study Research." *Public Administration Review* 61 (2001): 235–246.

Jick, Todd D. "Mixing Qualitative and Quantitative Methods: Triangulation in Action." *Administrative Science Quarterly* 24 (1979): 602–611.

Joinson, Adam N. "Self-disclosure in Computer-mediated Communication: The Role of Self-awareness and Visual Anonymity." *European Journal of Social Psychology* 31 (2001): 177–192.

Jordan, Brigitte and Austin Henderson. "Interaction Analysis: Foundations and Practice." *Journal of the Learning Sciences* 4 (1995): 39–103.

JupiterResearch. "JupiterResearch Sees Steady Growth for Online Personals, Despite Explosion of Social Networking" (2008). Available at: http://www.businesswire. com/portal/site/google/index.jsp?ndmViewId=news_view&newsId=200802110 05037&newsLang=en. Last accessed May 30, 2008.

Kafka, Peter. "Topless Miley Cyrus = Record Traffic for Vanity Fair." *Silicon Alley Insider*, April 30, 2008. Available at: http://www.alleyinsider.com/2008/4/ topless _miley_cyrus_record_traffic_for_vanity_fair. Last accessed May 30, 2008.

Kassarjian, Harold H. "Content Analysis in Consumer Research." *Journal of Consumer Research* 4 (1977): 8–18.

Kates, Steven M. and Glenda Shaw-Garlock. "The Ever Entangling Web: A Study of Ideologies and Discourse in Advertising to Women." *Journal of Advertising* 28 (1999): 33–49.

Kattoura, Mark. "Envirotronically Speaking: A Case Study of Dis-Identification in Online Industrial and Oppositional Discourse About Global Warming." M.A. dissertation, Florida Atlantic University, 2003.

Kellner, Douglas. "Technological Transformation, Multiple Literacies, and the Re-visioning of Education." *E-Learning* 1 (2004): 9–37.

Kemmis, Stephen and Robin McTaggart. "Participatory Action Reseach." In *Handbook of Qualitative Research*, 2nd edn, edited by Norman K. Denzin and Yvonna S. Lincoln. Thousand Oaks, CA: Sage, 2000.

Kidd, Pamela S. and Mark B. Parshall. "Getting the Focus and the Group: Enhancing Analytical Rigor in Focus Group Research." *Qualitative Health Research* 10 (2000): 293–308.

Kim, Janna L. et al. "From Sex to Sexuality: Exposing the Heterosexual Script on Primetime Network Television." *Journal of Sex Research* 44 (2007): 145–157.

Kim, Jeong and John Zimmerman. "Cherish: Smart Digital Photo Frames for Sharing Social Narratives at Home." *Conference on Human Factors in Computing Systems* (2006): 953–958. Available at: http://portal.acm.org/citation.cfm?id=112563. Last accessed May 30, 2008.

Kindberg, Tim et al. "The Ubiquitous Camera: An In-depth Study of Camera Phone Use." *Pervasive Computing,* April–June (2005): 42–50.

Kitzinger, Jenny. "Qualitative Research: Introducing Focus Groups." *British Medical Journal* 311 (1995): 299–302.

Kivits, Joelle. "Online Interviewing and the Research Relationship." In *Virtual Methods: Issues in Social Research on the Internet,* edited by Christine Hine. Oxford: Berg, 2005.

Klepsch, Marvin and Laura Logie. *Children Draw and Tell: An Introduction to the Projective Uses of Children's Human Figure Drawings.* New York: Brunner/Mazel Publishers, 1982.

Knapp, Mark L. and Judith A. Hall. *Nonverbal Communication in Human Interaction,* 6th edn. Belmont, CA: Thompson Wadsworth, 2006.

Kobre, Kenneth. *Photojournalism: The Professionals' Approach,* 6th edn. Burlington, MA: Focal Press, 2008.

Kolbe, Richard H. and Melissa S. Burnett. "Content-analysis Research: An Examination of Applications with Directives for Improving Research Reliability and Objectivity." *Journal of Consumer Research* 18 (1991): 243–250.

Koppitz, E. M. *Psychological Evaluation of Children's Human Figure Drawings.* New York: Grune & Stratton, 1968.

Kosslyn, Stephen M. *Image and Brain: The Resolution of the Imagery Debate.* Cambridge, MA: MIT Press, 1994.

Kozhevnikov, Maria, Mary Hergarty, and Richard E. Mayer. "Revising the Visualizer-Verbalizer Dimension: Evidence for Two Types of Visualizers." *Cognition and Instruction* 20 (2002): 47–77.

Kozhevnikov, Maria, Stephen Kosslyn, and Jennifer Shephard. "Spatial Versus Object Visualizers: A New Characterization of Visual Cognitive Style." *Memory & Cognition* 33 (2005): 710–726.

Kozol, Wendy. *Life's America: Family and Nation in Postwar Photojournalism.* Philadelphia, PA: Temple University Press, 1994.

Kress, Gunther. "Multimodality." In *Multiliteracies: Literacy Learning and the Design of Social Futures,* edited by Bill Cope and Mary Kalantzis. New York: Routledge, 2000.

Kress, Gunther. *Literacy in the New Media Age.* New York: Routledge, 2003.

Kress, Gunther and Theo van Leeuwen. *Reading Images: The Grammar of Visual Design.* New York: Routledge, 1996.

Kress, Gunther and Theo van Leeuwen. "Representation and Interaction: Designing the Position of the Viewer." In *The Discourse Reader,* edited by Adam Jaworski and Nikolas Coupland. London and New York: Routledge, 1999.

Krueger, Richard A. *Focus Groups: A Practical Guide for Applied Research,* 2nd edn. Newbury Park, CA: Sage, 1994.

Krueger, Richard A. *Focus Groups: A Practical Guide for Applied Research,* 3rd edn. Newbury Park, CA: Sage, 2000.

Kunkel, D. et al. *Sex on TV: A Biennial Report to the Kaiser Family Foundation.* Menlo Park, CA: Henry J. Kaiser Family Foundation, 2003.

Kvale, Steinar. *InterViews: An Introduction to Qualitative Research Interviewing.* Thousand Oaks, CA: Sage, 1996.

Lacity, Mary C. and Marius A. Janson. "Understanding Qualitative Data: A Framework of Text Analysis Methods." *Journal of Management Information Systems* 11 (1994): 137–155.

Lapadat, Judith C. and Anne C. Lindsay. "Transcription in Research and Practice: From Standardization of Technique to Interpretive Positionings." *Qualitative Inquiry* 5 (1999): 64–86.

Laurenceau, Jean-Philippe and Niall Bolger. "Using Diary Methods to Study Marital and Family Processes." *Journal of Family Psychology* 19 (2005): 314–323.

Laurenceau, Jean-Philippe, Lisa F. Barrett, and Paula R. Pietromonaco. "Intimacy as an Interpersonal Process: The Importance of Self-Disclosure, Partner Disclosure, and Perceived Partner Responsiveness in Interpersonal Exchanges." *Journal of Personality and Social Psychology* 74 (1998): 1238–1251.

Laurenceau, Jean-Philippe, Lisa F. Barrett, and Michael J. Rovine. "The Interpersonal Process Model of Intimacy in Marriage: A Daily-diary and Multilevel Modeling Approach." *Journal of Family Psychology* 19 (2005): 86–97.

Lee, Yew-Jin and Wolff-Michael Roth. "Making a Scientist: Discursive 'Doing' of Identity and Self-Presentation During Research Interviews." *Forum: Qualitative Social Research* 5 (2004). Available at: http://www.qualitative-research.net/fqs-texte/1-04/1-04leeroth-e.htm. Last accessed May 30, 2008.

Liechti, Olivier and Tadao Ichikawa. "A Digital Photography Framework Enabling Affective Awareness in Home Communication." *Personal Technologies* 4 (2000): 6–24.

Lindlof, Thomas R. and Bryan C. Taylor. *Qualitative Communication Research Methods*, 2nd edn. Thousand Oaks, CA: Sage, 2002.

Lippert, Tonya and Karen J. Prager. "Daily Experiences of Intimacy: A Study of Couples." *Personal Relationships* 8 (2001): 283–298.

Lomax, Helen and Neil Casey. "Recording Social Life: Reflexivity and Video Methodology." *Sociological Research Online* 3 (1998). Available at: www.socresonline.org.uk/socresonline/3/2/1.html/. Last accessed May 30, 2008.

Lombard, Matthew, Jennifer Snyder-Duch, and Cheryl C. Bracken. "Content Analysis in Mass Communication: Assessment and Reporting of Intercoder Reliability." *Human Communication Research* 28 (2002): 587–604.

Look, Gary, Robert Laddaga, and Howard Shrobe. "One-push Sharing: Facilitating Picture Sharing from Camera Phones." *Mobile Human–Computer Interaction* (2004). Available at: http://books.google.com/books?hl=en&lr=&id=ZUCv0oQ9kCoC&oi=fnd&pg=PA466&ots=D5hAQQgTlU&sig=8ILWOVHYfV3vjhZUSEg7h8A7GbI. Last accessed May 30, 2008.

Lopez, Ellen D. S. et al. "Quality-of-Life Concerns of African American Breast Cancer Survivors Within Rural North Carolina." *Qualitative Health Research* 15 (2005): 99–115.

Lowry, Dennis T. and Jon A. Shidler. "Prime Time TV Portrayals of Sex, 'Safe Sex,' and AIDS: A Longitudinal Analysis." *Journalism Quarterly* 79 (1993): 628–637.

Lykes, M. Brinton. "Activist Participatory Research Among the Maya of Guatemala: Constructing Meanings from Situated Knowledge." *Journal of Social Issues* 53 (1997): 725–746.

Lykes, M. Brinton, Martin Terre Blanche, and Brandon Hamber. "Narrating Survival and Change in Guatemala and South Africa: The Politics of Representation and a

Liberatory Community Psychology." *American Journal of Community Psychology* 31 (2003): 79–90.

MacGregor, Andrew S., Candace E. Currie, and Noreen Wetton. "Eliciting the Views of Children About Health Through the Use of the Draw and Write Technique." *Health Promotion International* 13 (1998): 307–318.

Machin, David. "Building the World's Visual Language: The Increasing Global Importance of Media Banks in Corporate Media." *Visual Communication* 3 (2004): 316–336.

McIntyre, Alice. "Constructing Meaning About Violence, School, and Community: Participatory Action Research with Urban Youth." *The Urban Review* 32 (2000): 123–154.

McKim, Robert H. *Experiences in Visual Thinking.* Belmont, CA: Brooks Cole, 1972.

McMillan, Sally J. "The Microscope and the Moving Target: The Challenge of Applying Content Analysis to the World Wide Web." *Journalism and Mass Communication Quarterly* 77 (2000): 80–98.

MacQueen, Kathleen M. et al. "Codebook Development for Team-based Qualitative Analysis." *Cultural Anthropology Methods* 10 (1998): 31–36.

McWhirter, Jenny M., Amanda J. Young, and Noreen Wetton. "In a Class of Its Own: Introducing a New Tool for Understanding Adolescents' Perceptions of the World of Drugs." *Health Education Journal* 63 (2004): 307–323.

Markus, Hazel and Elissa Wurf. "The Dynamic Self-concept: A Social Psychological Perspective." *Annual Review of Psychology* 38 (1987): 299–337.

Martin, Maryanne and Rachel Williams. "Imagery and Emotion: Clinical and Experimental Approaches." In *Imagery: Current Developments*, edited by P. J. Hampson, D. F. Marks, and J. T. E. Richardson. New York: Routledge, 1990.

Maxwell, Joseph A. *Qualitative Research Design: An Interactive Approach*, 2nd edn. Thousand Oaks, CA: Sage, 2005.

Mays, Nicholas and Catherine Pope. "Qualitative Research: Rigour and Qualitative Research." *British Medical Journal* 311 (1995): 109–112.

Meiselas, Susan. *Carnival Strippers*, 2nd edn. New York: Whitney Museum of Modern Art, 2003.

Melamed, Leslie and Martin K. Moss. "The Effect of Context on Ratings of Attractiveness of Photographs." *Journal of Psychology* 90 (1975): 129–136.

Meyer, Phil. "Why a Jury Trial is More Like a Movie Than a Novel." *Journal of Law and Society* 28 (2001): 133–146.

Miles, Matthew B. and A. Michael Huberman. *Qualitative Data Analysis: An Expanded Sourcebook*, 2nd edn. Thousand Oaks, CA: Sage, 1994.

Mitchell, Claudia et al. "Giving a Face to HIV and AIDS: On the Uses of Photo-voice by Teachers and Community Health Care Workers Working with Youth in Rural South Africa." *Qualitative Research in Psychology* 2 (2005): 257–270.

Moloney, Margaret F. et al. "Using Internet Discussion Boards as Virtual Focus Groups." *Advances in Nursing Science* 26 (2003): 274–286.

Morgan, David L. "Qualitative Content Analysis: A Guide to Paths Not Taken." *Qualitative Health Research* 3 (1993): 112–121.

Morgan, David L. "Focus Groups." *Annual Review of Sociology* 22 (1996): 129–152.

Moriarty, Sandra E. "Abduction: A Theory of Visual Interpretation." *Communication Theory* 6 (1996): 167–187.

Morrison, Diane M., Barbara C. Leigh, and Mary R. Gillmore. "Daily Data Collection: A Comparison of Three Methods." *The Journal of Sex Research* 36 (1999): 76–81.

Morrow, Virginia. "Using Qualitative Methods to Elicit Young People's Perspectives on their Environments: Some Ideas for Community Health Initiatives." *Health Education Research* 16 (2001): 255–268.

Morse, Janice M. "Designing Funded Qualitative Research." In *Handbook of Qualitative Research*, edited by N. K. Denzin and Y. S. Lincoln. Thousand Oaks, CA: Sage, 1994.

Mullen, Lawrence J. "Television News and Contentiousness: An Exploratory Study of Visual and Verbal Content in News About the President." *Journal of Broadcasting & Electronic Media* 43 (1999): 159–174.

Murdock, Graham and Sarah Pink. "Ethnography Bytes Back: Digitalising Visual Anthropology." *Media International Australia Incorporating Culture and Policy* 116 (2005): 10–23.

Nah, Seungahn, Aaron S. Veenstra, and Dhavan V. Shah. "The Internet and Anti-War Activism: A Case Study of Information, Expression, and Action." *Journal of Computer-Mediated Communication* 12 (2006): 230–247.

Neuman, W. Lawrence. *Social Research Methods: Qualitative and Quantitative Approaches*, 5th edn. Boston, MA: Allyn & Bacon, 2003.

Norton, Andrew. "Experiencing Nature: The Reproduction of Environmental Discourse Through Safari Tourism in East Africa." *Geoforum* 27, 3 (1996): 355–373.

Nowell, Branda L. et al. "Revealing the Cues Within Community Places: Stories of Identity, History, and Possibility." *American Journal of Community Psychology* 37 (2006): 29–46.

Okabe, Daisuke. "Social Practice of Camera Phone in Japan." Pervasive Image Capture and Sharing Workshop (2005). Available at: http://keitai.sfc.keio.ac.jp/lab/blog/pdf/okabe_ubicomp.pdf. Last accessed May 30, 2008.

Olson, Gary M. and Judith S. Olson. "Distance Matters." *Human Computer Interaction* 15 (2000): 139–178.

Onwuegbuzie, Anthony J., Q. G. Jiao, and S. L. Bostick. *Library Anxiety: Theory, Research, and Application*. Needham Heights, MA: Allyn & Bacon, 2004.

Ouchi, William G. *Theory Z: How American Business Can Meet the Japanese Challenge*. Reading, MA: Addison-Wesley Publishing, 1981.

Pacanowsky, Michael E. and Nick O'Donnell-Trujillo. "Communication and Organizational Cultures." *The Western Journal of Speech Communication* 46 (1982): 15–130.

Palen, Leysia and Amanda Hughes. "When Home Base is Not a Place: Parents' Use of Mobile Telephones." *Personal and Ubiquitous Computing* 11 (2007): 339–348.

Palen, Leysia and Marilyn Salzman. "Voice-mail Diary Studies for Naturalistic Data Capture Under Mobile Conditions." *ACM Conference on Computer-Supported Cooperative Work* (2002): 87–95. Available at: http://portal.acm.org/citation.cfm?id=587092. Last accessed May 30, 2008.

Paley, Vivian Gussin. *Wally's Stories: Conversations in the Kindergarten*. Cambridge, MA: Harvard University Press, 1981.

Pascale, Richard and Anthony Athos. *The Art of Japanese Management: Applications for American Executives*. New York: Simon & Schuster, 1982.

Patton, Michael Q. *Qualitative Evaluation and Research Methods*, 2nd edn. Newbury Park, CA: Sage, 1990.

Pennycook, Alastair. "Incommensurable Discourses?" *Applied Linguistics* 15 (1994): 115–138.

Pink, Daniel H. *A Whole New Mind: Why Right-brainers Will Rule the Future*. New York: Riverhead Books, 2005.

Pink, Sarah. "Performance, Self-representation and Narrative: Interviewing with Video." *Studies in Qualitative Methodology* 7 (2004a): 61–77.

Pink, Sarah. "Visual Methods." In *Qualitative Research Practice*, edited by C. Seale et al. Thousand Oaks, CA: Sage, 2004b.

Pink, Sarah. *The Future of Visual Anthropology: Engaging the Senses*. New York: Routledge, 2006.

Pink, Sarah. *Doing Visual Ethnography: Images, Media and Representation in Research*, 2nd edn. Thousand Oaks, CA: Sage, 2007.

Pridmore, Pat and Gill Bendelow. "Images of Health: Exploring Beliefs of Children Using the 'Draw-and-write' Technique." *Health Education Journal* 54 (1995): 473–488.

Pridmore, Pat and R. G. Lansdown. "Exploring Children's Perceptions of Health: Does Drawing Really Break Down Barriers?" *Health Education Journal* 56 (1997): 219–230.

Prosser, Jon and Dona Schwartz. "Photographs Within the Sociological Research Process." In *Image-based Research: A Sourcebook for Qualitative Researchers*, edited by Jon Prosser. London: Falmer Press, 1998.

Rapley, Timothy J. "The Art(fullness) of Open-ended Interviewing: Some Considerations on Analysing Interviews." *Qualitative Research* 1 (2001): 303–323.

Reis, H. T. and Patrick Shaver. "Intimacy as an Interpersonal Process." *Handbook of Personal Relationships*, edited by S. Duck. Chichester, England: Wiley, 1988.

Rieman, John. "The Diary Study: A Workplace-oriented Research Tool to Guide Laboratory Efforts." *ACM* (1993): 321–326.

Rodriguez, Joseph. *East Side Stories: Gang Life in East L.A.* New York: PowerHouse Books, 1998.

Rosenbloom, Stephanie. "On Facebook Scholars Link up with Data." *New York Times*, December 17, 2007. Available at: http://www.nytimes.com/2007/12/17/style/17facebook.html?_r=1&scp=1&sq=+facebook+scholars+link+data&st=nyt&oref=slogin. Last accessed May 30, 2008.

Rosenbloom, Stephanie. "Putting Your Best Cyberface Forward." *New York Times*, January 3, 2008. Available at: http://www.nytimes.com/2008/01/03/fashion/03impression.html?_r=1&scp=1&sq=Putting+Your+Best+Cyberface+Forward&oref=slogin. Last accessed May 30, 2008.

Rubin, A. M. "The Uses-and-gratifications Perspective of Media Effects." In *Media Effects: Advances in Theory and Research*, 2nd edn, edited by J. Bryant and D. Zillmann. Mahwah, NJ: Lawrence Erlbaum, 2002.

Ruby, Jay. "Exposing Yourself: Reflexivity, Anthropology, and Film." *Semiotica* 30 (1980): 153–179.

Ryan, Gery W. and H. Russell Bernard. "Techniques to Identify Themes." *Field Methods* 15 (2003): 85–109.

Schein, Edgar H. *Organizational Culture and Leadership: A Dynamic View*. San Francisco: Jossey-Bass Publishers, 1985.

Schneider, Sid J. et al. "Characteristics of the Discussion in Online and Face-to-face Focus Groups." *Social Science Computer Review* 20 (2002): 31–42.

Schwartz, Joan M. "*The Geography Lesson*: Photographs and the Construction of Imaginative Geographies." *Journal of Historical Geography* 22 (1996): 16–45.

Scollon, Christie N., Chu Kim-Prieto, and Ed Diener. "Experience Sampling: Promises

and Pitfalls, Strengths and Weaknesses." *Journal of Happiness Studies* 4 (2003): 5–34.

Seidel, John V. "Qualitative Data Analysis" (1998). Available at: ftp://ftp.qualis research.com/pub/qda.pdf. Last accessed May 30, 2008.

Sekula, Alan. "The Body and the Archive." *October* 39 (1986): 3–64.

Sellen, Abigail and R. H. R. Harper. "Video in Support of Organizational Talk." In *Video-mediated Communication*, edited by K. Finn, A. Sellen and S. Wilbur. Mahwah, NJ: Lawrence Erlbaum, 1997.

Seppänen, Janne and Esa Väliverronen. "Visualizing Biodiversity: The Role of Photographs in Environmental Discourse." *Science as Culture* 12 (2003): 59–85.

Sherwin, Richard K. "Law in Popular Culture." In *The Blackwell Companion to Law and Society,* edited by A. Sarat. Oxford: Blackwell, 2004.

Sherwin, Richard K., Neil Feigenson, and Christine Spiesel. "What Is Visual Knowledge, and What Is It Good For? Potential Ethnographic Lessons from the Field of Legal Practice." *Visual Anthropology* 20 (2007): 143–178.

Short, John E., Ederyn Williams, and Bruce Christie. *The Social Psychology of Telecommunications.* New York: John Wiley, 1976.

Sim, Julius. "Collecting and Analysing Qualitative Data: Issues Raised by the Focus Group." *Journal of Advanced Nursing* 28 (1998): 345–352.

Sin, Chih Hoong. "Seeking Informed Consent: Reflections on Research Practice." *Sociology* 39 (2005): 277–294.

Singer, Amy. "Focusing on Jury Focus Groups." A version appeared in *Trial Diplomacy Journal* (1996). Available at: http://www.case-strategy.net/brochures/analysis/ Focusing%20on%20Jury%20Focus%20Groups.pdf. Last accessed May 30, 2008.

Smithson, Janet. "Using and Analysing Focus Groups: Limitations and Possibilities." *International Journal of Social Research Methodology* 3 (2000): 103–119.

Sohn, Timothy et al. "A Diary Study of Mobile Information Needs." *Conference on Human Factors in Computing Systems* (2008): 433–442. Available at: http:// portal.acm.org /citation.cfm?id=1357054.1357125. Last accessed May 30, 2008.

Spiggle, Susan. "Analysis and Interpretation of Qualitative Data in Consumer Research." *Journal of Consumer Research* 21 (1994): 491–503.

Stachenfeld, Avi and Christopher Nicholson. "Blurred Boundaries: An Analysis of the Close Relationship Between Popular Culture and the Practice of Law." *University of San Francisco Law Review* 30 (1996): 903–912.

Stafstrom, Carl E. and Janice Havlena. "Seizure Drawings: Insight into the Self-image of Children with Epilepsy." *Epilepsy & Behavior* 4 (2003): 43–56.

Stafstrom, Carl E., Kevin Rostasy, and Anna Minster. "The Usefulness of Children's Drawings in the Diagnosis of Headache." *Pediatrics* 109 (2002): 460–472.

Stafstrom Carl E., Shira R. Goldenholz, and Douglas A. Dulli. "Serial Headache Drawings by Children with Migraine: Correlation with Clinical Headache Status." *Journal of Child Neurology* 20 (2005): 809–813.

Steele, Jeanne R. "Teenage Sexuality and Media Practice: Factoring in the Influences of Family, Friends, and School." *Journal of Sex Research* 36 (1999): 331–341.

Steele, Jeanne R. and Jane D. Brown. "Adolescent Room Culture: Studying Media in the Context of Everyday Life." *Journal of Youth and Adolescence* 24 (1995): 551–576.

Stenhouse, Lawrence. "Case Study and Case Records: Towards a Contemporary History of Education." *British Educational Research Journal* 14 (1978): 21–39.

Stetsenko, Anna. "The Psychological Function of Children's Drawing: A Vygotskian

Perspective." In *Drawing and Looking*, edited by Christiane Lange-Kuttner and Glyn V. Thomas. New York: Harverster Wheatsheaf, 1995.

Stevens, Patricia E. "Focus Groups: Collecting Aggregate-level Data to Understand Community Health Phenomena." *Public Health Nursing* 13 (1996): 170–176.

Stone, Arthur A., Ronald C. Kessler, and Jennifer A. Haythornthwaite. "Measuring Daily Events and Experiences: Decisions for the Researcher." *Journal of Personality* 59 (1991): 575–607.

Stone, Arthur A. et al. "Patient Non-compliance with Paper Diaries." *British Medical Journal* 324 (2002): 742–754.

Strack, Robert, Cathleen Magill, and Kara McDonagh. "Engaging Youth Through Photovoice." *Health Promotion Practice* 5 (2004): 49–58.

Streng, J. Matt et al. "*Realidad Latina:* Latino Adolescents, Their School, and a University Use Photovoice to Examine and Address the Influence of Immigration." *Journal of Interprofessional Care* 18 (2004): 403–415.

Suchar, Charles S. "Grounding Visual Sociology Research in Shooting Scripts." *Qualitative Sociology* 20 (1997): 33–55.

Tarantino, John. *Personal Injury Forms: Discovery and Settlement.* Santa Ana, CA: James Publishing, 2004.

Taylor, Alex S. and Harper, Richard. "The Gift of the *Gab*? A Design Oriented Sociology of Young People's Use of Mobiles." *Computer Supported Cooperative Work* 12 (2003): 267–296.

Tétreault, Mary Ann. "The Sexual Politics of Abu Ghraib: Hegemony, Spectacle, and the Global War on Terror." *NWSA Journal* 18 (2006): 33–50.

Thompson, Craig J., William B. Locander, and Howard R. Pollio. "Putting Consumer Experience Back into Consumer Research: The Philosophy and Method of Existential-phenomenology." *Journal of Consumer Research* 16 (1989): 133–146.

Trice, Harrison M. and Janice M. Beyer. "Studying Organizational Cultures Through Rites and Ceremonials." *Academy of Management Review* 9 (1984): 653–669.

Tufekci, Z. and K. L. Spence. "Emerging Gendered Behavior on Social Network Sites: Negotiating Between the Pull of the Social and the Fear of the Stalker." Paper presented at the annual meeting of the International Communication Association, San Francisco, 2007.

Tufte, Edward R. *The Visual Display of Quantitative Information*. Cheshire, CT: Graphics Press, 1983.

Tufte, Edward R. *Envisioning Information*. Cheshire, CT: Graphics Press, 1990.

Tufte, Edward R. *Visual Explanations*. Cheshire, CT: Graphics Press, 1997.

Turkle, Sherry. *Life on the Screen: Identity in the Age of the Internet*. New York: Simon & Schuster, 1995.

Underhill, Christina and Murrey G. Olmsted. "An Experimental Comparison of Computer-mediated and Face-to-face Focus Groups." *Social Science Computer Review* 21 (2003): 506–512.

Van House, Nancy and Morgan Ames. "The Social Life of Cameraphone Images." Pervasive Image Capture and Sharing Workshop (2005). Available at: http://fusion.sims.berkeley.edu/GarageCinema/pubs/pdf/pdf_A611A197-5FEA-45FC-A9D1259A8523DD6A.pdf. Last accessed May 30, 2008.

Vasari, Giorgio. *Lives of the Artists*. New York: Noonday Press, 1957.

Vetere, Frank et al. "Mediating Intimacy: Designing Technologies to Support Strong-tie Relationships." *Conference on Human Factors in Computing Systems* (2005):

471–480. Available at: http://portal.acm.org/citation.cfm?id=1054972.1055038. Last accessed May 30, 2008.

"Video Phones: Why is No One Calling?" CNN.com, September 5, 2000. Available at: http://archives.cnn.com/2000/TECH/computing/09/05/picture.phones.ap. Last accessed May 30, 2008.

Walker, Rob. "Is There Anyone There? The Embodiment of Knowledge in Virtual Environments." In *Current Perspectives on Applied Information Technologies. Volume I: Distance Learning*, edited by Charalambos Vrasidas and Gene Glass. Ann Arbor: University of Michigan Press, 2003.

Walker, Rob and Ron Lewis. "Media Convergence and Social Research: The Hathaway Project." In *Image-based Research*, edited by Jon Prosser. London: Falmer Press, 1998.

Walker, Rob and Susan Groundwater Smith. "Case Study and Case Records: A Conversation about the Hathaway Project." In *Images of Educational Change*, edited by Herbert Altrichter and John Elliott. Milton Keynes, UK: Open University Press, 1998.

Walther, Joseph B. "Interpersonal Effects in Computer-mediated Interaction: A Relational Perspective." *Communication Research* 19 (1992): 52–90.

Walther, Joseph B. "Computer-mediated Communication: Impersonal, Interpersonal, and Hyperpersonal Interaction." *Communication Research* 23 (1996): 3–43.

Walther, Joseph B. et al. "The Role of Friends' Appearance and Behavior on Evaluations of Individuals on Facebook: Are We Known by the Company We Keep?" *Human Communication Research* 34 (2008): 28–49.

Wang, Caroline C. "Photovoice: A Participatory Action Research Strategy Applied to Women's Health." *Journal of Women's Health* 8 (1999): 185–192.

Wang, Caroline and Mary Ann Burris. "Empowerment Through Photo Novella: Portraits of Participation." *Health Education Quarterly* 21 (1994): 171–186.

Wang, Caroline and Mary Ann Burris. "Photovoice: Concept, Methodology, and Use for Participatory Needs Assessment." *Health Education & Behavior* 24 (1997): 369–387.

Wang, Caroline C. and Cheri A. Pies. "Family, Maternal, and Child Health Through Photovoice." *Maternal and Child Health Journal* 8 (2004): 95–102.

Wang, Caroline C. and Yanique A. Redwood-Jones. "Photovoice Ethics: Perspectives from Flint Photovoice." *Health Education & Behavior* 28 (2001): 560–572.

Wang, Caroline, Mary Ann Burris, and Xiang Yue Ping. "Chinese Village Women as Visual Anthropologists: A Participatory Approach to Reaching Policymakers." *Social Science & Medicine* 42 (1996): 1391–1400.

Wang, Caroline C. et al. "Photovoice as a Participatory Health Promotion Strategy." *Health Promotion International* 13 (1998): 75–86.

Ward, L. Monique. "Talking About Sex: Common Themes about Sexuality in the Prime-time Television Programs Children and Adolescents View Most." *Journal of Youth and Adolescence* 24 (1995): 595–615.

Weare, Christopher and Wan-Ying Lin. "Content Analysis of the World Wide Web: Opportunities and Challenges." *Social Science Computer Review* 18 (2000): 272–292.

Weiss, R. S. *Learning from Strangers: The Art and Method of Qualitative Interviewing*. New York: Free Press, 1994.

Wesson, Michaela and Karen Salmon. "Drawing and Showing: Helping Children to Report Emotionally Laden Events." *Applied Cognitive Psychology* 15 (2001): 301–320.

Winerip, Michael. "Talking About Sex, Then Again, Maybe Not." *New York Times*, November 25, 2007. Available at: http://www.nytimes.com/2007/11/25/nyregion/nyregionspecial2/25Rparenting.html. Last accessed May 30, 2008.

Winerip, Michael. "Parenting: Talk to Parents About Sex? Yeah, Right." *New York Times* April 6, 2008. Available at: http://www.nytimes.com/2008/04/06/nyregion/nyregionspecial2/06Rparent.html?scp=3&sq=winerip&st=nyt. Last accessed May 30, 2008.

Yen, Yi-Wyn. "YouTube Looks for the Money Clip." CNN.com, March 25, 2008. Available at: http://techland.blogs.fortune.cnn.com/2008/03/25/youtube-looks-for-the-money-clip/. Last accessed May 30, 2008.

Yin, Min and Shumin Zhai. "The Benefits of Augmenting Telephone Voice Menu Navigation with Visual Browsing and Search." *Conference on Human Factors in Computing Systems* (2006): 319–328. Available at: http://portal.acm.org/citation.cfm?id =1124772.1124821. Last accessed May 30, 2008.

Yin, Robert K. "The Case Study Crisis: Some Answers." *Administrative Science Quarterly* 26 (1981): 58–65.

Yin, Robert K. *Case Study Research: Design and Methods*, 3rd edn. Thousand Oaks, CA: Sage, 2003.

Young, Lorraine and Hazel Barrett. "Adapting Visual Methods: Action Research with Kampala Street Children." *Area* 33 (2001): 141–152.

Index